"The men and women who
rode the freedom buses
through Alabama, who
walked in Montgomery, who
knelt in prayer in Albany,
who hold and sing
We Shall Overcome Some Day
in the face of hostile mobs—
their acts cry out for
songs to be sung about them
and pictures to
be painted of them."

—Dr. Martin Luther King, Jr. in a statement printed for the
April 1963 announcement for "Freedom Riders",
an exhibition of artwork by May Stevens at the Roko Gallery, NYC.

In the Spir

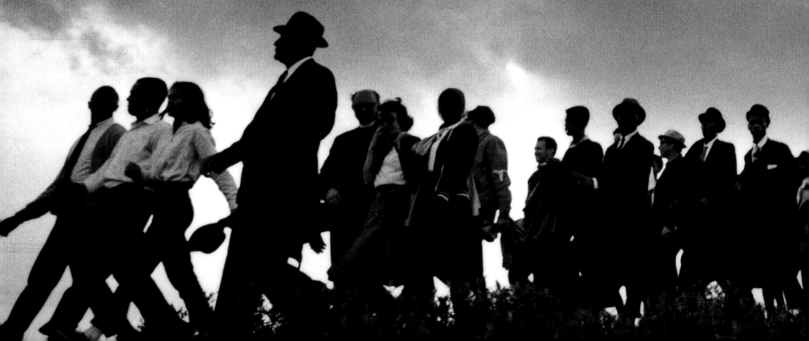

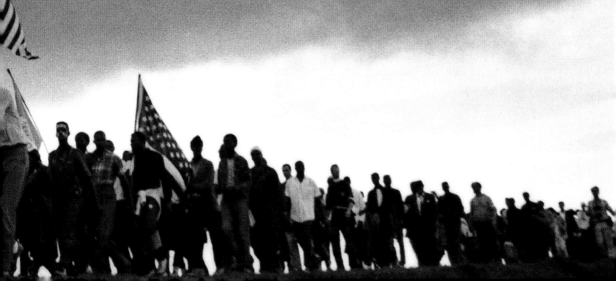

OF MEN

...ING LEGACY OF DR. MARTIN LUTHER KING, ...

GRETCHEN SULLIVAN SORIN • HELEN M. SHANNON

ON THE LIFE OF MARTIN LUTHER KING, JR.:
DR. WALTER LEONARD • NIKKI GIOVANNI • JULIUS LESTER
...NE JORDAN • STANLEY CROUCH • CONGRESSMAN JOHN LEWIS
BERNICE JOHNSON REAGON • DONZALEIGH ABERNATHY
GWENDOLYN BROOKS

CREATED AND DEVELOPED BY
GARY MILES CHASSMAN

TINWOOD BOOKS

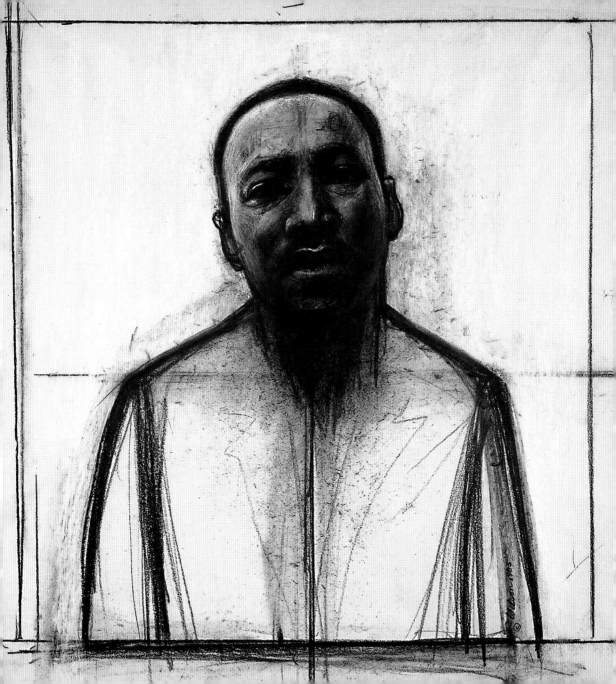

In the Spirit of Martin
THE LIVING LEGACY OF DR. MARTIN LUTHER KING, JR.

📖 DESIGNATES ART NOT INCLUDED IN EXHIBITION.

(PREVIOUS PAGE) THE SELMA TO MONTGOMERY MARCH, MARCH 21-25, 1965, JAMES H. KARALES (1930-), GELATIN SELVER PRINT, 16" x 20", COURTESY OF THE ARTIST, CROTON-ON-HUDSON, NY (OPPOSITE) STUDY FOR SCULPTURE OF MARTIN LUTHER KING JR., 1985, JOHN WILSON (1922-), CHARCOAL AND PASTEL, 20-3/16" x 21-5/16", MUSEUM OF FINE ARTS, BOSTON, MA © JOHN WILSON/LICENSED BY VAGA, NEW YORK, NY

IN THE SPIRI

This is a sacred poem...blood has been shed to consecrate it...
wash your hands...remove your shoes...bow your head
 ...I...I...I Have a Dream

 That was a magical time...Hi Ho Silver Away...
Oh Cisco/Oh Pancho...Here I Come To Save The Day...
I want the World to see what they did to my boy...
 No No No I'm not going to move...*If we are Wrong...
then the Constitution of the United States is Wrong*
...Montgomery...Birmingham...Selma...Four little Girls...
Constant Threats...Constant Harassment...Constant Fear...
 SCLC...Ralph and Martin...Father Knows Best...
Leave It To Beaver...ED SULLIVAN...*How Long...Not Long*

But what...Mr. Thoreau said to Mr. Emerson...are you doing out?

 This is a Letter from Birmingham City Jail...
This is a eulogy for Albany...This is a water hose for Anniston...
 This is a Thank You to Diane Nash...
 This is a flag for James Farmer...
This is a HowCanIMakeItWithoutYou to Ella Baker...
This is for the red clay of Georgia that yielded black men of courage...
 black men of vision...black men of hope...
 bent over cotton...or sweet potatoes...or pool tables and
baseball diamonds...playing for a chance to live free and
 breathe easy and have enough money to take care of
the folks they love...*This is Why We Can't Wait*

T OF MARTIN

That swirling Mississippi wind...the Alabama pine...
that Tennessee dust defiling the clothes the women washed...
thosehotwinds...the lemonade couldn't cool...
that let the women know...we too must overcome...
this is for Fannie Lou Hamer...Jo Ann Robinson...
Septima Clark...Daisy Bates ... All the women who said
Baby Baby Baby I know you didn't mean to lose your job...
I know you didn't mean to gamble the rent money...
I know you didn't mean to hit me...
I know the Lord is going to make a way...
I know I'm Leaning On The Everlasting Arms

How much pressure...does the Earth exert on carbon...
to make a diamond...How long does the soil push against the flesh...
molding... molding...molding the moan that becomes a cry that
bursts forth crystalline...unbreakable...priceless...incomparable Martin...
I Made My Vow To The Lord That I Never Would Turn Back...
How much pressure do the sins of the world press
against the heart of a man who becomes the voice of his people...
He should have had a tattoo, you know...Freedom Now...
or something like that...should have braided his hair ...
carried his pool cue in a mahogany case...
wafted that wonderful laugh over a plate of skillet fried chicken...
drop biscuits...dandelion greens on the side

This is a sacred poem...open your arms...turn your palms up...
feel the Spirit of Greatness...and be redeemed

—Nikki Giovanni

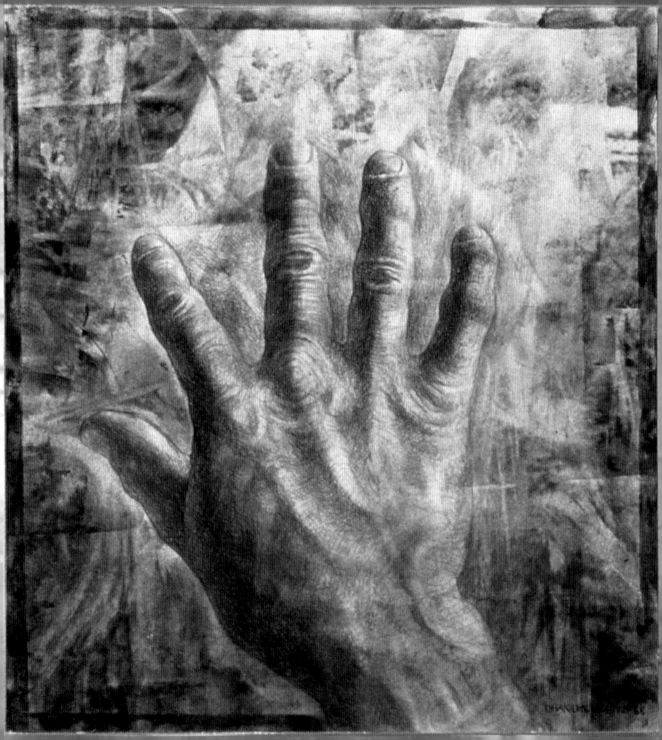

MARTIN LUTHER KING, JR.–THE MAN AND HIS MISSION

DR. WALTER J. LEONARD

A BRIEF EXAMINATION OF THE LIFE AND WORK OF THE REVEREND DOCTOR MARTIN LUTHER KING, JR., CALLS FOR A LOOK AT THE SOCIO-ECONOMIC, POLITICAL, RELIGIOUS, AND MORAL SETTING OF HIS EARLY LIFE: WE RECALL THE ENVIRONMENT, THE UNIVERSE THAT PRODUCED, PREPARED, AND NURTURED THE MAN WHO BECAME A MARTYR AND A PROPHET; WE FOLLOW THE DECISIONAL MID-PASSAGE THROUGH WHICH THE YOUNG PREACHER TRAVELED ON HIS WAY TO ACCEPTING THE CHARGE TO GIVE THE FULL MEASURE OF HIS BEING INTO SACRIFICE AND SERVICE; WE ARE INFORMED BY THE PROGRESSION OF HIS STRATEGY–FROM SUPPLICATION TO DEMAND, ALWAYS WITH DIGNITY, GRACE, AND RESPECT; WE CAN HEAR HIS WORDS OF COURAGE, AGONY, AND TRIUMPH; WORDS THAT ARE FLORID, POET-IC, STRONG, AND SWEEPING; WE STAND WITH HIM AT THE PULPIT OF ACCEPTANCE WHERE, AS A NOBEL LAUREATE, HE PREACHED A SOCIAL GOSPEL AND A CIVIL RELIGION TO THE WHOLE WORLD; AND WE CONTEMPLATE WHAT HE MIGHT SAY TO HIS NATION TODAY–AND MORE ESPECIALLY TO AFRICAN AMERICANS, YOUNG AND OLD. □ BORN IN ATLANTA, GEORGIA ON JANUARY 15, 1929, THE SECOND CHILD OF ALBERTA WILLIAMS AND THE REVEREND MICHAEL KING, SR.; HIS NAME WAS CHANGED FROM MICHAEL TO MARTIN LUTHER, ALONG WITH HIS FATHER'S IN 1934. MARTIN'S GREAT-GRAND-PARENTS, LIKE MY OWN, HAD BEEN VICTIMS AND SURVIVORS OF AMERICA'S HOLOCAUST: CHATTEL SLAVERY. THE LIVES OF HIS PARENTS, LIKE THOSE OF EVERY OTHER AFRICAN AMERICAN, WERE FILLED WITH EVERYDAY HURTS, HUMILIATIONS, REJECTIONS–THE CRIPPLING INSULTS OF SEGREGATION AND THE VENOM OF RACIAL BIAS. THESE ACTS

of denial and deprivation were so much of the legacy. And of the resolve, that Dr. King inherited. These factors fueled a persistent and undiluted quest for freedom; a bold determination to end the African American's long experience of cruelty and suffering; and nurtured his very strong belief in America's positive possibilities.

January 15, 1929—it was the eve of the Great Depression. Black workers, already suffering from the piercing stings of employment discrimination, were being paid less than half that paid to white workers, the black codes of segregation were rigidly enforced. Jim Crow was a way of life: buses, trains, schools, hospitals, housing, employers, colleges, universities, and all public accommodations made skin color the first line of acceptance or denial. Either by law in the South or by a so-called gentleman's agreement in the North, the economic and social realities of U.S. Apartheid were forcing and tightly entrapping more and more black Americans into the urban and rural slums.

The America of the 1920s was not a friendly place for black people. Lynchings, Ku Klux Klan raids, and police murder and brutality were commonplace. In fact, the black township known as Rosewood, Florida, and most of the African American community of Tulsa, Oklahoma, had been burned to the ground by white mobs. Such killings and violence usually followed false charges of rape or sexual encounters between black men and white women. Only a rumor was needed; the truth never seemed important. It was a mean and hypocritical America into which Martin Luther King, Jr., was born.

Martin Luther King, Jr. was fortunate—because of the relative position of his father—he was born into comfort and security, compared to thousands of other black children. But he shared a common burden with the poorest of these: He was black—a black baby born in the United States of America. His very color, and nothing else, declared him inferior, second-class, and unwanted by the majority of his fellow citizens. More than 300 years of myths and lies had declared him a nobody in his native land.

If we assume that the average life span of the black American, during and immediately following slavery, was 45 years, by 1929 African Americans had suffered and survived more than seven lifetimes of dehumanization. That history and that reality helped to shape the life of Martin King, Jr. These experiences, plus his studies at Atlanta's Booker T. Washington High School, Morehouse College, Crozer Theological Seminary, Boston and Harvard Universities, prepared the young preacher to confront America's long and constant shadow of hate and injustice and its struggle to become a democratic society. Nurtured by, and grounded in, the theology of Benjamin E. Mays, and influenced by George Kelsey and others, especially Mahatma Gandhi, Martin King was prepared for Montgomery and Memphis, and his rendezvous with destiny, history, and greatness.

Mrs. Rosa Parks, a calm and confident 43-year-old, law-abiding and very brave black seamstress, tired from a long day's work, paid her fare and took the first vacant seat on the Cleveland Avenue bus. The downtown section of Montgomery was crowded with shoppers, and the bus was soon filled to capacity. The bus driver, following customs of the day, ordered several black people to vacate their seats for white passengers. A few people moved, but Mrs. Parks did not budge; she refused to move!

Her refusal to accept further humiliation added fuel to a rising flame of self-worth; it accelerated the demand to end too many years of brutal attacks and intimidation. It was as if Langston Hughes' words had suddenly become the battle cry:

Freedom will not come

Today, this year

Nor ever

Through compromise and fear.

The Montgomery Movement—the drama and tension of the Boycott became a reality. According to Rev. King, for more than a year:

"...50,000 [black folk]...took to heart the principles of nonviolence...and fought...for their rights with a weapon of love...and in the process, acquired a new estimate of their own worth."

It was reported that one aged sister, when asked whether she was tired, responded, "My feets is tired, but my soul is at rest." But someone had to lead. Someone had to be a spokesperson. Someone had to negotiate. Someone had to inspire, plan, invoke, strategize, and articulate their demands and expectations. Martin Luther King, Jr.'s national and international ministry began on December 1, 1955. His active ministry would reach some 13 years into the future; it would span most of the second reconstruction.

The Dexter Avenue Baptist Church, located across the square from the Alabama State House, had recently appointed him their new pastor. His was a new voice in town. He had not become involved in the local politics, and his manner had won the respect of the black leadership in Montgomery.

Martin faced a staggering challenge. Those who control America had spent billions of dollars and more than 300 years enslaving the body and trying to destroy the spirit and the mind of black men and women. For years, the wives and daughters of black men had been raped and defiled, and too many of their sons had been beaten, jailed and mutilated. So powerful had been the mental genocide that many black people had reached a point of hating and destroying themselves.

So Martin knew that his first task was to build, and to rebuild, most of his own people; he had to rekindle and quicken that desire for freedom; to remove those negative mental chains; and to cause black men and women to declare, "I am somebody!" And cause them to believe, "There is nothing wrong with being black!" (After so many years of brainwashing, and facing daily false pronounce-

ments of black inferiority, it was difficult to get some black people to accept the fact that they were black, and that it was all right.) Facing such a negative history, how could he motivate, how could he coalesce the energies of millions of black people? With such a task before him, he had to determine what tools he would use. What would be his modus operandi?

So many have asked, what manner of man was Rev. King? Why had God selected him for this task? We saw him as a compassionate, honest, warm, and wise individual. One who relished intellectual and verbal debate; he loved good jokes; and his conversation sparkled with wit and wisdom. He used his gift of speech to its maximum. Words, to Dr. King, were to be employed like arrows, used like sledgehammers, or to be uttered like a soothing balm. With words, he could give friendship to the lonely; with words he could provide direction for the lost. With words, Martin could give hope to the poor and courage to those in fear. With his magnificent mastery of language, he could call forth that legacy of pride, and that reservoir of determination which have sustained oppressed people since the dawn of creation.

So, Martin Luther King, Jr. would speak to his people, and he would speak to his nation. And speak he did! Sometimes he spoke with a sharpness and stirring plea. At all times, he spoke with a sense of urgency, begging his country to put aside its dogma of racism and segregation, to bury its legacy of bias and hate.

Martin King had studied the history of past civilizations; he knew how they had disintegrated from within; he knew the folly and the danger of America's attempt to maintain an exploited colony, a second-class nation, within its borders. He knew, all too well, the great, great debt that American society and the western world owed, and still owe to black people. So, like a combination of Toussaint L'Overture, Nat Turner, Frederick Douglass, Monroe Trotter, Booker T. Washington, Charles Fortune, and W.E.B. Du Bois, he called on his people to rise up and throw off their chains. And he called on his nation to live out its creed: to take heed, and live according to the moral and religious pronouncements in its heritage.

Yes, he would lead by instruction and example. He would be beaten; he would be spat upon; he would be stabbed; his home would be bombed; his wife and children would be cursed and threatened; he would be jailed more than 30 times; and, eventually he would be assassinated. But, for now, he had work to do.

First, he recognized that there was the imbalance of power: his opponents were armed with cannons. Like the pharaohs of old, they had armies, while black people, his people, had B.B. guns. It would be suicidal to demand an armed confrontation. So, what weapons would he and his people use? He, himself was a pacifist and a strong advocate of nonviolence. But could he persuade Black America, once moved to a point of demanding immediate change, and once face-to-face with the most blatant of racial hatred; could he control that pent-up anger? He would try. He would preach and teach by showing his unswerving commitment to nonviolence—to the Gandhian principle of satyagraha. He told his people:

"I am convinced that the method of nonviolent resistance is the most potent weapon available to oppressed people in their struggle for freedom and human dignity. Therefore, I have advised all along that we follow the path of nonviolence, because if we ever succumb to the temptation of using violence in our struggle, unborn generations will be the recipients of the long and desolate night of bitterness..."

Lest he be misunderstood, as he often was, he quickly added:

"I do not want to give the impression that nonviolence will work miracles overnight. Men are not easily moved from mental ruts or purged of their prejudice or irrational feelings. When the underprivileged demand freedom, the privileged first react with bitterness and resistance. Even when the demands are couched in nonviolent terms, the initial response is the same— the nonviolent approach does not immediately change the heart of the oppressor. It first does something to the hearts and souls of those committed to it. It gives them a new self-respect; calls up resources of strength... it calls up... courage that they did not know they had. Finally it reaches the opponent and so stirs his conscience that reconciliation becomes a reality."

Many who followed Martin King found it difficult, in some of the days and events of the 1960s, to remain committed to the pledge of nonviolence. I recall a meeting where one follower asked, "M.L., what am I supposed to do when I have been slapped on two cheeks and kicked on the other two? At that point, I don't have any more to turn." Martin laughed heartily, but, understanding the statement, he quickly replied:

"Violence must never come from us... If we become victimized by violent acts... the pending daybreak of progress will be transformed into a gloomy midnight...."

Dr. Benjamin E. Mays, eulogizing Rev. King, told the world and the nation:

"I make bold to assert that it took more courage for Martin Luther to practice nonviolence than it took his assassin to fire the fatal shot. The assassin is a coward. He committed his dastardly act and fled. When Martin Luther disobeyed an unjust law, he suffered the consequence of his action. He never ran away and he never begged for mercy."

Martin King journeyed from one end of the United States to the other. From Birmingham to Boston; from Albany, Georgia to Augusta, Maine; from Dallas to Detroit; from Nashville to New

York; Charleston to Chicago; from Savannah to Seattle; from Manchester to Memphis—he left his footprints on the swell and sweep of a nation in conflict with itself. Like the Apostle Paul, the Prophet Isaiah, and John the Baptist, he generated a searching quickness in the hearts and minds of those who would listen. In bold, brave, challenging, and clear words he called on the United States to face the African American and the deprivation against which he struggled.

He said, *"Rationalization and the incessant search for scapegoats are the psychological cataracts that blind us to our individual sins."* Observing the nation's practices of blaming the victim, Martin King observed:

"It would be neither true nor honest to say that the Negro's status is what it is because he is innately inferior or because he has not sought to lift himself by his own bootstraps."

He added:

"...It is of no use to cite [or look for] comparisons with other races [or other groups]; there is no parallel. No other people was brought here in bondage and held in bondage... and there is not a section of the country that can discuss the matter of brotherhood with clean hands."

It was convincingly clear to him that the tendency to compare and equate the status of black people with that of other ethnic groups would undermine the national urgency to correct the many inequities which are so firmly rooted in racial conflict and racial bigotry.

Martin King called for an eradication of poverty, an end to exploitation by the corner store and the downtown merchant, a seat in the halls of power and prestige, an equitable share of the nation's resources, and a redefinition and realignment of class and power relationships. At that point, the majority of white Americans retreated from the Civil Rights Struggle. Many, if not most, white Americans who had registered outrage over the brutal and indecent social treatment of black citizens found no emotional outlet in the African American's fight for economic, educational, and political justice. Indeed, many former allies and friends abandoned the struggle, and some even characterized our persistence as ingratitude and looked upon meager advancement as some sort of unfair competition.

Martin King had seen this coming. He warned his people, and the nation that,

"The real cost lies ahead. The stiffening white resistance is recognition of that fact. The discount education given Negroes will, in the future, have to be purchased at full price if quality education is to be realized. Jobs are harder and costlier than voting rolls. The eradication of slums, housing millions, is complex far beyond integrating buses and lunch counters."

Rev. King proclaimed:

"Laws are passed in a crisis mood after a Birmingham or a Selma [I would add Los Angeles], but no substantial fervor survives the for-

mal signing of legislation. The recording of the Law itself is treated as the reality of reform. The... cost of change for the nation up to this point has been cheap. The limited reforms have been obtained at bargain rates. There are no expenses and no taxes required for Negroes to share lunch counters, libraries, parks, hotels and other facilities with whites. Even the psychological adjustment is far from formidable."

Then there was the Vietnam War, one of the most agonizing experiences of his life. How could he call on angry, young, black men in Atlanta, Boston, Chicago, Detroit, Los Angeles, Newark, and Washington to engage in nonviolence, when one could point to the United States as the greatest purveyor of violence during that war? He could not stand apathetic and silent while his nation spent thousands to kill a Vietnamese soldier and less than 100 dollars a year toward a better life for a needy, poor person of his country. So he risked his reputation and he risked his life as he called his country to return to its professed reverence for human rights and human life.

Can we imagine some thoughts he might share if he were with us today? I believe he would wonder what has gone wrong with voting rights. I am persuaded that he would be very unhappy with the state of things relative to employment, housing, educational opportunities, and the general enforcement of Constitutional and legislated civil rights. He would find that for about three years following his death the nation and its institutions discovered black people and began an effort toward erasing centuries of inequities.

Colleges and universities developed positive recruitment and admissions plans; private industry promulgated affirmative hiring and training programs; organized labor and the National Association of Manufacturers were trying to promote greater opportunities for black people; the Congress, the Supreme Court, and the President were working and acting cooperatively in support of basic rights; and many, many organizations and other groups were actively seeking ways to keep America's promises—to assist the needy and the oppressed; to provide for equity and equality.

He would find that much of that has changed. While Jim Crow is dead—yes, and I believe buried—his more sophisticated, college-trained, urbane cousin, J. Crow, Esquire, seems to be alive and well. J. Crow, Esquire, finds his effectiveness through the Hopwood Case in Texas and Proposition 209 in California, and through the writings and speeches of the neo-conservatives and the one-time liberals; through attempts to use the civil rights acts and the 13th, 14th, and the 15th Amendments to the Constitution against black people—the very group for whose protection and advancement the amendments and acts were intended to assure.

Martin King would find that so-called benign neglect should be more particularly described as malignant retreat; and that such conduct is again rapidly becoming the national, public, and private pos-

ture toward America's non-white groups. Moreover, he would find the old racism, enveloped in the new soft tones and intellectual garb of sociology and psychology. He could listen to the dictionary of negative terminology now employed to describe his people:

"Culturally deprived," "slow learners," "children of crisis," "educationally deprived," "underachievers," "ghetto children," "poor testers," "maladjusted," "products of disintegrated families," "poverty-prone," "special admits."

And that we represent:

"Academic insufficiency," "dilution of quality," "inherent incapacity," "inner-city children," "vouchers," "at-risk groups," "cultural minority," "educationally sub-normal," "urban mentality," "inferior background," "unqualified," "minority-conditioned."

Additionally, he would notice how the struggle of black people is being characterized as one demanding "reverse discrimination," "preferential treatment," and "quotas." He would know that such shibboleths, obscurants, and loaded language are designed to produce racial paranoia and to promote group conflict. He would be saddened.

He would ask America to pay attention to the well-being of its black citizens; pay as much attention as it has to the welfare of the British, Cubans, Germans, Greeks, Irish, Chinese, Vietnamese, Bosnian, Japanese, Israelis, Poles, Egyptians, Russians, Mexicans, and all of the other nations and people who have climbed to a point of security through an infusion of billions of American tax dollars—dollars made possible, in large measure, by the billions earned, but never received, by black Americans. He would ask: "*Why has there never been a 'Marshall Plan' for those who have suffered the most at the hands of America and Europe; slaves and their descendants?*"

It had long been the hope that America's large and richest corporations were beginning to modify some of the ugliest forms of bias and discrimination. But Dr. King would be distressed to read the names and negative records of so many for whom racism is business as usual. And he would see proof of racist acts by dozens of federal agencies, including the U.S. Supreme Court, the Secret Service, the F.B.I., the State Department, and the Capitol Police.

And there are other contemporary matters that would command his attention:

1. The murder/killing and emotional destruction of our children—how our black children are killing each other, and how white children are killing themselves, and are now beginning to kill each other.

2. The continuing retreat by both political parties from the goals of equality and fair play.

3. The neglect and near-destruction of the public school system.

4. The ease with which the world's richest country can tolerate hunger, homelessness, disease, and suffering.

5. The open and calculated appeals to raw and unmitigated racism.

6. He would remind us that America's most pressing issue remains black and white relations, and that race relations will remain a central concern for a long time to come. He would admonish America to understand that denial of its racial divide can only do further harm to its future.

7. He would ask why so many powerful people in the federal government seem to have taken a contract on poor people; and why has the District of Columbia been singled out for the brunt of so much meanness and disgraceful treatment?

He would remind African Americans that the challenges we face in 2002 are not different from those of 1902—which were the same as the challenges of 1802: arrogance, bigotry, greed, hypocrisy, racism, and sexism. But he would admonish us to understand that these evils have been modified, have become far more sophisticated, and far more ominous.

Dr. King would tell young men and women to be aware of the implications of automation, computers, and a rapidly changing global economy—an economy and a production system that no longer needs nor wants the mind and muscle of the colored, Negro, Afro-American, black, and African men and women who created the foundations of America's power and wealth.

He would advise that racism has tools which are more invisible, more powerful. An example is the racist use of the media: almost on a daily basis programs and news stories are represented in ways to penetrate the minds, hearts, souls, and thoughts of African Americans, and other disinherited people—stories presented in ways that rob them of self-esteem, destroy hope, erase pride, and imprison them in a mind-set of self-doubt and self-hate.

He would tell us not to forget that we started this trek far behind those who would do us harm. And, he would remind us, in the words of Benjamin E. Mays:

"One who starts behind in the race of life must run faster than the man in front or forever remain behind."

He would tell his people that you do not have to remain behind; you do not have to fear competition; you do not have to wonder whether you can catch up, or overcome the slander, the persecution, the violence, and the denial. All you need is a chance to use your God-given talents; an opportunity to show the world your skills; an avenue in which to share your genius with humanity.

He would admonish this generation of African Americans to be mindful of the fact that colored people and Negroes built banks, churches, educational institutions, stable families, proud communities, and strong organizations; and that black people and African Americans must be about the business of saving, restoring, and enhancing these many treasures.

13

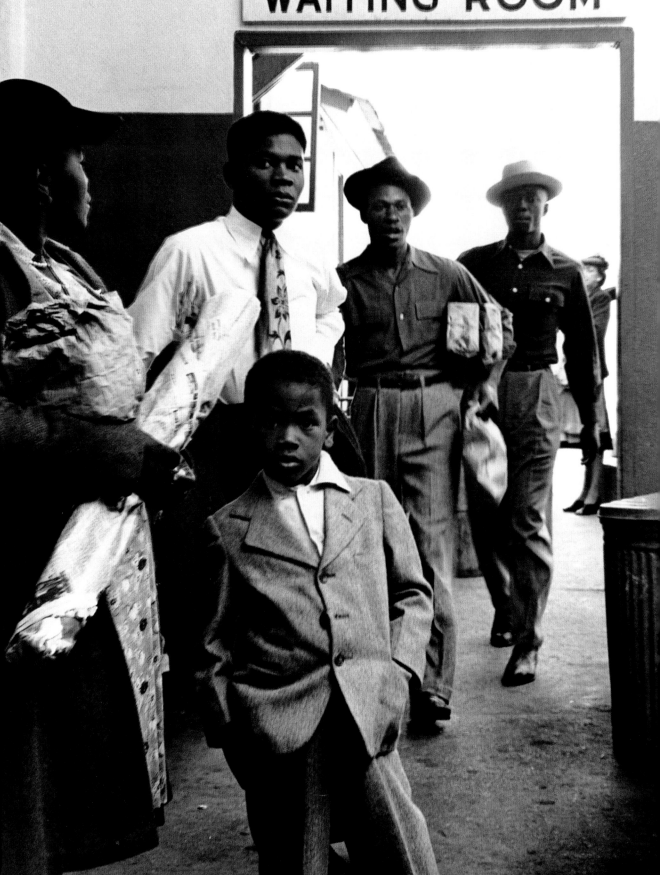

MARTIN LUTHER KING, JR.
AND THE ENDURING STRUGGLE
FOR FREEDOM

GRETCHEN SULLIVAN SORIN

THE BLACK FREEDOM MOVEMENT OF THE 1950s AND 1960s WAS PART OF A LONG LEGACY OF AFRICAN AMERICAN PEO-PLE—UNENDING AGITATION FOR CIVIL RIGHTS, INFUSED WITH STRUGGLE, TRIUMPH, AND PERSEVERANCE. FROM THE MOMENT THE FIRST AFRICANS SET FOOT ON THE SHORES OF THE NEW WORLD THEY RESISTED SLAVERY AND OPPRES-SION. THEY DID THIS IN MYRIAD WAYS, BOTH OVERT AND SUBTLE AS BONDSMEN AND AS FREE MEN AND WOMEN. THROUGH THEIR ACTIONS THEY PERSISTENTLY PUSHED THE LIMITS OF AMERICAN DEMOCRACY, MAKING IT MORE INCLUSIVE. ☐ THEY RAN AWAY. THEY TOOK UP ARMS ABOARD THE AMISTAD. THEY WROTE BOOKS AND POETRY ABOUT THEIR EXPERIENCES. THEY HELPED THEIR ENSLAVED BRETHREN ESCAPE. THEY PUBLISHED NEWSPAPERS. THEY PETI-TIONED THE GOVERNMENT. THEY EDUCATED THEIR CHILDREN. THEY ENDURED SLAVERY, DISCRIMINATION, LYNCH-ING, SEGREGATION, AND INDIGNITY. THEY FOUGHT BRAVELY IN EVERY AMERICAN WAR. THEY MARCHED IN SILENT PROTEST. THEY BUILT A STRONG FOUNDATION FOR THE MODERN CIVIL RIGHTS MOVEMENT. ☐ THROUGHOUT THESE THREE HUNDRED YEARS, AFRICAN AMERICANS EXPRESSED THEMSELVES THROUGH MUSIC, PAINTINGS, QUILTS, SCULP-TURE, AND DANCE. THESE CREATIONS ASSERTED AND CELEBRATED AFRICAN AMERICAN IDENTITY, DOCUMENTED PIV-OTAL EVENTS, AND PROTESTED AGAINST INJUSTICE. IN THE MORE THAN THIRTY YEARS SINCE THE ASSASSINATION OF MARTIN LUTHER KING, JR. A VERY SIGNIFICANT BODY OF ARTWORK RELATED TO HIS LIFE AND WORK SIMILARLY DEVELOPED, REFLECTING ONGOING CONCERNS ABOUT THE CONTINUING CIVIL RIGHTS STRUGGLE AND THE ENDUR

(OPPOSITE) TO THE COLORED WAITING ROOM, 1945-1949, MARION PALFI (1917-1978), GELATIN SILVER PRINT 13-1/3″ X 10-3/8″. HIGH MUSEUM OF ART, ATLANTA, GA; COURTESY OF LORETTA MORGENSTERN, LOS ANGELES, CA (ABOVE) SLAVE WITH INVENTORY NUMBER, 1860, UNIDENTIFIED PHOTOGRAPHER, ALBUMEN PRINT CARTE-DE-VISITE, 4″ X 2 -1/2″. THE BURNS ARCHIVE, NEW YORK, NY

ing nature of his message. This message reflects not only the voices of black Americans, but also many others who shared King's vision of the Beloved Community and were inspired by his life. The work of these artists is collected in this book and exhibition for the first time. Gary Chassman, a Vermont book publisher and art lover, began gathering the paintings, sculpture, and public murals representing Dr. Martin Luther King's legacy for this book. Personally inspired by the ideals by which Dr. King lived his life, Gary soon realized that the visual impact of these works and the importance of bringing them to a large audience demanded both a permanent record on these pages, but also the dramatic presentation of an exhibition. He set about to find a curatorial team and an exhibition collaborator—the Smithsonian Institution Traveling Exhibition Service. This book and the exhibition are the

events of that time became metaphors for injustice and outrage again and again. At its core, *In the Spirit of Martin* is about the tremendous outpouring of artistic expression in many different forms in memory of Dr. Martin Luther King, Jr. by people of different background and different colors. Most of this artwork was created since his death, but some of the pieces were made during the tumult of the Movement. This is the legacy of one man who had the power to inspire generations. Yet, as you will see, that one man stands on the shoulders of thousands of others with the courage to stand up for civil rights and social justice. This essay provides an overview of the themes of the exhibition and the curators' interpretation of Dr. King's legacy seen through the eyes of artists.

In the 1950s, as the NAACP led the battle in the courts, Martin Luther King emerged as the leader of hundreds of demonstrators who took to the streets in direct action against segregation in the South. The Montgomery Bus Boycott became one of the early events to launch the civil rights struggle. It is also one of the events that had great resonance for artists and photographers, thus gaining a permanent place in our visual history. It started when Rosa Parks refused to give up her seat for a white passenger. It continued for more than one year after her arrest as the determined African American citizens of Montgomery walked or carpooled to work rather than ride the segregated buses. "Love your enemies," Dr. King implored the crowd at the Dexter Avenue Baptist Church in Montgomery, where the black community gathered during the boycott.

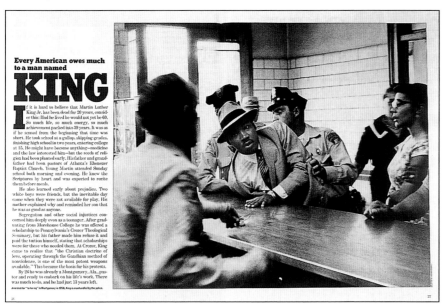

(ABOVE) LIFE SPECIAL ISSUE, THE DREAM THEN AND NOW, SPRING, 1988. FROM STORY DEPICTING THE ARREST OF DR. KING. ☐ (BELOW) ABOVE AND BEYOND THE CALL OF DUTY, DORRIE MILLER WITH HIS NAVY CROSS AT PEARL HARBOR, MAY 27, 1942. DAVID STONE MARTIN (1913-92), COLOR-OFFSET POSTER. LIBRARY OF CONGRESS, WASHINGTON, DC

realization of Gary's dream, and a tribute to his personal commitment to furthering race relations and social justice through education and public dialogue.

You will not find a complete history of the black freedom struggle here, although many of the events of the Civil Rights Movement inspired artists to create paintings and sculpture commemorating them. Many of these works will transport you back to the turbulent days when the evening news included scenes of vicious dogs attacking demonstrators, and angry-faced bullies taunting children on their way to school, although they may have been painted years later. The

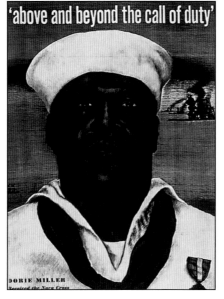

From his pulpit, a young Martin King would lead this growing movement of people who would push the country to live up to the ideals of its Declaration of Independence. A deep personal belief in Christian values and the ideas of Mahatma Gandhi in support of the oppressed people of India nurtured King's philosophy of non-violent social action. It grew into a powerful tool for social change—a powerful weapon of resistance. As African Americans pushed to close the chasm between the promises of American democracy and its reality, King's message mirrored the rhetoric of the founding fathers.

"If we are wrong, the Constitution of the United States is wrong. If we are wrong, God Almighty is wrong. If we are wrong, Jesus of

Nazareth was merely a utopian dreamer and never came down to earth! If we are wrong justice is a lie."

—MLK, Montgomery Bus Boycott, 1955

As the violent response to the non-violent movement escalated after Montgomery, the demonstrators required particular resolve. "We know through painful experience," wrote Dr. King from his Birmingham, Alabama, jail cell, "that freedom is never voluntarily given by the oppressor; it must be demanded by the oppressed."

Civil rights workers faced vicious dogs, guns, angry mobs wielding bats and chains, fire hoses, policemen, and jail with courage and song. With student sit-ins, marches, freedom rides and voter registration drives they attacked segregation in the South with Gandhian principles, meeting force with love escalating violence with nonviolence. Gradually reporters, particularly those in the

to jail. King knew the power of these images. As historian David Halberstam notes, journalists helped to move the Civil Rights Movement along more quickly, and thus the pace of social change. Artists responded powerfully to these dramatic events, constructing their own visual history. King's arrest in Birmingham, the Birmingham Church bombing, the slaughter of civil rights workers Goodman, Chaney, and Schwerner, the 1965 March on Washington, and the confrontation at the Pettus Bridge became the events indelibly preserved in memory through an outpouring of emotion on canvas and paper for many years afterward. Mainstream magazines like *Life* and *Look* brought people face-to-face with the courage of the demonstrators through Harvey Dinnerstein's sketches. The ugly violence of attacks on peaceful protesters was framed for readers by the photographer's lens. Similarly, Norman Rockwell's *The Trouble*

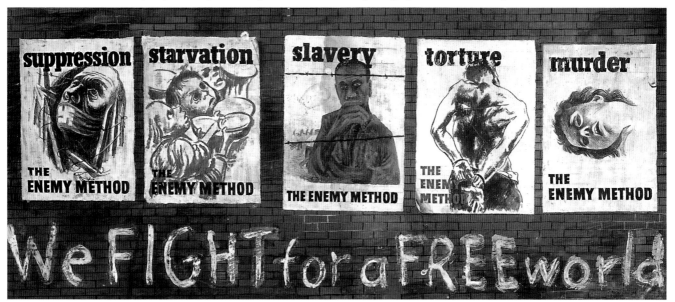

WE FIGHT FOR A FREE WORLD!, C. 1942, BEN SHAHN (1898-1969), GOUACHE ON BOARD, 13″ X 30″.
COURTESY OF MICHAEL ROSENFELD GALLERY, NEW YORK, NY © ESTATE OF BEN SHAHN/LICENSED BY VAGA, NEW YORK, NY

North, covered the stories that southern reporters simply ignored. But, it was television and the 6:00 news that put the Movement into every American living room. Gathered before their television sets with TV dinners on TV trays, Americans watched as dignified, well-dressed African Americans with their eloquent and soft-spoken leader, Martin Luther King, calmly faced caricaturish sheriffs, spewing nasty epithets. Southern mayors and members of white citizens councils epitomized all of the things that the United States was not supposed to be about—intolerance, injustice, bigotry, vigilantism, and hate. King and the other civil rights leaders learned to manipulate media images early in the Movement to their advantage. They chose villains by selecting cities for protests in which racist ideologues were sure to put on a show for the television cameras. Men like Mayor Gayle of Montgomery, Bull Connor of Birmingham and Jim Clark in Selma offered Americans disgraceful displays of paddy wagons arresting law-abiding citizens, or children being carted off

We All Live With, exposed another national shame to the light of public opinion. Ruby Bridges, a six-year-old child, proud and seemingly fearless, being escorted to school by federal marshals while invisible bystanders hurl tomatoes and racist slurs. At the same time that the popular media exposed the un-American behavior in the South it also helped to make King an American hero. His was the face that Americans came to associate with the Movement. He was the man who stood firmly against those who would undermine the values and ideals of American life.

"Indeed, we are engaged in a revolution, and while it may be different from other revolutions, it is a revolution just the same. It is a movement to bring about certain structural changes in the architecture of American society."—Martin Luther King, 1964

The black freedom struggle, which Dr. Martin Luther King led and came to symbolize, was one of the most significant social protest movements of the twentieth century. In addition to bring-

ing about fundamental changes in the lives of African Americans in the South, it also stimulated, inspired, informed and supported other struggles for social change including the women's liberation movement, the student movement, and the struggles of workers, particularly the farm workers led by Cesar Chavez. But, by the mid-1960s new troubles brewed in Black America. Despite civil rights successes in the segregated South, riots erupted in the North in poor, black neighborhoods. King struggled with the anger, frustration, and violence in the new northern battleground. *Black Power!* He realized that legal integration was not enough. Economic justice was necessary for real equality. Although there were no "white only" signs, the conditions in urban neighborhoods in the North reflected de facto segregation and poverty every bit as intractable as it was in the South. Now King's vision broadened to include the struggle of poor and oppressed people throughout the world, including taking a then unpopular stand against the war in Vietnam. King referred to himself as "much more than a civil rights leader," when he spoke of his opposition to the Vietnam War, preferring instead to be more broadly viewed as a spokesman against injustice who melded pragmatism with morality. There were two Americas in the 1960s—one affluent and largely white. The other, poor and largely black.

"The fight for equality must be fought on many fronts—in the urban slums, in the sweat shops of the factories and fields. Our separate struggles are really one—a struggle for freedom, for dignity, and humanity. You and your valiant fellow workers have demonstrated your commitment to righting grievous wrongs forced upon

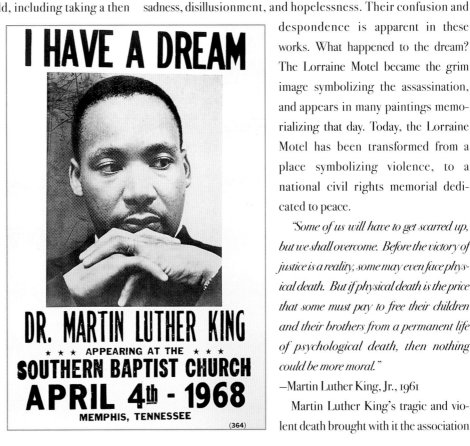

(ABOVE) ROLLING STONE MAGAZINE, APRIL 7, 1988. PUBLISHED TO COMMEMORATE THE TWENTIETH ANNIVERSARY OF THE DEATH OF DR. KING, THIS ISSUE INCLUDES AN ARTICLE BY MARTIN LUTHER KING III ON THE LIFE OF HIS FATHER. (BELOW) POSTER ANNOUNCING DR. KING'S APPEARANCE AT THE SOUTHERN BAPTIST CHURCH, IN MEMPHIS, TENNESSEE ON THE DAY OF HIS ASSASSINATION.

exploited people. We are together with you in spirit, and in determination that our dreams for a better tomorrow will be realized."

—Telegram from Martin Luther King, Jr. to Cesar Chavez and United Farm Workers, 1966

In April of 1968 Martin Luther King, Ralph Abernathy, and other members of the Southern Christian Leadership Council traveled to Memphis, Tennessee, to support the sanitation workers' strike. An assassin shot King to death as he stood on the balcony of the Lorraine Motel preparing to go to dinner. His death sparked anger and dashed hopes in the African American community and among those whites who supported the Movement. These were very dark days. The country had seen the assassinations of John Kennedy, Robert Kennedy, and Malcolm X within the space of five years. In some cities people responded with riots on the nights following King's murder. Churches offered prayers and memorial services. Many artists created elegies to him that reflected their sadness, disillusionment, and hopelessness. Their confusion and despondence is apparent in these works. What happened to the dream? The Lorraine Motel became the grim image symbolizing the assassination, and appears in many paintings memorializing that day. Today, the Lorraine Motel has been transformed from a place symbolizing violence, to a national civil rights memorial dedicated to peace.

"Some of us will have to get scarred up, but we shall overcome. Before the victory of justice is a reality, some may even face physical death. But if physical death is the price that some must pay to free their children and their brothers from a permanent life of psychological death, then nothing could be more moral."

—Martin Luther King, Jr., 1961

Martin Luther King's tragic and violent death brought with it the association

with angels. Through his martyrdom he was elevated to the status of mythic figure, perhaps more than he might have been had he lived out his life. His detractors used his human failings in an attempt to destroy his reputation. But his ability to blend morality, spirituality, and commitment to country into a modern retelling of the American story of democracy made him an American prophet for the modern age.

National holidays are times when we build and reinforce our national stories, the cultural mythology that focuses us on those things that we share rather than the many things that divide us. Who better then to become the first African American to be accorded a national holiday than the man who symbolized the best of American values? King's life reminds us of our strength as a people and the strength of our nation.

(ABOVE) LIFE, 1995, ANTHONY BONAIR (1945-) CIBACHROME, 60″ x 48″. SRAGOW GALLERY, NEW YORK, NY (LOWER LEFT) LIFE MAGAZINE, APRIL 12, 1968, DEVOTED TO THE STORY OF THE ASSASSINATION OF DR. KING. (LOWER RIGHT) LIFE MAGAZINE, APRIL 19, 1968, WITH EXTENSIVE COVERAGE OF THE ASSASSINATION OF DR. KING

theologian Joseph Lowrey, believe that we have elevated Dr. King's image beyond that of a mortal human being. "We have," he notes, "elevated the messenger and buried the message." Has Dr. Martin Luther King become simply a commodity to sell products and a day off from work to buy merchandise on sale rather than a time to commit ourselves to his ideals? Travis Sommerville suggests that we are using him as commonly as the Nike swoosh.

In the Spirit of Martin is both testament and cautionary tale. The memories and visions of these events still inspire and still define the artists whose work appears in these pages, and through their art his enduring message speaks to us. King's commitment to the ideals of social and racial equality, and his willingness to act on his principles, provide the inspiration for us to renew

19

We usually think of the Civil Rights Movement as bracketed by two events beginning with the Supreme Court case in Brown vs. the Board of Education of Topeka, Kansas, and ending with the assassination of Dr. Martin Luther King in 1968. Defining this fourteen-year period as something that has come and gone enables us to look comfortably back on an increasingly hazy past and see how far we have come from the grisly days of segregated water fountains and inferior black schoolrooms. However, the vision of Martin Luther King's colorblind America, in which all Americans are judged by the content of their character rather than the color of their skin, has yet to be attained. Some artists and others, like

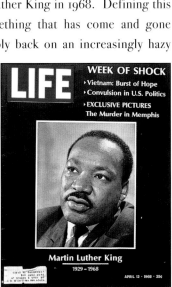

our lives and to follow his example.

In the Spirit of Martin is about an enduring American message, the power of love to turn aside hate, and the power of democracy as a force for positive social good. *"I still have a dream,"* proclaimed King in 1963, *"It is a dream rooted in the American dream. I have a dream that one day this nation will rise up and live out the true meaning of its creed—we hold these truths to be self-evident, that all men are created equal."* This exhibition is a visual testament to his leadership and the legacy of that dream. It is a clarion call to stand up to injustice for the sake of the "Beloved Community," where no one is free unless all are free.

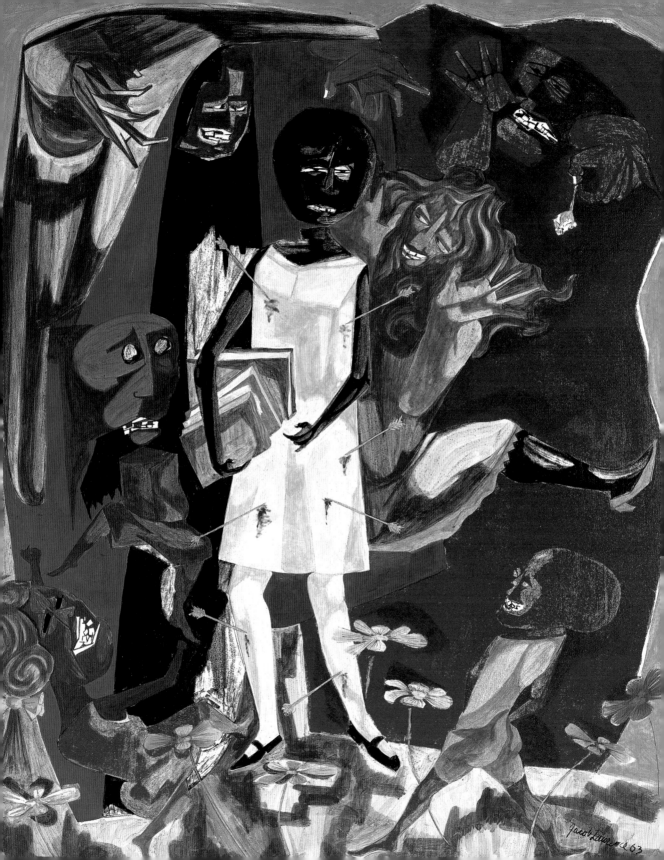

WATCHING HISTORY-MAKING IN THE MAKING

ARTISTS ON DR. MARTIN LUTHER KING, JR. AND THE CIVIL RIGHTS MOVEMENT

HELEN M. SHANNON

THERE ARE MANY TRIBUTARIES TO THAT GREAT CONFLUENCE NAMED HISTORY AND AMONG THEM ARE THE VISUAL ARTS. HOW MANY CULTURES AROUND THE WORLD HAVE BEEN LOST TO MEMORY AND THEN TO HISTORY BECAUSE THEY LEFT NO TEMPLES, SCULPTURE, TEXTILES, OR MANUSCRIPTS, FOR EXAMPLE? FOR THOSE OBJECTS THAT DO SURVIVE, HOW CAN WE DETERMINE THEIR PLACE IN THAT SHIFTING NARRATIVE CALLED "HISTORY"; CAN WE DETERMINE HOW AN ARTIST HAS SHAPED HIS OR HER VISUAL IMAGERY AROUND ACTUAL EVENTS? THIS EXHIBITION ON ARTISTS' RESPONSES TO MARTIN LUTHER KING, JR. AND HIS LEADERSHIP OF THE CIVIL RIGHTS MOVEMENT, TELLS US MUCH ABOUT HOW HISTORY IS CREATED AND PRESERVED THROUGH THE VISUAL ARTS. □ IN THE SPIRIT OF MARTIN: THE LIVING LEGACY OF DR. MARTIN LUTHER KING, JR. COMBINES PHOTOJOURNALISM WITH OTHER WORKS CREATED AFTER, SOMETIMES LONG AFTER, THE EVENTS OF THE 1950s AND 1960s. THE FACTUAL DATA OF DR. KING'S LIFE, HIS INFLUENCE ON THE MOVEMENT, AND HIS LEGACY ARE WELL KNOWN. THE ARTWORK THAT ASSESSES THIS HISTORICAL PERIOD IS ANOTHER MATTER. THERE HAVE BEEN SEVERAL INDIVIDUAL AND GROUP EXHIBITIONS OF PHOTOJOURNAL-ISTS; OTHER PRESENTATIONS HAVE EXAMINED WORKS BY AFRICAN AMERICAN ARTISTS IN OTHER MEDIA. THIS IS ARGUABLY THE FIRST GATHERING OF WORK PRODUCED BY A RANGE OF PEOPLE AS DIVERSE AS THE PARTICIPANTS OF THE MOVEMENT THEMSELVES: BLACK, WHITE, HISPANIC, JEWISH, AND OTHER RACES AND ETHNICITIES; MALE AND FEMALE; YOUNG, OLD, AND MIDDLE AGED; ARTISTS OF PHOTOGRAPHY, PAINTING, SCULPTURE, PRINTS, AND DRAWINGS.

This is also one of the few exhibitions on any subject to present on an equal footing the work of self-taught and academically trained artists, a gesture that resonates with the reciprocities among people of all levels of society in the Movement. The curatorial team sought powerful images from instant photojournalism as well as from more deliberative works in two and three dimensions. Here again, we believe this is one of the few exhibitions to mix news photography with artwork on an equal footing. All of the objects in this exhibition endure because they are striking and meaningful regardless of their place in the hierarchy of the art world. In Dr. King, the struggle for black self-determination had a leader whose eloquence moved many artists to their own heights of imagination.

When studying the visual culture of the Civil Rights Movement, one of the questions that immediately arises is the difference between the facts of the events themselves, their representations by the artists, and the curatorial choices that went into gathering them into a cohesive thematic statement. Beyond photojournalism, the most direct recording of events early in the Movement were the drawings of Harvey Dinnerstein. In 1956, Dinnerstein traveled to Montgomery, Alabama on assignment for *Esquire* magazine to observe the thousands of black people, primarily women with domestic jobs, who walked back and forth to work during the year-long bus boycott against segregated seating. *Walking Together* (1956) was the central image in the article.

Two years later, Charles Alston in *Walking* (1958) took paint to canvas to present his study of the same forceful citizens using a more abstract visual language, which was then his current style. Both artists focused on the walking that was the propulsive force, the Movement, that drove social protest. Images of walking were inherently more dramatic than the journalists' photographs of carpools and their waiting passengers, the other part of the equation that sustained the boycott. In the selection of walking, are we witnessing the development of an iconography, those preferred images that speak through their directness and persuasion?

What is saved, what is remembered, what becomes history, and why? The works in the exhibition and in the book do not constitute a complete and balanced narrative of the events of these decades;

some moments seem not to have captured the imagination and others have become disproportionately dominant. For instance, although legal and de facto segregation flowed through all aspects of American life in the South and the North, in the early years the primary focus of artists was on public transportation.

Trains, buses, and trolleys, unlike restricted restaurants, hotels, and stores, were ironically some of the few public spaces of segregation that were actually occupied by both blacks and whites. As a result, the very arbitrary division of the races within a shared space illustrated the absurdity of this social construction. To mark other cases of segregation in public accommodations meant to represent the non-presence of blacks in, for example, pools and lunch counters, a difficult aesthetic problem.

THE NEW YORK TIMES SUNDAY MAGAZINE, JANUARY 7, 1996, ARTICLE ABOUT THE MONTGOMERY BUS BOYCOTT BY CLAYBORNE CARSON INCORPORATING DRAWINGS BY HARVEY DINNERSTEIN AND BURT SILVERMAN

Robert Frank, a Swiss-born photographer and Jacob Lawrence, an African American painter both captured racial demarcations in New Orleans. In *Trolley, New Orleans* (1955-56), Frank contrasted the closed posture of the white woman with the open pose of a younger black male passenger behind her. Lawrence in *Bus* (1941) emphasized the wasted empty seats between the races. As generations pass on, these types of images will be the few visible reminders of the "black on the bus."

There are other incidents that have infrequently been the subjects of works of art. As curators we found few works beyond the images of photojournalists that depicted sit-ins and Freedom Rides of the early 1960s or Mississippi Freedom Summer in 1964. Passive resistance is not an inherently compelling visual subject: college students being dribbled with mustard as they attempt to integrate lunch counters. The Movement needed pictures of initiative and agency on the part of African Americans and their supporters. Thus, walking and marching became potent signals of self-determination.

After the self-possession of the Montgomery Bus Boycott in 1955–56, the next group of events to capture the attention of artists were the acts of increasing violence by whites against the Movement in the early 1960s. The period from the mid-1950s had been marked by the obstructionist actions by city and state governmental agencies against school and university desegregation. The Little Rock school desegregation crisis in 1957 was one of the earliest of these

acts of defiance by states' supporters. Attacks by whites were mounted against integration at several universities in the Deep South from 1956 to 1962. Those events, however, seem not to have inspired much artwork at the time.

Yet around 1963, two artists portrayed a young, black girl, younger and more vulnerable than the college students, making her the protagonist of their narratives. (White violence against school bussing occurred in the 1970s.) For the January 14, 1964 cover of *Look* magazine with the theme *The Problem We All Live With*, Rockwell shows a stalwart, mature child walking within the four-cornered perimeter of federal marshals who still cannot protect her from objects derisively thrown. In *The Ordeal of Alice* (1963), Lawrence objectified in line and color the internalized struggle that must have been going through the minds of all those protagonists of integration, both young and old.

By choosing to use children as the subjects of their work, Rockwell and Lawrence demonstrate how often youth were witness to the actions of the Movement and the victims of the white backlash against it. Artists often positioned them as subjects. Clarissa Sligh included photographs from the integration court suit to which she had been a party in *Witness to Dissent* (1998). Marion Palfi (*Colored Waiting Room*, 1946–49) and Robert Frank (*Trolley, New Orleans*) placed children both black and white at the center of their commentaries on segregation. John Biggers illustrates the chilling prelude to the deaths of Addie Mae Collins, Denise McNair, Carol Robertson, and Cynthia Wesley as they approached the Birmingham church that would be their doom (*Children of the Morning*, 1964). James Karales in *The Selma to Montgomery March* (1965) and Bruce Davidson in *Three Youths on the Selma to Montgomery March* (1965) depict teenaged idealism.

After the assassination, the stunned reactions of young people moved several artists: Beuford Smith in *Youth Responding to News of King's Murder* (1968); Ben Fernandez in *Memorial to Martin Luther King, Central Park, New York* (1968); Harry Gottlieb's *Amy's Response to the Assassination of MLK* (1968). Artists also made children central to their memorials to him: Eugene Richards' *Girl with a Fan* (1991) and Sue Coe's *Martin Luther King* (1986).

By the early 1960s, as the use of civil disobedience increased, King and other leaders sensed the power of using newspapers, magazines, and television images of demonstrations to develop sympathy for their cause. The white reaction against nonviolent protesters

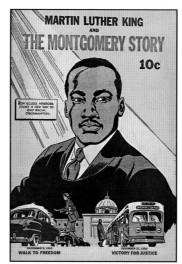

MARTIN LUTHER KING AND THE MONTGOMERY STORY, C. 1956. THIS BOOKLET, DOCUMENTING IN COMIC BOOK FORM THE MONTGOMERY BUS BOYCOTT, WAS PUBLISHED BY THE FELLOWSHIP OF RECONCILIATION. THE TEXT ON THE BACK OF THE BOOKLET READS:... "THE FELLOWSHIP....WHOSE THOUSANDS OF MEMBERS THROUGHOUT THE WORLD ATTEMPT TO PRACTICE THE THINGS THAT JESUS TAUGHT ABOUT OVERCOMING EVIL."

could not be predicted, but in May 1963 Bull Connor, Commissioner of Public Safety of the Birmingham Police Department played directly into their hands by ordering fire hoses and police dogs against black teenagers. News photographs by such men as Charles Moore (*Firemen trying to dislodge demonstrators, 1963*) galvanized world opinion for the Movement. Andy Warhol used such photos in a series of works entitled *Race Riot* (1963).

In the 1960s, the Civil Rights Movement coincided with the tendency of artists to appropriate media images. Not all, like Andy Warhol, were identified with Pop Art. Romare Bearden, in a direct reaction to the events of 1963, began his signature style of collage using magazine photographs (*Untitled*, 1964). Peter Gee in *Martin Luther King, Jr.* (1968) and *L'Merchie Frazier*, in *From A Birmingham Jail : MLK* (1996) used the photo of the leader resolutely looking through prison bars. Several artists including Philip Morseberger in *Missing (No.1)* (1964), Clarissa Sligh in *Mississippi in America* (1989–1991), and Kerry James Marshall in *Souvenir I* employed the shots from the FBI's missing poster for Goodman, Chaney, and Schwerner. Thus, these photographs were already invested with the currency of familiarity and potency.

Besides artists working in various realist styles, those who had adopted abstraction also made political statements. In the early 1960s, Alma Thomas was creating paintings with large rectangular patches of brightly colored pigments. She seems to have used that vocabulary of shape and color to recall the teeming marchers and their placards in *Study for the March on Washington* (ca. 1963). Where Charles Alston had painted recognizable figures in *Walking* to commemorate the Montgomery Bus Boycott, Norman Lewis in *Processional* (1965) used immense calligraphic strokes to render the participants on the Washington Mall.

A history of art consists of those moments when a critical mass of people share similar themes, techniques, styles, or media. In the late 1960s with the ruptures in American life caused by assassinations of Dr. King, Medgar Evers, and the Kennedy brothers, the unsettling tensions of the Vietnam War with its battling supporters and critics, and the upheavals of the youth movement, many felt a fracturing of the nation's fabric. Several of the works related to the black freedom struggle and its progeny movements for women and Hispanics used the technique, or at least the appearance, of collage. It is not a coincidence that collage appeared during a moment of increasing factionalization and tenuous social cohesion.

23

The title of Archibald Motley's *The First One Hundred Years: He amongst you who is without Sin shall Cast the First Stone: Forgive Them Father For They Know Not What They Do* (ca. 1963–72), itself a concatenation of Biblical sayings and a reference to the signing of the Emancipation Proclamation, suggests the inability of one statement to succinctly speak all of the artist's thoughts. Motley, usually an urbane painter of scenes of his native Southside Chicago, piles incident upon incident of unrequited violence, relating his dissatisfaction with the slow progress of change. In a three-year period, Lois Mailou Jones in *Homage to Martin Luther King, Jr.* (1968), Kay Brown in *The Black Soldier* (1969), Joe Tilson in *Martin Luther King, 1969,* Lev Mills in *Out-Loud Silent* (1969), and Robert Rauschenberg in *Signs* (1970) all created compositions of disparate elements brought together into a dynamic whole. Much later, in works that reference the 1960s, Lou Barlow in *1963–We Have a Dream–1984* (1984) and Emmanuel Martinez in *Chronicles of the 1960s Civil Rights Movement* (2000) both continued employing the collage format.

With King's assassination, we can watch the immediate creation of an iconography of murder, anger, and grief. Joseph Louw's iconic AP/Wide World photograph of aides on the balcony of the Lorraine Motel pointing in the direction of the bullets received instant coverage on wire services. Artists soon used the architecture of the balcony as an abstract design to designate the cold-blooded nature of the shooting by James Earl Ray. In Tilson's *Martin Luther King*, the right-angled balcony resonates with the chair by the Dutch artist Gerrit Rietveld who believed that art and design had the force to change society. In the re-readings that typically take place after an event is processed through recollection and individual intent, King appears standing alone on the balcony in works by Leroy Almon, Sr. (*Assassinations,* 1988), Gary Bibbs (*They've Killed the King,* 1996), and Bernice Sims (*Civil Rights Triptych of Birmingham Dogs, Selma Bridge*, and the *Lorraine Motel-Memphis,* 1997). Rather than being prostrate, King stands tall, either in the moments before the shooting or in an apotheosis afterward.

The aftermath of the murder provoked artistic responses using visual languages both natural and conventional. Agitated forms and swirling motions in Howardena Pindell's *Homage to MLK* (1968) and Jack Whitten's *For MLK,* (1968) identified the emotional turmoil that beset many artists as well as other Americans, and people around the world. During the same year, Sam Gilliam began producing his canvases with dripped paint; *April 4, 1968* (1969) looks like a blood-stained shroud. The blues and purples of William Major's *Dear Martin* (1968) are the colors of mourning; he uses large abstract elements to contrast a solid form with a broken one–life and an abrupt death.

In the period after his death, some artists used the gestures and postures of religious symbolism to portray King. In his three-part paintings shaped like an altar *Legacy of MLK triptych,* 1998, Sam

Adoquei takes the murdered leader's body from the cross in Christian iconography. Sue Coe imbues King with the spiritual light of beatification in *Martin Luther King* (1986). Yet what seems to predominate more than images of a saintly King are those of a secular one, still human, still approachable. Posters and inexpensive flyers depicting King and the Kennedy brothers proliferated in the years following their assassinations. His image then appeared in the typical places of African American sociability–the barbershop (Chester Higgins' *Barbershop,* 1968); the home (Kerry James Marshall, *Souvenir,* 1997), and the bar (Gerald Cyrus, *The Casablanca Lounge, Harlem, New York City, N.Y.,* 1995).

Martin Luther King's philosophical message was so elemental in its logic and idealism it was typically rendered in either widely known symbols or with direct text. Malcah Zeldis includes him in her version of the *Peaceable Kingdom* (1999); Alex Maldonado designs a utopian setting of pristine architecture in *Memorial to Martin Luther King* (1987). Other artists use such straight-forward declarations as "Love" (Elijah Pierce, *Martin Luther King (Love),* 1969); "Vote" (Malaika Favorite, *Georgia Voter,* (2000) and "Dream" *Dream Big,* (2000). Tim Rollins and his young artists' group K.O.S. (Kids of Survival) literally take King's words in writing and use the texts as the base for a painting whose superimposed red triangle speaks of blood as well as the prescient, legendary mountain top.

Martin Luther King's life in the Civil Rights Movement parallels the trajectory drama–a problem; mounting tensions, if not outright violence; a cataclysmic and telling event; decreasing agitation, and then resolution, that is, American segregation challenged by King's call for nonviolence and passive resistance; his political ascendancy beginning with the Montgomery Bus Boycott, followed by white obstruction and retaliatory acts of violence against marchers, demonstrators, and Freedom Fighters; the beloved leader's murder followed by the assuaging passage of civil rights legislation. But has the last act been completely resolved? Has racism ended; have economic and social equity been achieved?

The production of works of art evoking Martin Luther King, Jr. continues. If they do not occur as frequently early in his career, it is, of course, because artists then did not have the foresight to know his impending significance. In the 1990s, King appears in historicizing works such as Willie Birch's *Memories of the 60s* (1990) and Thornton Dial, Sr.'s *Graveyard Traveler/ Selma Bridge* (1992). But his presence is also invoked for causes that developed long after his death. The fact that King can be called upon to preside over new initiatives in equal rights proves that much more still needs to be corrected before people around the world all have the freedoms for which he struggled.

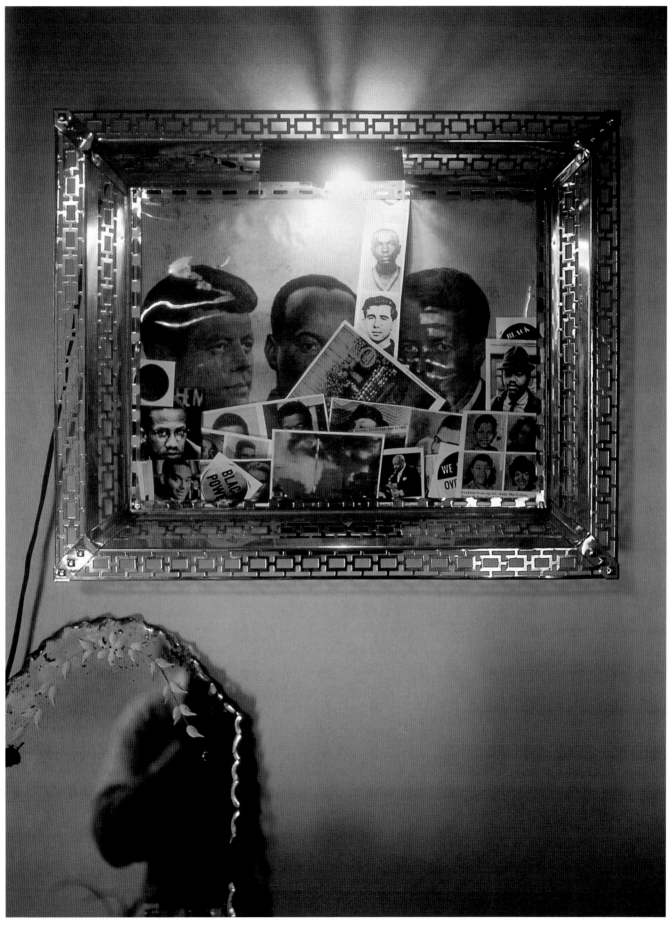

25

UNTITLED, 1998, KERRY JAMES MARSHALL (1955-), C-PRINT, 30" X 20". COURTESY OF JACK SHAINMAN GALLERY, NEW YORK, NY

"In a real sense,
America is essentially
a dream, a dream as
yet unfulfilled.
It is a dream where men
of all races, of all
nationalities,
and of all creeds
can live together
as brothers."

— Martin Luther King, Jr.

We as a People Will Get to The Promised Land

MARTIN LUTHER KING

1929 1968

*"... we are determined to shake off our bondage,
and for this purpose we stand on a good foundation."*

—WILLIAM, AN ENSLAVED AFRICAN, 1822

Let your motto be resistance! Resistance! RESISTANCE!" Reverend Henry Highland Garnet exhorted his audience at the 1843 National Negro Convention in Buffalo, New York. And resistance it was. From the moment 20 slaves arrived at Jamestown in 1619 to the beginning of the modern freedom movement in the 1950s, African Americans resisted the conditions in which they found themselves, in the tradition of American democracy. □ Enslaved Africans stole themselves from slavery, broke tools or worked slowly. They found ways to maintain African cultural and religious traditions and pass them on to their children. Freedmen and women educated themselves and pursued cases of injustice in the civil courts; they vociferously spoke out against discrimination and for the electoral franchise. They wrote books of poetry and prose and published newspapers to "plead our own cause." □ In 1839 a group of Africans taken from their homes in Mendi overwhelmed their captors and took possession of the Spanish schooner, Amistad. Adrift off the coast of Long Island after a long voyage, the Amistad was brought to port in New London, Connecticut and the Africans were jailed and put on trial. The case was ultimately appealed to the United States Supreme Court and the Africans were returned to their homeland. Artist Hale Woodruff selected this event, symbolic of heroism and resistance to injustice, for his 1939 mural, *Mutiny Aboard the Amistad.* □ At every turn in American history African Americans worked to demonstrate their value as citizens while protesting the indignities perpetrated against them. They fought in every American war for the freedom that they were denied at home. Silent protest marches and anti-lynching campaigns gave witness to the ongoing resistance to discrimination. Each generation built on the efforts of the one before, moving a few steps closer to the prize—the full rights of American citizenship. Images of the fight against injustice appear throughout the canon of African American art—the legacy of a people whose history and art are tied together by the shared experience of slavery, discrimination, and resistance.

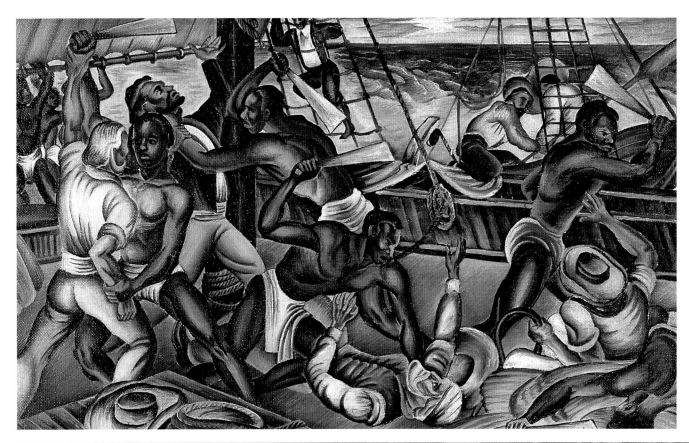

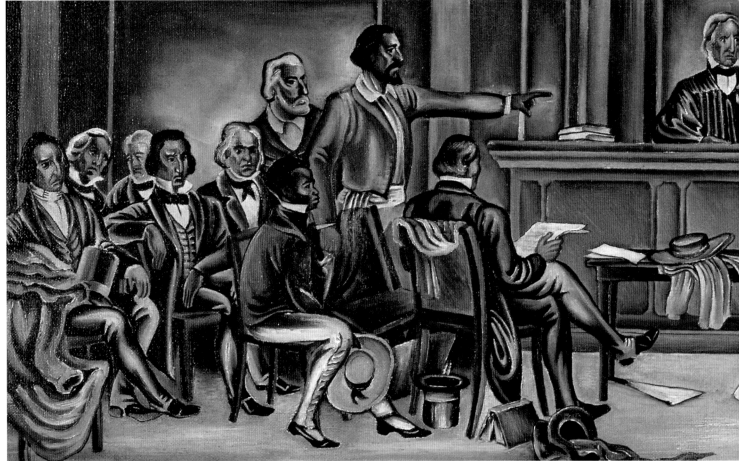

(Top left) The Mutiny Aboard the Amistad, 1839, 1939, Hale Woodruff (1900–1980), oil on canvas, 12-1/4″ x 20″. Local Church Ministries, United Church of Christ, Cleveland, OH. Courtesy of Kenkeleba Gallery □ (Top right) The Return to Africa, 1842, 1939, Hale Woodruff (1900–1980), oil on canvas, 12-1/4″, x 20″.

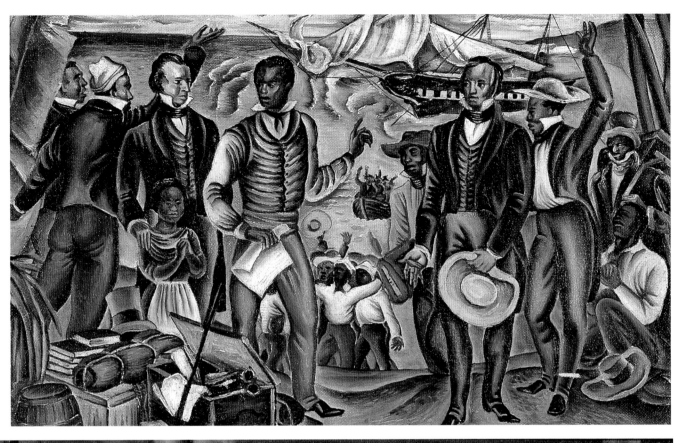

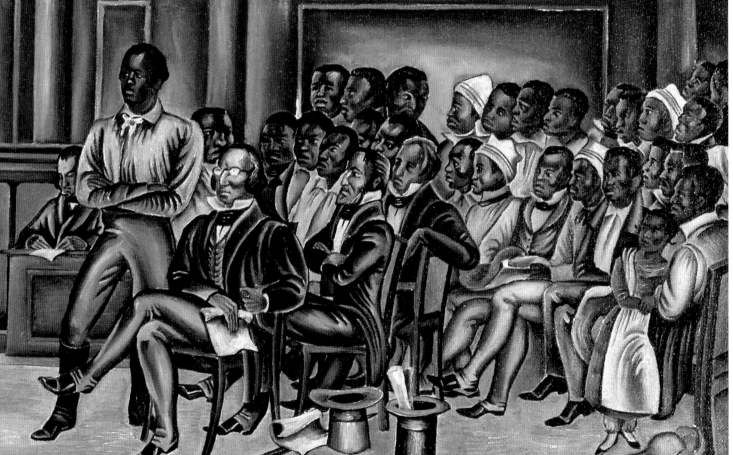

Local Church Ministries, United Church of Christ, Cleveland, OH. Courtesy of Kenkeleba Gallery □ (Bottom) The Amistad Slaves on Trial at New Haven, 1840, 1939, Hale Woodruff (1900-1980), oil on canvas, 12″ x 40″. Local Church Ministries, United Church of Christ, Cleveland, OH, Courtesy of Kenkeleba Gallery

32

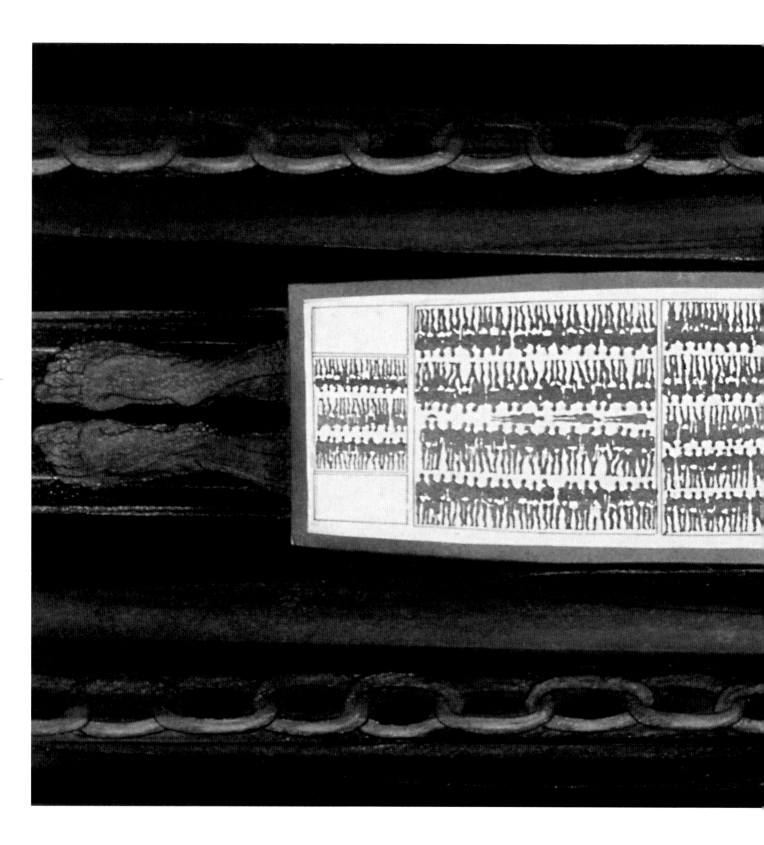

(Above) The Middle Passage, 1995, (from *The Middle Passage, White Ships/Black Cargo*, by Tom Feelings, Dial Books, 1995), Tom Feelings (1933-), pen and ink and tempera on rice paper,

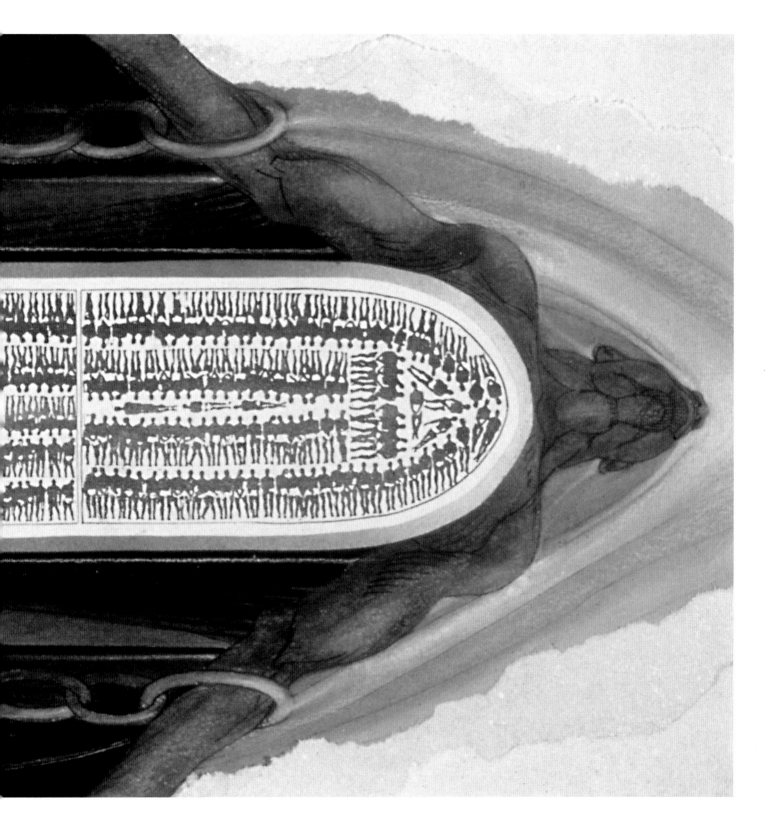

8-1/2″ x 18″. Collection of the artist, Columbia, SC (Overleaf) Slave Ship, 1987, Thornton Dial (1928–), mixed media, 71″x 102″x 29″, Collection of William S. Arnett, Atlanta, GA

📖 (Above) Flora, 1796, Anonymous, cut paper and brown ink, 13″ x 14″. The Stratford Historical Society, Stratford CT □ (Below, left) Slave with Inventory Number, 1860, unidentified photographer, albumen print carte-de-visite, 4″ x 2 1/2″. The Burns Archive, New York, NY □ (Below, right) Farmer (Richards Family Slave, Monticello, Missouri) c. 1850, unidentified photograph, daguerrotype, 5″ x 4″. Collection of Greg French, Jamaica Plain, MA □ (Opposite page, top, first row, left to right) □ Minda, Leah, Sarah, Tom, and Little Paul, Servants of B. W. Fosdick, Savannah, Georgia, 1854, unidentified photographer, daguerreotype, 6″ x 4″. Collection of Greg French, Jamaica Plain, MA □ Man in a Fraternal Society Outfit, 1875, unidentified photographer, carte de visite, 4″ x 2-1/2″. Collection of Greg French, Jamaica Plain, MA □ Mother and Son, c. 1855, unidentified photographer, daguerreo-

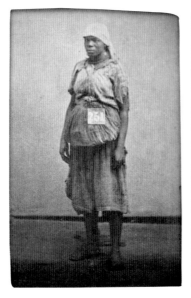

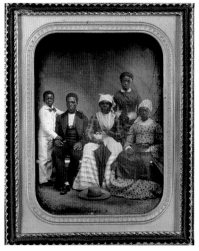
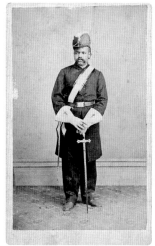

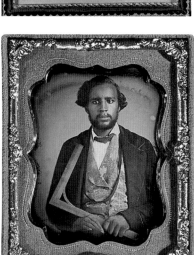

type, 3 1/2″ x 2 1/2″. Collection of Greg French, Jamaica Plain, MA □ (Above, second row, left to right) Haywood Dixon (Architect), c. 1860, unidentified photographer, daguerreotype, 3″ x 2″. Collection of Becky Hollingsworth, Atlanta, GA □ Senator Hiram Revels, U. S. Senator from Mississippi, c. 1870, unidentified photographer, gelatin silver cabinet card, 6″ x 4″. Collection of Greg French, Jamaica Plain, MA □ Fireman, c. 1875, unidentified photographer, tintype, 3 1/2″x 3″. Collection of Greg French, Jamaica Plain, MA □ (Below) Mr. D. Jackson Steward and family of Goshen, NY with his servant staff, c. 1857, unidentified photographer, ambrotype, 4″ x 6″. Collection of Greg French, Jamaica Plain, MA

Harriet, 1975
Elizabeth Catlett
linocut
12 1/2″ x 10 1/8″.
Sragow Gallery, New York, NY
© Elizabeth Catlett/Licensed by
VAGA, New York, NY

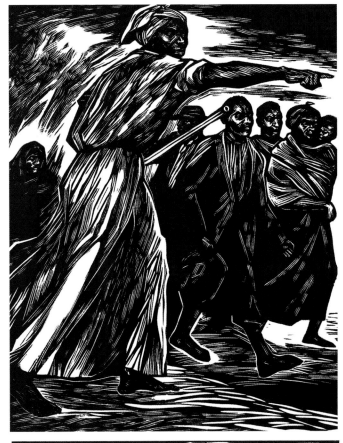

Sojourner Truth,
I fought for the Rights of Women, 1947
Elizabeth Catlett (1915-)
linocut
10″ x 7″.
Howard University Gallery of Art,
Washington, DC
© Elizabeth Catlett/Licensed by
VAGA, New York, NY

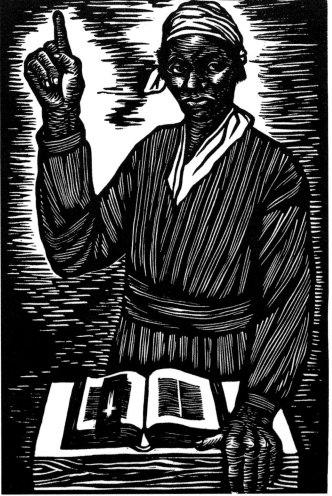

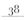 (Opposite)
The Ride for Liberty–
The Fugitive Slaves, 1862
Eastman Johnson (1824-1906)
oil on board
22″ x 26-1/4″.
The Brooklyn Museum, New York

"Where could I begin to build pride?
In church, God and the saints and angels
were always white. In school, the textbooks
always showed my ancestors picking cotton,
dancing jigs or strumming banjos.
Africans were always depicted as
savages. My history books never mentioned
heroic blacks like Hiram Revels,
Peter Salem, Benjamin Banneker,
or Harriet Tubman."

— Gordon Parks

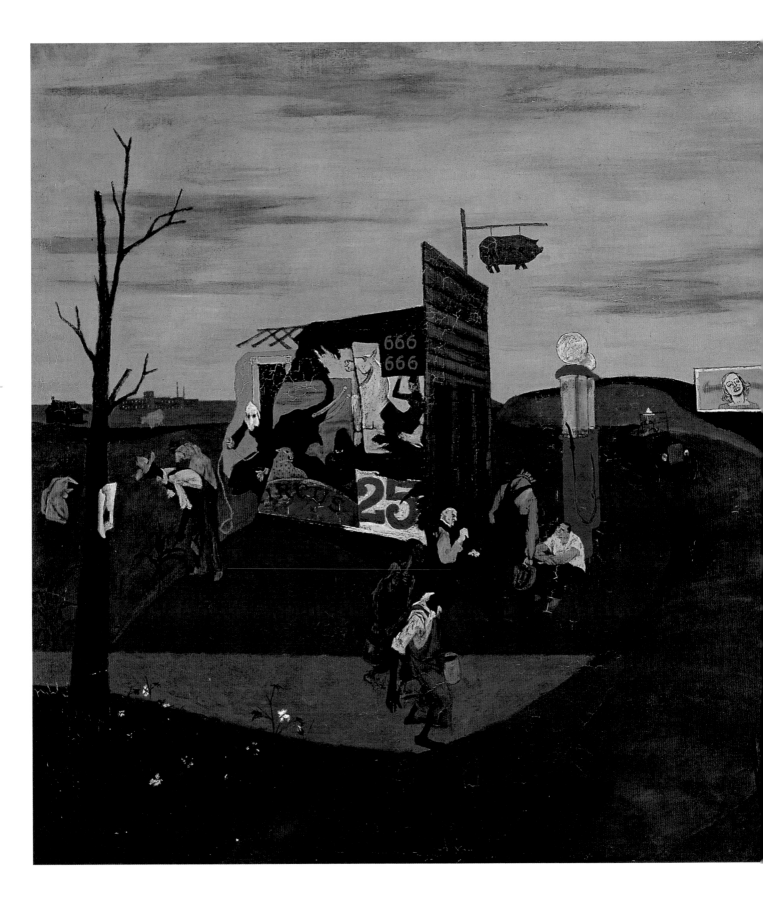

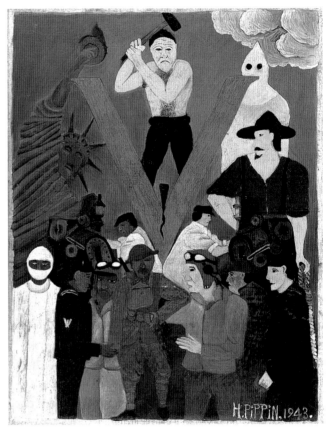

(Left)
From Out of the South, c. 1941
Robert Gwathmey (1903-1988)
oil on canvas
39 1/2″ x 60″.
The David and Alfred Smart Museum of Art,
The University of Chicago;
The Mary and Earle Ludgin Collection,
Chicago, IL
© Estate of Robert Gwathmey/
Licensed by VAGA, New York, NY

(Above)
Mr. Prejudice, 1943
Horace Pippin (1888-1946)
oil on fabric
18″ x 14″.
Philadelphia Museum of Art;
Gift of Dr. and Mrs. Matthew T. Moore,
Philadelphia, PA

42

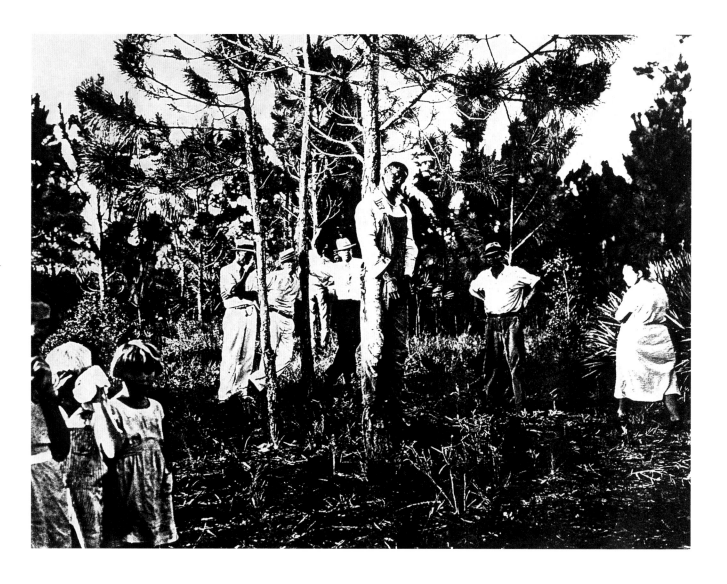

(Above) Lynching, 1935, unidentified photographer, black and white photograph, 8″ x 10″. Stanley B. Burns, M.D. and The Burns Archive, New York, NY □ (Opposite)
To the Lynching!, 1935, Paul Cadmus (1904-1999), graphite and watercolor on paper, 20 1/2″ x 15 3/4″. Whitney Museum of American Art, New York, NY

"Paint is the only weapon (that)
I have with which to fight what I resent.
If I could write, I would write about it
If I could talk, I would talk about it.
Since I paint, I must paint about it."
— Charles White

(Opposite) Freeport, 1946, Charles White (1918-1979), charcoal and ink, 14-3/4″ x 20-3/4″. Collection of Jim Powers; Courtesy of Heritage Gallery, Los Angeles, CA.

(Above) America the Beautiful, 1960, Norman Lewis (1909-1979), oil on Canvas, 50″x 64″. Private Collection, Courtesy of Michael Rosenfeld Gallery, New York, NY

(Below)
To the Colored Waiting Room, 1945-49
Marion Palfi (1917-1978)
gelatin silver print
13 1/3″ x 10 3/8″.
High Museum of Art, Atlanta, GA;
Courtesy of Loretta Morgenstern,
Los Angeles, CA

(Right)
White Only, 1963
May Stevens (1924-)
gouache on paper
48 1/4″ x 18 1/8″
Collection of Francesca Estevez,
Gila, NM

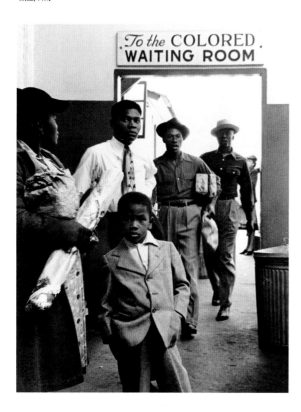

Opposite, top)
Untitled (Drinking Fountains), 1998
Travis Sommerville (1963-)
watercolor on paper
22″ x 30″.
Courtesy of Marnee S. Colburn and
Family, and Catherine Clark Gallery,
San Francisco, CA

(Opposite, bottom)
Segregated Water Fountains,
North Carolina, 1950
Elliot Erwitt (1928-)
black and white photograph
8″ x 10″.
Magnum Photos,
New York, NY

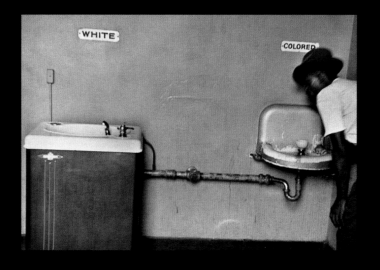

Emerging Man, 1952
Gordon Parks (1912-)
gelatin silver print
16″ x 20″.
© Gordon Parks 1952;
Courtesy of Howard Greenberg Gallery,
New York, NY

MARTIN LUTHER KING, JR.

JOHN LEWIS

There have been four great influences on my life: my mother, my father, God, and Dr. Martin Luther King, Jr. God and my parents instilled in me fundamental values, a profound sense of right and wrong. They taught me what is just, and fair, and right. They are responsible for me being the person that I am.

Dr. King is responsible for me doing the things that I have done. He inspired me to act on the beliefs and values that

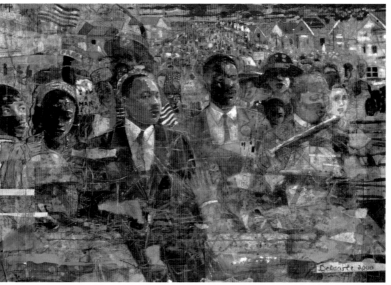

FROM SELMA TO MONTGOMERY, 2000, LOUIS DELSARTE (1941-), ACRYLIC AND MIXED MEDIA, 34″ X 36″, COLLECTION OF DRS. HERBERT AND DARLENE CHARLES (OPPOSITE, TOP) LIFE SPECIAL ISSUE COVER. THE DREAM THEN AND NOW, SPRING, 1988. (OPPOSITE, BOTTOM) MLK: PRINCE OF PEACE, 1999, ADEMOLA OLUGEBEFOLA, COLLAGE, 11 ″ X 15″, COLLECTION OF THE ARTIST, NY, NY

learn was called the social gospel, taking the teachings of the Bible and applying them to problems and issues confronting a community and a society. I was on fire with the words I was hearing. I felt that this man, Martin Luther King, Jr., was speaking directly to me. This young preacher had given voice to everything I'd been feeling and trying to figure out for years.

At that moment, Dr. King became my role

burned within me. By his words and his deeds, he taught me that we can change the world through nonviolent protest. It was Dr. King who led me to Mohandas Gandhi, James Lawson, and a life founded on the principle of nonviolence.

I remember quite clearly the first time I heard Dr. King speak. It was a Sunday morning in early 1955, and I was 15. I was listening to WRMA Montgomery on our family radio. On the air came a sermon from a man I had never heard before, a young minister from Atlanta. His voice held me right from the start. It was a strong, deep voice, clearly well trained and well schooled in the rhythmic, singsong, old-style tradition of black Baptist preaching.

But even more than his voice, it was his message that sat me bolt upright with amazement. I listened as this man explained how it wasn't enough for black people to be concerned only with getting to the Promised Land; how it was not enough for people to be concerned with roads that are paved with gold and gates to the Kingdom of God. He said that we needed to be concerned with the gates of schools that were closed to black people and the stores that refused to hire or serve us. His message was one of love and the Gospel, but he was applying those principles to now, to today.

This was the first time I had ever heard something I would soon

model. In one radio broadcast, he provided me direction for acting upon my beliefs. I always knew that segregation was wrong, and now I had hope that I, by acting upon the words of Dr. King, could change society, could end segregation. In fact, I had a moral obligation to end segregation, discrimination, and racial hatred.

Dr. King preached the Bible's message of love and nonviolence and gave them relevance to the world in which I was living. He preached that we must act upon these principles to pursue justice, fairness, and righteousness on Earth, not just in Heaven. This was my Clarion Call, the defining moment that pointed me down the path that would lead me to the Nashville Sit-ins, the Freedom Rides, Mississippi Freedom Summer, and Bloody Sunday.

After hearing Dr. King on the radio, his words stirred and grew within me. I graduated Pike County Training School and moved on to American Baptist Theological Seminary in Nashville, Tennessee. There, I studied the gospel, but I remained sold on the social gospel. The more I preached, the more I began to feel a sense of obligation to do something. I began to feel a sense of shame because I did not act. I still believe today one should: Act out of a sense of community; do something that is aimed beyond yourself. And be ashamed if you do not.

It was that sense of mission that moved me to do my part, and led me to meet Dr. King himself. Troy State, the closest college to where I was raised, allowed no black students at that time. I felt a searing sense that it was simply, inherently wrong that a black student could not attend Troy State. I decided to apply as a transfer student to Troy State University. I decided that I would be the first black student to walk through those doors.

My application received no response. After two months passed, I took another step. I wrote a letter to Dr. King seeking support and counsel. Shortly thereafter, I received a reply from Fred Gray. Fred Gray had represented Rosa Parks during the Montgomery Bus Boycott and now was Dr. King's attorney. After a series of correspondence, I learned that Dr. King wanted to meet with me, and I received a Greyhound ticket to make the trip.

I was overwhelmed. I kept telling myself to be calm, that fate was moving now, and that I was in the hands of the Spirit of History. But I was still nervous. I had only just turned 18, and now I had an appointment with destiny. During that bus ride to Montgomery, I thought of what I would say to Dr. King. I rehearsed this sentence and that, but nothing stuck. I was anything but calm.

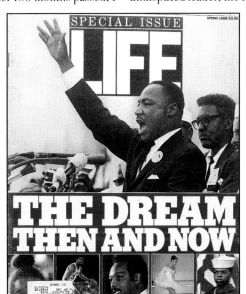

When I arrived at First Baptist, the Reverend Ralph David Abernathy's church, I was led down to the basement pastor's office. Sitting inside were two men, the Reverend Abernathy and Dr. King.

Dr. King rose from behind a desk and smiled at me. "So you're John Lewis," he said. "The boy from Troy." The Reverend Abernathy and Fred Gray chuckled softly. "I just want to meet the boy from Troy," Dr. King said again. Then Reverend Abernathy joined in. "Who is this young man who wants to desegregate Troy State?"

I was petrified. I did not say a word. These men, this moment, this whole experience, were bigger than life to me. I had no sense of myself at that moment. I was mesmerized, just listening, trying to take it all in. They interviewed me, and they seemed willing to support my effort. Then Dr. King spoke.

"You know, John, if they do this, something could happen to you. It's not just you who could be hurt, John," he continued. "Your parents could be harassed. They could lose work, lose their jobs. They could be assaulted. Your home could be attacked.

The farm could be burned."

He seemed genuinely concerned, troubled even. I remember wondering at that moment—and this was something I would think about again many times over the coming years—how heavy, how terrifying the responsibility must have felt to him for all those people he inspired to take up his struggle.

Throughout the Civil Rights Movement, of which he became the undisputed leader, the Reverend Dr. Martin Luther King, Jr. never lost this sense of humanity. He never lost sight that this great movement for social change was a movement of people, and that each person in that movement had his or her own hopes, fears, desires, joys, and frustrations.

I remember eight years later, when we were marching from Selma to Montgomery. This was my second attempt to make this march, the first ending with Bloody Sunday. There would be no violence or bloodshed on the second march. It was like a holy march, like Gandhi marching to the sea.

As we marched, the heavens opened up, and it began to rain hard. Dr. King was wearing a little brown cap on his head. He took it off and gave it to me to cover my bandaged wounds from the first march. He said simply, "You've been hurt. You need to protect your head."

Dr. King understood humanity, and he understood human beings. While leading the most powerful nonviolent movement our nation has ever witnessed, he remained sensitive and caring. He was a wonderful man and a wonderful friend. He was a man that I admired and loved.

Today, I still speak of the "Beloved Community," the social gospel that Dr. King introduced me to so many years ago. I am still inspired by his vision of a truly integrated, interracial democracy. I continue to believe that we must learn to love one another if we are going to survive. As Dr. King said, "we must learn to live together, or we will perish as fools."

I also know that I am not alone in my continued work toward the Beloved Community. Dr. King has inspired millions of people, not just in the United States, but throughout the world. Every day, we are working to make our world a more just, more caring and more loving place. The Civil Rights Movement and Dr. King's dream continue to live in each of us. This is his legacy.

"Then I came upon the life and teachings of Mahatma Gandhi. As I read his works I became deeply fascinated by his campaigns of non-violent resistance. The whole Gandhian concept of Satyagraha (...truth-force or love-force) was profoundly significant to me. I came to see for the first time that the Christian doctrine of love operating through the Gandhian method of nonviolence was one of the most potent weapons available to the oppressed people in their struggle for freedom. This principle became the guiding light for our movement. Christ furnished the spirit and motivation while Gandhi furnished the method."

— Martin Luther King, Jr.

The Vision of the Beloved Community

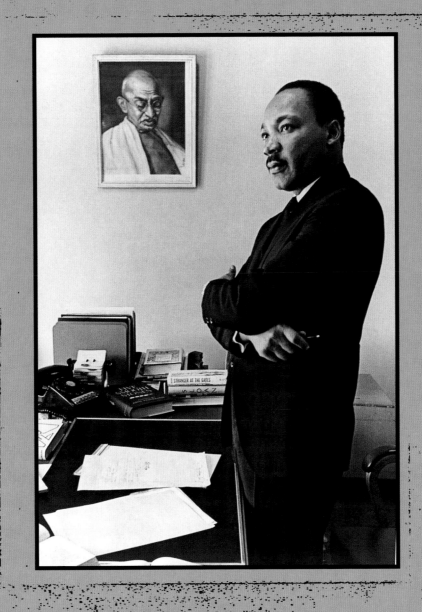

As a student at Crozer Theological Seminary, Martin Luther King wrestled with the meaning of social justice and the methods that might be employed to obtain it. He was deeply inspired by the social gospel writings of Walter Rauschenbusch. He avidly read *Moral Man and Immoral Society*, the 1932 book by philosopher Reinhold Niebuhr about the role of power and politics inherent in the struggle for justice. And, in *satyagraha*, the philosophical basis for Mohandas Gandhi's nonviolent movement for India's poor, he found a practical way to confront the problems of racism and segregation in the United States. Thoughtful reflection of these ideas, along with his personal experiences as a black man in the South, shaped King's philosophy about American racism that would become the foundation of the modern freedom struggle. □ Upon assuming the pastorate of the Dexter Avenue Baptist Church in Montgomery, Alabama and accepting the leadership of the Montgomery Improvement Association to spearhead the bus boycott, the opportunity for direct action had arrived. King's beliefs and the hard work and resolve of hundreds of civil rights workers began to come together. □ The bus boycott began when Rosa Parks refused to give up her seat for a white passenger. It continued after her arrest, for more than one year, as the determined black citizens of Montgomery walked or car-pooled to work rather than ride the segregated buses. King's philosophy of nonviolence tempered with love and the need for justice grew from experience. It reflected both the morality of Christian teaching and the ideals of democracy inherent in the Declaration of Independence and the Constitution. King believed strongly in the intrinsic dignity of every human being regardless of race, class, or gender and in personal responsibility to help others. □ "I want to tell you this evening that it is not enough to talk about love. Love is one of the pivotal parts of the Christian faith. There is another side called justice...Justice is love correcting that which revolts against love...Not only are we using the tools of persuasion but we've got to use the tools of coercion."—MARTIN LUTHER KING, JR., 1955

(PREVIOUS PAGE) KING AND GANDHI, 1966, BOB FITCH (1939-), BLACK AND WHITE PHOTOGRAPH, 10" x 8", © BOB FITCH PHOTO; COURTESY OF HOWARD GREENBERG GALLERY, NEW YORK, NY (OPPOSITE) DON'T SAY WHAT SIMON SAYS, 2000, PHEOBE BEASLEY (1943-), COLLAGE, 40" X 30". COURTESY OF M. HANKS GALLERY, SANTA MONICA, CA (OVERLEAF) TROLLEY, NEW ORLEANS, 1955-56 ROBERT FRANK (1924-), GELATIN SILVER PRINT, 11" X 14", ADDISON GALLERY OF AMERICAN ART, ANDOVER MA © THE AMERICANS, ROBERT FRANK; COURTESY OF PACE/MACGILL GALLERY, NEW YORK, NY

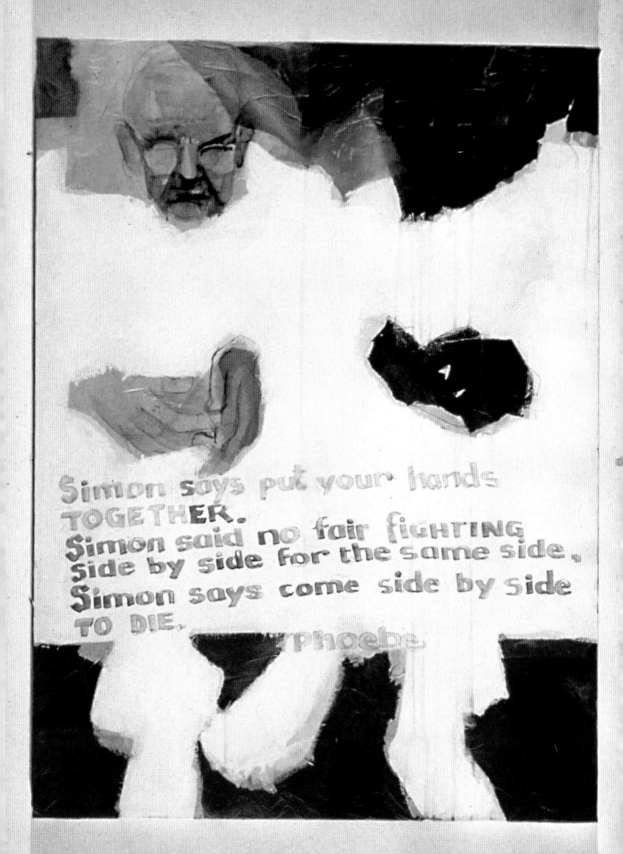

Simon says put your hands
TOGETHER.
Simon said no fair fighting
side by side for the same side.
Simon says come side by side
TO DIE. phoebe

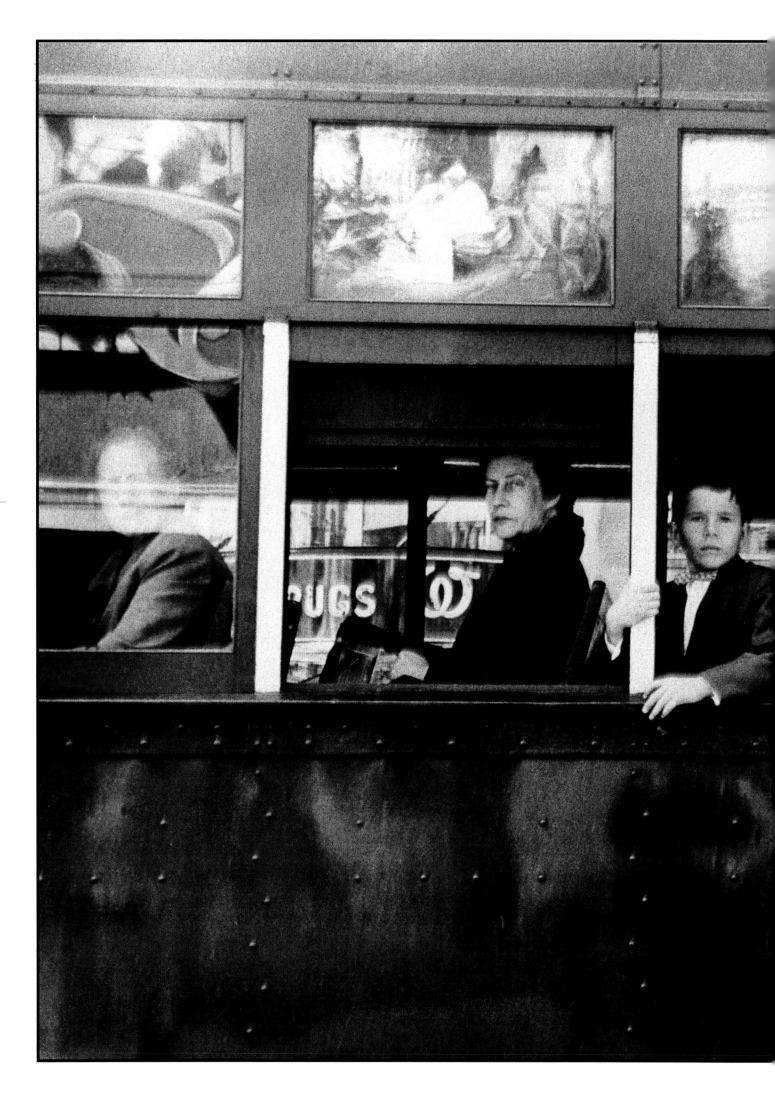

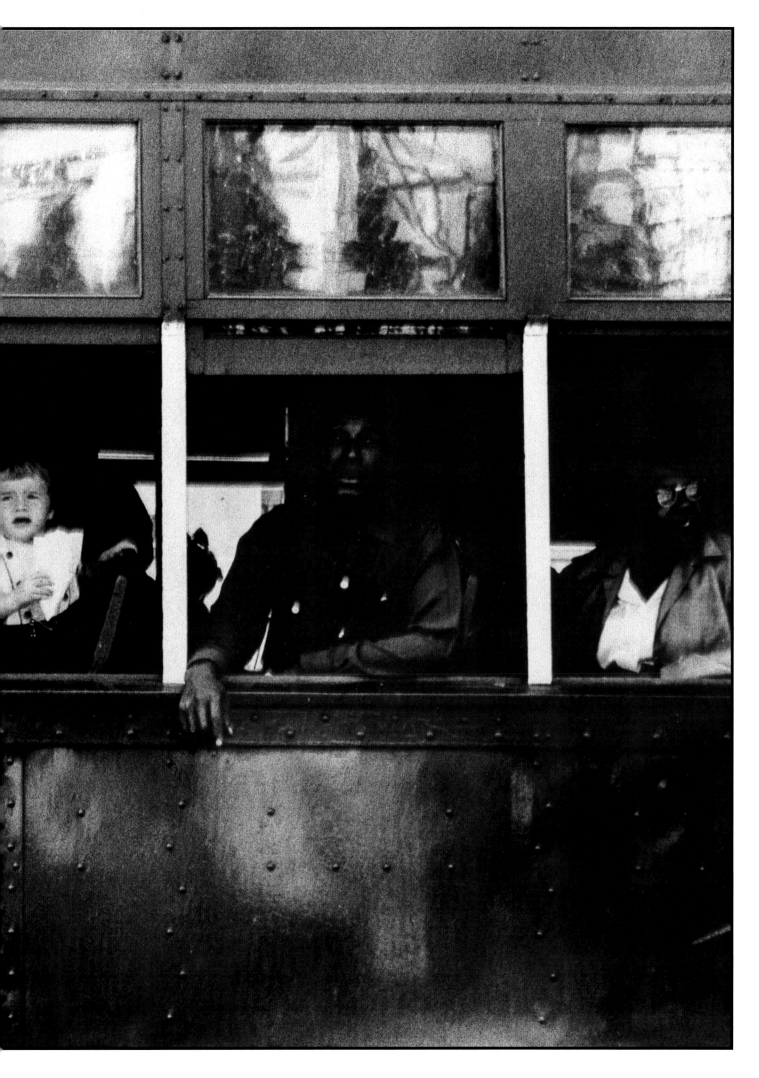

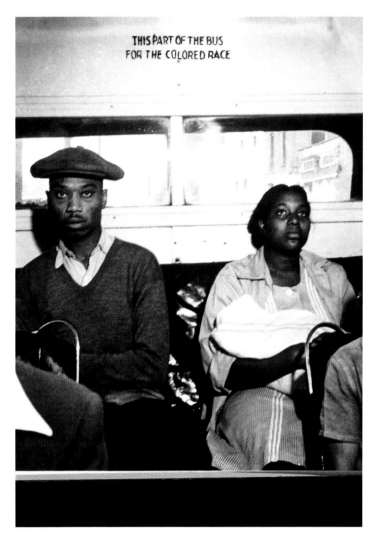

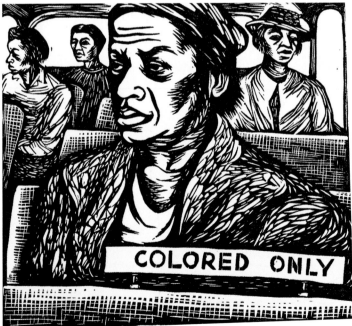

📖 (Top) Somewhere in the South, 1946-49, Marion Palfi (1917-78), gelatin silver print. Center for Creative Photography, The University of Arizona, Tucson, AZ 📖 (Bottom) I Have Special Reservations, 1946, Elizabeth Catlett (1915-), linoleum cut, 11″ x 10″. Courtesy of Sragow Gallery, New York, NY © Elizabeth Catlett/Licensed by VAGA, New York, NY 📖 (Right) Bus, 1941, Jacob Lawrence (1917-2000) gouache on paper 17″x 22″. Private Collection © Gwendolyn Knight Lawrence, courtesy of the Jacob and Gwendolyn Lawrence Foundation

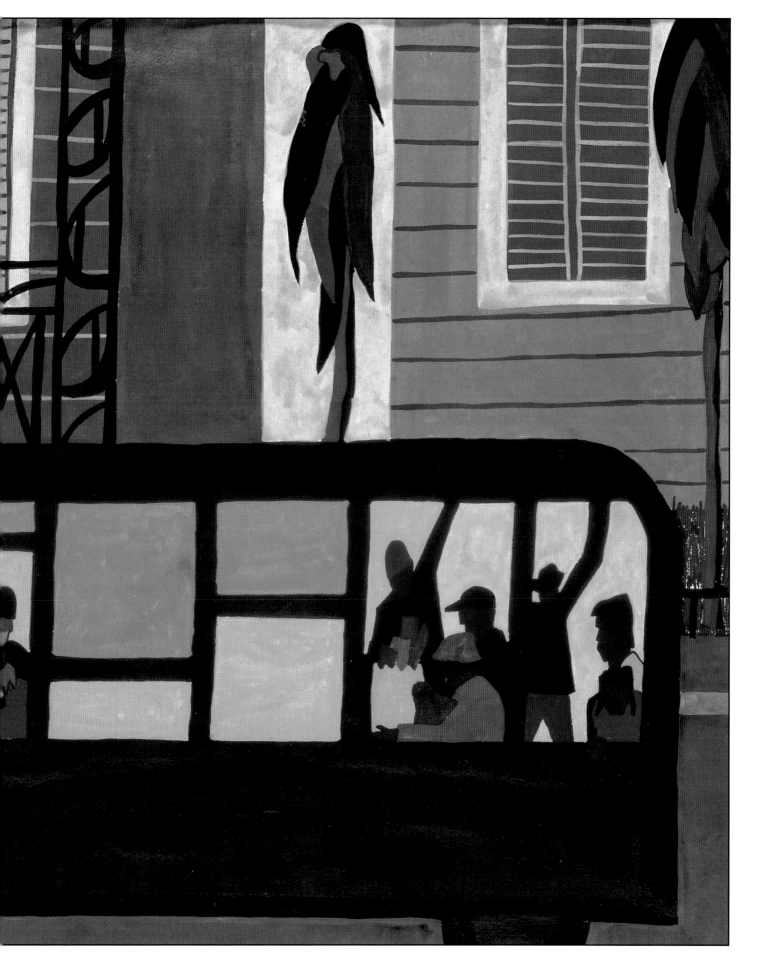

60

(Above) Southern Schools, 1945, Richard W. Dempsey (1909-1987), oil on canvas, 19-3/4″ x 24-3/8″. The Barnett Aden Collection/BET Art Collection, Washington, DC
Reproduced with permission of RLJ Acquisition II, LLC, Washington, DC
(Opposite) The Problem We All Live With, c.1963, Norman Rockwell (1894-1978), oil on canvas, 36″ x 58″. The Norman Rockwell Museum, Stockbridge, MA
Printed by permission of the Norman Rockwell Family Trust © 2002 The Norman Rockwell Family Trust

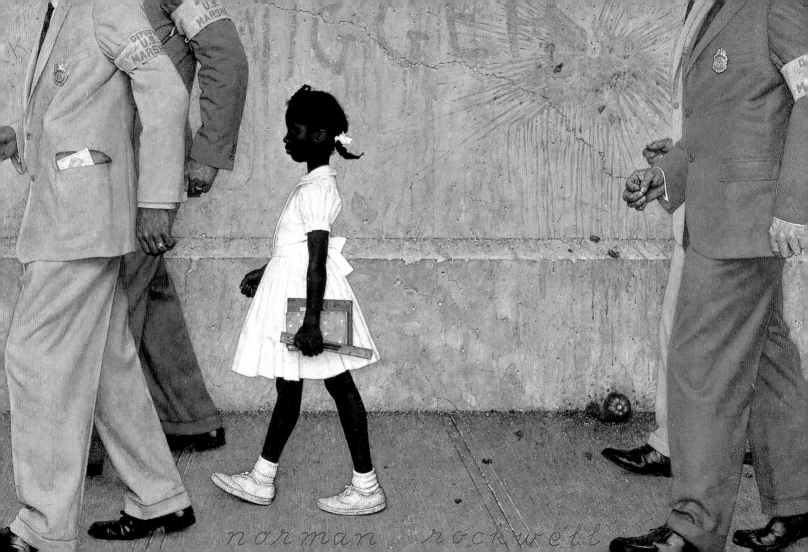

norman rockwell

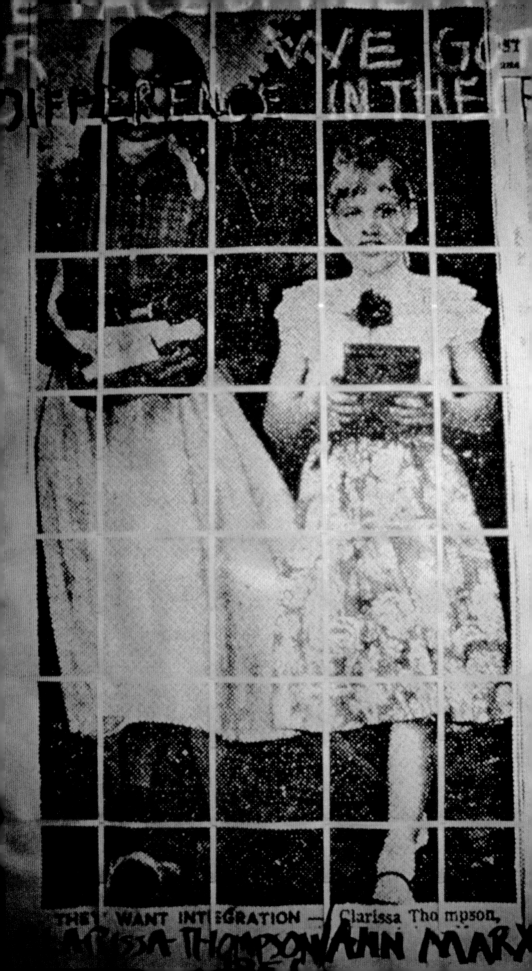

THEY WANT INTEGRATION — Clarissa Thompson,

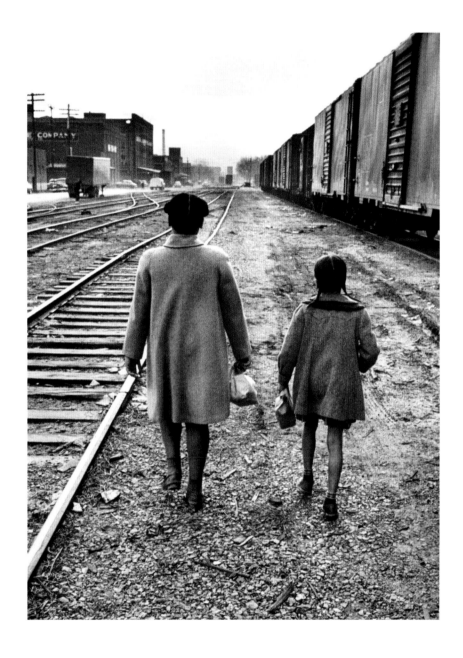

(Opposite) Witness to Dissent: Remembrance and Struggle, 1991, Clarissa Sligh (1939-), collage, 72″ x 32″, Collection of the artist, New York, NY
(Above) Linda Brown and Her Sister Walking to School, 1953, Carl Iwasaki (1923-), gelatin silver print, 20″ x 16″, Carl Iwasaki/TimePix, New York, NY

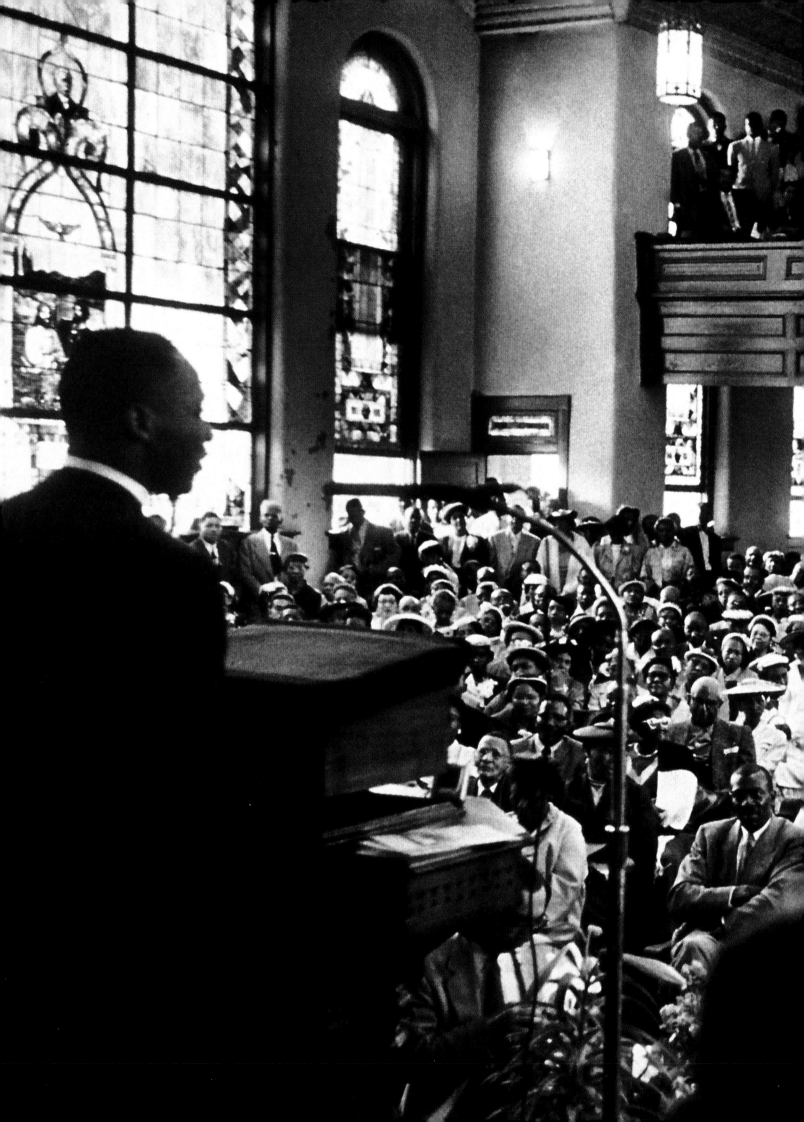

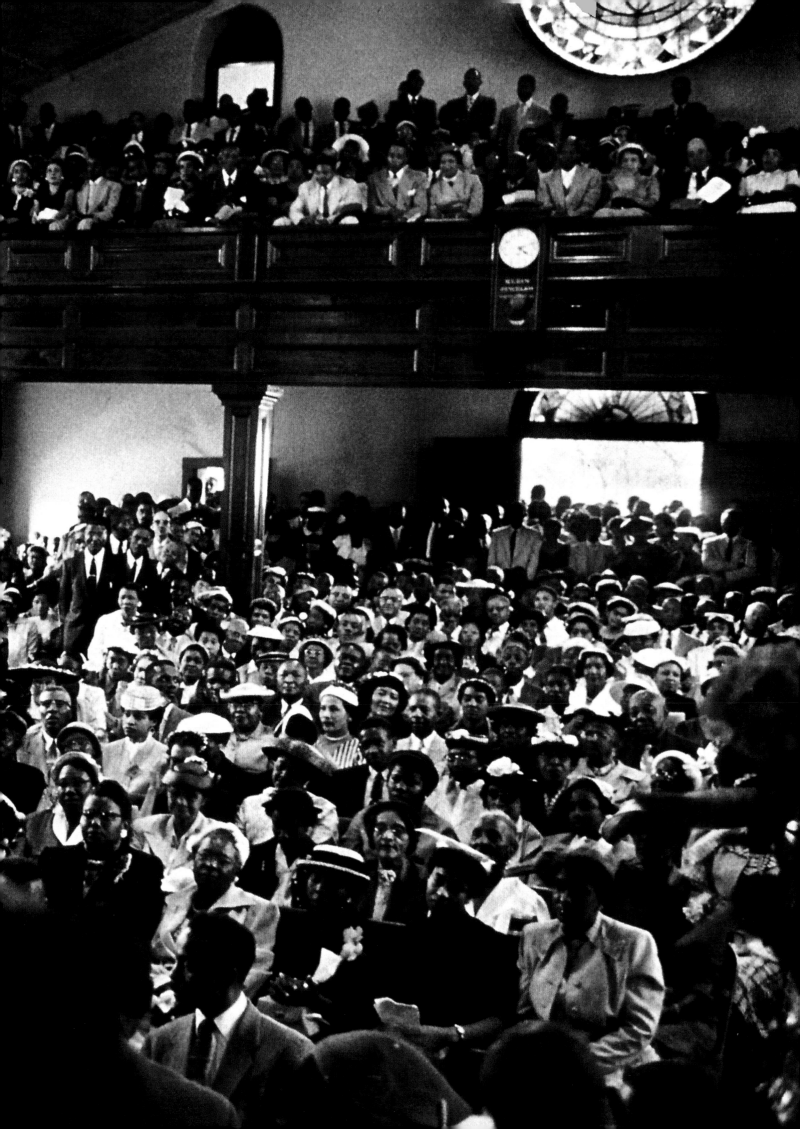

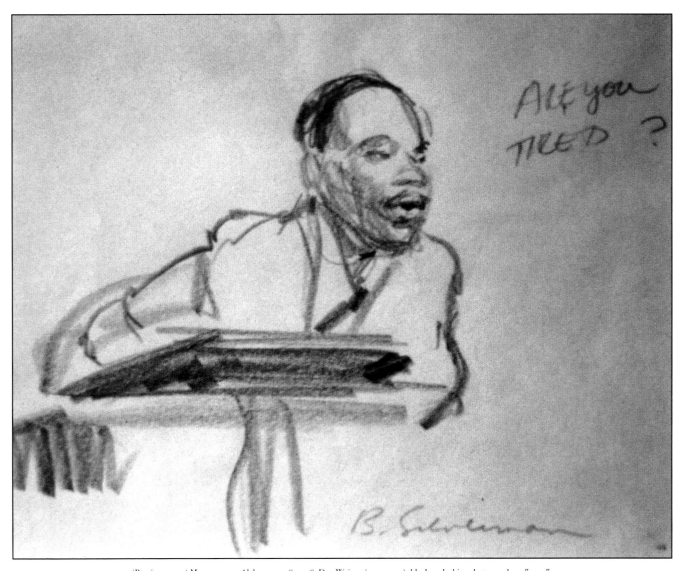

(Previous page) Montgomery, Alabama, 1956, 1956, Dan Weiner (1919-1959), black and white photograph, 14″ x 19″.
Courtesy of Sandra Weiner and Howard Greenberg Gallery, New York, NY

(Above) Martin Luther King, Jr., Montgomery, 1956, Burton Silverman (1928-), graphite on paper, 5″ x 6-1/4″, Delaware Art Museum, Wilmington, DE

(Opposite) Walking Together, Montgomery, 1956, Harvey Dinnerstein (1928-), Iris print on paper 30″ x 40″.
Collection of Lois and Harvey Dinnerstein, Brooklyn, NY © Harvey Dinnerstein

"We were in Montgomery...and the spirit of resurrection was in the air.
We did approximately 90 drawings on the trip...at church meetings,
in the courtroom, streets and homes of the people involved in the boycott.
Some of the drawings were of the leaders like Martin Luther King, Jr.,
Rosa Parks, E.D. Nixon... But the large majority of the drawings were of
ordinary people, a struggle that went beyond specific issues of segregation in
the buses, to address larger concerns of inequality across the nation."

"An image evolved in my mind of specific individuals
I had sketched walking the streets of Montgomery...coming together
at this singular moment, to project a spiritual force
that sought to change the heart and soul of America."

—Harvey Dinnerstein

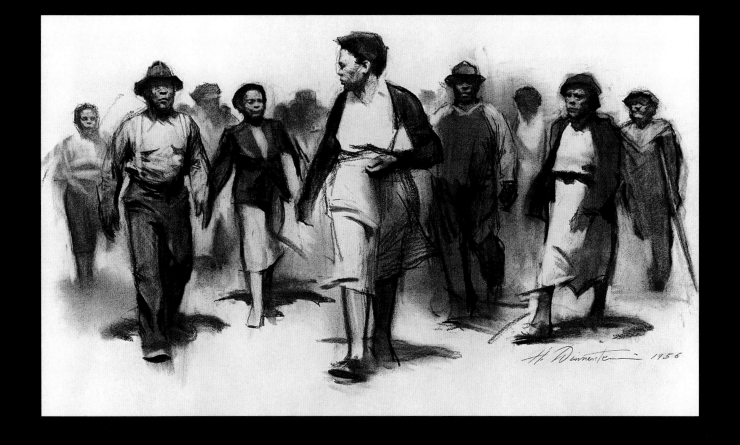

"The secret lies, I think, in his
intimate

(Opposite) Walking, 1958, Charles Alston (1907-1977), oil on canvas, 48″ x 64″. Collection of Sydney Smith Gordon, Chicago, IL

(Above) Bus With White Walls, 2001, Geoffrey Moss (1938-), oil on canvas, 30″ x 40″. Collection of the artist, New York, NY

(Below) Rosa Parks, 1983, Marshall D. Rumbaugh (1948-), painted limewood sculpture, 33″ high. National Portrait Gallery, Washington, DC
(Top right) King and Abernathy on the First Desegregated Bus, Montgomery, December 21, 1956, Ernest Withers (1922-), gelatin silver print, 16″ x 20″.
Courtesy of Panopticon Gallery, Waltham, MA © Ernest Withers
(Bottom right) Rosa Parks (on desegregated bus), Montgomery, Alabama, December 21, 1956, unidentified photographer, gelatin silver print, 16″x 20″. UPI Corbis/Bettman, New York, NY

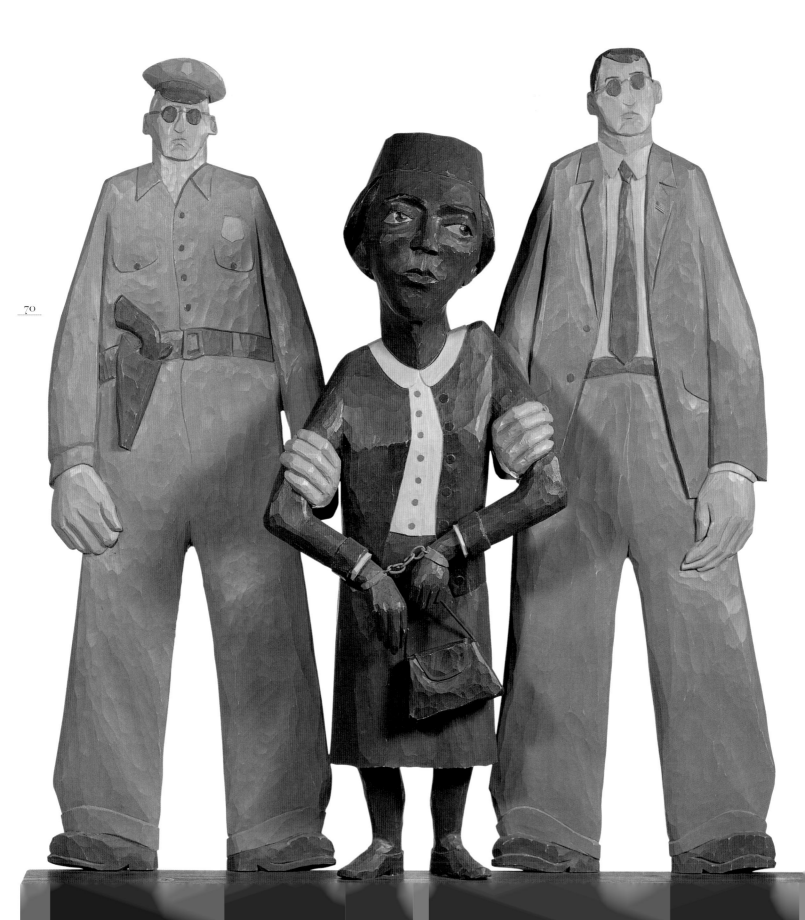

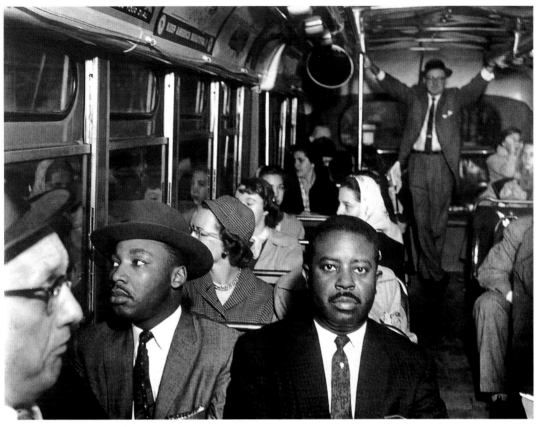

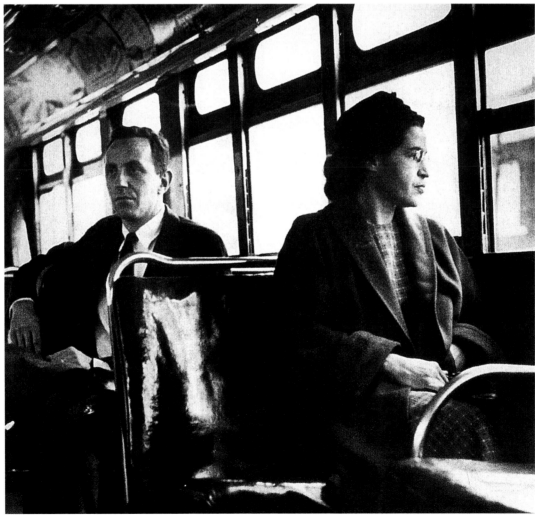

A MAN MADE REAL BY SOUND

STANLEY CROUCH

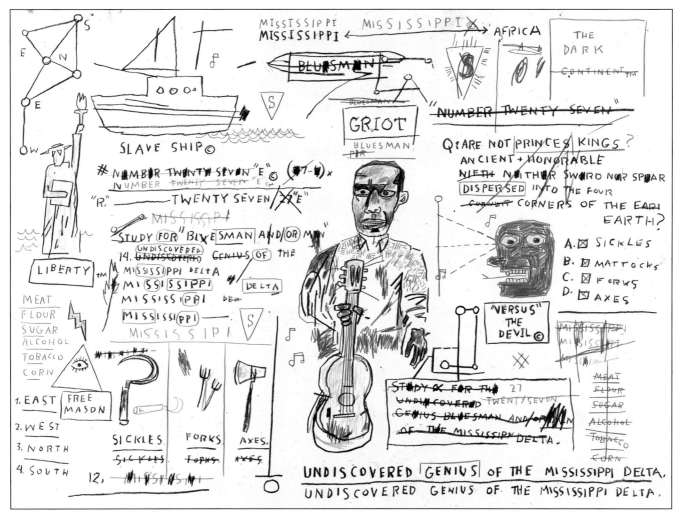

📖 **UNDISCOVERED GENIUS, 1982-83, JEAN-MICHEL BASQUIAT (1960-1988), ACRYLIC, OIL PAINTSTICK, CRAYON, GRAPHITE, COLORED PENCIL AND CHARCOAL ON PAPER, 22-1/2″ X 30″. COLLECTION OF THOMAS AMMANN FINE ART AG**

Image is a term that we are quite familiar with in our time of photographs, film, and videotape. Pictures, still or moving, are everywhere and they often tell us something about the past; they give history a kind of specificity. The power of visual technology has a unifying effect on our lives and on what we tend to think about the human qualities that define certain eras. That is why we so often remember how great men and women look. Martin Luther King, Jr. is an exception.

When we think of King, for all of the photographs and all of the footage and the millions of words that have been written about him, we think as much about the sound of his voice as we think of anything else. He defined himself in a basso-profundo manner that made him truly seem like "God's trombone," as James Weldon Johnson might have said—had Johnson lived long enough to hear that magnificent voice run like a mighty river through a southern course filled with dams built to hold back the sound of injustice exposed. The Civil Rights Movement itself was also defined by sound. It was the sound of a song, which eventually took on such profound international symbolism that it was sung in Czechoslovakia when Dujek returned and the square in Prague was filled with thousands upon thousands acknowledging their victory over the Communist repression. It was also on placards in Tiananmen Square when Beijing boiled over, as students demanded more freedom.

The song was "We Shall Overcome" and the racial context of America became secondary to those who understood that injustice in any society

72

is injustice and that its manifestations transcend its contexts. In the voice of Martin Luther King, Jr. the sound of "We Shall Overcome," the theme of the orchestra that was the movement, achieved national focus through the gifts of a master soloist. His voice carried the grief, disillusionment, melancholy, and the kind of heroic engagement against all odds that defines unsentimental optimism. It was the acknowledgment of great sorrow that made the sound unsentimental and even transformed phrases King used that were common or clichéd or, as with the March on Washington speech, here and there rife with the stuff of sentimentality.

That is why we are sometimes quite startled when we read an address of King's that has haunted or inspired or made some kind of indelible mark on our memories. We look at those words and we cannot believe that we were so moved by them or that they seemed to encompass the very epic nature of the struggle to make America live up to its own ideals, its own claims, its own promises. It was the summoning accuracy of his voice that remade his material and allowed his listeners to hear and see themselves at their best and the country at its worst, all the while realizing that the heroism demanded of them was a heroism far from futile.

There was both exaltation and disturbance in the sound of that heroism since it contained so many vital remnants of history. The long travail of slavery; the great joy and insecurity that swept through the slave compounds when the Civil War had ended and the plantation system was no more; the revolutionary black legislators of Reconstruction; the bloody reassertion of white rule at the end of Reconstruction; the removal of the Constitution from the lives of black people below the Mason-Dixon line when segregation and voting restrictions were imposed; and the many examples of violence, exploitation, and every kind of abuse of power all rang or murmured or sobbed or roared from the throat of Martin Luther King, Jr.

From that throat rose the lifeblood of the past. Every form of Negro American rhetoric elevated into the engagement with the references and the diction of exalted speech was brought to the podium. No matter the obvious of education that his style projected, the small man who had a giant spirit could always remind one of the humming heard in the morning before church, or the street chants of the boys and girls taunting and challenging one another, or the mood so true in its expression of the struggle with the hardships of life central to the blues, or the moment when some kid reveals the special light of talent on stage, or how subjects are turned over and over when examined in the public arenas of barber shops, or the camaraderie that those who do difficult jobs have for each other and that are reduced to single syllables of affirmation. So it could reverberate with something old, something young, something lived, something dreamed. No one was left out.

In the sound of Martin Luther King, Jr., every white person who had stood tall against slavery from the very first protests came alive again. In that sound every slave who had run away or who had helped someone else run away or who had made the most human world possible within the terms of bondage came alive again. The Underground Railroad ran once more, blacks and whites together risking all God's dangers as they spirited the most hearty into the North. Captured slaves came back as well, such as the runaway woman who had her toes torn off by a trap but stood with her back to a tree, kicking at the dogs sent to find her. The Negroes who were indispensable to the Union effort to defeat the Confederacy were there once more, training and marching and dying and burying casualties. Those black men in blue uniforms or doing whatever else was needed were fully there, inspiring Abraham Lincoln to write that if the 180,000 black people turned away from the conflict, the South would take the day and maintain itself. The great sorrow at Lincoln's assassination was real again as were the racist decisions of the Supreme Court and the many examples of terrorist tactics used by whites masked by the winding sheets of a ruthless order.

The ability to make such things real is essential to how we understand ourselves. Any sound that can bring us to recognize those kinds of epic feelings will take on a timeless quality and will expand in meaning as we discover more about the past. The more we learn about slavery, about the Civil War, about the various racist and unconstitutional laws that governed the South, and about the efforts to dismantle all that was un-American, the richer King's statements become, whether he was personally aware of those facts or not. That is what all epic poets of the public spirit have in common. They call upon the known and the unknown with such accuracy that more information only underscores what they had to say. It is like Shakespeare. The more we come to understand the complexities of the human condition, the greater a writer he becomes, having touched upon so much of that complexity through his imagination, his talent, and his ability to ring and ring the triangle of the present, the past, and the future.

When we think of Martin Luther King, Jr., we will always hear him and we will always understand that to "let freedom ring" is to lift one's hammer and swat that triangle of the present, the past, and the future. That is not as far out as some might think, since we all live in those terms, if we are lucky and until our luck runs down to nothing. The present breath is immediately made a part of the past by the next breath, which was waiting in the future. But what Martin Luther King, Jr. represents is the way that the species speaks across much, much larger units than those of individual lives. As God's truest trombone of the Civil Rights Movement—which should be capitalized like the Civil War because it was probably the most profoundly redefining American social event of its century—King left no one out. He spoke for those in the great past who had no idea what freedom was and for those who later did and for those who will, even much, much later, be made happy or more resolute by the fact that someone could so clearly give immeasurable feeling to their dreams. Only the most truly gifted can place such presents under the Christmas tree of the world.

73

"The ultimate weakness of violence is that it is a descending spiral, begetting the very thing it seeks to destroy. Instead of diminishing evil, it multiplies it. Through violence you may murder the liar but you cannot murder the lie, nor establish the truth."

— Martin Luther King, Jr.

The Alternative to Violence is Non-Violent Resistance

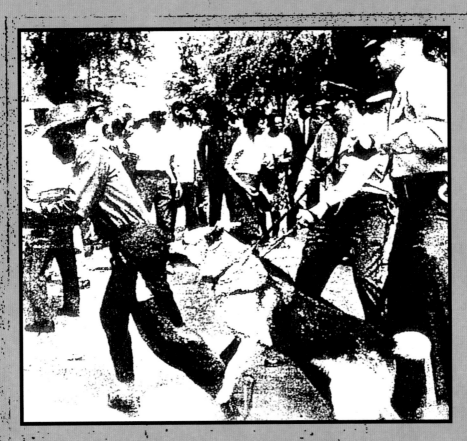

You may well ask, why direct action? Why sit-ins, marches, etc.? Isn't negotiation a better path? You are exactly right in your call for negotiation... Indeed, this is the purpose of direct action. Nonviolent direct action seeks to create such a crisis and establish such creative tension that a community that has constantly refused to negotiate is forced to confront the issue. It seeks so to dramatize the issue that it can no longer be ignored." □ Dr. King wrote these words to white clergymen who criticized the Birmingham civil rights march as, "unwise and untimely." It was 1963 and King was under arrest and writing from a Birmingham, Alabama jail cell. As nonviolent direct action against segregation in the South escalated, so too did southern resistance. The Civil Rights Movement was seen as a massive attack on the southern way of life. Indeed the hundreds of civil rights workers from the North who descended on the region disrupted the routine practice of separate public accommodations and shined the bright lights of the national press on these undemocratic practices. Escalating pressure from the civil rights workers—freedom rides, marches, sit-ins, voter registrations drives—were met with increasing violence. □ Artists responded powerfully to these dramatic and historic events, providing representations of significant moments that are forever burned into the American psyche. The works of art in this volume recall the days when angry white citizens became violent and law enforcement officers confronted peaceful demonstrators with vicious dogs and water hoses. As viewers, each of these works places us in the position of facing the events head-on and examining our own prejudices. We are asked to consider our own involvement or passivity in the violence visited on some Americans by other Americans. Which side would each of us choose?

(PREVIOUS PAGE) BIRMINGHAM RACE RIOT, 1964, ANDY WARHOL (1928-1987) SILKSCREEN INK ON PAPER, 20″ x 24″, COURTESY RONALD FELDMAN FINE ARTS © 2002 ANDY WARHOL FOUNDATION FOR THE VISUAL ARTS/ARS, NEW YORK, NY (OPPOSITE) MARTIN LUTHER KING, JR., 1968, PETER GEE (1932-), SILKSCREEN POSTER, 35-1/4″ x 22″, COLLECTION OF DUKE PAULO SERRA

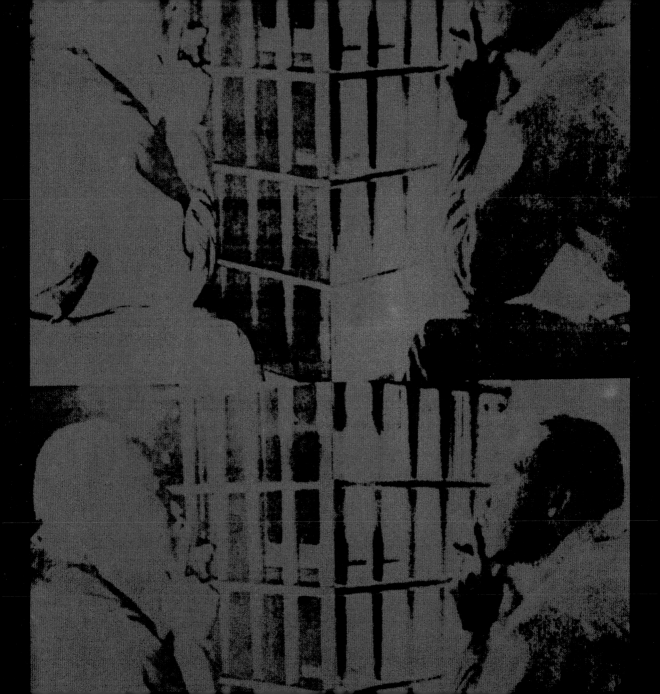

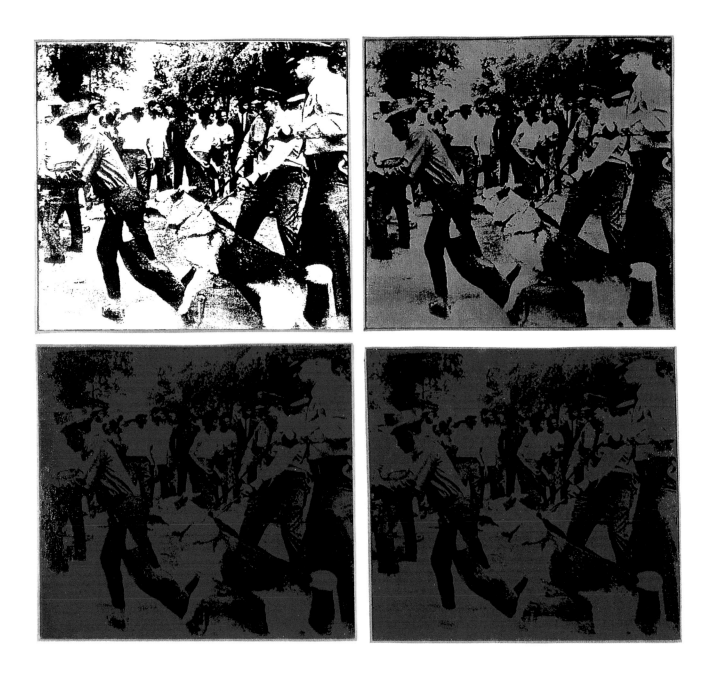

(Opposite) Birmingham '63, 1963, Jack Levine (1915-), oil on canvas, 71″ x 75″. Fine Arts Museums of San Francisco.
Museum Purchase, Dr. Leland A. Barber and Gladys K. Barber Fund, American Art Trust Fund and Mildred Anna Williams Collection by exchange
© Jack Levine/Licensed by VAGA, New York, NY

(Above) Race Riot, 1963, Andy Warhol, acrylic and silkscreen on canvas, Four panels, 30″ x 33″ each. © 2002 Andy Warhol Foundation for the Visual Arts/ARS, New York, NY

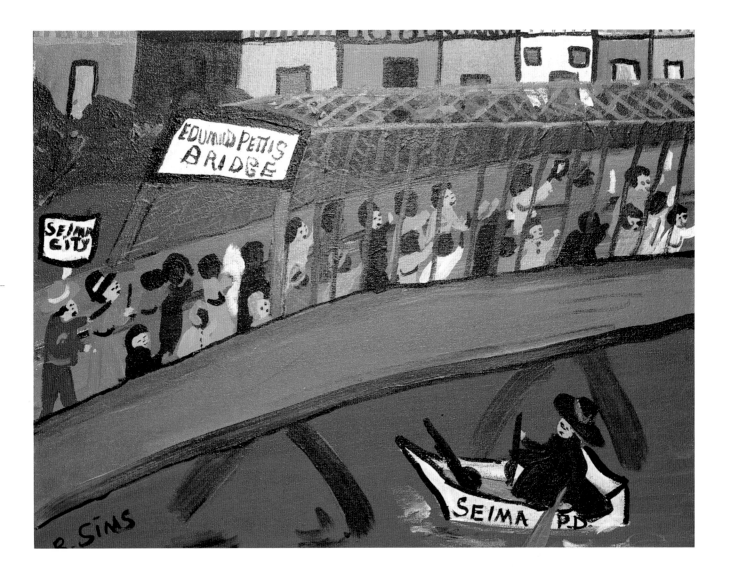

(Above) Selma March, 1991, Bernice Sims (1926-), acrylic on canvas, 16″ x 20″ Collection of the Law Office of Micki Beth Stiller, P.C.

(Opposite) Confrontation at the Bridge, 1975, Jacob Lawrence (1917-2000), screenprint on paper, 19-1/2″ x 25-7/8″. Private collection, Washington, DC

© Gwendolyn Knight Lawrence, courtesy of the Jacob and Gwendolyn Lawrence Foundation

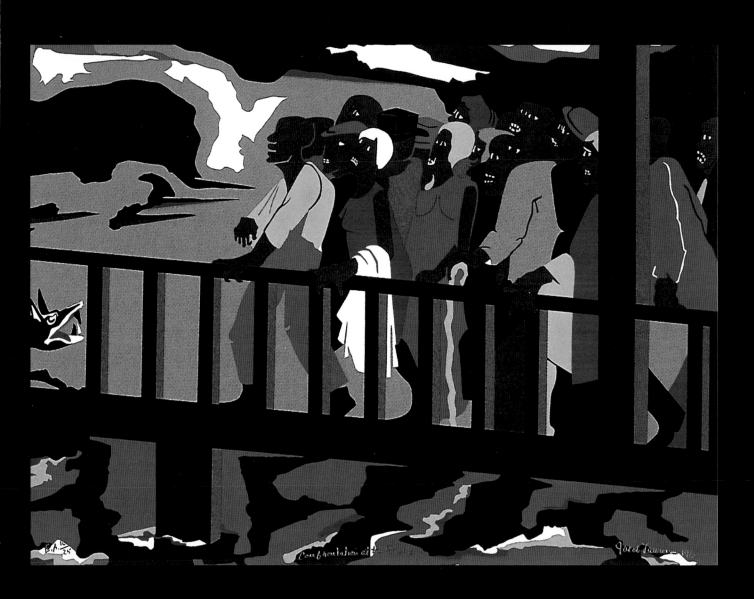

82

Graveyard Traveler/Selma Bridge, 1992, Thornton Dial (1928-), mixed media on wood, 85-1/2″ x 146″ x 6″. Collection of William S. Arnett, Atlanta, GA

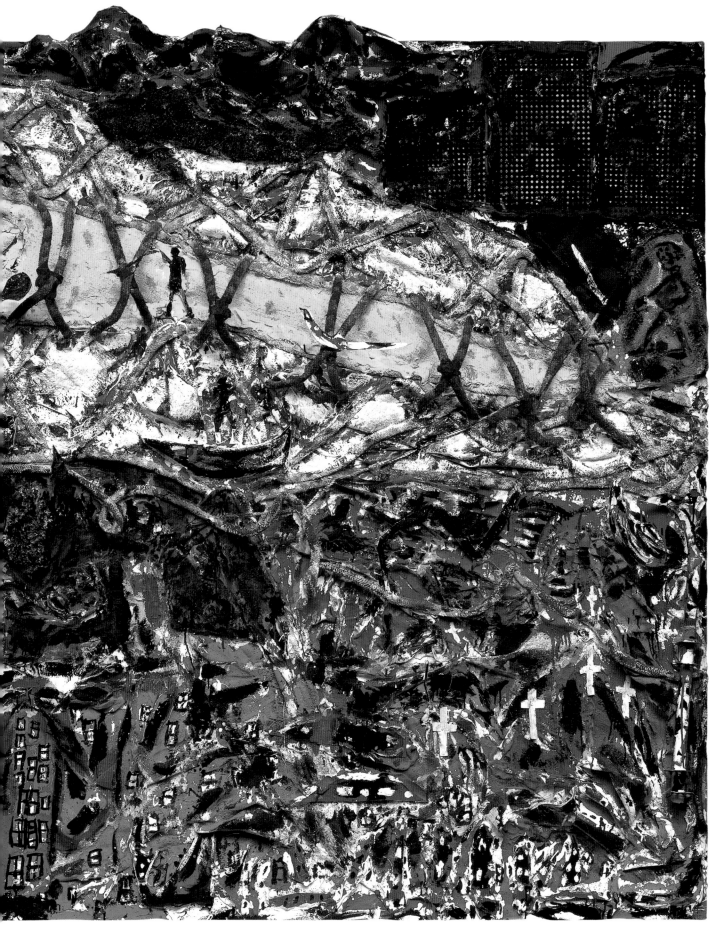

(Overleaf) Processional, 1965, Norman Lewis (1909-1979), oil on canvas , 38 -1/4″ x 57 -3/4″. Courtesy of Stella Jones Gallery, New Orleans, LA

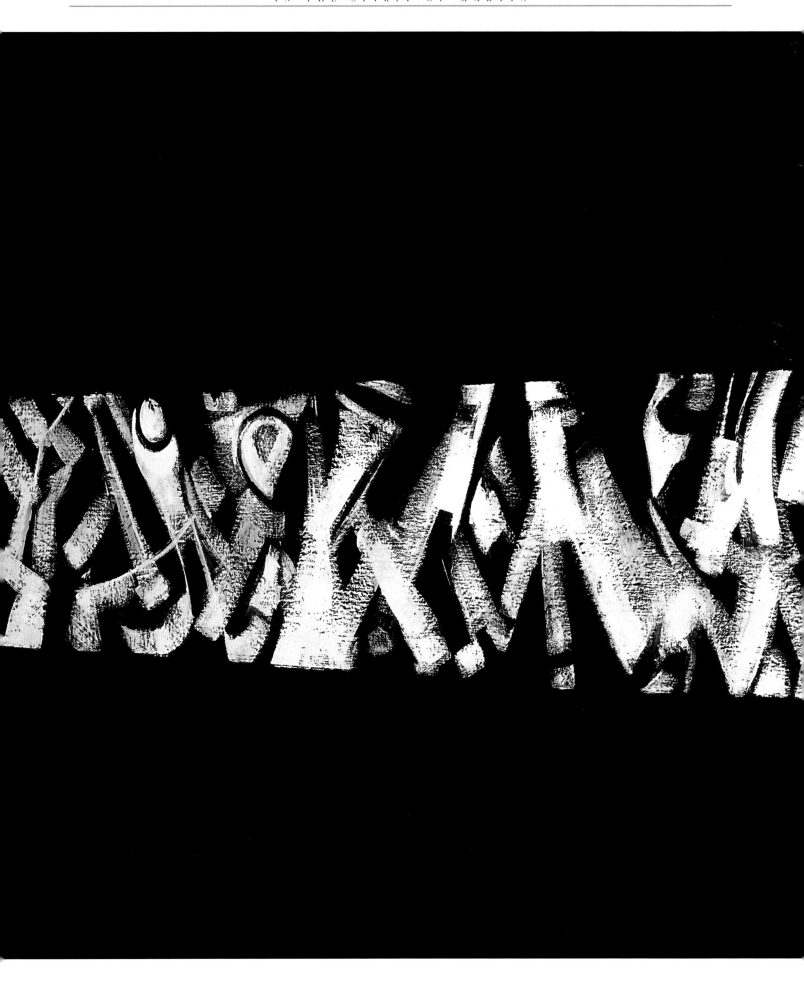

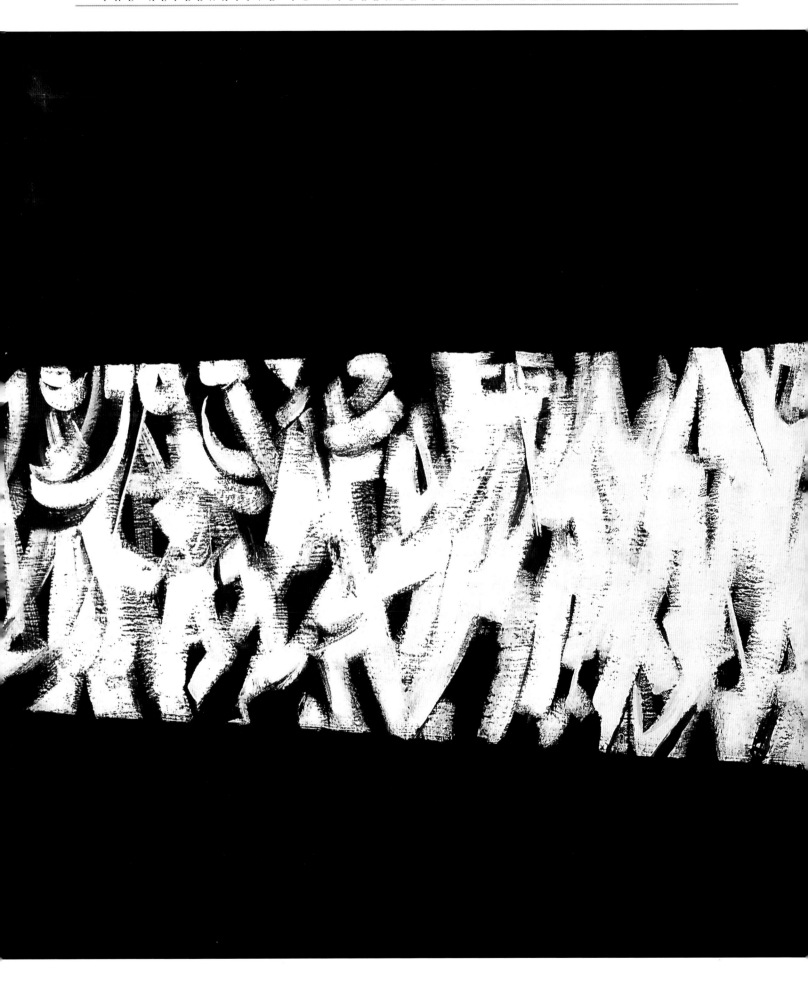

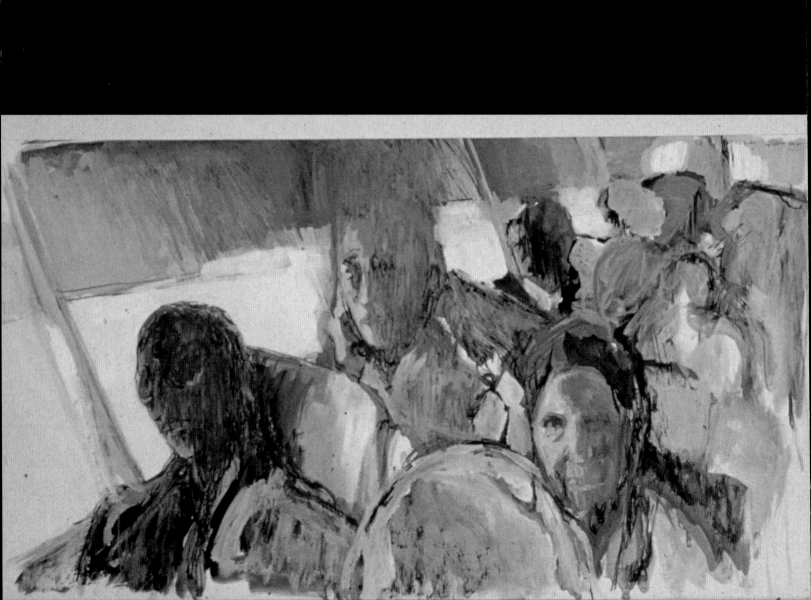

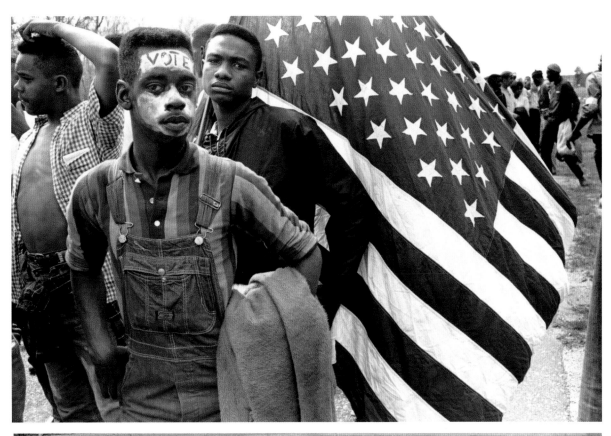

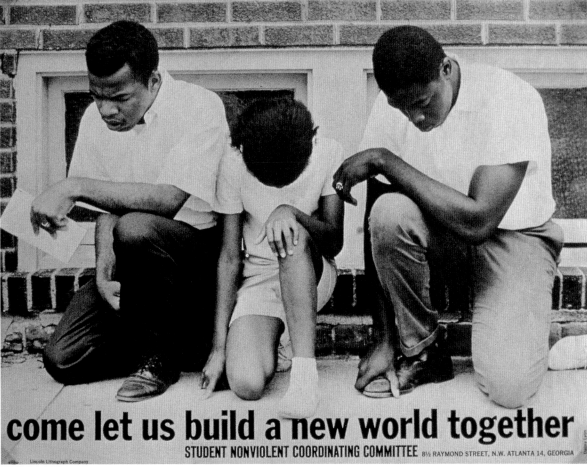

come let us build a new world together

STUDENT NONVIOLENT COORDINATING COMMITTEE 8½ RAYMOND STREET, N.W. ATLANTA 14, GEORGIA

□ (Opposite page) Freedom Riders, 1963, May Stevens (1924-), gouache on paper, 48″ x 60″. Private Collection, New York, NY

(Top) Three Youths on the Selma to Montgomery March, March 21-25, 1965, Bruce Davidson (1933-), gelatin silver print, 16″ x 20″. Magnum Photos, New York, NY

(Bottom) Come Let Us Build a New World Together, c.1962, Danny Lyon (1942-), offset poster, 14″ x 18-1/2″. Center for the Study of Political Graphics, Los Angeles, CA

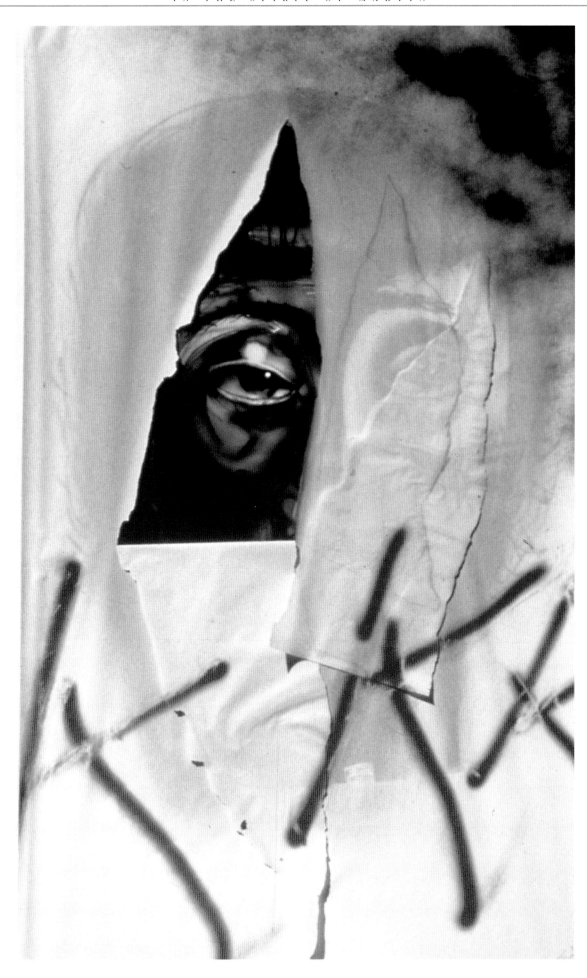

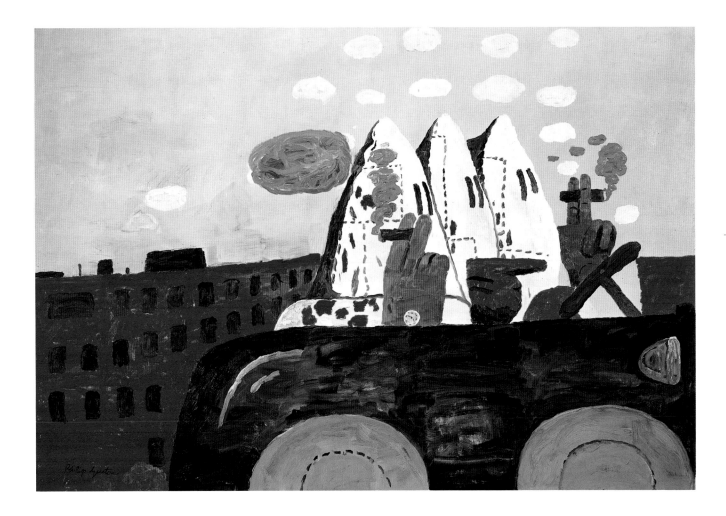

(Opposite) KKKK, 1994, Calvin Burnett (1921-), mixed media collage, 60″ x 40″. Collection of the artist, Medway, MA

(Above) Riding Around, 1969, Philip Guston (1913-1980), oil on Canvas, 54″ x 79″. Private Collection, Courtesy of McKee Gallery, New York, NY

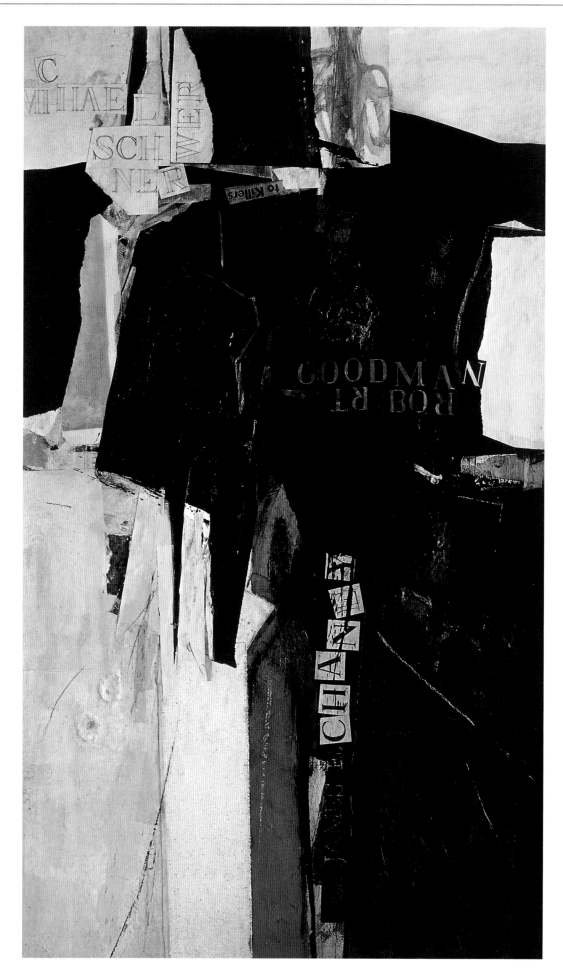

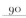

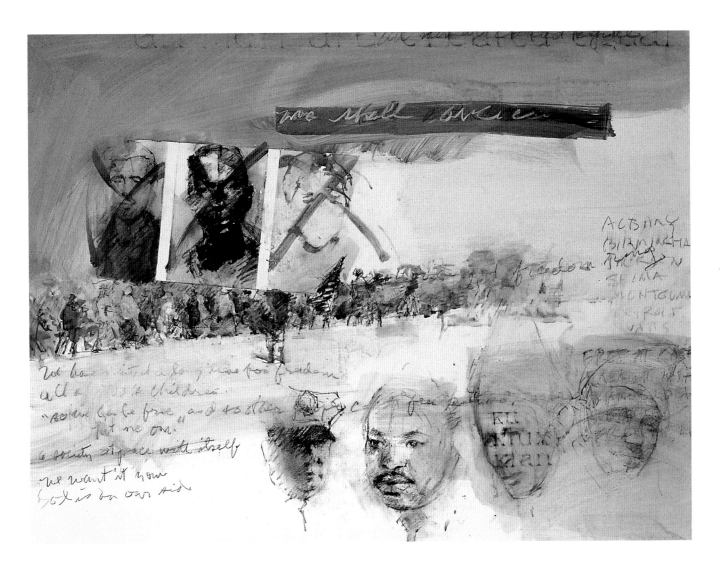

(Opposite) Neshoba Specter, 1966, Alvin Smith (1933-), oil on canvas with collage, 60″ x 35-1/2″. Clark Atlanta University Art Galleries, Atlanta, GA
(Above) All of God's Children, 1993, Alex Powers (1940-), acrylic, charcoal, pastel, 30″ x 40″. Collection of Peter and Amelia Boyer, Toledo, OH

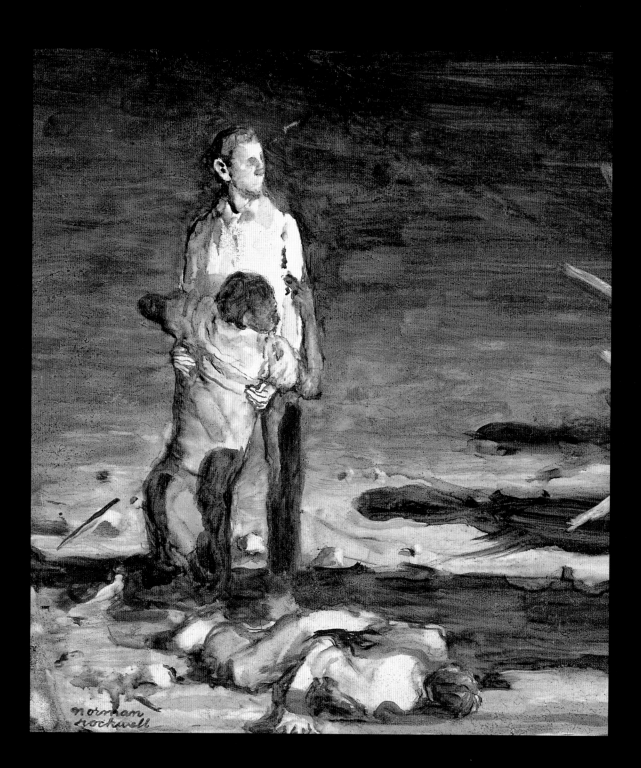

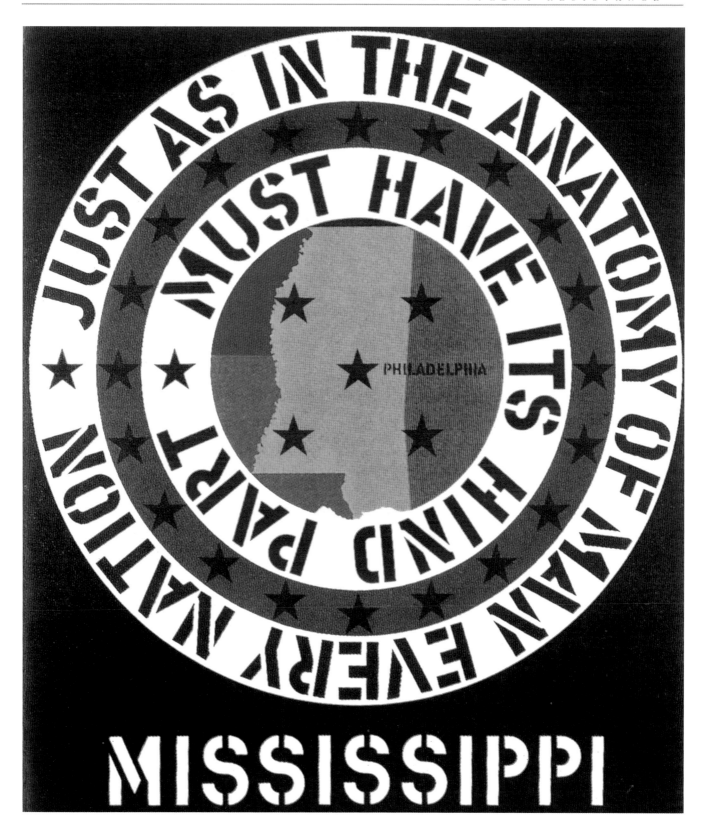

(Opposite) Murder in Mississippi (Study), c. 1964, Norman Rockwell (1894-1978), oil on board, 15″ x 12-3/4″.

The Norman Rockwell Museum, Stockbridge, MA, Printed by permission of the Norman Rockwell Family Trust © 2002 The Norman Rockwell Family Trust

(Above) The Confederacy: Mississippi, 1965, Robert Indiana (1928-), silkscreen print, 34-7/8″ x 29-7/8″. © 2002 Morgan Art Foundation Ltd./Artists Rights Society (ARS), New York, NY

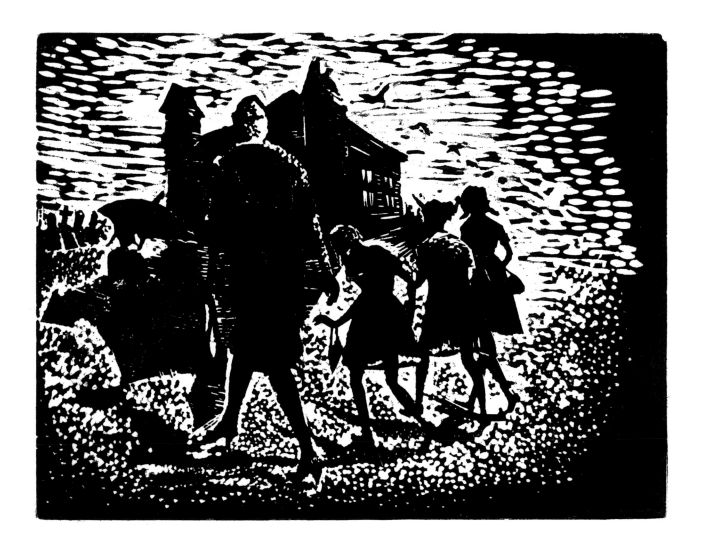

(Opposite) Easter Sunday, 1966, Vincent Smith, oil on masonite, 24″ x 20″. Courtesy of G.W. Einstein Company, Inc., New York, NY

(Above) Children of the Morning, 1964 (Printed 1989), John Biggers (1924-2001), linocut, 17″ x 20″. Hampton University Museum, Hampton, VA

96

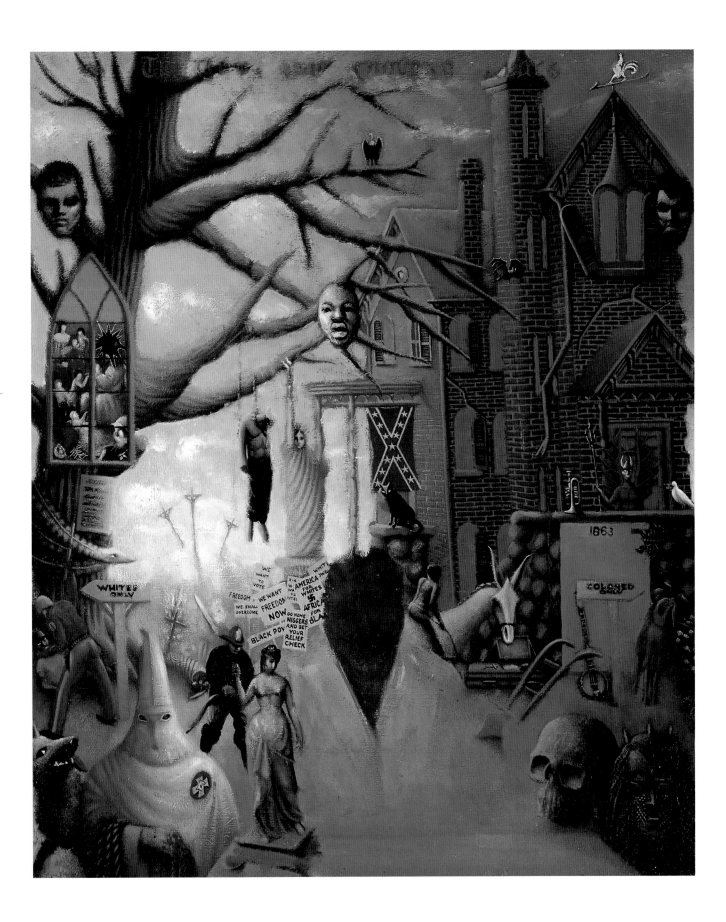

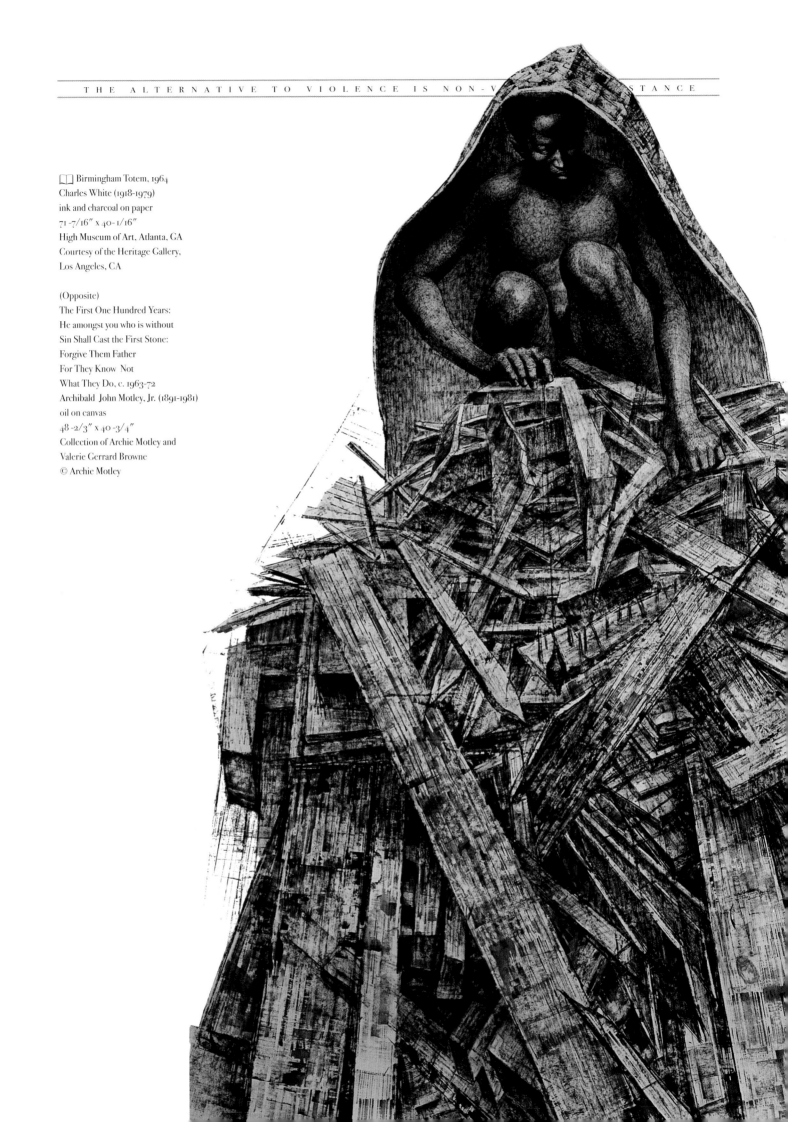

Birmingham Totem, 1964
Charles White (1918-1979)
ink and charcoal on paper
71-7/16″ x 40-1/16″
High Museum of Art, Atlanta, GA
Courtesy of the Heritage Gallery,
Los Angeles, CA

(Opposite)
The First One Hundred Years:
He amongst you who is without
Sin Shall Cast the First Stone:
Forgive Them Father
For They Know Not
What They Do, c. 1963-72
Archibald John Motley, Jr. (1891-1981)
oil on canvas
48-2/3″ x 40-3/4″
Collection of Archie Motley and
Valerie Gerrard Browne
© Archie Motley

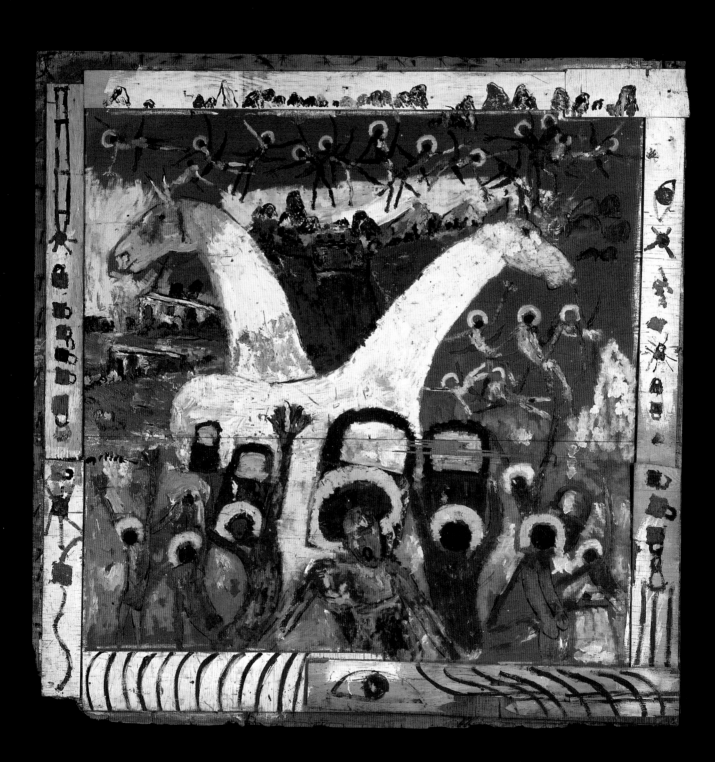

FREEDOM SONGS AND SINGING:

THE UNBREAKABLE BOND BETWEEN AFRICAN AMERICAN SONGS AND STRUGGLE

BERNICE JOHNSON REAGON

From 1955 to 1965 the equilibrium of American society was racked by waves of social and political protest. Black people engaging in massive civil disobedience served notice on the nation and the world that they would no longer tolerate the abuses of American racism. The Civil Rights Movement heralded a new era in the African American struggle for equality.

The Movement spread throughout the South. Initial organizers were black college students who set aside their studies to work in segregated rural and urban communities. They received support from local leaders who listened to them, housed, and fed them. Sharecroppers, ministers, hairdressers, restaurant owners, independent business people, teachers: these were the first to try to register to vote, apply for a job, or use a public facility previously reserved for whites.

The response was swift and brutal: economic reprisals, jailings, beatings, and killings. Nonetheless, the Movement grew, pulling recruits from all segments of the black community and forcing change in legal, political, and social processes. But its essence lay in the transformation of a people. I grew up in Dougherty County, just outside of Albany, Georgia, in a community steeped in black southern cultural traditions. From the late 1950s through the mid-1960s, I celebrated and participated in the wedding of our traditional culture with our contemporary struggle for freedom. All the established academic categories in which I had been educated fell apart during this period, revealing culture to be not luxury, not leisure, not entertainment, but the lifeblood of the community. My culture and my traditions came alive for me as they shaped the context of the Civil Rights Movement.

As a singer and activist in the Albany Movement, I sang and heard the freedom songs, and saw them pull together sections of the black community at times when other means of communication were

☐ (OPPOSITE) LOCKED UP THEIR MINDS, 1972, PURVIS YOUNG, (1943-), PAINT AND WOOD ON WOOD, 84″ X 84″, COLLECTION OF WILLIAM S. ARNETT (ABOVE) COMMEMORATIVE SHEET MUSIC FOR THE MOST SIGNIFICANT SONG OF THE MOVEMENT, WE SHALL OVERCOME. PUBLISHED UPON THE DEATH OF DR. MARTIN LUTHER KING, JR.

ineffective. It was the first time that I experienced the full power of song as an instrument for the articulation of our community's concerns.

In Dawson, Georgia, where blacks were 75 percent of the population, I sat in a church and felt the chill that ran through a small gathering when the sheriff and his deputies walked in. They stood at the door, making sure everyone knew they were there. Then a song began. And the song made sure that the sheriff and his deputies knew *we* were there. We became visible; our image of ourselves was enlarged when the freedom songs filled all the space in that church. Music has always been integral to the African American struggle for freedom. Its central participants shaped the music culture of the Civil Rights Movement: black southerners. The freedom songs, though recorded, transcribed, committed to the written page, and read, truly came to life in an older black oral tradition, where song and struggle were inseparable. The power of the songs came from the linking of traditional oral expression with everyday Movement experiences. Charles Sherrod, field secretary of the Student Nonviolent Coordinating Committee (SNCC), witnessed how music galvanized the first mass meeting held in Albany, Georgia at the Mt. Zion Baptist Church in December 1961: *"The church was packed before eight o'clock. People were everywhere, in the aisles, sitting, and standing on the choir stands, hanging over the railing of the balcony, sitting in trees outside the window. When the last speaker among the students, Bertha Gober, had finished, there was nothing left to say. Tears filled the eyes of hard grown men who had seen with their own eyes merciless atrocities committed... and when we rose to sing 'We Shall Overcome,' nobody could imagine what kept the church on four corners. I threw my head back and sang with my whole body."*

While the Albany Movement elevated singing, song as an expression

of power and communal unity emerged as early as the 1955 Montgomery, Alabama Bus Boycott. After Rosa Parks's arrest for refusing to let a white man take her seat on a bus, black leaders led by the Women's Political Council, called for a one-day bus boycott on December 5, 1955. It proved effective, and that night, Montgomery's African American community crowded into Holt Street Baptist Church. Martin Luther King, who had been elected leader of the Montgomery Improvement Association, later recalled the singing: *"The opening hymn was the old familiar 'Onward Christian Soldiers,' and when that mammoth audience stood to sing, the voices outside swelling the chorus in the church, there was a mighty ring like the glad echo of Heaven itself."*

Onward Christian soldiers, marching as to war
With the cross of Jesus, going on before!
Christ, the royal Master, leads against the foe
Forward into battle, see his banner go.

This hymn, penned by Sabine Baring-Gould at the end of the Civil War in 1865, was a staple of Sunday School and academic school devotional services. It was often sung without fervor, the congregation minding text and melody, that is until it became the contemporary freedom anthem of the Montgomery Bus Boycott. The way the text compares the marchers being soldiers and the struggle being a war with Christ in the lead suited the time and illustrated the situation for many of the participants. The other hymn that saw a lot of use during that year was Johnson Oatman, Jr.'s (1856–1922) "Lift Him Up."

How to reach the masses, men of every birth
For an answer Jesus gave the key
And I, if I be lifted up from the earth,
Will draw all men unto me.

The white city fathers who ran Montgomery refused to sit in council with African Americans who sought to change the segregated practices by which their communities were run. The lyrics of this hymn suggests that if Jesus was the leader, then he could even draw the racist city fathers of Montgomery to the negotiating table. While old songs would continue to be given new life throughout the Movement, new songs began to appear as the boycott continued and reprisals became more severe. After 89 leaders were arraigned for allegedly organizing a boycott, they walked to the Dexter Avenue Baptist Church. Writing for *the Nation*, Alfred Mound described the scene:

With the spirit and ingenuity that has characterized the leadership of this historic movement, Reverend Martin Luther King offered a new hymn for the occasion, set to the tune of 'Old Time Religion.' Indeed the blending of 'Old Time Religion' with a new determination to achieve racial equality is the essence of the boycott. The stanzas went like this:

We are moving on to victory
We are moving on to victory
We are moving on to victory
With hope and dignity
We will all stand together
Until we all are free

The meeting that day closed with the singing of "Nobody Knows the Trouble I've Seen." Here were two songs that were both a part of black traditional sacred music repertoire. "Old Time Religion," was updated to address an immediate need for the Movement. "Nobody knows the Trouble I've Seen," was sung in its traditional form. On many occasions, the new borrowed from the old in the midst of Movement activity. These transformed songs, used in conjunction with older songs, effectively conveyed the message that the black struggle had a long history.

Montgomery also saw the use of songs and songleaders to mobilize the Movement. Mary Ethel Dozier Jones, a member of what would become a highly regarded trio of songleaders, talked of her involvement during that period: *"I was a member of the trio before the Movement. I was in elementary school; in 1954 I was ten years old. Pretty soon after the first mass meeting in 1955 we started singing for the Montgomery Improvement Association. We were doing songs of the Movement, 'This Little Light of Mine, I'm Gonna Let It Shine.' 'We Shall Overcome' came later. We would make up songs. All the songs I remember gave us strength to go on. It was kind of spontaneous; if somebody started beating us over the head with a billy club we would start singing about the billy club..."*

The Montgomery Gospel Trio, made up of Jones, Minnie Hendricks, and Gladys Burnette Carter, later went to the Highlander Folk School in Mt. Eagle, Tennessee and met Guy Carawan. They appeared at a Carnegie Hall benefit for Highlander Folk School in 1961. A recording of their music was produced by Carawan and released by the Folkways Recording Company.

There were many songs which arose from a rich communal tradition; moved into protest forums, then to concert stages; connected with the budding folk music revival gathering steam in the Northeast; and culminated in recordings that reached national audiences throughout the 1960s. This progression of songs would occur again and again.

The sit-ins brought young black college students into the Movement in droves. The Greensboro, North Carolina sit-in at the local Woolworth lunch counter by four freshmen, Ezell Blair, Jr., Joseph McNeil, David Richmond, and Franklin McClain, on February 1, 1960, sparked national and international attention. While other sit-ins were staged all over the country, this form of nonviolent resistance was especially successful in Southern cities with large black college populations.

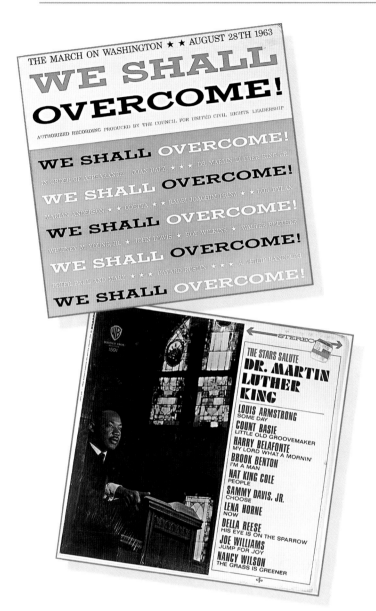

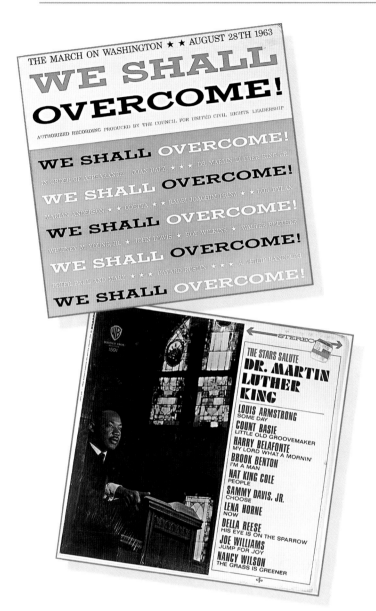

(TOP) RECORD ALBUM COMMEMORATING THE MARCH ON WASHINGTON, AUGUST 28, 1963, PRODUCED BY THE COUNCIL FOR UNITED CIVIL RIGHTS LEADERSHIP. AMONG THOSE INCLUDED IN ADDITION TO DR. KING ARE: JOAN BAEZ, JOHN LEWIS, PETER, PAUL AND MARY, ODETTA, AND A. PHILIP RANDOLPH. (BOTTOM) THE STARS SALUTE DR. MARTIN LUTHER KING, RECORDED TRIBUTE TO DR. KING, PUBLISHED BY WARNER BROS. DURING HIS LIFETIME (DATE UNKNOWN).

Out of the pressures and needs involved in maintaining group unity while working under conditions of intense hostility and physical threat, the Sit-in Movement developed its culture and music was its mainstay. During the early sit-ins, music was not usually a part of the actual street demonstrations. Sit-in leaders wanted to avoid being charged with rowdiness or uncouth behavior. Most demonstrations were carried out in silence. The media did not miss this point. *The Richmond Newsleader*, which published an editorial after demonstrations began in that city made special note of the dignity of the marchers:

Many a Virginian must have felt a tinge of regret at the state of things as they were reading of Saturday's "sit-down" by Negro students in Richmond stores. Here were the colored students in coats, white shirts, ties and one of them reading Goethe, and one was taking notes from a biology text. And here, on the sidewalk outside, was a gang of white boys come to heckle; a rag tail rabble, slack-jawed, black-jacketed, grinning to fit to kill, and some of them, God save the mark, were waving the proud and honored flag of the Southern states in the last war fought by gentlemen. Phew! It gives one pause.

Silent marches were the general practice during the early months and the songs of this period came out of the mass meetings, rallies, and workshop sessions. Still, John Lewis, Nashville, Tennessee sit-in leader and later chairman of the Student Nonviolent Coordinating Committee (SNCC), explains why, even then, singing sustained marching:

"At the rallies and meetings we sang. One of the earliest songs I remember very well that became very popular was 'Amen.'"

Amen Amen Amen Amen Amen

Freedom Freedom Freedom Freedom

"This song represented the coming together, you really felt as if you were part of a crusade, a holy crusade. You felt uplifted and involved in a great battle and a great struggle. We had hundreds and thousands of students from the different colleges and universities around Nashville gathering downtown in a black Baptist church. That particular song became the heart of the Nashville Movement."

There is a close correlation between changes made to songs during the most highly organized Sit-in Movement in Nashville and those that were heard during the Montgomery Bus Boycott. "Amen," sung as a one-word traditional black sacred chant with a one-word lyric, was chanted over and over again. The melodic statement was musically simple, with one singer leading each lilting cycle of "Amen":

Everybody say

Amen Amen Amen Amen

Let the Church say

Amen Amen Amen Amen

Let the Deacons say

Amen Amen Amen Amen

The power of this traditional song came from the richness of black harmonic techniques and improvisations in choral singing. With the Nashville situation, it gained a new force by being wed to a dynamic social upheaval. A simple word change from "Amen" to "Freedom" made it a musical statement of the ultimate national goal of the student activists. In Montgomery, the words of the song "Old Time Religion" were changed to "We Are Marching on to Victory," after the leaders had been arraigned by local law officials. This can be equated with the singing of "Amen" in the Nashville church after a

round of sit-ins. In both cases, the activists were returning to a haven after a confrontation with the system they were seeking to change. Many times it appeared that traditional songs went through text changes when the protesters needed to affirm their commitment to continue in the face of seemingly insurmountable odds.

The first freedom songs, such as "Amen" issued from the musical tradition of the black church. Both Lewis and noted writer Julius Lester, who was at the time a student at Fisk University, identified another important song that received constant use during the rallies. Rallies would start and end with "Lift Every Voice and Sing," which became known as the "Negro National Anthem." This song was composed in 1926 by James Weldon Johnson and set to music by his brother, J. Rosamund Johnson. It had long been required within educational circles. During the Nashville Sit-in Movement, the song served initially as a theme anthem.

> **Lift every voice and sing**
> **Till earth and heaven ring**
> **Ring with the harmonies of Liberty;**
> **Let our rejoicing rise**
> **High as the listening skies,**
> **Let it resound loud as the rolling sea.**
> **Sing a song full of the faith that the dark past has taught us,**
> **Sing a song full of the hope that the present has brought us,**
> **Facing the rising sun of our new day begun**
> **Let us march on till victory is won.**
> **Stony the road we trod,**
> **Bitter the chastening rod,**
> **Felt in the days when hope unborn had died;**
> **Yet with a steady beat,**
> **Have not our weary feet**
> **Come to the place for which our fathers sighed?**
> **We have come, over a way that with tears have been watered,**
> **We have come, treading our path through the blood of the**
> **slaughtered,**
> **Out from the gloomy past,**
> **Till now we stand at last**
> **Where the white gleam of our bright star is cast.**
>
> **God of our weary year,**
> **God of our silent tears,**
> **Thou who has by Thy might**
> **Led us into the light,**
> **Keep us forever in the path, we pray**
> **Lest our feet stray from the places, Our Go where we met Thee,**
> **Lest our hearts drunk with the wine of the world, we forget thee;**
> **Shadowed beneath Thy hand,**
> **May we forever stand,**

THE STEVIE WONDER SONGBOOK FROM 1985. INCLUDES THE SONG HAPPY BIRTHDAY, DEDICATED TO DR. MARTIN LUTHER KING, JR.

> **True to our GOD.**
> **True to our native land.**

Soon after the Nashville Sit-ins began, a quartet was formed that was similar to local amateur rhythm and blues groups on most black campuses and street corners of black neighborhoods of the day. The Nashville Quartet differed from other rhythm and blues groups in that their songs were statements of their current political and social struggles. Joseph Carter, Bernard Lafayette, James Bevel, and Samuel Collier, who formed this a cappella ensemble, were students at the American Baptist Theological Seminary in Nashville. For their freedom songs they used the melodies and arrangement techniques

of contemporary "rhythm and blues" hits, which were played on the college jukebox and their favorite radio station. Rhythm and blues singer Little Willie John's recording of "You'd Better Leave My Kitten Alone" became a freedom song when new lyrics were created:

> **You better leave, segregation alone**
> **Because they love segregation like a hound dog loves a bone**
> **I went down to the dime store to get myself a coke,**
> **The waitress looked at me and said, what's this a joke?**
> **You better leave, segregation alone.**

The rhythm and blues tunes of the sit-ins were heavily influenced by the soul music of Ray Charles. Born in Albany, Georgia, Ray Charles reached national prominence in 1954 and stayed on the record charts throughout the next decade. His songs, a rich blend of gospel and blues laced with his earthy, graveled, textured voice, launched a new genre of popular songs that came to be known as soul.

Soon after the breakthrough in Nashville of citywide integration of lunch counters, James Bevel and Bernard Lafayette took the tune and chorus lyrics of Charles' "Moving On" and produced a song about the approaching demise of the Jim Crow system of segregation:

> **Segregation's been here from time to time**
> **But we just ain't gonna pay it no mind**
> **It's moving on, it's moving on, it's moving on, it's moving on**
> **Moving on Moving on Moving on**
> **Old Jim Crow moving down the track**
> **He's got his bags and he won't be back.**

The identification of the new genre as "soul" is important when one thinks about the fact that on the local level, the Movement that often challenged segregation within institutions governing everyday activities was hosted by black churches who chose to be a part of this struggle. Most marches began in churches with devotional services that included sacred songs, prayers, and scriptural readings before opening the meeting to the activities of the local struggle. Then when arriving at the point of protest, usually a city hall or jail, the marches held another short rally of song and prayer. If arrested, the cells rang with singing and prayers continued. In other words, the church left its building and went into the streets and jails, and the popular music called soul named that evolution.

It was through the Nashville Sit-in Movement that the song "We Shall Overcome" became the preeminent freedom song. According to Miles Horton, who founded the Highlander Folk Center in Mount Eagle, Tennessee in 1932, this song was first brought to Highlander during the 1940s by white tobacco workers on strike at the American Tobacco Company plant in Charleston, South Carolina. The striking workers, at Highlander for a workshop in union organizing, reportedly told Miles' wife Zilphia Horton, then Highlander's director of music, that this song was sung by black members of the union local on the picket line. Horton added the

song to her workshop repertoire.

She taught it to Peter Seeger in 1947 and it was published in a People's Song Bulletin in 1949.

But Nashville students were not the first activists to hear the song. Guy Carawan recounted an incident at a Highlander workshop in 1959, attended by people from Montgomery where the song was pressed into service: *"It's amazing what strength the song has. It's just unbelievable sometimes how it can bring people together. One night in 1959, a group of about 60 of us had assembled at the Highlander School. It was the end of a workshop, and we were having punch and cake and seeing a movie. The local police and sheriff burst in. You see, Tennessee officials were always trying to break up the school—they considered it subversive—and a couple of years later they succeeded. Well, for an hour and a half they forced the people—some of them students—to sit in the dark while they went through rooms and searched suitcases and bags. Somebody started to hum 'We Shall Overcome' and someone else took it up. Then from a Negro girl, a high school student [Mary Ethel Dozier] from Montgomery, Alabama, a new verse came into being. Sitting there in the dark, this girl began to sing, 'We are not afraid, we are not afraid today.'"*

From workshops at Highlander, to rallies, jails, and sit-in activities, "We Shall Overcome" traveled to a gathering of over 200 sit-in leaders on April 15–17, 1961 at Shaw University in Raleigh, North Carolina. This meeting was organized by Ella Baker, then executive director of the Southern Christian Leadership Conference (SCLC). At the end of the first evening, Guy Carawan began to lead songs. When "We Shall Overcome" began, everybody stood and joined hands and from that point it became the theme song of the Movement.

It was also at this meeting that the students decided to form their own organization rather than becoming a junior branch of SCLC.

> **We Shall Overcome**
> **We Shall Overcome**
> **We Shall Overcome Someday**
> **Oh Deep in my heart, I do believe**
> **We Shall Overcome Someday**

Other lines: *we are not afraid, God is on our side, we'll walk hand in hand, black and white together, we are not alone.*

Of this song, Reverend Wyatt T. Walker, Second Executive Director of SCLC wrote:

One cannot describe the vitality and emotion this hymn evokes across the Southland. I have heard it sung in great meetings with a thousand voices singing as one. I've heard a half dozen sing it softly behind the bars of the Hinds County Prison in Mississippi. I heard old women singing it on the way to work in Albany, Georgia. I've heard the students singing it as they were being dragged away to jail. It generates power that is indescribable. It manifests a rich legacy of

103

musical literature that serves to keep body and soul together for that better day which is not far off.

As the Sit-in Movement was gaining momentum, the Congress of Racial Equality (CORE) organized a Freedom Ride to challenge segregation in public commerce and transportation. On May 4, 1961, participants met in Washington, D.C. and boarded a bus that would take them eventually to New Orleans, Louisiana. On May 14, (Mother's Day) in Anniston, Alabama, the first bus was burned. Later that same day, the second bus was mobbed in Birmingham and the injuries sustained were so severe that CORE decided, reluctantly, to end the trip. The Nashville and Atlanta sit-in leaders immediately initiated a call for volunteers to take up the trip. On May 20, the reconstructed Freedom Rides were met with intense violence in Montgomery, Alabama. With the intervention of the Kennedy Justice Department and the imposition of martial law, the bus left Montgomery under escort.

According to the Riders, when their bus crossed the state line into Mississippi, their protection escort disappeared and songs helped to push back the fear. When they pulled into the bus station at Jackson, Mississippi, they were promptly jailed. But that didn't stop them from singing.

James Farmer, executive director of CORE, who had rejoined the Riders and ended up in Hinds County Prison along with the others, wrote new words to a song he had heard in Chicago during the late 40s, "Which Side Are You On?".

That song had been written during the 1930s Harlan County, Kentucky, coal mine strike by Florence Reese. When the local "goon squad," some of them familiar to Reese, entered her home in search of her husband, strike leader Sam Reese, she wrote this song:

Which side are you on boys, which side are you on?
Which side are you on boys, which side are you on?

In jail, the new lyrics for the verses by Farmer and others explained who the Freedom Riders were, what had happened as a result of their actions, and their need for "men" instead of "Uncle Toms."

Don't Tom for Mister Charlie
Don't listen to his lies
Cause Black folks haven't got a chance unless we organize
Come all you freedom lovers, oh listen while I tell
Oh how the freedom riders came to Jackson to dwell
Which side are you on boys?

The songs poured forth as Movement activity increased. In Albany, Georgia during July and August, 1962, over 1,000 demonstrators were arrested. At the height of tensions, Federal Chief Judge Tuttle of the fifth District Court of Appeals issued an injunction banning further demonstrations. Reverend Ralph David Abernathy, assistant to Martin Luther King, told the mass meeting audience about the injunction. Then a song began, "Ain't Gonna let

No Injunction Turn Me Round," based on the spiritual:

Ain't gonna let nobody turn me round,
Turn me round, turn me round, turn me round
Ain't gonna let nobody
Turn me round, keep on a- walkin' keep on talkin'
Marching up to Canaan land

The song went on for several minutes and each time a new term was inserted signifying an obstacle that would no longer halt the struggle. "Canaan," the goal identified in the last line of the traditional version, was changed to

"Freedom" at the Albany meeting.
Keep on a-walking, keeping on a-talking
Marching up to Freedom land

The music of the Albany Movement attracted national attention. Robert Shelton, folk music critic of the *New York Times*, had journeyed to Albany and written several articles based on music he heard there. One of those pieces captured the power and vitality of the singing in a quote from SNCC Field Secretary Charles Jones:

"There could have been no Albany Movement without music. We could not have communicated with the masses of people without music and they could not have communicated with us. But through songs, they expressed years of suppressed hope, suffering, even joy and love."

Out of the Albany Movement came the decision by SNCC at the suggestion of Peter Seeger, to form a group of traveling singers. The Montgomery Trio, the Nashville Quartet, and the CORE Freedom Singers had already been documented in recordings. Now the SNCC Freedom Singers (Cordell Reagon, Rutha Mae Harris, Charles Neblett, and Bernice Johnson) would expand that work as an organizing, fundraising, and informational instrument of the student organization. Beginning in the winter of 1962, as field secretaries and singers for SNCC, we traveled the country carrying news of the Movement and building needed support groups. For me it was the first time I had an opportunity to travel outside of Georgia.

As a field secretary of SNCC, I also got to meet and sing with the great songleaders of different campaigns. Brenda Gibson from Albany, Georgia; Fannie Lou Hamer, Sam Black, Hollis Watkins, Willie and James Peacock from Mississippi; James Orange, Betty Mae Fikes, Carlton Reese, Mattie Smith, Cleo Kennedy—all great Alabama singers; Dorothy Cotton, and singer-songwriter Jimmy Collier. Guy Carawan encouraged us to not only share our own stories and songs, but also know the repertoires of older generation singers. Here we met and were taught by Bessie Jones and the Georgia Sea Island Singers, and the Moving Star Hall Singers. This exchange actually provided a vision for my future work as a cultural activist and scholar.

The Freedom Singers' concerts featured the old and new songs of freedom interspersed with commentary by Cordell Hull Reagon

from the jails, rallies, and marches of the Southern Movement. We sang a cappella as the music was sung in the South. Due to the folk music revival sweeping the country during the sixties, the Freedom Singers and their musical techniques received national attention. A review of a benefit concert at Carnegie Hall featuring Mahalia Jackson stated that:

Even if the quartet was not dealing in matters so urgent as the topical freedom songs of the Integration Movement, it would be outstanding for its singing. The unaccompanied voices, the rhythmic drive, and the sense of conviction put the Freedom Singers at the top of American folk groups.

The Freedom Singers are the ablest performing group to come out of what is perhaps the most spontaneous and widespread singing Movement in the world today. The Freedom Singers stimulated an increase in unaccompanied singing among folk artists who sometimes seem to be vocal extensions of their guitars and banjos. The Freedom Singers were invited to the Newport Folk Festival in 1963, the closest thing the folk song revival had to a "National Convention." Almost every top performer or performing group there included an unaccompanied selection and/or a freedom song in their set. Topical songwriters, a vital part of the folk song revival, increasingly incorporated issues raised by the civil rights struggle into their new work.

Singing songwriters like Pete Seeger, Bob Dylan, Phil Ochs, and Len Chandler presented songs that reflected specific aspects of Movement activity, as well as events and ideas that symbolized the nature of the crisis gripping the nation. Bob Dylan wrote "Oxford Town," in the fall of 1962 when James Meredith's entrance into the University of Mississippi resulted in riot and a call up of the National Guard:

He went down to Oxford Town
Guns and clubs followed him down
All because his face was brown
Better get away from Oxford Town
He went around and around the bend
Come to the door and he couldn't get in
All because of the color of his skin
What do you think of that my friend
Oxford Town in the afternoon
Everybody signing a sorrowful tune
Two men died under the Mississippi moon
Somebody better investigate soon.

Pete Seeger and Lee Hays's "Hammer Song" became popular within folk revival circles and within the southern based Movement:

If I had a hammer
I'd hammer in the morning
I'd hammer in the evening
All over this land

I'd hammer out warning, I'd hammer out justice,
I'd hammer out love between my brothers and my sisters
all over this land

Birmingham, Alabama had long been a strong center of gospel music, so when demonstrations exploded in the summer of 1963, it was the music of Carlton Reese, founder and director of the Alabama Christian Movement Choir, that the community turned to for inspiration.

One of Reese's most powerful songs was his reworking of "Ninety-nine and a Half Won't Do." The lyrics of this song proclaimed a commitment to completing a task, and an awareness that nothing less than total involvement in the struggle was required. Reese kept the standard gospel text intact except for the insertion of the word freedom:

Oh Lord, I'm running
Lord, I'm running trying to make a hundred
Running for Freedom
Lord, I'm running trying to make a hundred
Ninety-nine
Ninety-nine
And a half
And a half
Won't do
No it won't do!

This song was charged by Reese's powerful lead and the thundering response by the choir, all of it driven by his accompaniment on the Hammond organ. Birmingham represented a new level in street demonstrations. The use of children in its D-Day March on April 30, 1963 was severely criticized in the press. The response by the authorities was unequaled in its brutality and violence. One of the most dynamic songs out of Birmingham grew out of the use of dogs and fire hoses against peaceful demonstrators by Sheriff "Bull" Connor, who instantly became the visible symbol of the unleashed wrath of white segregationists. This song, together with stark images of the event captured by television crews and photo-journalists, stirred the nation's conscience and infused the Movement with new determination:

Ain't scared of you dogs
Cause I want my Freedom
I want my Freedom
I want my Freedom
Ain't scared of your dogs
Cause I want my Freedom
I want my Freedom now.

Another pivotal musical statement, this one born of the Mississippi experience, eulogized the death of Reverend Herbert Lee, an early supporter of the 1961 voter registration drive. Bertha Gober, the student arrested with Blanton Hall in Albany, Georgia in 1962, was a beautiful singer.

Suspended from Albany State College for her activities she returned to Atlanta, and upon learning about the death of Reverend Lee wrote "We'll Never Turn Back." This song became important throughout the expanding activist communities, but especially in Mississippi because the danger of working in voter registration for blacks was so great. Although the presence of civil rights organizers automatically made local supporters targets for physical abuse, there was no turning back:

We've been buked and we been scorned

We've been talked about sure you're born

But we'll never turn back

No we'll never turn back

Until we've all been freed

And we have equality

We have hung our heads and cried

Cried for those like Lee who died

Died for you and died for me

Died for the cause of equality

But we'll never turn back

SNCC Field Secretary Matthew Jones wrote a ballad for Medgar Evers, state director of the NAACP when he was assassinated by Byron de la Beckwith in Jackson, Mississippi:

In Jackson, Mississippi in 1963

There lived a man who was brave

He fought for freedom all of his life

But they laid Medgar Evers in his grave

On June 21, 1964 when three civil rights organizers who had gone out to investigate a church bombing near Philadelphia, Mississippi were reported missing, another song memorializing the cost of freedom could be heard on the Oxford, Ohio campus where volunteers were being trained for a summer of state-wide organizing in Mississippi:

They say that freedom is a constant struggle

Oh Lord, we've struggled so long,

We must be free, we must be free

Other lines: "freedom is a constant dying," mourning Richard Farina, a singer-songwriter in the folk song revival, who wrote "Birmingham Sunday", memorializing the bombing deaths of Addie Mae Collins, Denise McNair, Cynthia Wesley, and Carol Robertson when their church, 16th Street Baptist, was bombed on Sunday morning, September 15, 1963:

On Birmingham Sunday, a noise shook the ground

And people all over the earth turned around,

For no one recalled a more cowardly sound

And the choirs kept singing for Freedom

As the violence continued, boundaries began to erode and this was also captured in the music of the Movement. During the

Danville, Virginia campaign in 1963, SNCC Field Secretary Matthew Jones wrote a song commemorating the act of a Negro soldier who, while home on furlough in 1963, participated in demonstrations supporting a Danville economic boycott while in uniform. His actions drew severe criticism throughout the military, from the Secretary of Defense to the Chairman of the Armed Services Committee down to his sergeant. The song lyrics for "Demonstrating G.I." were drawn from comments made by the soldier at a mass meeting.

BROCHURE FROM A NINA SIMONE CD THAT INCLUDES THE DR. MARTIN LUTHER KING, JR. SUITE, THREE SONGS PERFORMED BY NINA SIMONE AND DEDICATED TO DR. MARTIN LUTHER KING, JR. MS. SIMONE PERFORMED THESE SONGS AT A CONCERT IN WESTBURY, LONG ISLAND THREE DAYS AFTER THE ASSASSINATION OF DR. KING.

I'm an American fighting man

I'll defend this country as long as I can

And if I can defend it overseas,

Why don't you set my people free!

Chorus:

I'm a demonstrating G.I. from Fort Bragg

The way you treat my people you know it makes me mad

You know that I couldn't still

Because my home is in Danville

The 1964 and 1965 Selma Campaign was so bloody that when the march from Selma to Montgomery began, the marchers were surrounded by United States Army troops for protection. Songs supplied a steady spiritual nourishment throughout the activities of that march. And the verses that people made expressed what their intentions were, and why they were there. This song was created with new lyrics by SCLC organizer James Orange, from a recording called

"Kidnapper" by Ruby and the Jewels:

> I don't want no mess
>
> I don't want no jive
>
> I want my freedom
>
> In sixty-five
>
> Oh Wallace, you never can jail us all
>
> Oh Wallace, segregation's bound to fall

When SCLC moved to Chicago, Jimmy Collier, a singer and organizer, wrote songs that mirrored the urban discontent that led to riots and rebellions in Watts, Newark, and Detroit:

> Middle of the summer,
>
> Bitten by flies and fleas
>
> Sitting in a crowded apartment
>
> about a hundred and 10 degrees
>
> I went outside
>
> it was the middle of the night
>
> All I had was a match in my hands
>
> And I wanted to fight
>
> So I said Burn Baby Burn
>
> Nowhere to be, no one to see
>
> Nowhere to turn
>
> Burn Baby Burn

The music of the Top 40 charts began to resonate with the fervor created by more than a decade of intense activism. One of the strongest statements came from the Impressions out of Chicago singing the songs of Curtis Mayfield. Some radio stations would not play Mayfield's anthem, "Keep on Pushing!"

> People get ready, there's a train a-coming
>
> You don't need no ticket, you just get on board,
>
> All you need is faith to hear the diesel humming
>
> You don't need no ticket, you just thank the Lord

There was increasing unrest and strain that occurred when Movement activities pushed out of the South to urban centers. Nonviolence, though challenged, continued to be the bedrock of the Movement's strategy and song.

Frederick Douglas Kirkpatrick, who was a founder of the Louisiana Deacons for Defense, was converted to nonviolence and became a staff organizer for SCLC. He was also a powerful singer and songwriter. He was one of the major organizers who led a contingent of marchers and campers to the SCLC-sponsored Poor People's March on Washington, D.C. in 1968. This tent city on the federal mall had been called for by Martin Luther King, Jr. before his assassination April 4, 1968 in Memphis, Tennessee.

Kirkpatrick, a powerful singer and organizer, wrote a song in a blues mode called "The Cities Are Burning" that captured the rebellions and burnings that followed King's death. He also created one of the most important songs that summer for the Poor People's March,

signaling changes in activism that questioned not only racism, but the violence of poverty in a land as rich as the United States:

> Everybody's got a right to live
>
> Everybody's got a right to live
>
> And before this campaign fail
>
> We'll all go down in jail
>
> Everybody's got a right to live
>
> We are down in Washington, feeling mighty bad
>
> Thinking about an income, that we've never had
>
> Everybody's got a right.

The Civil Rights Movement was born in struggle, breaking new ground and laying the foundation for ever-widening segments of the society to call for fundamental rights and human dignity. As it expanded into corners of American society, new songs offered hope for those seeking justice and peace through nonviolent resistance to discrimination and war. The struggle to end the war in Vietnam had its songs; the Women's Movement produced its new songs; and Hispanics, Native Americans, and other minorities tapped into their traditions and talents to voice their own agonies and aspirations in song.

Coming out of the Civil Rights Movement, my major contribution had been through doing concerts with SNCC Freedom Singers. I found that song continued to be a major tool for giving my social, political, and moral ideals witness. In the later part of the 1960s I joined with five other black women in Atlanta, Georgia, forming the Harambee Singers. We performed at the major black nationalist conferences, black studies programs, community schools, and other gatherings that came forth during the Black Consciousness and Black Power thrusts of the late sixties.

In 1973, having moved to Washington, D.C., I organized another group of black women singers called Sweet Honey In The Rock. This group came out of the D.C. Black Repertory Theater Company, founded by actor Robert Hooks, where I served with Artistic Director Vantile Whitfield as vocal director.

Sweet Honey In The Rock, now celebrating more than a quarter of a century, has proven a powerful, effective, creative force through the latter decades of the 20th century, covering a wide range of radical, political, and social issues from the black women's perspective. And the beat goes on.

As we move into the 21st century, the search for freedom continues both here and abroad. Wherever in the world today people gather to redress a society's ills, they pull strength from the Black American struggle. We know this by the sounds of the songs they sing—for along with their new songs one can also hear the strains of our beacon song: "We Shall Overcome."

*This essay is based on the accompanying booklet for Voices of the Civil Rights Movement, African American Freedom Songs, 1955–1965, Smithsonian Folkways Recordings, 1998.

"When the architects of our republic wrote the magnificent words of the Constitution and the Declaration of Independence, they were signing a promissory note to which every American was to fall heir...This note was a promise that all men would be guaranteed the inalienable rights of life, liberty, and the pursuit of happiness. It is obvious today that America has defaulted on this promissory note insofar as her citizens of color are concerned."

— Martin Luther King, Jr.

Injustice Anywhere is a Threat to Justice Everywhere

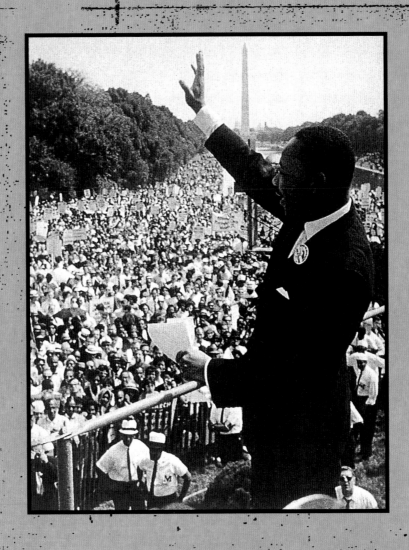

Riots rocked the nation during the second half of the 1960s and white Americans became increasingly concerned about maintaining law and order. The Civil Rights Movement was moving into northern cities, and as King listened to the angry voices of the young, the old, the disenfranchised and the poor, his views about the focus of the struggle changed. □ Dr. King questioned how the United States could spend hundreds of millions of dollars on an unjust war in Vietnam. He questioned our failure to address the 40 to 50 million Americans living in poverty, and he questioned the depth of America's commitment to obliterate racism. Ending the blatantly undemocratic, segregationist practices in the South would be a far less difficult task than changing the hearts of Americans to accept their black brethren in their neighborhoods and schools. A war on segregation was easier to fight than a war for economic justice. □ Despite the scope of the problem, King did not lose hope. Instead his theology of love became one that emphasized justice and hope, trusting in God's power. As Civil Rights Movement leaders considered the appropriate response to the Vietnam War and increasing militancy in the cities, they faced criticism. No matter the source of the reproach, King maintained a steadfast love for his country and pledged to ignore the expedient, and do what his heart told him was right. □ "I don't care who criticizes me in an editorial. I don't care what white person or Negro criticizes me. I'm going to stick with the best.

On some positions, cowardice asks the question, is it safe? Expediency asks the question, is it politic? Vanity asks the question, is it popular? But conscience asks the question, is it right?" □ In the wake of the Civil Rights Movement, the nonviolent, direct action model used in demonstrations and sit-ins in the South was adopted by other social justice advocates. Anti-war protesters, the women's movement, and the farm workers used the power of nonviolence to bring their respective cases before the American people. Other countries, particularly those on the African continent, were inspired in their fight for independence by the American struggle. King wrote the following in a telegram to Cesar Chavez and the United

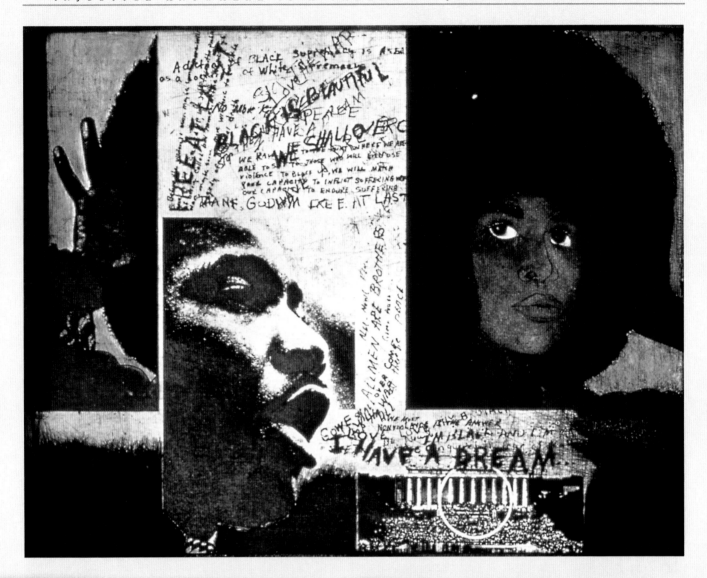

Farm Workers in 1966. ☐ "The fight for equality must be fought on many fronts—in the urban slums, in the sweat shops of the factories and fields. Our separate struggles are really one—a struggle for freedom, for dignity, and humanity. You and your valiant fellow workers have demonstrated your commitment to righting grievous wrongs forced upon exploited people. We are together with you in spirit, and in determination that our dreams for a better tomorrow will be realized."

112

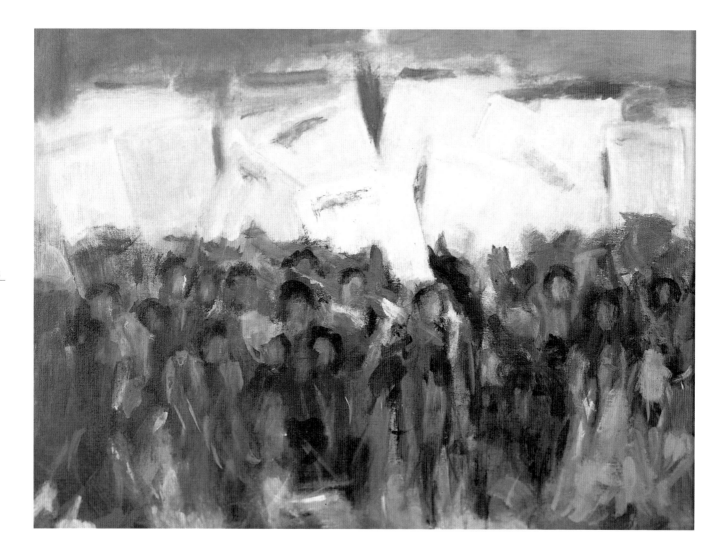

(Above) Study for the March on Washington, c. 1963, Alma Thomas (1895-1978), oil on canvas, 20″ x 24″.
The Columbus Museum of Art, Columbus, GA; Gift of Miss John Maurice Thomas in memory of her parents
John H. and Amelia W. Cantey Thomas and her sister Alma Woodsey Thomas
(Opposite) Dream 2: King and the Sisterhood, 1988, Faith Ringgold (1930-), oil on fabric, 94″ x 60″. Museum of Fine Arts, Boston, MA © 1988 Faith Ringgold

Dream Two: King and the Sisterhood
a collaboration with Faith Ringgold and Michele Wallace

1
Today, we pay tribute to Dr. Martin Luther King, Jr. on an official American holiday to commemorate his birthday. Because of the many recollections of this day passing without our freedom yet won—some twenty days these twenty years since his death—it was moved to wonder anew about the nature of freedom and equality in the United States, and the nature of the struggle for black liberation in which Martin Luther King so valiantly fought.

Almost ten years ago I was 26 years old and the author of a new book called *Black Macho and the Myth of the Superwoman*. As you may know, I am a black feminist. My commitment to feminism wasn't a commitment to the notion that the so-called personal is also political, and needs to be examined seriously if all our political, economic and civil rights are going to be fulfilled.

In 1978 I think perhaps I failed to understand the deeply profound literary, spiritual and political controversies of Martin Luther King's struggle. As Martin Luther King explained it, the Civil Rights Movement embraced America's ambiguous love affair with the ideas of freedom and equality dating from the American Revolution.

2
In his last book he wrote before he died, *Where Do We Go From Here: Chaos or Community?* King says:

Ever since the birth of our nation, white America has had a schizophrenic personality on the question of race. She has torn between flashes of luster—a self of which the guiding principle of democracy and decent principles of democracy and a self in which she daily practiced the antithesis of democracy. This deep duality produced a strange inner conflict and ambivalent towards the Negro, leaving America to take a two broken world simultaneously until every step forward on the question of racial justice, to be met attracted and repelled by laws, by law, and to hate him. There had never been a single, united and determined thrust to make justice a reality for the Afro-American.

There has been a continuous struggle on the part of blacks since slavery to achieve civil rights. Not the least of that struggle had been a slim volume of poetry by the black poet Lamenting the late 18th century but merely we think of the modern civil rights movement as beginning [...] on American reality to transform the lives of the black and as of social beings and white Americans and to increase the faith and the aspirations of blacks in particular. This phase of Civil Rights probably began with King's leadership of the Montgomery Improvement Association and the boycott of the segregated Montgomery buses in 1955.

3
I remember being 26 and writing *Black Macho* not by understanding the insult and duplication of oppression, or the injury and applicability of the notion "the personal is political." I was spurred on very crucial thing upon oppression. By the time that a society has gotten around to legislating where a person can sit in a public conveyance/situation between both vegans and the ride are practically undermined.

[...continues in handwritten text...]

4
When you're a child, if your parents love you, or somebody loves you on a regular basis, you expect that everybody will. Nobody ever recovers from the disappointment of children. [...]

Eight years later, I was teaching in the English department at the University of Oklahoma [...]

5
I found that day at OU a campus enthralled in a huge celebration to change the numbers on a large board confirming their victory at the National Football Championship. [...]

6
That day I devoted much of my classes to the memory of King in order to express solidarity with my black students, and for that white girl in my composition class who told me, "King never did anything for us," as though she made no blues [...]

7
No doubt, Martin Luther King was a great man. No doubt King's nonviolent civil disobedience was the only way the movement for black liberation could advance at that point in time [...]

First, it is necessary to understand that Black Power is a cry of disappointment. The Black Power slogan did not spring full grown from the head of some philosophical Zeus; it was born from the wounds of despair and disappointment. It is a cry of daily hurt and persistent pain.

7
For centuries the Negro has been caught in the tentacles of white power. Many Negroes have given up hope in the white majority because of the many inequalities of the past and present. They have concluded in reality one call for Black Power is a reaction to the failure of white power.

It is no accident that the birth of this slogan in the civil rights movement took place in Mississippi—the state symbolizing the most total and brutal expression of white power. [...]

8
But he also says:
Power, properly understood, is the ability to achieve purpose. It is the strength required to bring about social, political or economic changes. In this sense power is not only desirable but necessary in order to implement the demands of love and justice. One of the greatest problems of history is that the concepts of love and power are usually contrasted as opposites [...] What is needed is a realization that power without love is reckless and abusive, and that love without power is sentimental and anemic. Power at its best is love implementing the demands of justice. Justice at its best is love correcting everything that stands against love. (p.37)

But the attitude to King's analysis was the common sense statement at that time that "You can't legislate feelings." Indeed, if you can't legislate feelings, if you cannot at a movement address the problem of collective racial animosity, how will anything ever change?

9
It is precisely these uninsulatable feelings that reassert themselves as ever more imperious reactions of existing Civil Rights legislation as are more thoughtless, inconsiderate and criminally negligent Supreme Court, Congress and executive branch of unfair hiring, firing and education, at a cloak of invisibility that reflects the burden of guilt for racism, on the system in or herself, the inability to legislate feelings is precisely the attitude that the struggle for women's rights faces at all, among the middle class and the poor, in the united states and the world.

The problem becomes complex and interlocking when you add the issues of race in the bosom of sex. And yet I argued in 1978, and would still argue that it is impossible to finally contend with that unegotistic, intractable and unfathomable body of collective feelings that condemn us to continue the social death of slavery in this society without facing head-on that blacks are female as well as male, that slavery involved a procreation that was often specifically sexual and that trampled on traditional gender roles, that black male leadership often defines itself [...] intrinsically male, that blacks have too often defined freedom as manhood.

10
It was my argument in *Black Macho* that, in fact, the struggle for black manhood made the bitterness of the Black Power movement necessary and inevitable. [...]

It wasn't the first time this had happened. It happened in the struggle between black male abolitionists and white suffragists over whether or not the 15th Amendment's provision of the franchise to ex-slaves would include women. Only Sojourner Truth dared to argue that black women needed the vote as much as black men. [...]

What I realize now, at last, is that it goes to the heart of the matter in regard to the necessity for changing the social order in which we live and enduring change is happening.

Women's liberation and Black Power were born of the struggle over the issues of gender and sexuality within the Civil Rights Movement. Black women—Rosa Parks, Ella Baker, Fannie Lou Hamer—just to mention the most obvious ones—provided crucial although often anonymous leadership in the Civil Rights Movement.

11
These years from 1966 to 1976 during which Black Power and then Women's Liberation flowered were also the years in which the politics and philosophical import of the black woman was argued and her feminist consciousness was delivered on [...]

It wasn't the first time that what happened to the struggled between black male abolitionists and white suffragists over whether or not the 15th Amendment's provision of the franchise to ex-slaves would include women. Only Sojourner Truth dared to argue that black women needed the vote as much as black men. [...]

12
I once thought King romantic, idealistic, visionary. Now I realize that he had plainly figured it out that America had no conception of what equality and justice would mean when it was first properly. It would be of all the citizens, black and white, male and female, the people and muslim nation power could influence and define, at work, at home, in government, in the streets, in concrete and in business—to struggle with and through its feelings and its thoughts to give equality legitimacy and concrete significance.

The End

Recommended Reading
Sara Evans, Personal Politics: The Roots of Women's Liberation in the Civil Rights Movement & the New Left, Vintage Books, 1980.
Paula Giddings, When and Where I Enter: The Impact of Black Women on Race and Sex in America, 1984.
David Lewis, King: A Biography, 2nd ed. rev. Illini Books, University of Illinois Press, 1978.
Stephen B. Oates, Let the Trumpet Sound: The Life of Martin Luther King, Jr., New York, New American Library, 1982.
Howell Raines, My Soul Is Rested: The Story of the Civil Rights Movement in the Deep South, New York, Viking Penguin Books, 1983.
Alice Walker, Meridian, 1976.

Text by Michele Wallace © 1988
Quilt by Faith Ringgold 1988

WE SHALL OVERCOME
PEACE
FREEDOM
LOVE
FREE
AT
LAST
PEACE
RACE
JUSTICE
FREEDOM NOW
WE SHALL OVER NON VIOL

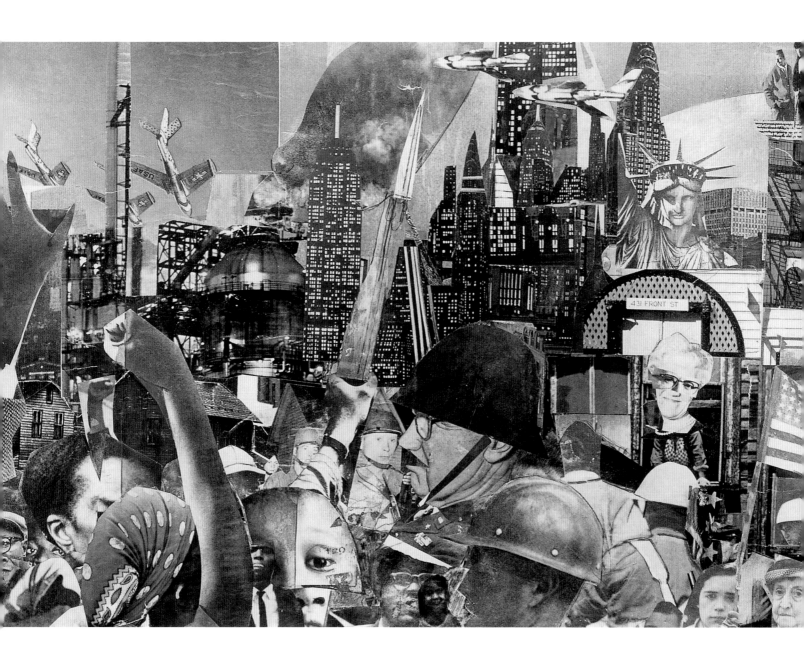

(Above) Untitled, 1964, Romare Bearden (1914-1988), photocollage, 35″ x 48″. Richard Clarke © Romare Bearden Foundation/Licensed by VAGA, New York, NY

(Opposite) 1963-We Have A Dream 1983, 1984, Lou Barlow (1908-), wood engraving on paper, 12″ x 14″. Courtesy of Sragow Gallery, NYC

(Overleaf) Chronicles of the 1960s Civil Rights Movement, 2000, Emanuel Martinez (1947-), collage, 4′ x 8′. Collection of Emanuel Martinez, Morrison, CO

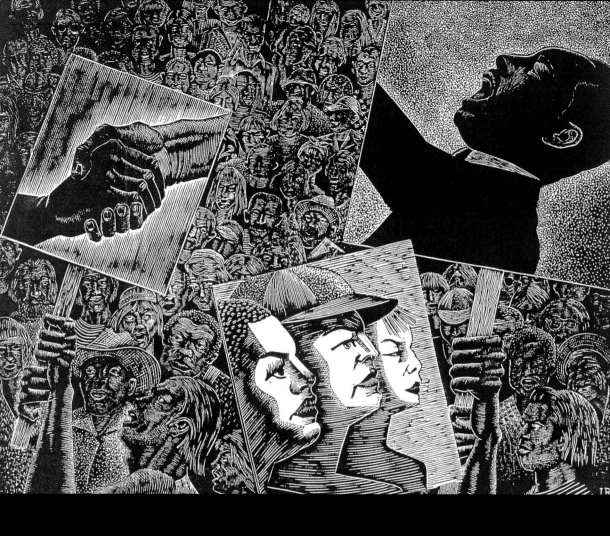

"Martin Luther King, Jr. inspired the leadership of the Chicano Civil Rights Movement with his philosophy and life commitment to humanity." —Emanuel Martinez

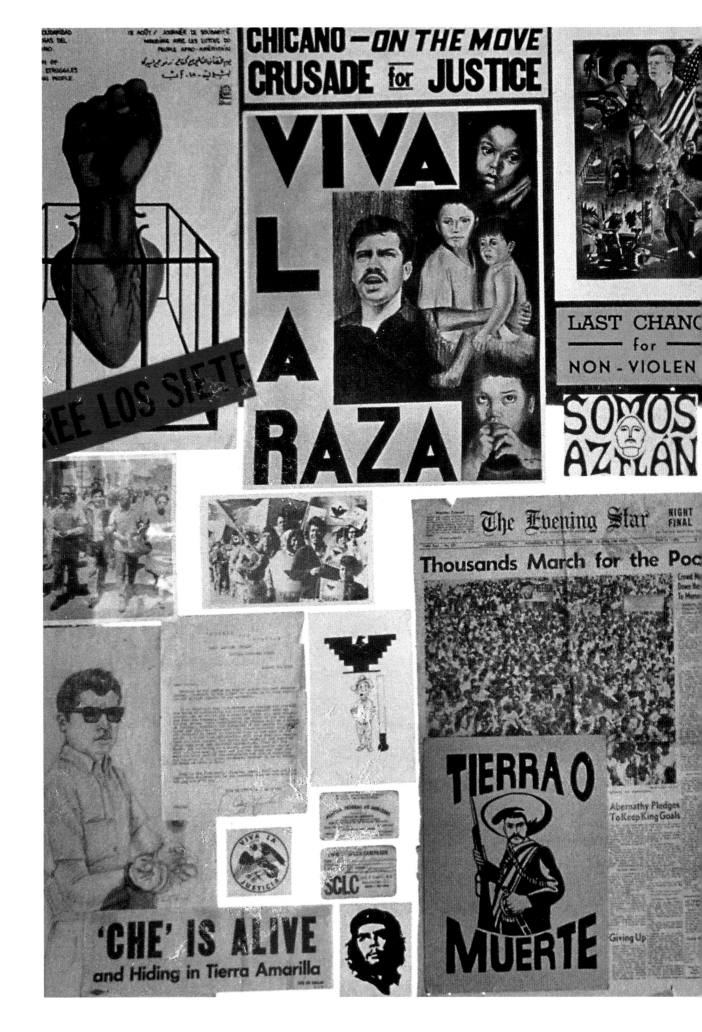

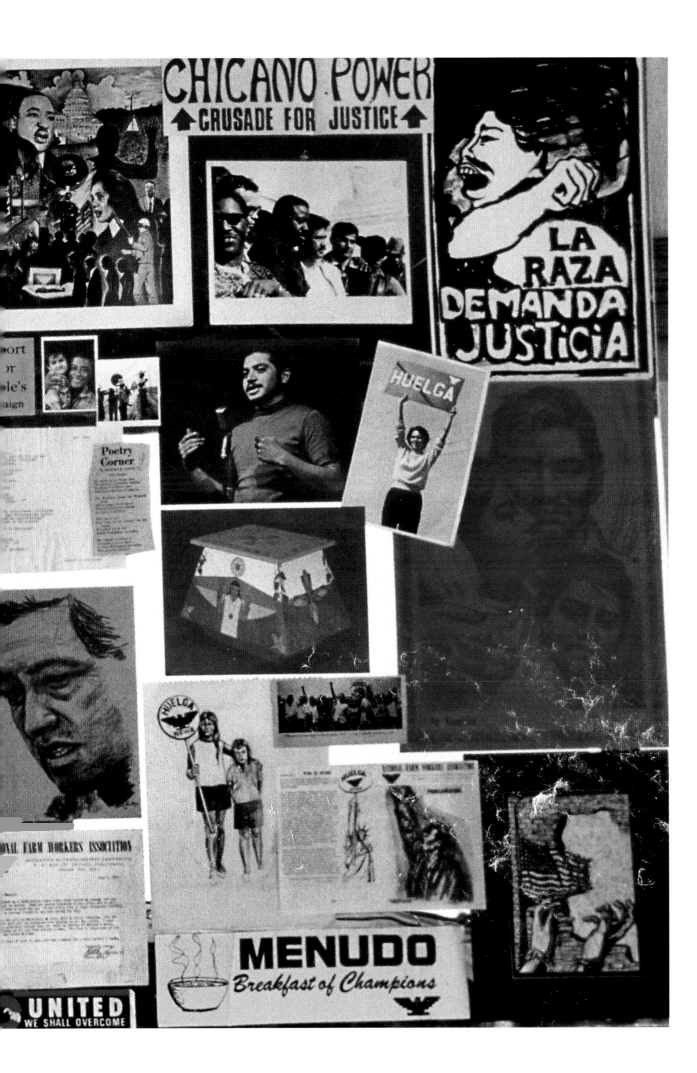
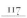

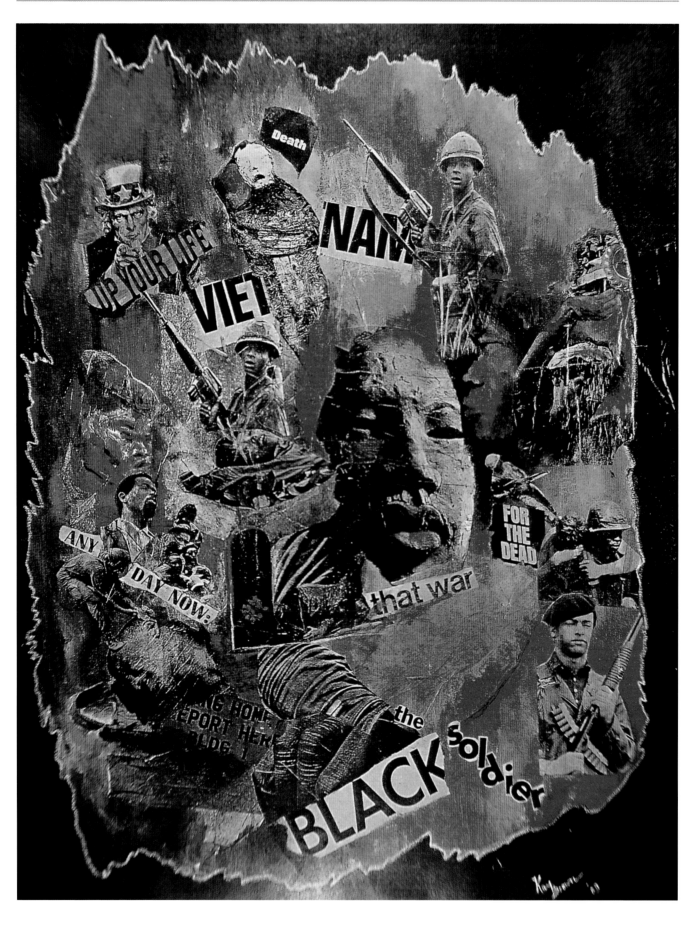

(Opposite) War Protest, 1969, Audrey Flack (1931–), oil on canvas, 24″ x 31″. Courtesy of Philip Desind Collection, Capricorn Galleries, Potomac, MD

(Above) The Black Soldier, 1969, Kay Brown (1932–), mixed media collage, 49″ x 37″. Collection of the artist, Washington, DC

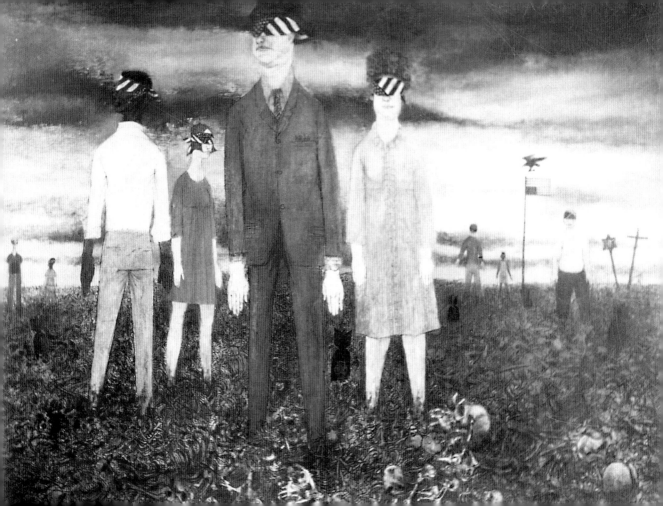

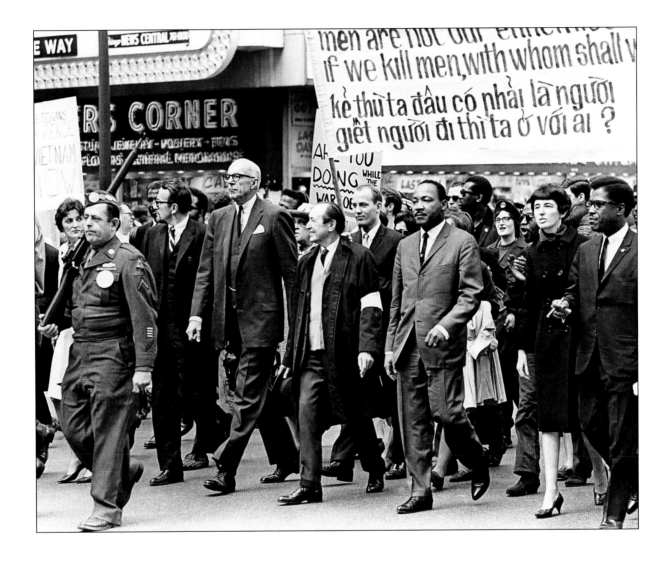

(Opposite) My Country Right or Wrong, 1968, Cliff Joseph (1927-),oil on masonite, 36″ x 48″. Collection of the artist, Chicago, IL © 1968 Cliff Joseph

(Above) March 25, 1967, King joins with Dr. Benjamin Spock to lead anti-war rally, Chicago,1967, unidentified photographer, gelatin silver print, 16″ x 20″. AP/Wide World, New York, NY

122

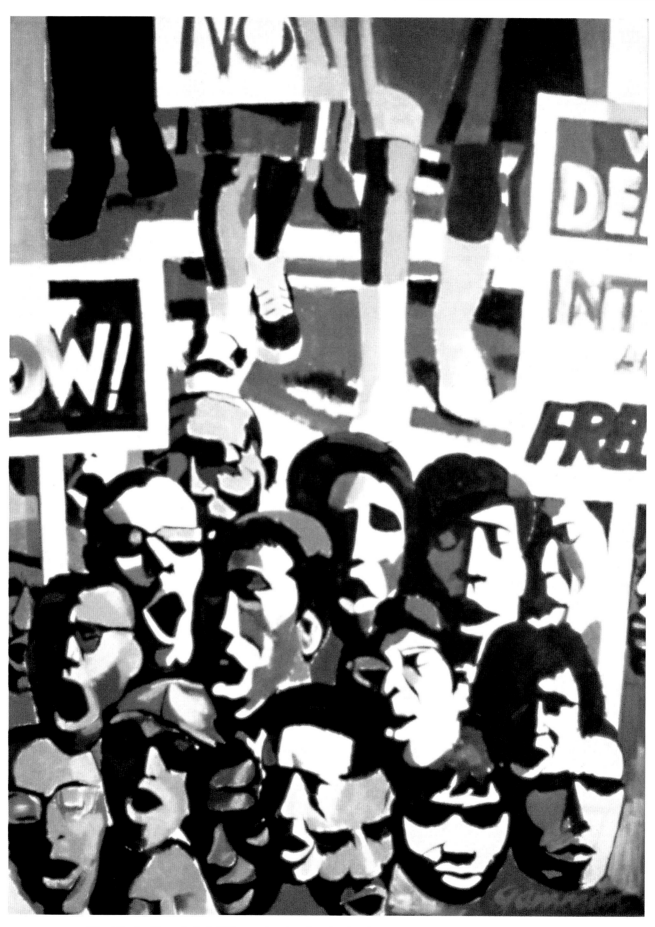

(Above) Freedom Now, 1963, Reginald Gammon (1921-), acrylic on board, 40″ x 30″. African American Museum, Wilberforce, OH
(Opposite) I Am a Man, 1996, Napoleon Jones-Henderson (1943-), mixed media, 31 1/2″ x 24″.Collection of the Artist, Columbia, SC

"I remember entertaining the possibility of a better life. A life in which words like freedom, justice and conscience had a place. I recall Martin Luther King, Jr. exhorting us to imagine ourselves as participants in the ancient drama of sacrifice, redemption and salvation. A dream of better, not more. Truly better. Not more pigs slopping at the TROUGH, not a larger bite of a rotten pie, not more, but better. For everyone, and everyone meaning really everyone."

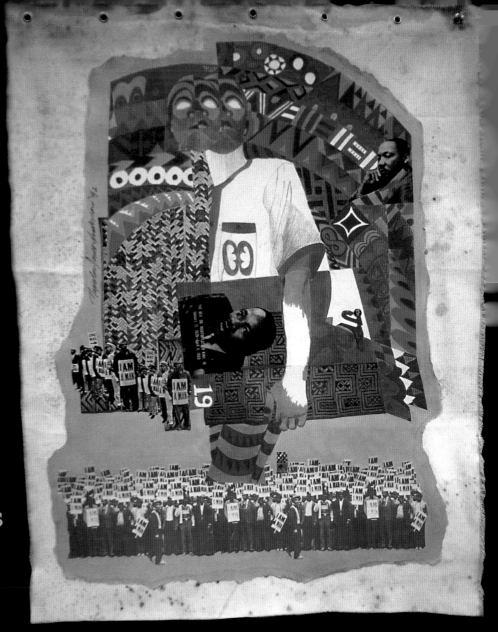

—John Edgar Wideman, Ebony Magazine, Spring, 1988

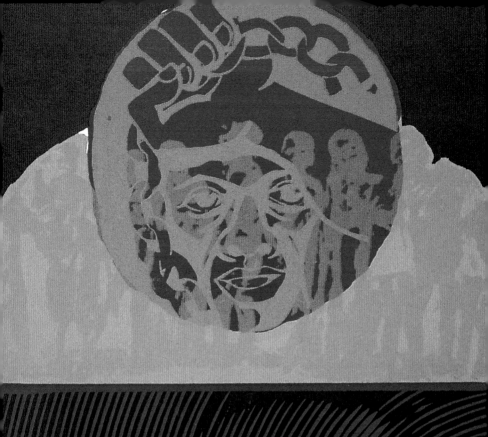

"King was an answer to our prayers, like a Moses who arrived in the nick of time." —Elliot Pinkney

(Opposite) *King*, 1975 , Elliot Pinkney (1934-), serigraph, 24″x 16″. Collection of Evangeline J. Montgomery, Washington, DC
(Above) *Malcolm, Martin*, 1991, Glenn Ligon (1960-), oil stick, acrylic on canvas, 30″ x 20″. Collection of the Hort Family, New York, NY

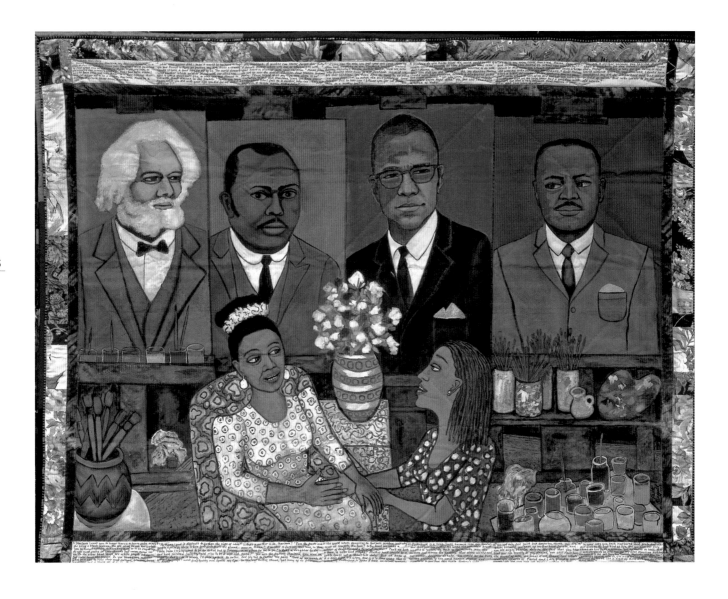

(Above) The Moroccan Holiday, 1997, from the series The French Collection Part II; #12, Faith Ringgold (1930-), acrylic on canvas with pieced fabric border, 74-3/4″ x 92″. The Norton Museum © 1997 Faith Ringgold

(Opposite) Memories of the 60's, 1990, Willie Birch (1942-), mixed media and papier mache, 54″ x 102″ x 90″. Courtesy of Arthur Roger Gallery, New Orleans, LA

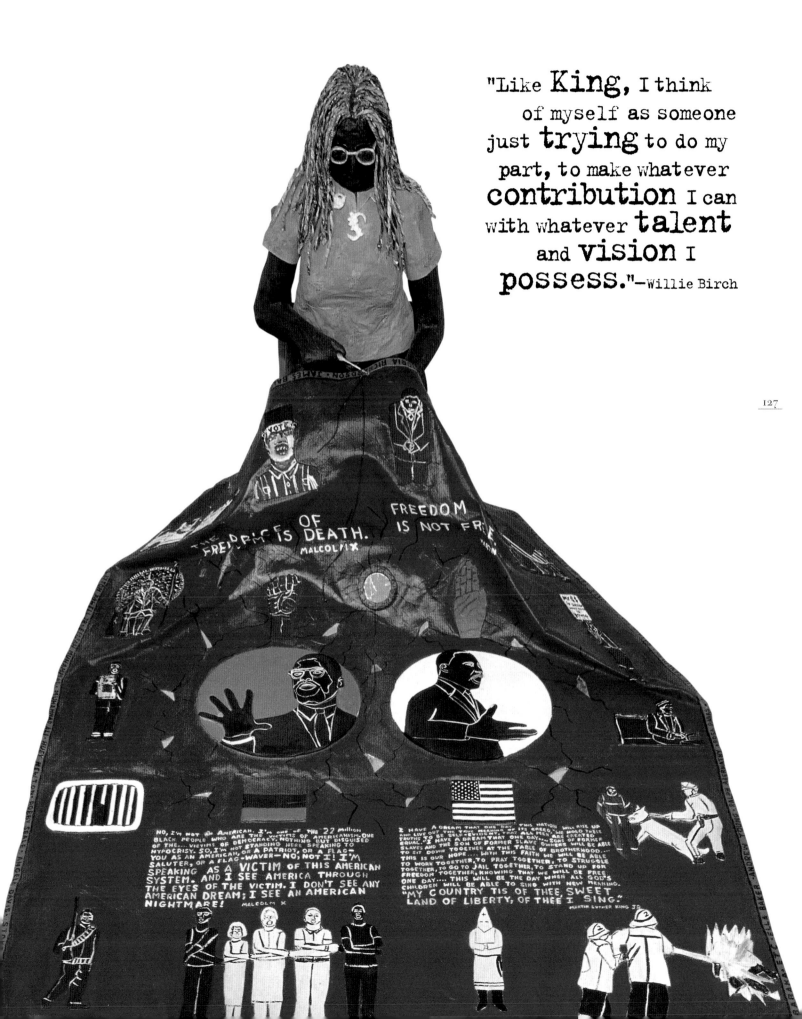

"Like **King,** I think of myself as someone just **trying** to do my part, to make whatever **contribution** I can with whatever **talent** and **vision** I **possess.**"—Willie Birch

127

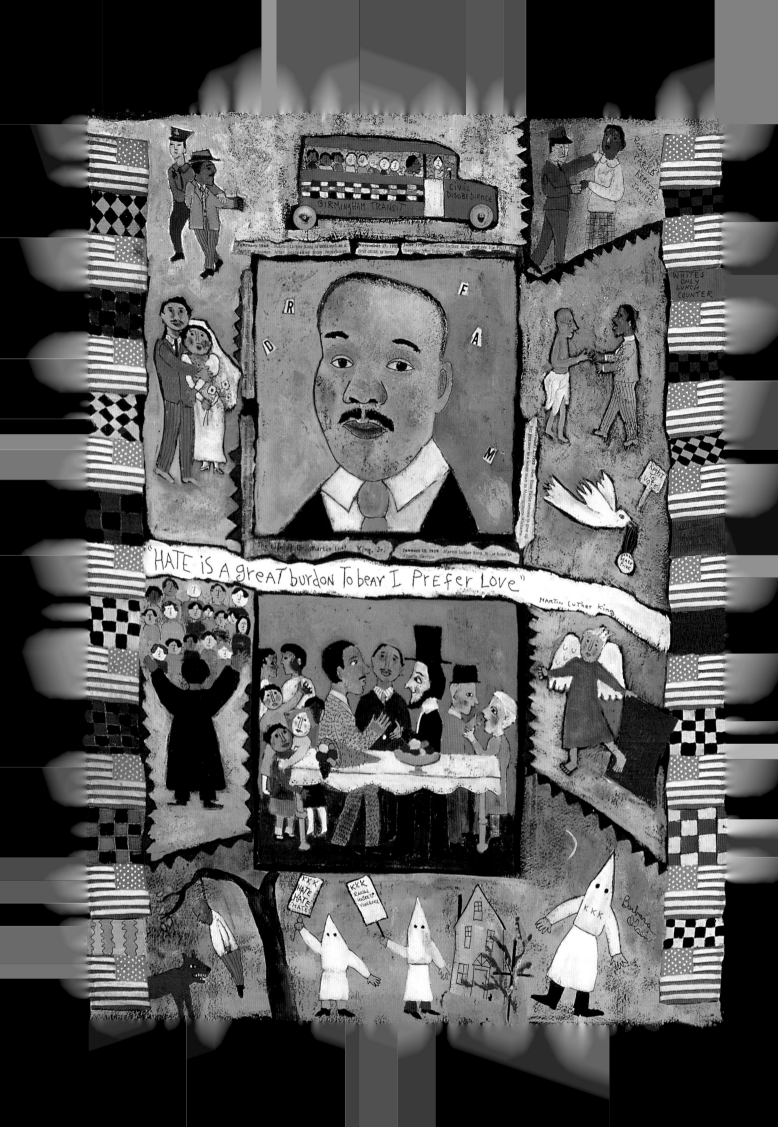

...JUDGED NOT BY THE COLOR OF THEIR SKIN,

BUT BY THE CONTENT OF THEIR CHARACTER. I HAVE A DREAM... *MLK*

DONZALEIGH ABERNATHY

It was hot that August day in 1963 on the steps of the Lincoln Memorial. My little legs had had difficulty walking the mall, through the crowd and climbing those steep stairs to the monument. I had never seen so many different people before in my life. I remember walking those grounds with my sister, brother, our babysitter and some extremely large men with armbands to guide and protect us. The sight of all those people was a feast for my eyes. There was a great euphoria of music and laughter in the air. I remember running uncontrollably around the statue of Lincoln, which was the only shaded open area above the platform. An elderly gentleman seated at the base of the statue called me over to him. His face seemed familiar, so I didn't protest too much when he wrapped his arms around my waist to contain me. Concerned about my safety, he cautioned me about falling down and skinning my already bruised knees and about possibly getting lost in that sea of people, if I wandered too far from my babysitter.

📖 (OPPOSITE) DR. MARTIN LUTHER KING, JR., 1999, BARBARA OLSEN (1935-), MIXED MEDIA, 30-1/2″ X 22-1/2″, COLLECTION OF THE ARTIST
📖 (ABOVE) DR. MARTIN LUTHER KING, JR. (FOR THE COVER OF TIME MAGAZINE, JANUARY 3, 1964), ROBERT VICKERY (1926-) TEMPERA ON PAPER, NATIONAL PORTRAIT GALLERY, SMITHSONIAN INSTITUTION, WASHINGTON, DC

Knowing that my parents were down on the platform, and that my father had just finished speaking to the crowd of over 250,000, he briefly tried to talk to me about the importance of the day. I told him that I knew that I had come to Washington, D.C. for my freedom. My father and Martin had gone to jail several times for our freedom, now I was in Washington to do my part. I asked him what was his name and he said, "Benjamin Mays". He was the president of Morehouse College, a prestigious, all male university. He knew that my name was Donzaleigh and that Martin Luther King had recently moved my family from Montgomery, Alabama to Atlanta. President Mays told me that he had taken part in the installation services of my father as the new pastor of the West Hunter Street Baptist Church. He even knew that my nursery school was a part of his university system. He seemed to know a lot for an old man, I thought. I spent a few more moments talking with President Mays because he was sitting alone and no one else was spending time with him. Even though I tried to be attentive, he

must have realized that I was restless and too young to comprehend his lesson on freedom, because he let my waist go and gave me permission to run free.

I ran around aimlessly for a few more moments, smiling at my old friend, then feeling quite guilty for playing and enjoying myself on such an important day, I quietly took my seat in the sun on the monument steps. I don't remember everything that President Mays said, but as I sat on the steps of the Lincoln Memorial, at that tender age, I decided what course my life would take.

To the left of me were the movie stars that had come to lend their support to the March on Washington. I had seen some of their faces in the old movies my grandmother would let us watch with her on Saturdays and Sundays. That afternoon at the March on Washington, I knew that when I grew up, I wanted to play dress up and make believe by becoming a movie actor, yet remain true to my convictions as a Freedom Fighter, as well.

Even though I loved my father dearly and wanted to be just like him, his work with Martin, as a minister and Civil Rights Leader, was very dangerous, serious, and extremely frightening. Already, I was afraid to go to sleep at night, thinking that they might bomb our house again. And every evening, during supper, the telephone would ring with death threats for my mother. Dinnertime became the most dreaded hour of the day. The cruel realities of racial hatred were extremely perplexing to me as a child, and the sacrifices of the Civil Rights Movement were already taking a toll on me.

Shortly after we moved to that "boathouse" on Cerro Street in Atlanta, Bud Walker, a kind, strikingly handsome theological seminary student came to live with us from New York. Because I was less than three feet at the time, Bud seemed so tall, and he had the softest dark brown hair, which curled at the nap of his neck with bangs that fell in his face. Although his skin was beige-pink, I could not understand why the world perceived that there were differences between us

because of color. Bud lived in the guest's room on the second floor of my parents' house and after we would take our nightly baths, we would slide around in the crisply ironed sheets of Bud's mahogany four poster bed, while he read stories to us. Sometimes I would fall asleep in his bed and awaken as he was carrying me upstairs to my bunk bed. His was a constant presence in my life during those formative years. He was there in the morning when I awakened, helped me through my childhood day and listened to my prayers at night. How could people say that we were enemies, to be segregated and not equal enough to share the same accommodations in public, when we graciously shared the same accommodations in private, at home? Why did people think that he was an evil white man, not to be trusted, but hated for the crimes of man's inhumanity to man. When my father was away during the week with Uncle Martin, working for the Civil Rights Movement, he entrusted the care of our family and his pastoral duties to Bud. Why didn't they see Bud, as I saw him? Bud was love, laughter and my friend. We would sing together a song that no amount of racial hatred can undo. *"Jesus loves the little children, all the children of the world. Red and Yellow, Black and White, they are precious in his sight. Jesus loves the little children of the world."* Forever, I will cherish the memory of our lives, living together, and that last Sunday afternoon when he taught us to spell Mississippi and he moved away. *M I crocked letter, crocked letter, I crocked letter, crocked letter I hump back, hump back I.*

My father used to say, *"We hate each other because we fear each other. We fear each other because we don't know each other. We don't know each other because we won't sit down at the table together."*

Years later when I began elementary school, I personally experienced the racial hatred that I had learned so much about from the Civil Rights Movement. It seemed illogical that I was categorized and hated by other children because my skin was toasted peanut butter brown. Or that society wouldn't permit Bud to date a lady that he liked because his skin was a differ-

BACKSTAGE

As we celebrate the 61st anniversary of the birth of Martin Luther King Jr., we remember with pride that *we were there* in the beginning when nobody—or almost nobody—knew the future prophet's name.

We were there in the first days of the historic Montgomery Boycott, we were with Martin Luther King Jr. in Oslo when he received the Nobel Peace Prize, and we followed the Georgia mules that pulled his coffin on a farm cart through the streets of Atlanta. We also went behind the scenes to record the private moments, young Yolanda King doing the Hula-Hoop (right), and concert singer Coretta Scott King accompanying herself at the piano in the frame house on South Jackson Street in Montgomery.

We were there, and we speak as witnesses and participants. Publisher John H. Johnson sent Jet Executive Editor Robert E. Johnson to Montgomery in December 1955, and the publisher himself marched with King in the March on Washington. Executive Editor Lerone Bennett Jr. covered the early days of the Boycott and contributed eyewitness stories from Selma and the March on Washington and the funeral. Managing Editor Charles L. Sanders accompanied the King party to Oslo for the Nobel Prize ceremonies, Managing Editor Hans J. Massaquoi covered his crucial Chicago campaign. And photographer Moneta Sleet Jr. covered the Kings from Montgomery to Memphis and beyond. He won the Pulitzer Prize—he was the first Black man awarded a Pulitzer—for his photograph of Coretta Scott King and her young daughter, Bernice, at the funeral.

It was against this background that Senior Staff Editor Lynn Norment and photographer Moneta Sleet Jr. revisited Coretta Scott King for the exclusive story on Page 116.

The February issue will once again carry you behind the scenes of the great moments of the time with special stories on Black History/Black Love.

(ABOVE) MAGAZINE STORY COMMEMORATING THE BIRTH OF DR. MARTIN LUTHER KING, JR. DEPICTING THE KING FAMILY AT HOME.

📖 **(OPPOSITE) MIRACLES AND MADNESS, ICON SERIES: REV. DR. MARTIN LUTHER KING, JR., 1992, TRUDI Y. LUDWIG, HAND COLORED LINOCUT, COLLECTION OF THE ARTIST** 📖 **(BELOW) LOVE AND DEVOTION, 1999, JAMES DIXON AND DEBRA WATKINS, WOOD, GLASS, PAPER, AND CERAMIC, COLLECTION OF THE ARTISTS**

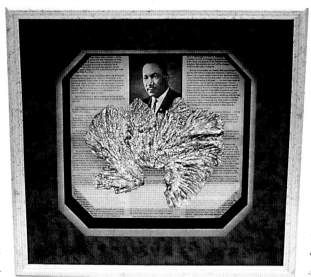

ent color. After a white boy in my class called me the N_____ word, and another offered to carry my books, if I let him kiss me, I realized that racial hatred was not innate. Hatred had to be taught.

Fear of those who are different from us generates the cowardly behavior of racial hatred and prejudice. This fear-stricken mentality of racial categorizing perpetuates separatism, competition, and hatred toward those that are different or anyone outside of our group. The common expectation in society has been that one should be taught through socialization to stay within one's religious, racial, and socioeconomic group. Having been categorized because of my skin color, it was an accepted theory that I was to remain within those boundaries that society had created for me, regardless of my individual opinions. In order for society to control and maintain this status quo, laws, written and unwritten, were established, in conjunction with societal pressures from the community and family demanding that the individual conform to the "norm" or rules of the group. Outside interactions, intimate associations and familiar relationships with those not belonging to one's designated group was rebellious behavior. We challenge the group mentality by our association with one another, and threaten the ideology of the group by our love for one another. It takes great courage to love and accept our differences. As a little girl, I realized that it was right to love and embrace those whom were different from me, to judge someone not by the color of their skin but by the content of their character.

We went to Washington on August 28th, 1963 to say, *"black and white together, we shall overcome. We are not afraid, because God is on our side."* That day, every living American with a social conscience agreed with what was being proclaimed in Washington, that black people must be granted full rights to American citizenship. President John Fitzgerald Kennedy said, *"A Negro baby born in America has about half as much of a chance in completing a high school education, one third as much of a chance of becoming a professional; a life expectancy which was*

seven years shorter than a white person, and the prospect of earning half as much." He asked the nation to be properly proud of what happened that day.

Martin said, "I have a dream. A dream deeply rooted in the American dream" and I thought about my friend Bud, who was teaching me about love and about all the hundreds of thousands of people that were asking America to give black people freedom. Then Martin closed that day with words that will forever echo in the annals of history. *"Let Freedom ring. ...We will be able to speed up that day when all of God's children—black men and white men, Jews and Gentiles, Catholics and Protestants—will be able to join hands and sing in the words of the old Negro spiritual, 'Free at last. Free at last. Thank God Almighty, we are free at last!'"*

It was Martin's Pastor's Anniversary, late one Sunday evening. The year and month I do not remember. We sat on folding chairs in the dimly lit basement of old Ebenezer Baptist Church, in the fellowship hall with the black and white linoleum check floor. The evening service was followed by a reception with finger sandwiches. The altar was decorated with flowers, perhaps gladiolus. Pulpit chairs set to the side were wrapped in white fabric like a throne. There was a chair for Uncle Martin, a chair for Aunt Coretta and special seating for the children. There was a traditional order of service and I don't remember if my father was to deliver the sermon or to bring greetings. Most importantly, we were there to be supportive friends, an extended family, like we were every Sunday. The highlight of the service was always the tribute presentation of the various church organizations and auxiliaries to Martin and the family. Then, each organization would present a special offering that they had raised in honor of his years of service to Ebenezer. As the presentations continued, time came for the choir to make its tribute.

A man stepped up to the microphone and sang the most beautiful soulful ballad to Martin, that I had ever heard. The feeling and memory of that moment lingers with me still. My life was enriched that Sunday evening, by this moment, which I hope that I will never forget. It was one of Uncle Martin's most favorite songs and the words went something like this: *"To dream... the impossible dream; to fight the unbeatable foe; to bare with unbearable sorrow; to run where the brave dare not go. To right the unrightable wrong; to love...pure and chaste from above; to strive when your arms are to weary; to reach the unreachable star."* I remember. After so many years, praise be to God that I remember.

Tears streaming down Martin's cheeks. He was so humble that evening. The words of "The Impossible Dream" touched a place so deep in his heart. I felt sad at that moment as I looked at him. I loved him so much that his sorrow made me cry, too. He had given so much, tried so hard and asked for so little. He was not a cold man of steel, but a gentle, peaceful warrior; a reluctant hero that summoned his courage, swallowed his fear, quelled his pride and went into battle, to serve God. With my father by his side all the way, they tried to reach the impossible dream.

There wasn't a crowd, just a handful of dedicated believers that came by to say "Thank you, Martin Luther King, Jr. for coming by this way." Thank you for blessing our lives, for gracing us with your mighty presence, for sharing your love. Thank you for the generosity, the kindness, the compassion, and the unselfish spirit, the understanding and above all for your time. Your dream is not an impossible dream.

It is the spirit of Martin Luther King, Jr. and the Dream of Integration that brings us together in the moment of reflection. "What manner of man was he?" I wonder if he ever thought that I would be one to answer that question? I was merely a little girl, his closest friend's youngest daughter; born after the Montgomery Bus Boycott, which served as the beginning of the Civil Rights Movement, which was the greatest struggle for human dignity that America has ever known. Uncle Martin loved me from the very beginning of my life, held me in his arms before God and blessed me as a baby. Before I knew myself, he was there to watch me learn to walk, to hear me speak my first words, to celebrate my birthdays and to open my Christmas gifts. Until April 4th, 1968, I had never known a day when he wasn't in my world.

Why did God take Martin, so soon? He was only 39 years old. They carried his body in a beautiful wooden casket placed upon a wagon drawn by mules. Daddy wanted it that way: simple and humble, reflective of the people Martin served. When we got to the entombment, I remember being so weary with grief that it was difficult to hold my little body up. So I leaned into my mother's side. Daddy called the children; one by one to the tomb, to touch the casket one last time and say our goodbye. He called my name last and as I tried to get through the people, I heard him say, "And now we commit your body—Earth to Earth, Ashes to Ashes, Dust to Dust." Then they sealed the wall. I never got that last chance to touch Uncle Martin's casket, before I had to say Goodbye.

"He was The One, The Hero, The Fearless Person for whom we had waited. I hadn't even realized before that we had been waiting for Martin Luther King Jr., but we had. And I knew it for sure when my mother added his name to the list of people she prayed for every night."

—Alice Walker, In Search of Our Mother's Garden's, 1983

CHAPTER FIVE

An American Hero

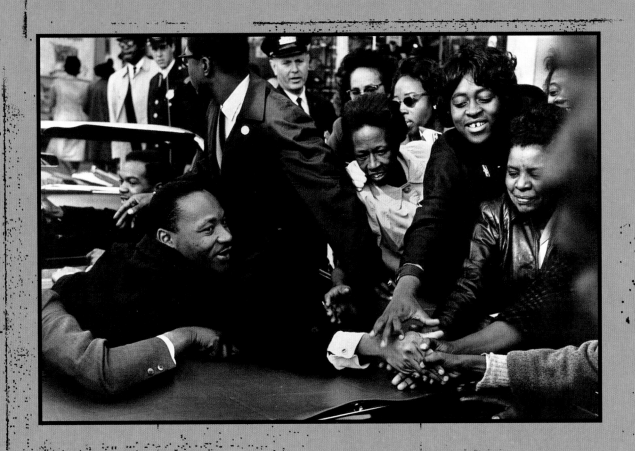

When outrage and shame together shall one day
have vindicated the promise of legal, social and economic opportunity for
all citizens, the gratitude of peoples everywhere and of generations of
Americans yet unborn will echo our admiration.

— *YALE UNIVERSITY, FROM A SPEECH PRESENTING AN HONORARY DEGREE TO DR. KING IN 1963.*

What makes an American hero? As an African American leader, Martin Luther King, Jr. courageously and selflessly led a nonviolent campaign for social justice that offered a beleaguered black community an enduring self-image of worth and dignity. "I am black and beautiful," he told the students of a black high school in Ohio. The struggle against oppression began with the struggle against shame. King's message was one of black value and self-esteem. But his message reached far beyond America's black communities. □ As a leader of all Americans Dr. King echoed the most sacred texts of American democracy, through the words of the Declaration of Independence and the Constitution. Through a soaring and hopeful oratory he illustrated the injustice of segregation and captured the imagination of people from many different backgrounds and faiths. Martin Luther King, Jr. became the conscience of a nation, proposing the only course of salvation for a country of so many colors and cultures to find a way to love one another and live peacefully together in mutual respect. Reaching far beyond the United States, his rhetoric touched the oppressed and downtrodden around the world. □ Throughout King's public life, controversy swirled about him and there were those who sought to discredit him as

a communist or an agitator who inspired violence. The increasing militancy of his push for equality, particularly when the struggle moved to northern cities, frightened many political leaders, but it was always tempered by his passionate commitment to nonviolence and his dream of the "Beloved Community"– a truly integrated America. These accomplishments made Dr. King, at the age of 35, the youngest recipient of the Nobel Peace Prize. Martin Luther King, Jr. offered all Americans a vision of what the United States could be and crossed the barrier from African American hero to American hero.

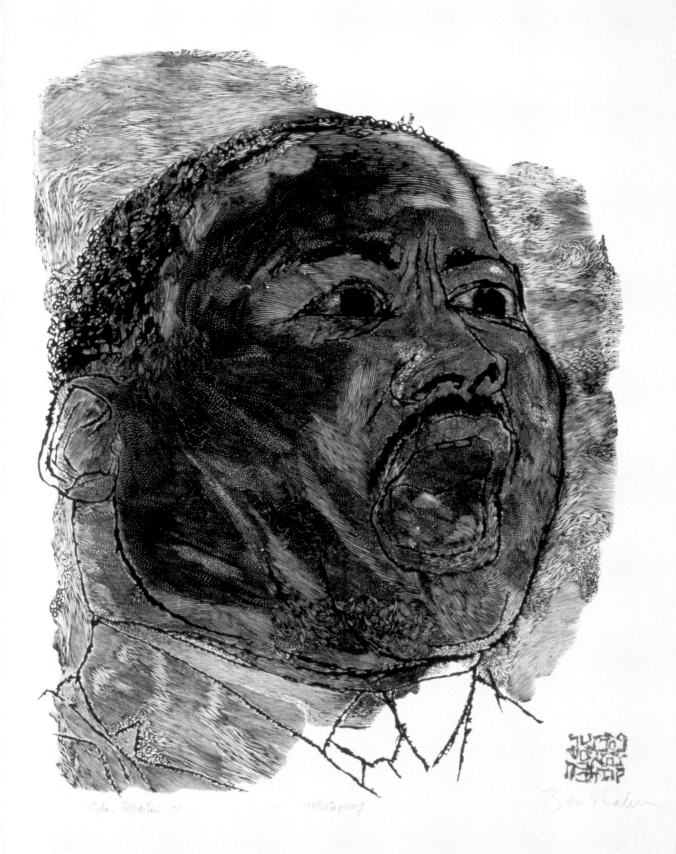

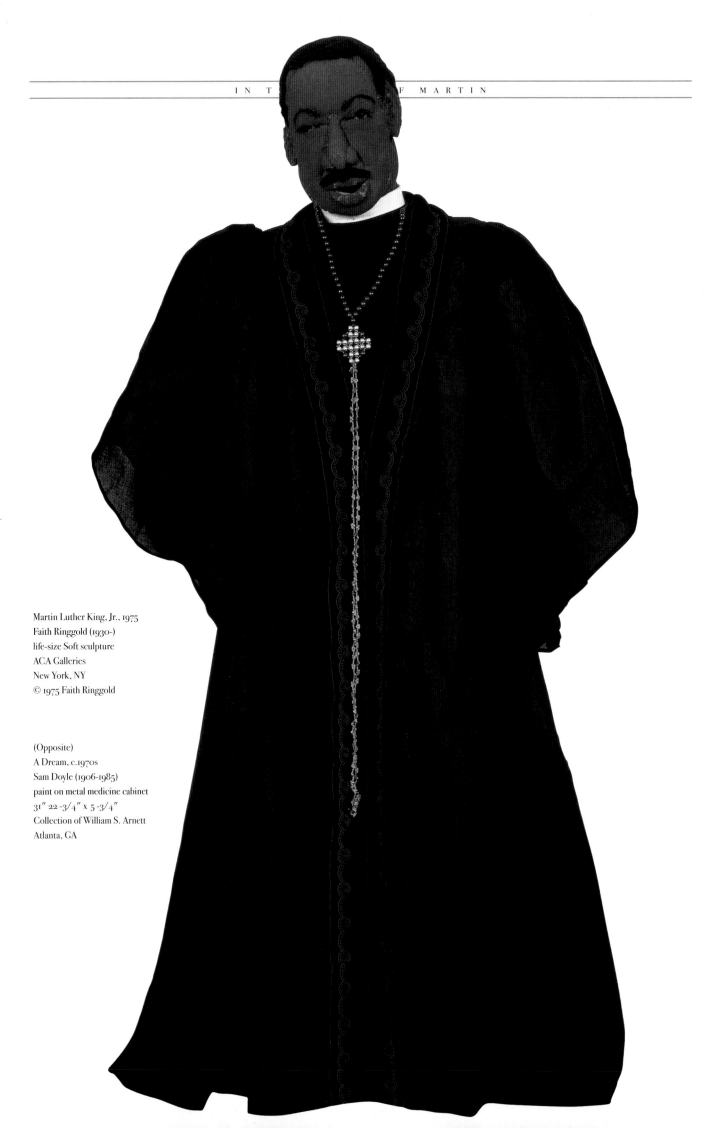

Martin Luther King, Jr., 1975
Faith Ringgold (1930–)
life-size Soft sculpture
ACA Galleries
New York, NY
© 1975 Faith Ringgold

(Opposite)
A Dream, c.1970s
Sam Doyle (1906-1985)
paint on metal medicine cabinet
31″ 22 -3/4″ x 5 -3/4″
Collection of William S. Arnett
Atlanta, GA

139

(Opposite, top)Martin Luther King, Jr., 1974, Archie Byron (1928-), sawdust, Elmer's glue, 36″ x 36″. Collection of George and Sue Viener, Reading, PA

(Opposite, bottom) Martin Luther King, Jr., 1997, Carl Dixon (1960-), carved wood and enamel paint, 30″ x 24″. Courtesy of Webb Gallery, Waxahachie, TX

(Above left) Martin Luther King, Jr., 1988, Arliss Watford (1924-1998), carved wood sculpture, 12″ x 6″ x 4″. Collection of Edward V. Blanchard and M. Anne Hill

(Above right) M.L. King, Jr., Ulysses Davis (1913-1990), carved mahogany, 9-1/4″ x 5″ x 5″. Collection of Jane and Bert Hunecke

(Above left) Martin Luther King, Jr., Charles Arthur Wells (1935-), alabaster bust, 10 5/8″ high. National Portrait Gallery, Smithsonian Institution, Washington, DC

(Above right) Martin Luther King, Jr., 1970, Charles Alston (1907-1977), bronze bust, 12 5/8″ high.

National Portrait Gallery, Smithsonian Institution, Washington, DC © Estate of Charles Alston

(Opposite page) Maquette for Monument to MLK, Jr. (Buffalo, New York) 1982, John Wilson (1922-), plaster, 29″ x 23″ x 23-1/2″. © John Wilson/Licensed by VAGA, New York, NY

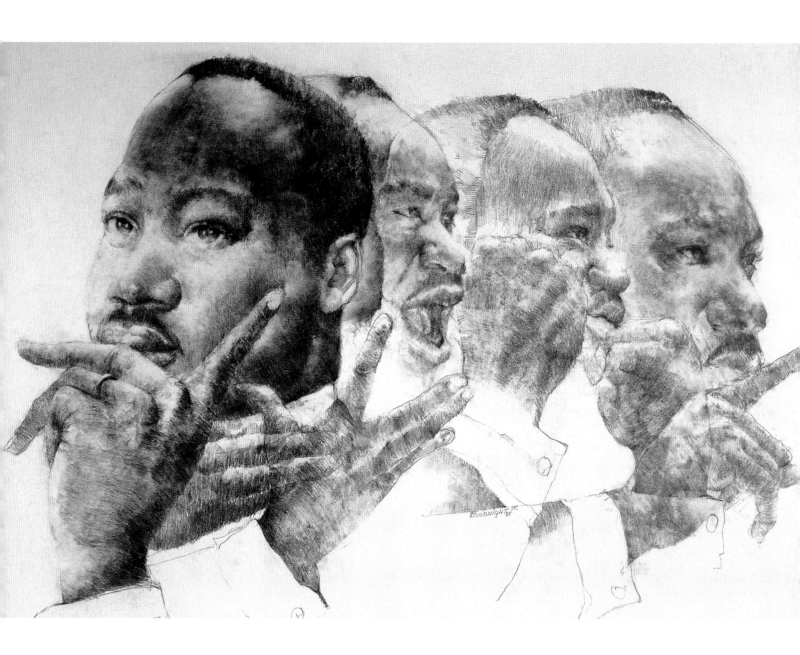

(Above) Let Kingdom Come, 1992, Paul Goodnight (1946-), charcoal on paper, 31″ x 45″. Collection of Leon Braithwaite, Cambridge, MA
(Opposite) MLK's Humanity of Man, 2001, Allan Edmunds (1949-), offset lithography, screenprint, stenciling, collage, 59″x 40″. Collection of the artist, Philadelphia, PA

unearned suffering is redemptive

we loved him dearly, th...
children loved him dear...
Wife Coretta

THE COURAGE OF IDEALISM

JULIUS LESTER

I was not a follower or supporter of Dr. Martin Luther King, Jr. during his lifetime. I thought his political philosophy sought the integration of blacks in a socio-economic system that needed to be fundamentally changed rather than accommodated. I found his practice of nonviolence shallow when measured against that of Mahatma Gandhi who had an understanding of the spiritual dimensions of nonviolence King never approached. While I appreciated Dr. King's charisma and oratorical skills, his personality-based leadership style weakened or undermined grass-roots organizing efforts in many areas of the South. I recognized and respected his standing and influence as a leader who took great personal risks but this did not exempt him from justifiable criticism.

In the more than three decades since his death, this more realistic and balanced attitude toward Dr. King that existed during his lifetime has been buried beneath an increasing hagiography. This does an injustice to Dr. King and, more importantly, ourselves. We now have a national holiday in his name but like all our holidays, this one is merely an excuse for a long holiday weekend, sales at the mall, and an opportunity to mistake their pious clichés about race relations for insight and oratorical eloquence.

Yet, for all my criticisms of Dr. King's career, for all my distaste of his public transformation into a secular saint, I sense something else at work in his elevation to sainthood, something which has as much to do with us as it does with him.

One of the courses I teach at the University of Massachusetts at Amherst is "Social Change and the 1960s." Having taught the course for most of my 30-year career at the university I have witnessed several changes in the students who take it. The number of students wanting to take the course has risen from 30 in the early seventies to 200 by the late eighties to over 800 today. (The largest lecture hall on campus limits class size to 470.) The students of the early seventies had witnessed, if only on television, many of the events of the sixties. Some had been taken to anti-Vietnam war and civil rights demonstrations by their parents. As the decades progressed, however, fewer and fewer students had personal memories of the sixties. Today's students obviously have no personal memories of that era and their parents have only vague recollections since most of them were still children.

Despite the absence of actual memories of the sixties, my students have a strong impression of it as a time when something mattered, though they are not sure what it was. But something mattered then and nothing matters now. As one student put it a few years ago, "In the sixties students did something. We haven't done a thing. We're shit!"

Although such a statement is an exaggeration, it is an accurate reflection of how many of today's students feel about their ability to effect change. In my efforts to counter such negative self-assessments, I have come to a new understanding and appreciation of King's enduring importance in American culture. My students have helped by letting me witness and experience their aching need to believe and their concomitant fear of doing so.

It would be flattering for me to believe that 800 students want to take my course on the sixties because I am a great teacher. Although I received the University's Distinguished Teacher Award some years ago, I am also aware that none of my other classes attract so many students. But none of my other classes speak with such immediacy to an emptiness students perceive in their lives, a void produced in part by having grown up with the cynical exploitation of the spirituality wounded on daytime television talk shows and the national scandal of a president having an affair with a girl barely older than themselves. They look around for something or someone to believe in and the landscape is as promising as a desert of shifting sand dunes. But when they look back to the sixties, a time represented vaguely in their minds by The Beatles, Martin Luther King, Jr., walking on the moon, hippies, and the Vietnam War, they sense that this was an era when the lives of people their own age had a meaning and significance theirs lack. And while they are simultaneously intrigued by and suspicious of the sixties, they are also nostalgic for its idealism and no one embodied and expressed that idealism more forcefully and eloquently than Martin Luther King, Jr.

It was this I failed to appreciate about Dr. King during his lifetime. But I understood my mistake immediately that night of April 4, 1968 as I watched on television the reports of riots breaking out across the nation, as I looked out the window of my apartment in New York City at black young people breaking into stores. What bitter irony that the murder of the man who preached nonviolence evoked such violence. And the famous lines from Yeats' "Second Coming" came to mind:

Things fall apart; the centre cannot hold;
Mere anarchy is loosed upon the world,
The blood-dimmed tide is loosed, and everywhere
The ceremony of innocence is drowned;
The best lack all conviction, while the worst
Are full of passionate intensity.

Martin Luther King, Jr. gave forceful expression to an idealism that had lain dormant in American life since the Abolitionist movement of the mid-nineteenth century, an idealism not ashamed to speak openly and unsentimentally of love, not only as an instrument of social change but of love as the currency of daily life. It was an idealism that encouraged us to be vulnerable to each other through the tangled barbed wire barrier of racism. It was an idealism that encouraged us to believe that we could be better human beings than we thought we could.

In his last book, *Where Do We Go From Here: Chaos or Community?*, Dr. King warned against the ethnic separation that has become almost the norm in American life:

"There is no salvation for the Negro through isolation. In a multiracial society no group can make it alone. To succeed in a pluralistic society, and an often hostile one at that, the Negro obviously needs organized strength, but that strength will only be effective when it is consolidated through constructive alliances with the majority group."

Many blacks today, especially those my students' ages, do not understand that whites have a claim to Dr. King also, because he inspired whites to hope and work for a society in which they, too, would not be judged by the color of their skin. Many blacks do not recognize that whites grieve Dr. King's death as a loss for the best in them, too.

As he wrote:

"The black man needs the white man and the white man needs the black man. There is no separate path to power and fulfillment that does not intersect white paths, and there is no separate white path to power and fulfillment, short of social disaster, that does not share that power with black aspirations for freedom and human dignity. We are bound together in a single garment of destiny....This is a multiracial nation where all groups are dependent on each other, whether they want to recognize it or not."

It is this idealism and hope and unwavering belief in the best of people that so many long for in their desire to keep alive the memory of Martin Luther King, Jr. The mistake is in believing that such hope and idealism belonged only to him. How often I have heard students and adults say, "What we need is another Martin Luther King, Jr." And my response is: "Why? So he can get killed?"

By being so much the charismatic leader, the idealism King voiced became entwined with his personality, and with his death the idealism died. People long for another King. We should instead, take responsibility for the idealism he awakens within us.

It is easy to look at images of Dr. King and feel the pain of his absence. It is easy to look at images of Dr. King and long for someone to take his place—as if that were possible. What is not easy is to look at images of him and realize that we are looking at ourselves. The idealism we think we perceive in him is really our own but we are afraid to take possession of it, to take responsibility for it, to have the courage it demands.

The persistence of Dr. King's memory indicates our need for some touchstone to remind ourselves that an America which emphasizes ethnic identity over a common identity as human beings is not an ideal to which we should aspire, that an America rife with television shows in which the language of insult and anger is acceptable is not an ideal to which we should aspire, that an America in which greed is an acceptable value is not an ideal to which we should aspire, that an America in which more money is allocated for the military and weapons systems than health care for all is not an America with which any of us should be content.

Dr. King wrote that the first law of life was not self-preservation but *"other-preservation. We cannot preserve self without being concerned about preserving other selves. The self cannot be self without other selves. Self-concern without other-concern is like a tributary that has no outward flow to the ocean."*

Dr. King is like an icon we need to look at to remind us that we can aspire to be heroes and heroines instead of being content to be role models. Roles are something actors learn and perform before cameras or on stage. In roles we recite lines written by someone else. Heroes and heroines inspire us to take risks, to do something heretofore unthinkable, to be passionate about a vision even though we may not be sure what to do to make it real.

When we respond to Martin Luther King, Jr., it is the heroic in ourselves to which we are really responding. When we mourn the absence of Martin Luther King, Jr., we are yearning for our lives to be expressions of idealism. His memory awakens in us a yearning for lives of integrity and wholeness. Most of all, perhaps, we ache for the courage to make our ideals a reality.

It is here that I come to a love of Dr. King, despite everything else I think of him. Martin Luther King, Jr. was an ordinary man who was afraid many times. He was a man who allowed History to use him, a man who often did not know what History wanted of him, a man who often did not know even what he should do. And he was certainly a man who did not want to die at age thirty-nine. Yet, he was most certainly a man of courage and I understand courage as the will to persist in one's ideals at the moment when one is most afraid.

All too many of us, black and white, have forgotten or never learned what an arching vision of humanity Martin Luther King, Jr. had. It is a vision we need more desperately than ever. Do we have the courage of the vision, namely, to risk the terror of seeing our humanity in another?

"If any of you are around when I have to meet my day...I'd like somebody to mention...that Martin Luther King, Jr. tried to give his life serving others. I'd like for somebody to say that day, that I tried to be right on the war question. I want you be to able to say that day, that I did try to feed the hungry. And I want you to say that day, that I did try, in my life, to clothe those who were naked.

Yes, if you want to say that I was a drum major, say that I was a drum major for justice; say that I was a drum major for peace; I was a drum major for righteousness....I won't have any money to leave behind. I won't have the fine and luxurious things of life to leave behind. But I just want to leave a committed life behind."

—MLK, Sermon, Ebenezer Baptist Church, February 4, 1968

I May Not Get There With You

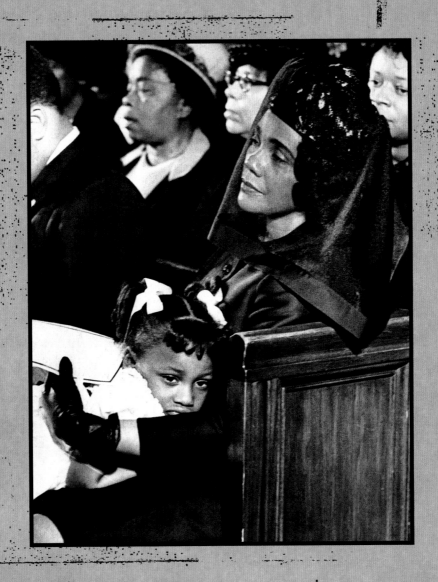

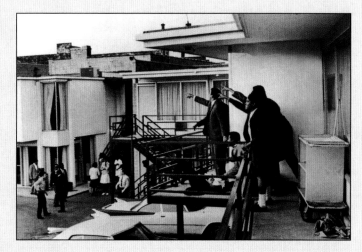

Martin Luther King, Jr. expanded his vision of civil rights to include the struggle for justice, peace, and social equity around the world. A new approach to the nonviolent marches of the South was needed to address the problems of the urban centers of the North, and a massive program of civil disobedience was planned. Would such a plan move Congress to act and quell the summer riots? Many people did not think so. Support for the Poor People's Campaign was difficult to obtain from both militant blacks, like Student Nonviolent Coordinating Committee Chairman Stokely Carmichael, and previously supportive whites. □ A request from a Memphis pastor sent King to that city in April of 1968 to support sanitation workers. He was, after all, in the midst of a campaign to aid America's poor, and the strike included an odious racial element. Black workers were sent home without pay during bad weather while white workers were kept on and paid. While standing on the balcony of the Lorraine Motel in Memphis, an assassin's bullet shattered King's jaw and the dreams of many Americans. □ "Freedom is not free," Dr. Martin Luther King, Jr. prophetically told an audience in Montgomery in 1959. And, indeed, there was a dear price to be paid by all Americans. Following King's assassination there was a sense of hopelessness and rage in the black community. Black and white people seemed further apart than ever. "How do you feel now that your leader has been killed?" a white man on the subway asked a startled little girl. □ Many African American artists found it particularly difficult to work during these depressing days, feeling lost, despondent and fearful of the future. Their art reflects their profound sadness and disillusionment. The Civil Rights Movement had lost its leader, but not all of its resolve. Reverend Ralph Abernathy, Martin Luther King's friend and associate in the Southern Christian Leadership Council, insisted that the Poor People's Campaign continue. Their encampment would be called Resurrection City.

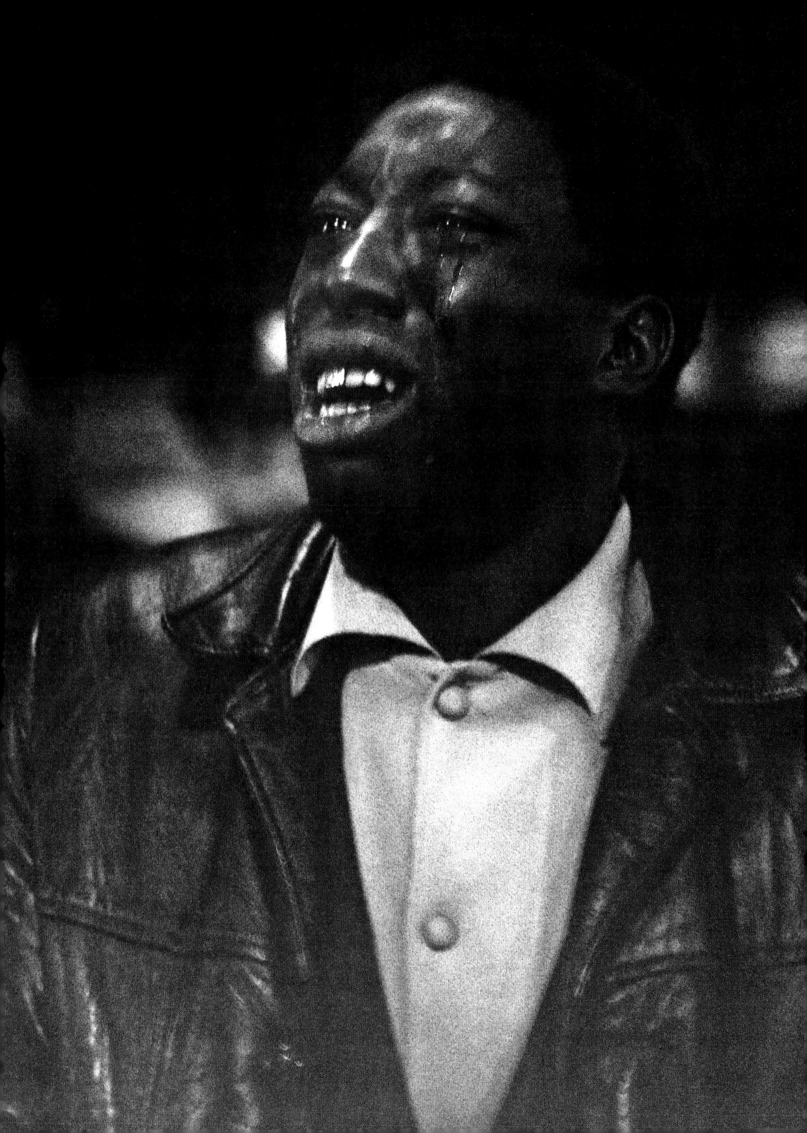

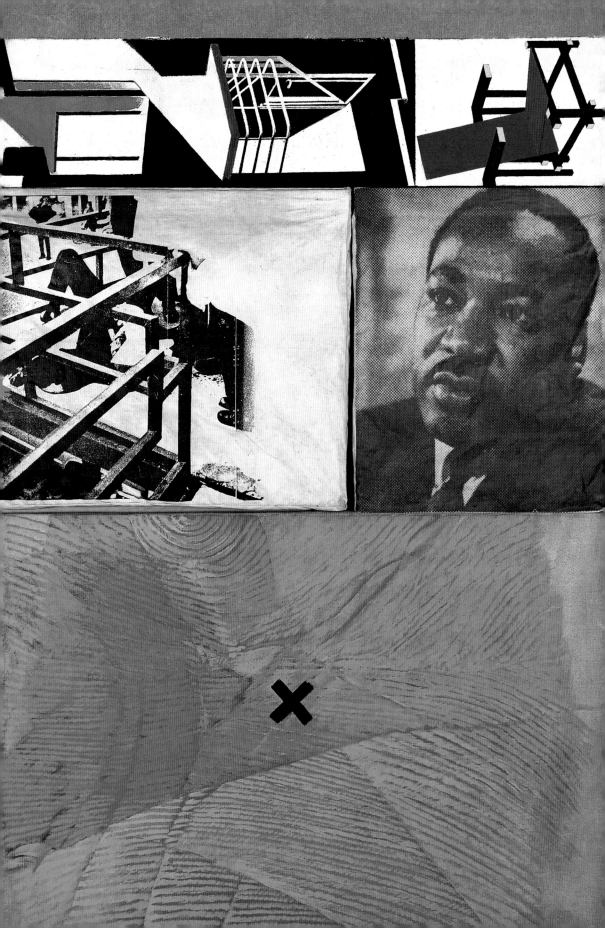

(Opposite) Martin Luther King, 1969, Joe Tilson (1928-), screen and oil on canvas and wood relief, 70″ x 50″.
The Appleton Museum of Art of Florida State University and Central Florida Community College, Ocala, FL
(Above) Target Memphis, 1968, David G. Pease (1932-), mixed media, colored pencil on paper, 22-1/2″ x 25″.
Gift of Dr. Luther W. Brady, H'88, The Luther W. Brady Collection of 20th-Century Works on Paper, Picker Art Gallery, Colgate University, Hamilton, NY

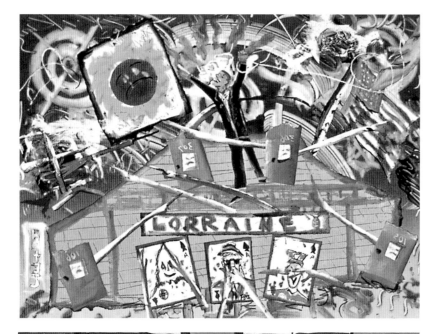

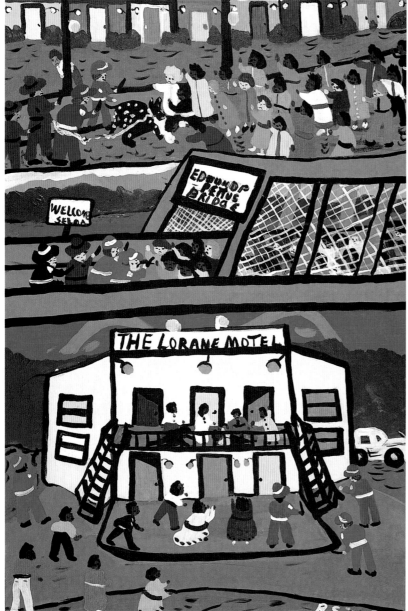

152

(Top left)
They've Killed the King, 1996
Gary Bibbs (1960-)
monoprint
18″ x 26″
Black Culture Center,
Purdue University,
Purdue, IN

(Bottom left)
Civil Rights Triptych of
Birmingham:
 Dogs, Selma Bridge,
and the Lorraine Motel -
Memphis, 1997,
Bernice Sims (1926-),
acrylic on canvas,
36″ x 24″
Collection of Micki Beth Stiller

(Opposite)
Assassinations, 1988
Leroy Almon (1938-1997)
painted wood relief
36″ x 22-1/2″
Courtesy of
Robert Cargo Folk Art Gallery,
Tuscaloosa, AL

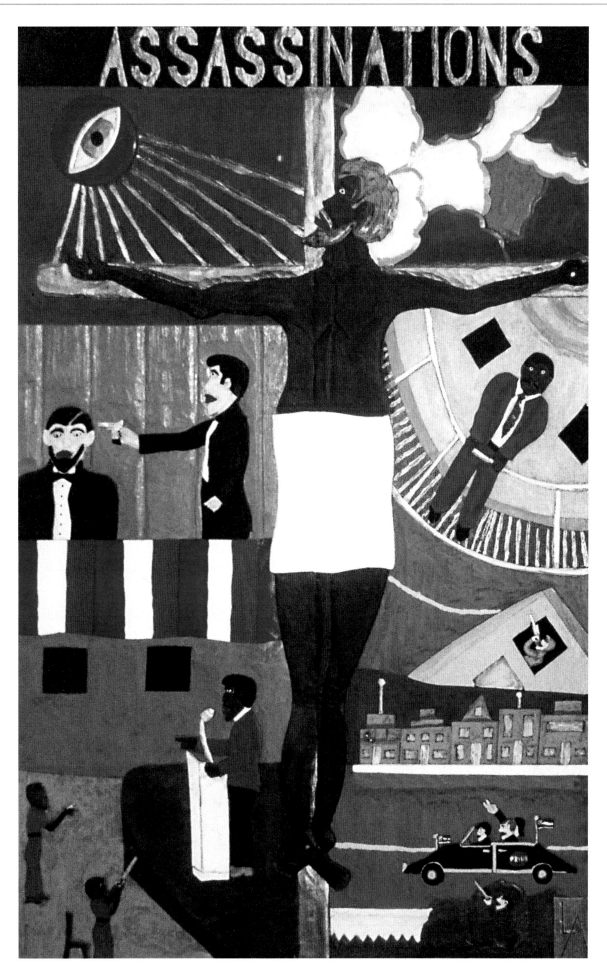

(Opposite)
A Price for Freedom, 1985
Sherman Watkins (1940-)
oil on canvas
48″ x 36″
Collection of the artist
Hampton, VA

(Right)
About Martin, 1975
John Outterbridge (1933-)
mixed media
40″ x 24″
Courtesy of lender:
Dolores Van Rensalier,
great granddaughter of
black abolitionist
William Van Rensalier

(Below)
The Soprano at the
Mourning Easter Wake of 1968, 1997
Daniel Pressley (1918-1971)
wood relief
35-1/4″ x 18″ x 1″
Smithsonian American Art Museum,
Washington, DC
Gift of Chuck and Jan Rosenak and
museum purchase through the
Luisita L. and Franz H. Denghausen
Endowment

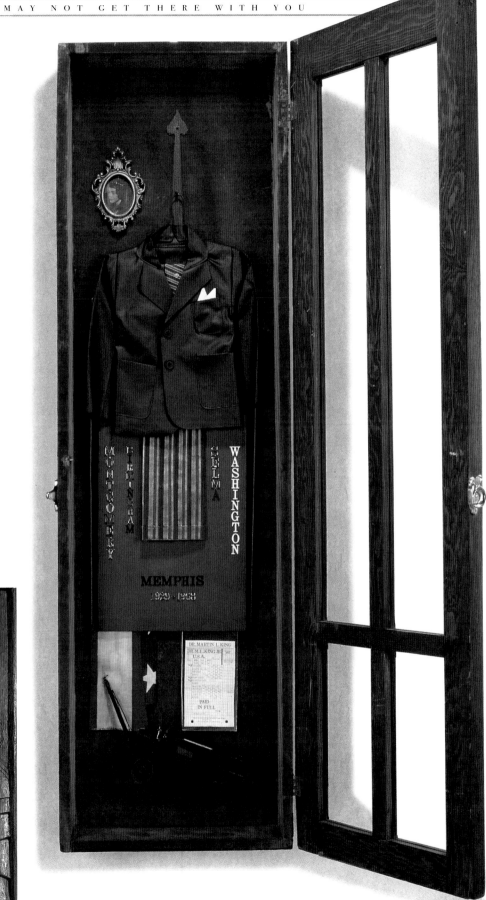

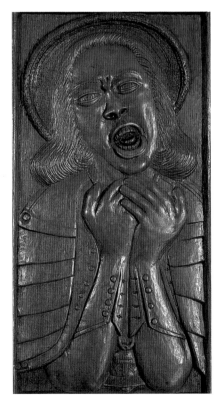

156

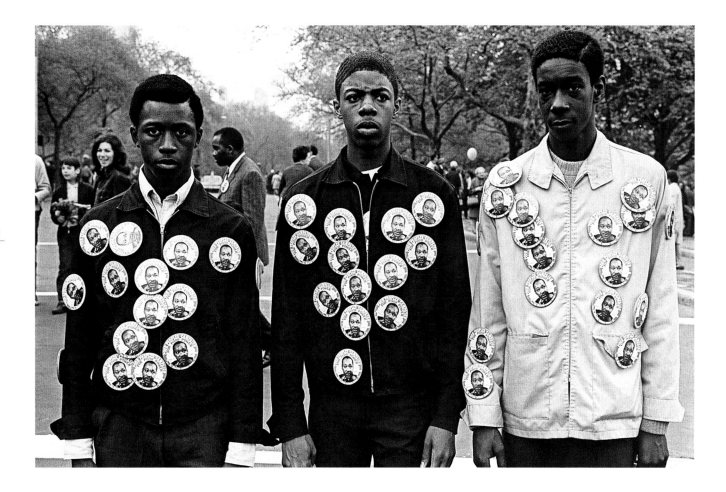

(Above) Memorial to Martin Luther King, Central Park, New York City, April 5, 1968, Benedict J. Fernandez (1936-),
gelatin silver print, 16″ x 20″ Collection of the artist, North Bergen NJ
(Opposite) Amy's Response to the Assassination of MLK, 1968, Harry Gottlieb (1895-1992),
silkscreen/lithograph, 18-3/4″ x 14″. Courtesy of Reading Public Museum, Reading, PA

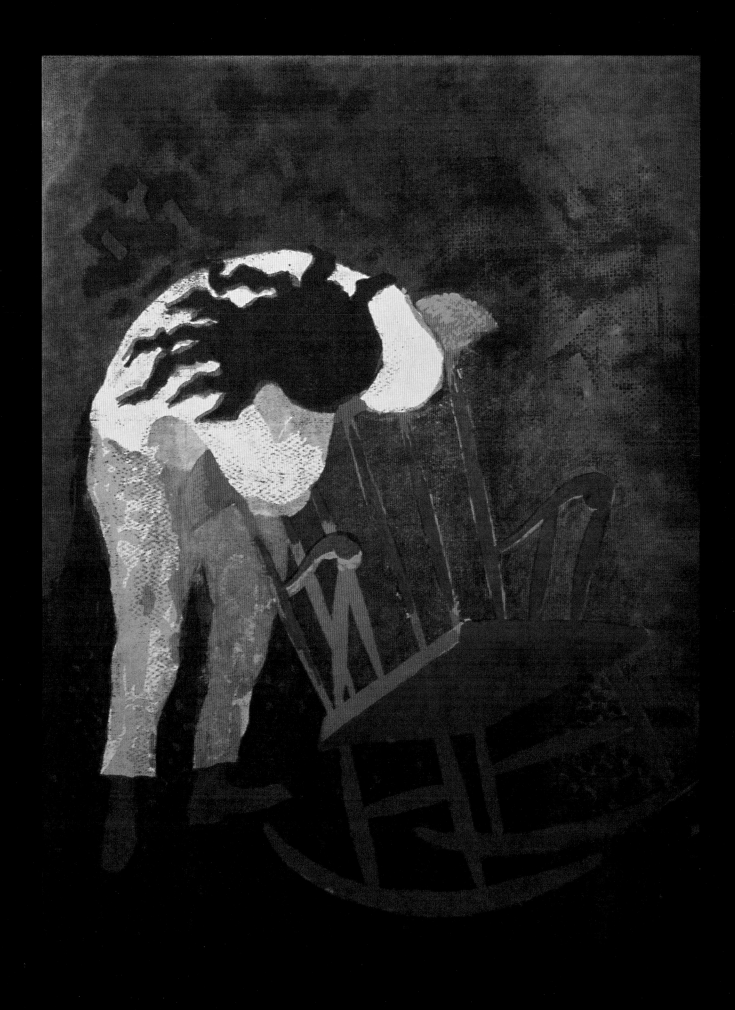

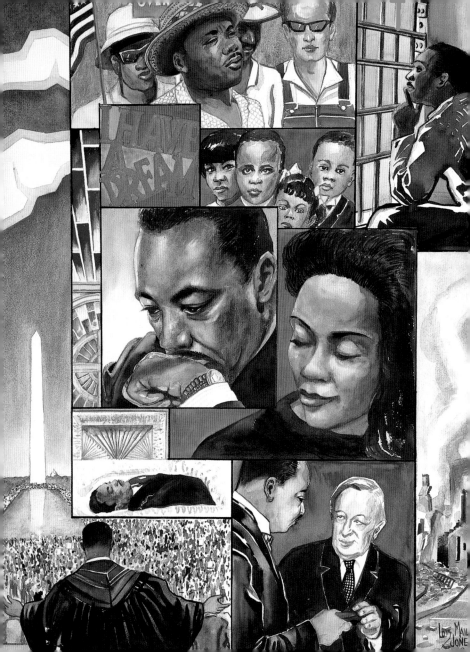

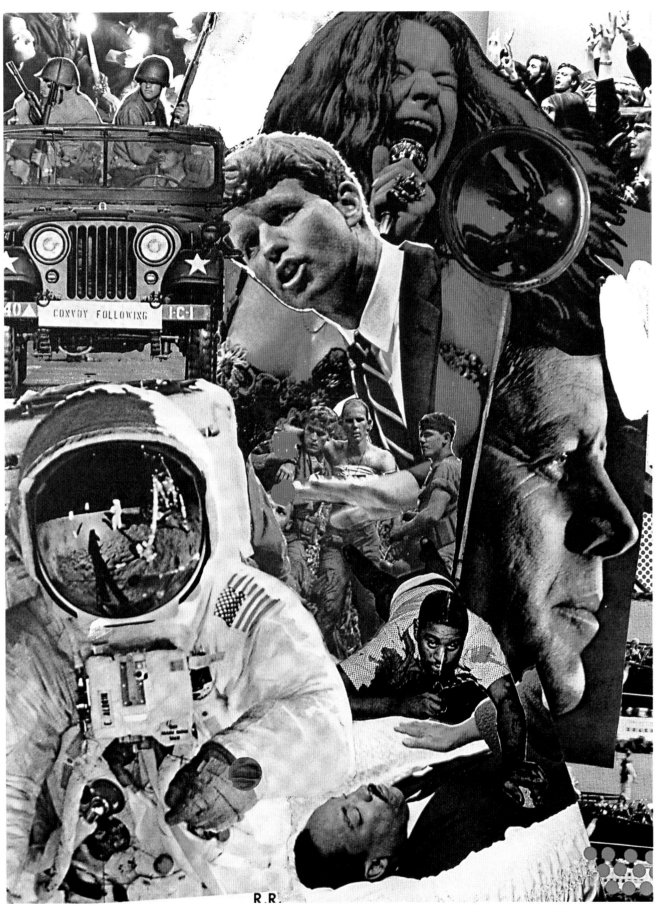

(Opposite) Homage to Martin Luther King, Jr.,1968, Lois Mailou Jones (1905-1998), watercolor on paperboard, 29 1/2″ x 21 5/8″.
The National Museum of Women in the Arts, Washington, DC, On loan from The Honorable Joseph P. Carroll and Mrs. Carroll
(Above) Signs,1970, Robert Rauschenberg (1925-), screen print, 43″ x 34″. Collection of the artist, New York, NY © Robert Bauschenberg/Licensed by VAGA, New York, NY

(Above) MLK Elegi, 1968, Martin Puryear (1941-), aquatint on paper, 12-5/8″ x 14-1/2″. Collection of the artist, Accord, NY

(Opposite page) Homage to MLK, 1968, Howardena Pindell (1943-), ink, watercolor, collage, Craypas on graph paper, 18-5/8″ x 23-5/8″ Collection of the artist, New York, NY

"I have **tried** to **address** the issue of **racism** in the **art world** through my **writings**, and Martin Luther King's life has given me the **courage** to **speak out**."

—Howardena Pindell

"Dr. King's spiritual guidance allowed all of us to survive the uncivilized indignities of racism..." —Jack Whitten

(Opposite)
For MLK, 1968
Jack Whitten (1939-)
oil on canvas
33″ x 39″
Collection of the artist,
New York, NY

(Left)
april IV, Part III, 1968, 1969
Sam Gilliam (1933-)
Acrylic on canvas
114″ x 21″
The Studio Museum in Harlem,
New York, NY;
Gift of Nina Felshin

163

(Right)
MLK + Peace, Lynch Fragment series
Mel Edwards (1937-)
welded Steel
16″ x 12″ x 10″
Courtesy of CDS Gallery, New York, NY

(Below)
I've Been to the Mountaintop, 1977
Richard Hunt (1935-)
bronze maquette
Approx. 12″ h x 20″ l x 18″ w
Collection of the artist, Chicago, IL

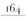 (Opposite)
American Dreamer, 2000
Paul Andrew Wandless (1967-)
clay, wood, tar and oil bar
30″ x 20″ x 7″
Collection of the artist

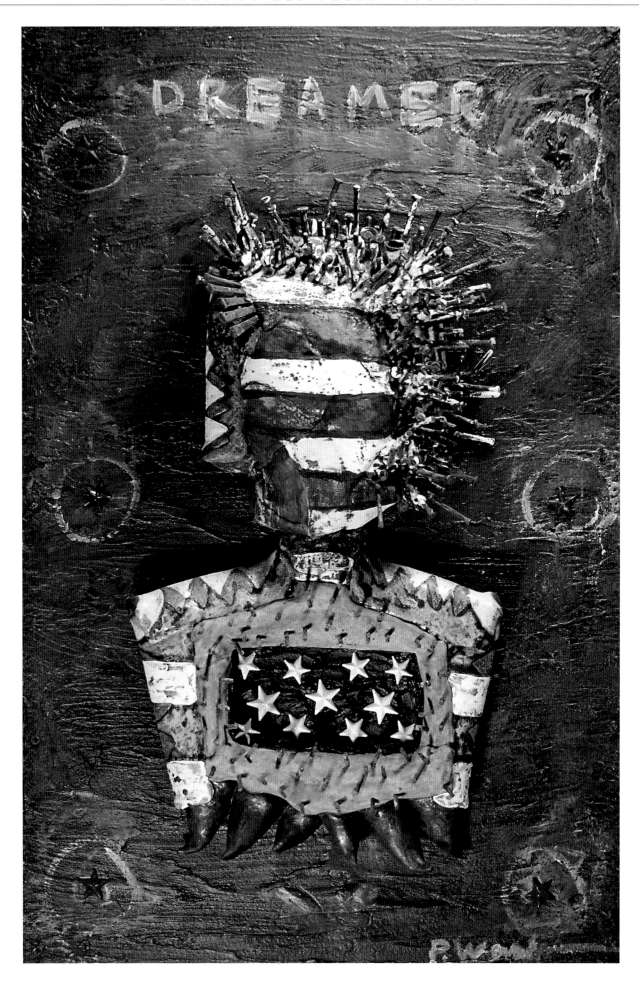

166

(Above) Harold, Martin & Sam, 1988, John L. Moore (1940-), oil on canvas, 60″ x 72″. High Museum of Art, Atlanta, GA; Gift of Jane Farver
(Opposite) Dear Martin, 1968, William Majors (1930-1982), oil on canvas, 88″ x 60″. Newark Museum, Newark, NJ and Art Resource, New York, NY

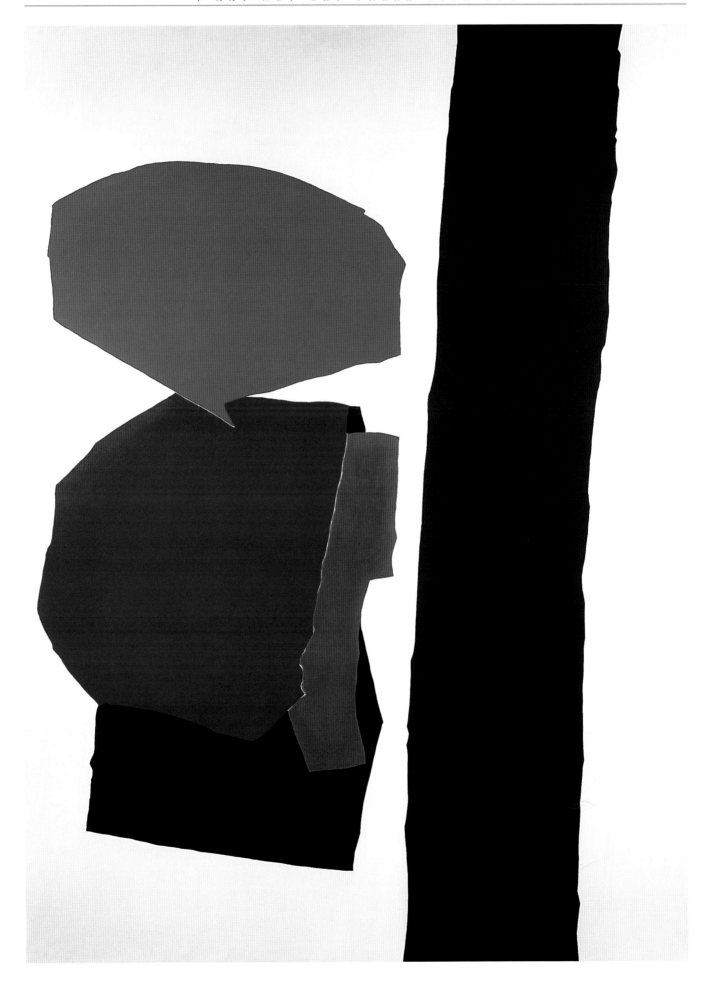

"...When I began to consider the true meaning of the word, I decided that perhaps I would like to think of myself as an extremist—in the light of the spirit which made Jesus an extremist for love. If it sounds as though I am comparing myself to the Savior, let me remind you that all who honor themselves with the claim of being Christians should compare themselves to Jesus."

— Martin Luther King, Jr.

I Have Seen the Promised Land

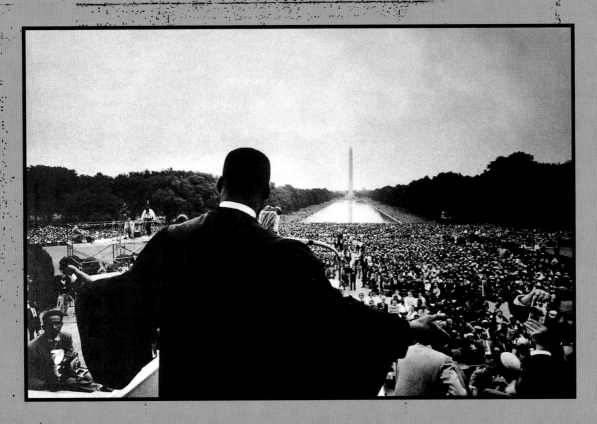

In Martin Luther King's theology, the way of the cross was a transformative experience. It represented the suffering of Jesus Christ, but also the suffering that was expected of his followers on earth. King compared his personal torment and the positive way that he tried to live his life to the teachings of Christ. During the Montgomery Bus Boycott he recounted a particular experience of faith. □ "I could hear an inner voice saying to me, 'Martin Luther, stand up for righteousness. Stand up for justice. Stand up for truth. And lo I will be with you, even until the end of the world.' I heard the voice of Jesus saying still to fight on. He promised never to leave me." □ After the assassination, others compared Martin Luther King to Christ as well. Were Dr. King's words and deeds those of a modern day prophet? Like other prophets, many of his countrymen did not treat Dr. King kindly. His family home in Atlanta was bombed and constant threats were made on his life. He was under close surveillance by the FBI, which was suspicious of the Civil Rights Movement; his telephones were tapped, his motel rooms bugged. When he spoke out against the War in Vietnam he was castigated for his views. □ Like other prophets, Martin Luther King's premature death at the hands of an assassin elevated him the status of a martyr for civil rights and the suffering of the poor. Like Jesus he eschewed wealth and profits for dignity and justice. His biting critique of white Christianity pointed out the insincerity of a religious community that professed a single human family while treating one segment of that family as second-class. Similarly King criticized the hypocrisy of a nation countenancing racism while professing to be a democracy. His views earned him the rebuke of conservatives. Despite his detractors, however, King's message has endured. □ During his brief 39 years of life, Dr. Martin Luther King, Jr. provided a steadfast moral compass for the nation, reminding us forcefully of the ideals on which this country was founded. It is his image as a founding father for the modern day that helps to keep us ever vigilant of the fragility of democracy.

(PREVIOUS PAGE) REVEREND MARTIN LUTHER KING, JR. SPEAKING AT "PRAYER PILGRIMAGE FOR FREEDOM" AT THE LINCOLN MEMORIAL, WASHINGTON, D.C., MAY 17, 1957, PAUL SCHUTZER (1931-1967), BLACK AND WHITE PHOTOGRAPH, 8" X 10" PAUL SCHUTZER/TIME PIX, NEW YORK, NEW YORK (OPPOSITE) MARTIN LUTHER KING, 1986, SUE COE (1951-), GRAPHITE DRAWING ON WHITE BRISTOL BOARD, 15-1/2" X 14-1/2". COURTESY OF THE ARTIST AND GALERIE ST. ETIENNE, NEW YORK, NY © 1986 SUE COE □ (ABOVE) THE MEMORIAL FOR A PROPHET (NO.2) 1990, MIKE NOLAND (1958-), OIL ON CANVAS, 30" X 30". COLLECTION OF THE ARTIST

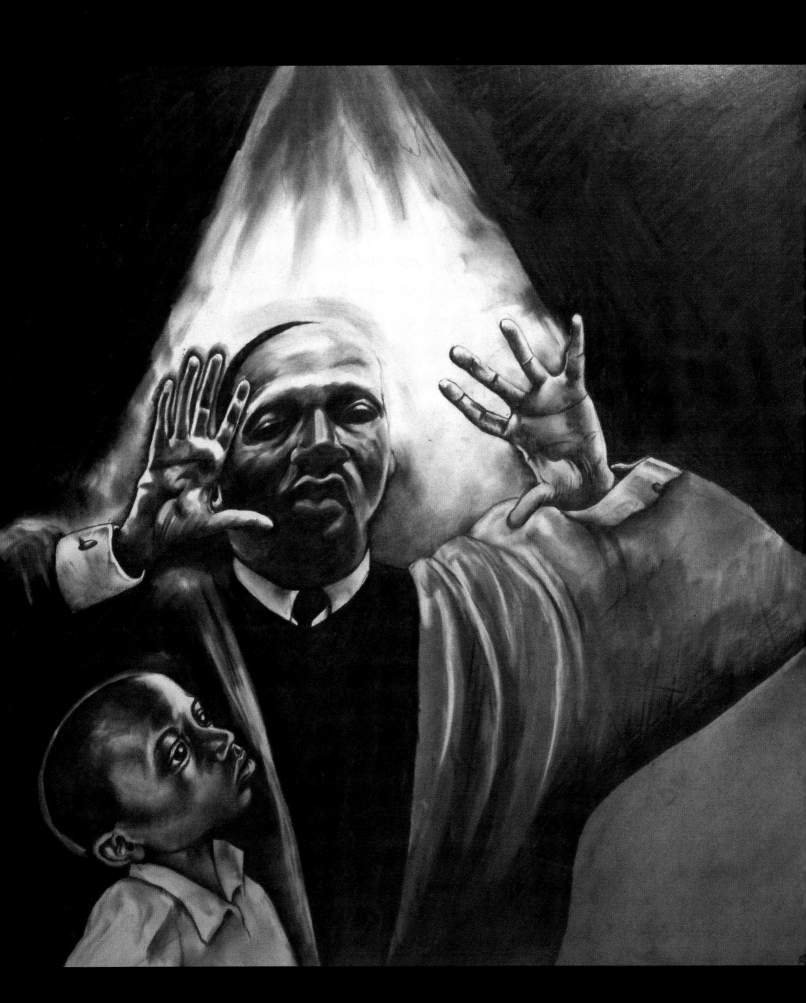

(Opposite) Martin Luther King, Jr. and the Kennedy Brothers, 1977, Elijah Pierce (1892-1984), Carved and painted wood relief with glitter, 21-1/8″ x 26-1/4″.
Columbus Museum of Art, Columbus, OH: Museum Purchase

(Above) Three Lions (Honoring Dr. King and the Kennedys), 1991, Thornton Dial, Jr. (1953-),
corrugated tin, woven rope, pebbles, industrial sealing compound, enamel on wood, 48″ x 51-1/2″. Collection of William S. Arnett, Atlanta,GA

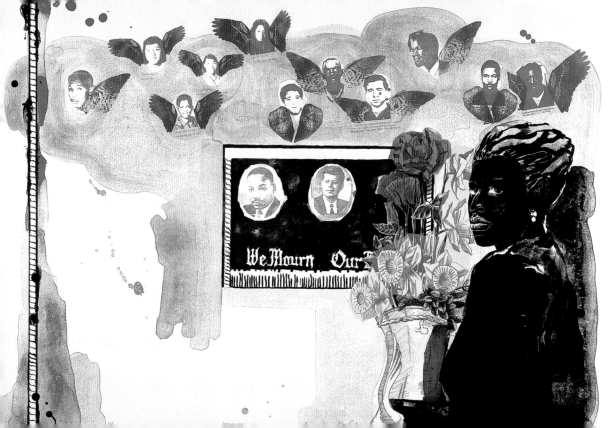

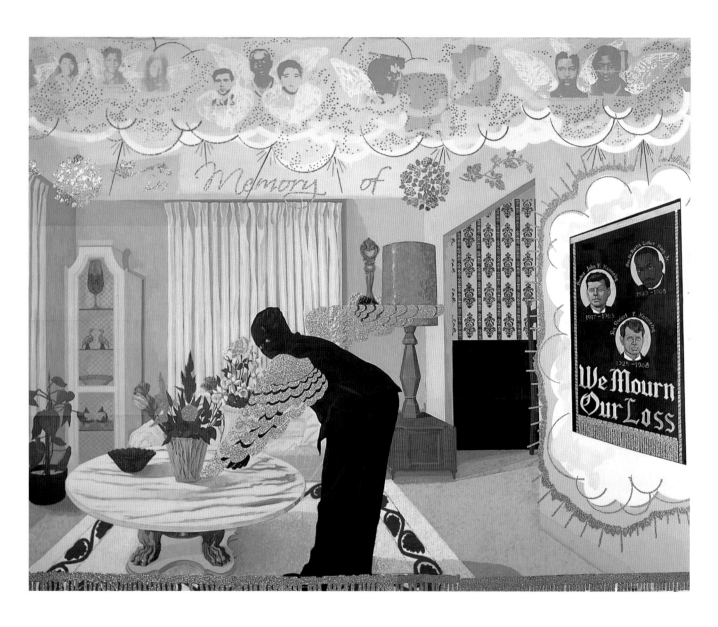

(Opposite) Memento, 1996, Kerry James Marshall (1955-), seven-color lithograph with gold powder, 30″ x 44″. Courtesy of Greg Kucera Gallery, Seattle, WA

(Above) Souvenir I, 1997, Kerry James Marshall (1955-), acrylic, collage, glitter on canvas, 108″ x 156″. Museum of Contemporary Art, Chicago, IL

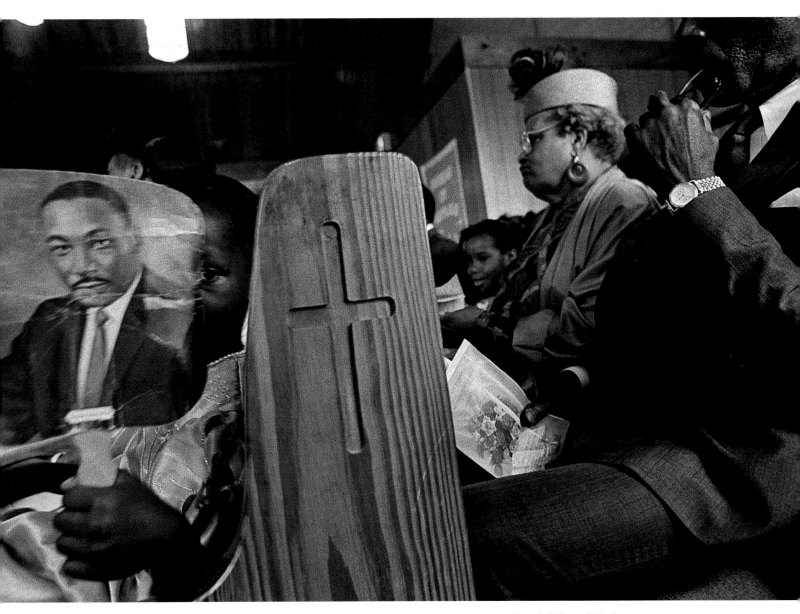

(Above) Late in the Church Service, 1991 , Eugene Richards (1944-), gelatin silver print, 16″ x 20″. © Eugene Richards

(Below) Fan (Portrait of Martin) 1993, Willie Birch, acrylic on board with wood handle, 12″x 9″. Arthur Rogers Gallery, New Orleans LA

(Opposite top) The Casablanca Lounge, Harlem, New York City, N. Y., 1995, Gerald Cyrus (1957-), gelatin silver print, 16″ x 20″. Collection of the artist, Philadelphia, PA

(Opposite bottom) Barbershop, 1968, Chester Higgins, Jr. (1946-), gelatin silver print, 16″ x 20″. © Chester Higgins Jr. All Rights Reserved.

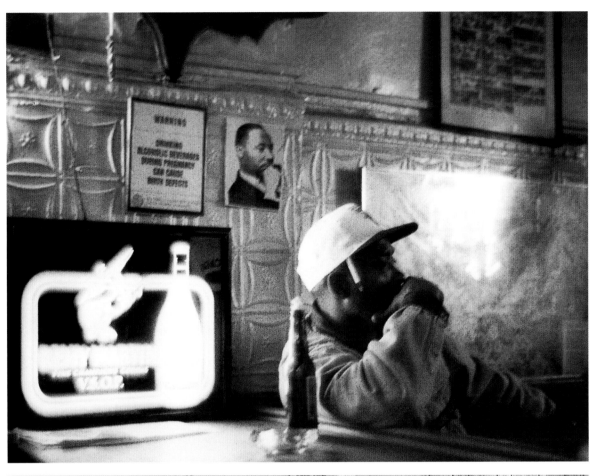

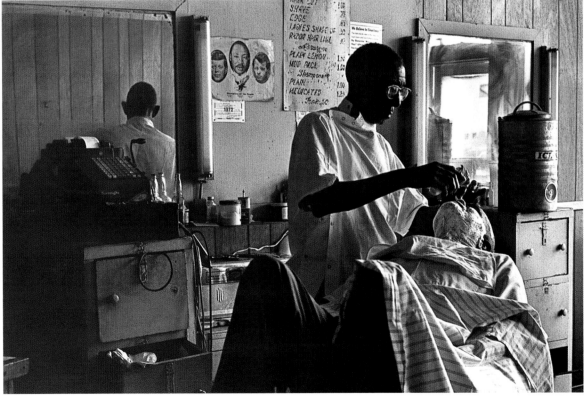

"...The Barber, like almost everybody else in that small town, wanted something of King to be in his life." —Chester Higgins, Jr.

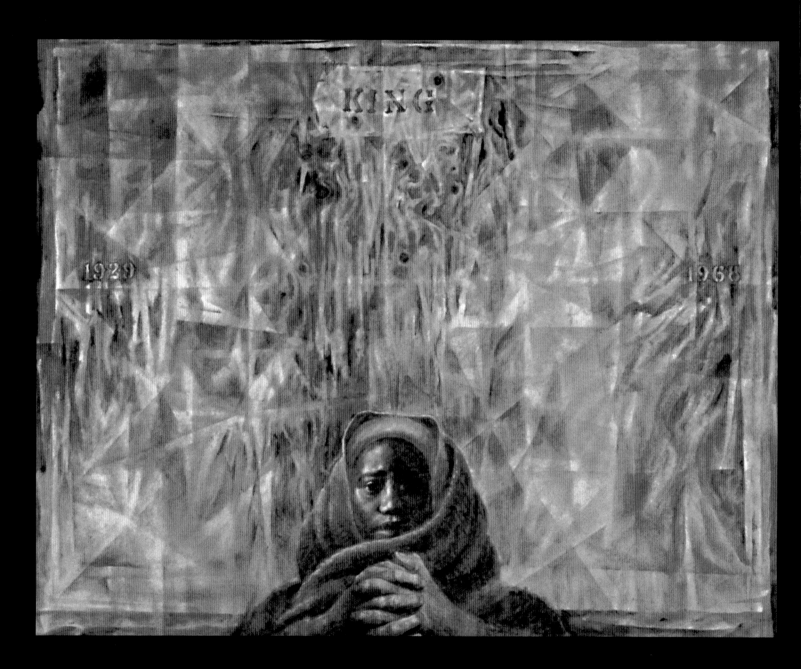

(Opposite) Wanted Poster Series #7, 1970, Charles White (1918-1979), oil on board, 38″ x 47-1/2″.
Robert Hull Fleming Museum, University of Vermont, Burlington, VT, Museum Purchase.
(Above) Untitled, 1993, Raymond Saunders (1934-), mixed media on wood, 24″ x 24″. Collection of Judy and Sheldon Greene, Berkeley, CA.
(Overleaf) Legacy of MLK triptych, 1998, Sam Adoquei (1962-), Oil on canvas, 72″ x 120″. Collection of the artist, New York, NY

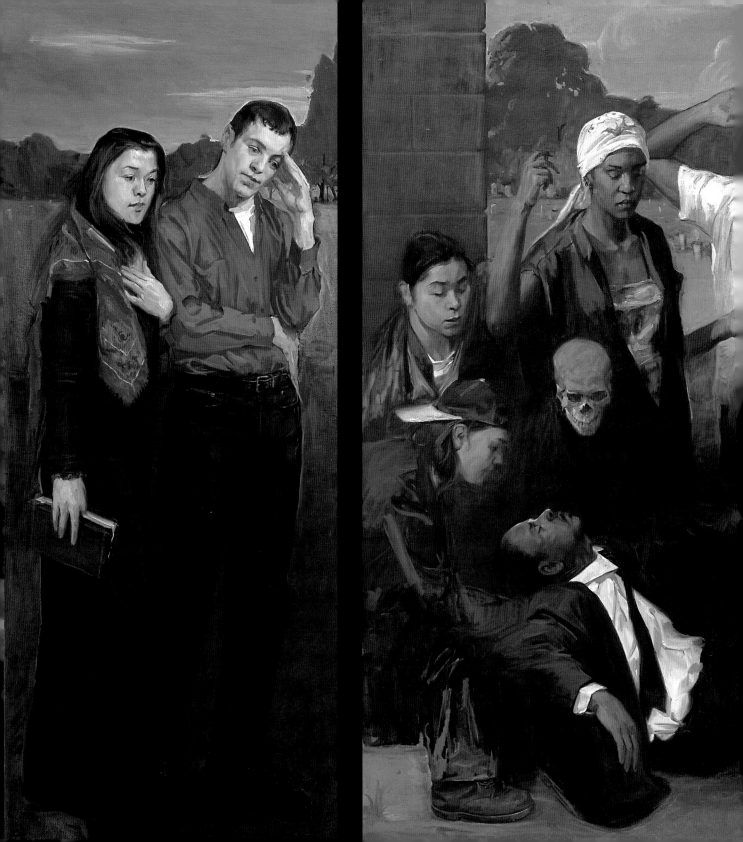

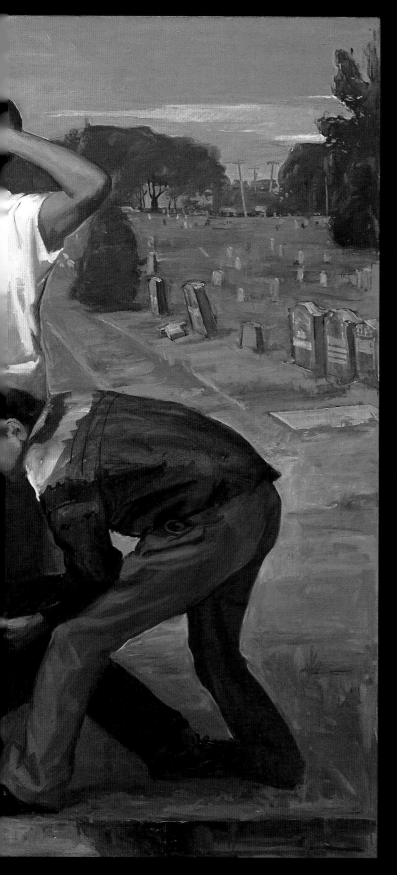
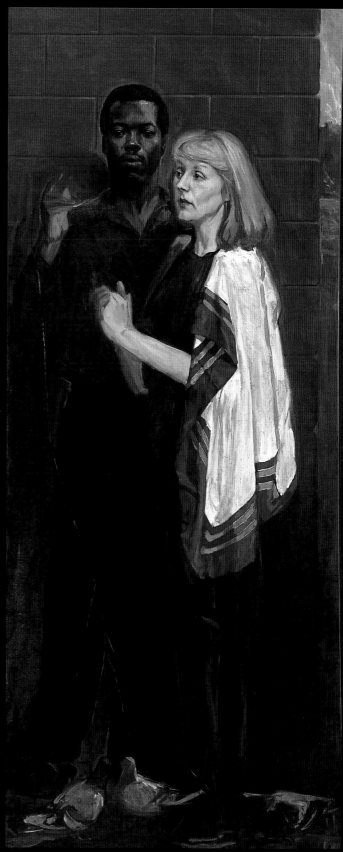

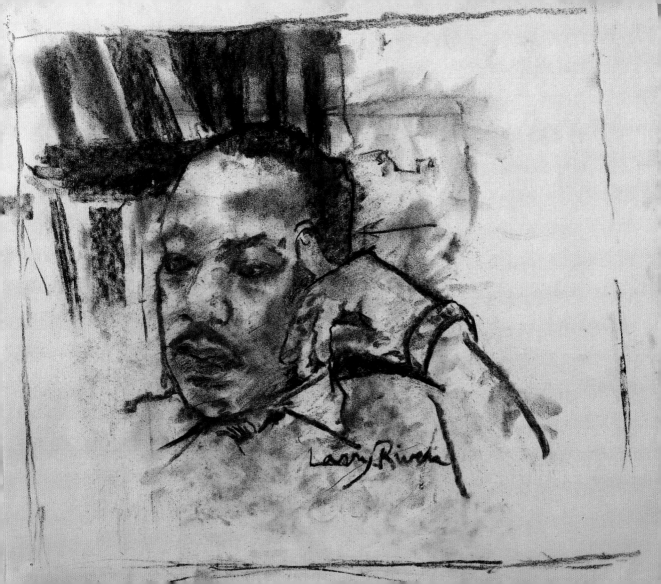

UPDATE ON MARTIN LUTHER KING, JR.,
AND THE BEST OF MY HEART

J U N E J O R D A N

I have not always loved Dr. King. In the sixties I could not understand his reaching beyond race to stand on principle. I could not understand, or support, his own example of "nonviolence".

There was so much I didn't know!

For instance, when Dr. King invoked "the Beloved Community" as an ideal, I thought he meant something simple-minded like the Bad Guys Stop the Bad Stuff and the Good Guys Then Forgive Them—for the sake of an okay coexistence. It took me a while to get past the "we" versus "they" way of looking at things. It took me a long time, absolutely, before I understood that "Beloved Community" means everybody is sacred. Nobody is excluded from that deliberate embrace.

But gradually, the political, daily, omnipotent success of Dr. King's leadership overcame my infantile eye-for-an-eye fantasy inclinations and a good deal of my willful ignorance as well.

I noticed that for Dr. King, "nonviolent" did not mean cowardly. I learned that the original concept of "nonviolence" comes from the Hindu practice of satyagraha, which translates as "firmness of truth", rather than yield and kneel.

And I noticed that Dr. King's commitment to equality and justice, per se, did not diminish, or confuse, my personal fight for these prerequisites to dignity and happiness. On the contrary, by enlarging his concern for Blackfolks to a concern for universal equality, Dr. King heightened the likelihood of equality in all of our lives. The more people you could hinge to the principle of equality, the more people you could rally together in that fight—on the basis of common self-interest.

I had a lot to learn!

I had opposed the U.S. war against Vietnam mainly because I opposed the draining of finite U.S. resources into weaponry and war. It was Dr. King's principled—and isolated—condemnation of that war that lifted me out of my prior, and mistaken, narrow-mindedness. Dr. King's impassioned analysis—that it was evil and racist to punish, poison, pulverize, and decimate another people, an innocent people, an Asian people of the Third World—infused a new moral level of energy into my political activity.

Dr. King budged me from the limiting perspectives of those days; as he insisted upon the sanctity of values and people I could neither see nor touch; as he taught and preached about connections that hold among suffering men and women everywhere—inside this country and throughout the world—I could not help but love him.

He pushed me to think and feel way beyond "myself".

I began to notice Americans who were neither black nor white, nor English-speaking.

I began to notice coincidental histories among these growing American diversities.

I noticed varieties of hell on earth following from the Gospel of White Supremacy.

I noticed an unbelievable developing crisis following from the Gospel of Efficiency and Maximum Profit.

I saw how national spokesmen (black and white alike) played the race card in order to blame and blind different groups victimized by the same enemies of white supremacist policies and corporate determination to eliminate the labor force. ASAP.

And every year since Dr. King's assassination in 1968, every year I have seen our deepening need for A Beloved Community composed of unemployment teachers and unemployment engineers, and teenage drop-outs, and Vietnamese-Americans, and Haitian refugees, and recent and old and wannabe immigrants of every description reaching their arms around this tenuous, muscled, embittered, faltering, miserly, violent, and gorgeous, and open, and resistent, and huge nation-state that is our America. Our need for Dr. King's Beloved Community—right here—becomes with every month, with every AT&T layoff of 40,000 workers and so forth, an imperative, collective shelter we must build and defend, or else give it up; give up that strangely American pursuit of happiness and justice.

And because I am able to remember this hero of astonishing courage and visionary compassion, I do love him now. I love Dr. King.

I have come to understand how the very fact of his presence and his achievements among us means that, without him, we are not hopeless. Without him, we are not helpless. Because he consecrated his life to the principles of equality and justice, we have become potentially, more powerful than the hatred that surrounds and seeks to divide us.

Because he showed us the value of our lives, we have become capable of saving them.

(OPPOSITE) MARTIN LUTHER KING I, 2001. LARRY RIVERS (1925-), CHARCOAL ON PAPER, 15" x 17", COLLECTION OF THE ARTIST, NEW YORK, NY

"I have come to understand how the very fact of his presence and his achievements among us means that, without him, we are not hopeless. Without him, we are not helpless. Because he consecrated his life to the principles of equality and justice, we have become, potentially, more powerful than the hatred that surrounds and seeks to divide us. Because he showed us the value of our lives, we have become capable of saving them."

— June Jordan

The Legacy of Martin Luther King Jr.

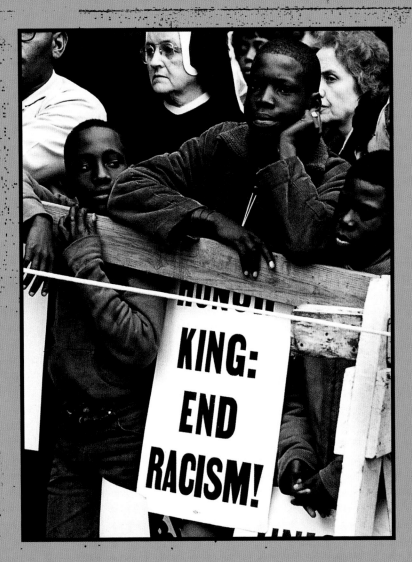

"If a man hasn't discovered something that he will die for, he isn't fit to live."

—MARTIN LUTHER KING, JR., 1963

On January 20, 1986 Martin Luther Kings' birthday was celebrated as a national holiday for the first time. Such celebrations are opportunities for civic education, introspection and remembrance. They remind us of who we are as Americans, and the values that we share. □ Dr. King's vision and poetic rhetoric brings us together as one people whether black or white, rich or poor. While the deeds of the Founding Fathers are reminders of the ideals of American democracy, the deeds of this modern day prophet are tangible evidence of democratic ideals yet to be achieved, and the need to narrow the distance between promise and reality in America. □ Dr. King's image of America is a modern retelling of the American dream, and his stature is that of a present day founding father—a hero whose writing and teaching inspires our collective identity. King's America is a utopian community in which racism is ended, justice is balanced, and all are free. As our national conscience, he continues to make us mindful of the times when we have trampled on the rights of others and failed to live up to the grand promises of the Declaration of Independence and the Constitution. The echoes of his voice give us the strength to work ever harder to secure our democracy. □ Since Dr. King's death, the impact of his message continues to resonate across the country through an outpouring of creative expression in response to the ideals to which Dr. King consecrated his life. In the Spirit of Martin explores the depth of these outward signs of inner values and beliefs, asking each of us to consider not only Martin Luther King's greatness and the cause for which he died, but also our own responsibility in creating a just and color-blind world. They are a lasting legacy of his life and the America he helped create for us all. □ "By idolizing those whom we honor", said noted black educator Charles Willie, "we do a disservice both to them and ourselves...By exalting the accomplishments of Martin Luther King, Jr. into a legendary tale that is annually told, we fail to recognize his humanity...we fail to realize that we could go and do likewise". □ In each of us is the courage to stand up for that which we believe, to do that which is right, and to love one another. □ The art in this book represents a small portion of the hundreds of works created to commemorate the memory of Dr. Martin Luther King, Jr., and in some way to respond to the immense impact of his life and message.

(PREVIOUS PAGE) AT THE MEMORIAL MARCH FOR KING, MEMPHIS, APRIL 8, 1968, ROBERT SENGSTACKE (1943-), BLACK AND WHITE PHOTOGRAPH, 10″ X 8″. COLLECTION OF THE ARTIST, CHICAGO, IL (OPPOSITE) MARTIN LUTHER KING (LOVE), 1969, ELIJAH PIERCE (1892-1984), CARVED AND PAINTED WOOD RELIEF, 19″ X 16″, COLLECTION OF JILL AND SHELDON BONOVITZ

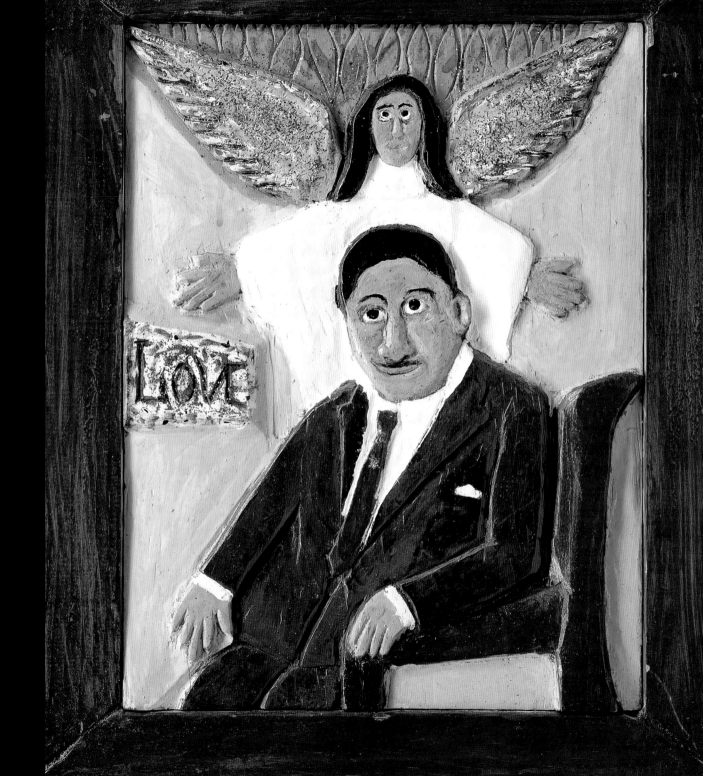

RAINBOW

little black boys
and little black girls
of poverty
let your dreams
rise high above you
fly 'em high
high above Beaufort S.C.
high above Bed. Sty.
high above Mississippi
plant them
where no rats
or roaches
can climb
plant them
on clouds
with warm winters
cool and breezy summers

plant them
beyond
the dream robber's reach
tuck them deep
in your hearts
away
from those
who would
discourage you
let your dreams
fly high above you
fly 'em high
and study
and work
and study
and work

LISTERVELT MIDDLETON
FROM FATBACK & CAVIAR, 1981
A BOOK OF POEMS

📖 (Above) For Listervelt Middleton from his poem Rainbow, 1995, Leo Twiggs (1934-), batik, 15″ x 15″, Private Collection

📖 (Opposite) Black and White Love from the Decade Portfolio, 1971, Robert Indiana (1928-), silkscreen on paper, 32″ x 39″, Portland Museum of Art, Portland, ME

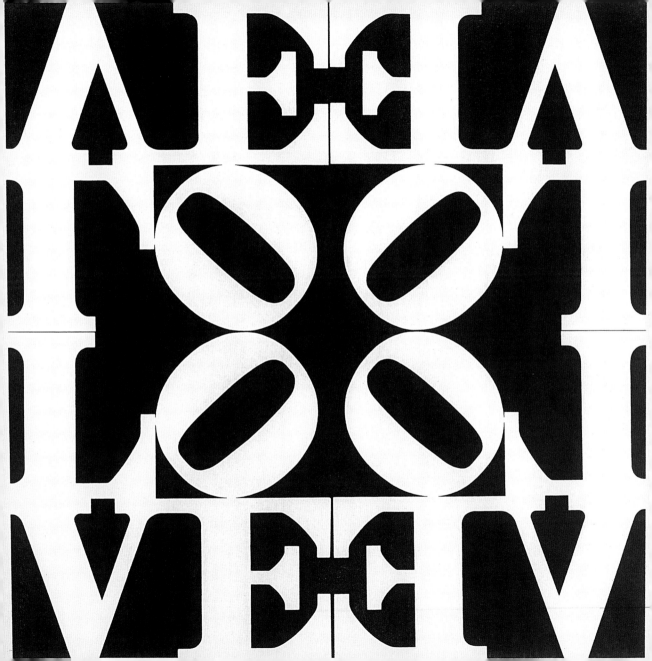

"Martin Luther King, Jr. gave us back our heritage. He gave us back our homeland; the bones and the dust of our ancestors, who may now sleep within our caring and our hearing...He gave us continuity of place, without which community is ephemeral. He gave us home."
—Alice Walker, In Search of Our Mother's Gardens, 1983

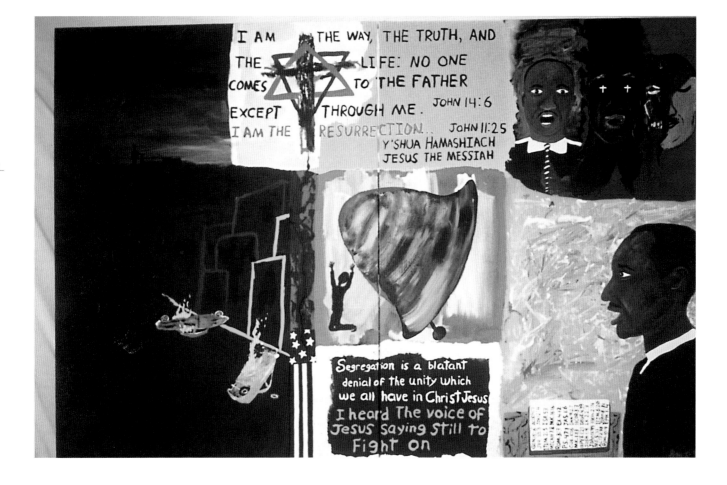

(Above) The Inspiration, 1999, Reginald K. Gee (1964-), acrylic on canvas, 40″ x 60″. Courtesy of Joyce R. Furhman and Joshua R. Platt, Art Search, Clifton, NJ

(Opposite) The Freedom Cat and the Hard Tin Men, 1990, Thornton Dial (1928-), enamel, wood and tin on wood, 71″ x 48″ x 3″. Collection of the Honorable John Lewis

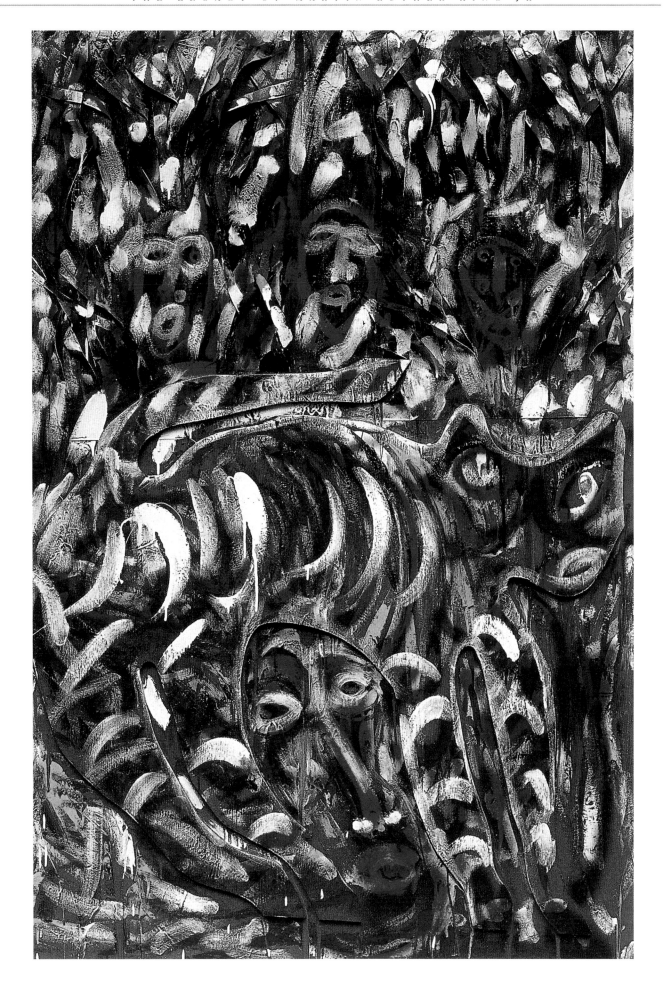

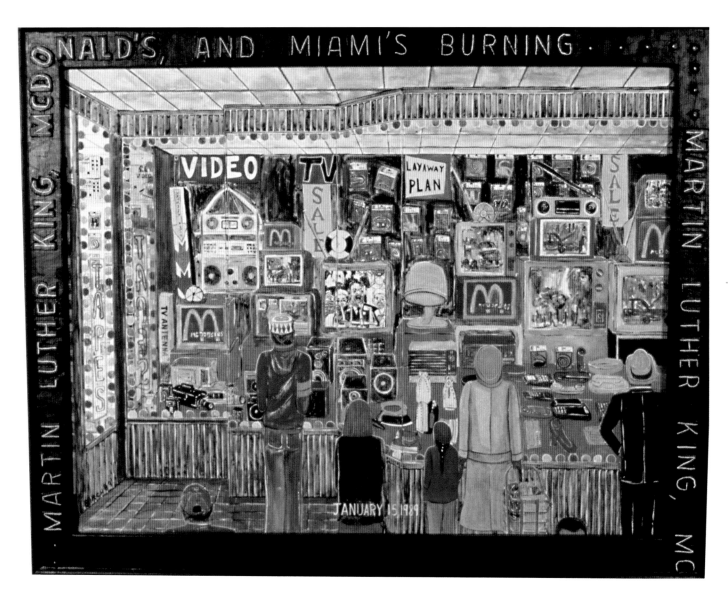

(Opposite) East 126th Street, Harlem, 1977, Idelle Weber (1932-), 63-1/2″ x 50″. oil on linen, Boise Art Museum, Boise, ID
(Above) Martin Luther King, McDonald's and Miami's Burning, 1989, Willie Birch (1942-),
mixed media with papier mache frame, 43-1/2″ x 56-1/2″ x 1-3/4″. Courtesy of Arthur Roger Gallery, New Orleans, LA

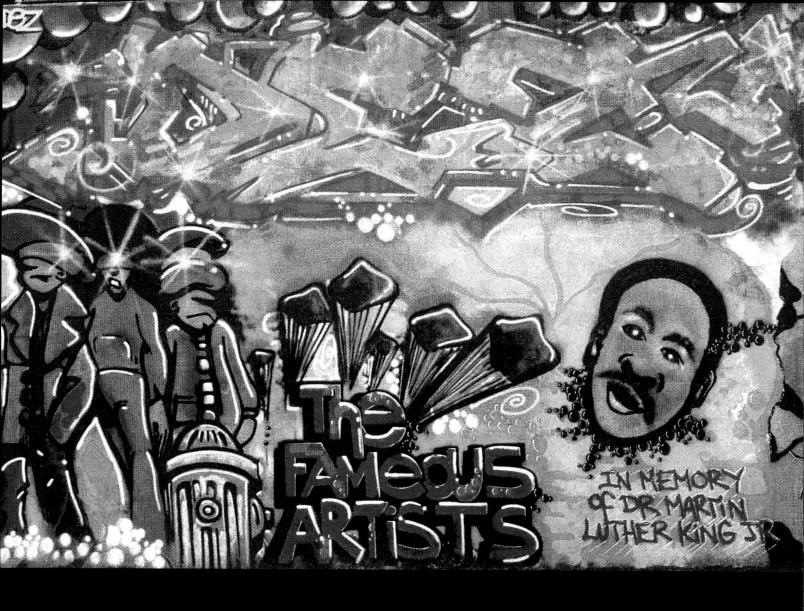

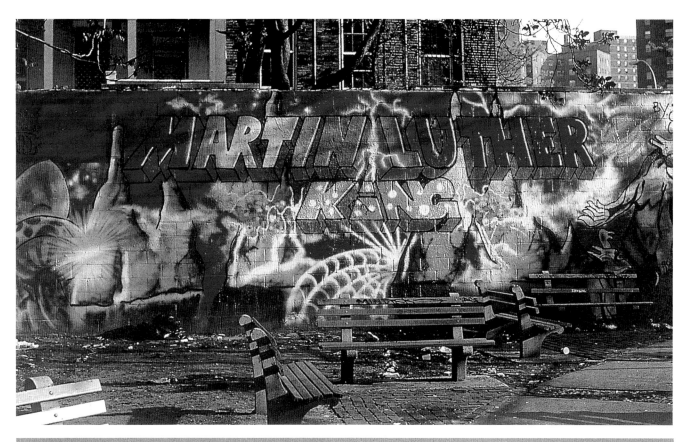

(Opposite) In Memory of Dr. Martin Luther King, Jr., D.E. Z., spraycan mural, Graffiti Hall of Fame, New York, NY

(Top) Martin Luther King, Jr., 1984, LAC, CEL & LED, spraycan mural, New York, NY

(Bottom) The Wall of Dignity, Edward Bailey, spraycan mural, New York, NY

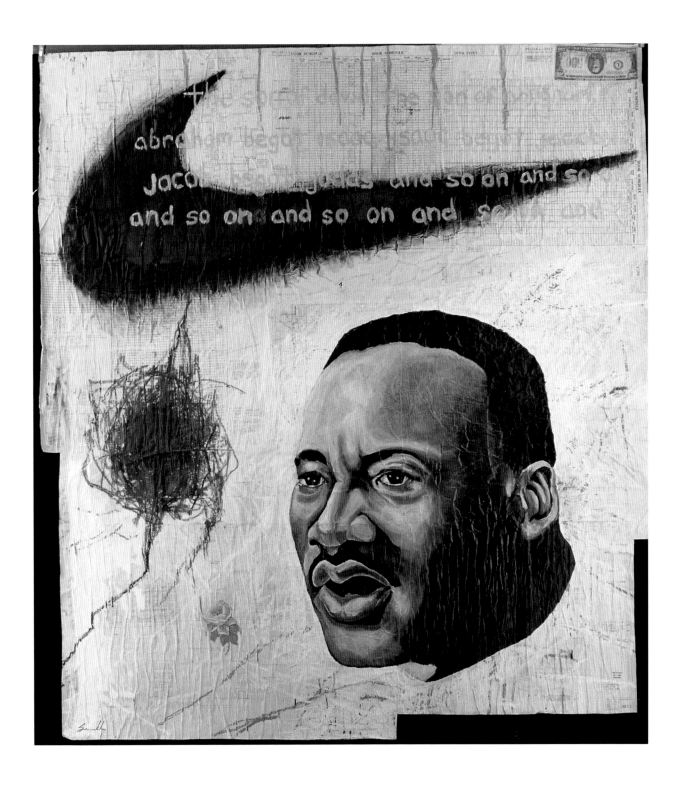

(Above) The Only Begotten Son, 1997-98, Travis Sommerville (1963-), mixed media on architectural paper, 98″ x 84″,

Courtesy of Daniel Dodt and Linda Blacketer Collection and Catherine Clark Gallery, San Francisco, CA

📖 (Opposite) M. L. King, 1998, Annette Lemieux (1957-), mixed media, 120″ x 60″, Collection of the artist

Mammoth pro
ductive facil
ities with comp
uter minds, cit
ies that engulf
the landscape a
nd pierce the c
louds, planes
that almost
outrace tim
e - these are awesome, but they can
not be spiritually inspiring. Nothin
g in our glittering technology can ra
ise man to new heights, because mater
ial growth has been made an end in it
self, and, in the absence of moral pu
rpose, man himself becomes smaller as
the works of man become bigger. Garg
antuan industry and government, woven
into an intricate computerized mechan
ism, leave the person outside. The s
ense of participation is lost, the fe
eling that ordinary individuals influ
ence important decisions vanishes, an
d man becomes separated and diminishe
d. When an individual is no longer a
true participant, when he no longer f
eels a sense of responsibility to h
is society, the content of democr
acy is emptied. When culture i
s degraded and vulgarity enth
roned, when the social system
does not build security but i
nduces peril, inexorably the
individual is impelled to pul
l away from a soulless societ
y. This process produces ali
enation - perhaps the most pe
rvasive and insidious develop
ment in contemporary society.
Mammoth productive facilities
with computer minds, cities t
hat engulf the landscape and
pierce the clouds, planes tha
t almost outrace time - these
are awesome, but they cannot
be spiritually inspiring. No
thing in our glittering techn
ology can raise man to new he
ights, because material growt
h has been made an end in its
elf, and, in the absence of m
oral purpose, man himself bec
omes smaller as the works of
man become bigger. Gargantua

📖 (Above) Homage to Martin Luther King, 1968, Mark di Suvero (1933-), painted metal and spring,
41″ x 72″ x 48″. Hirschhorn Museum and Sculpture Garden, Smithsonian Institution, Washington, DC
📖 (Opposite) The Civil Rights Memorial, Dedicated November 5, 1989, Maya Lin (1959-) polished granite wall with circular fountain
9′ x 40′ (12′ in diameter). Southern Poverty Law Center, Montgomery, AL

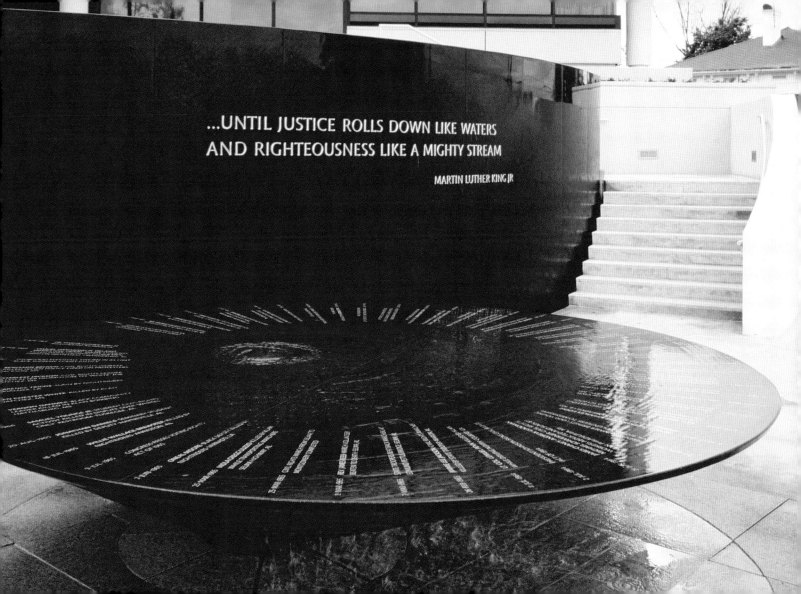

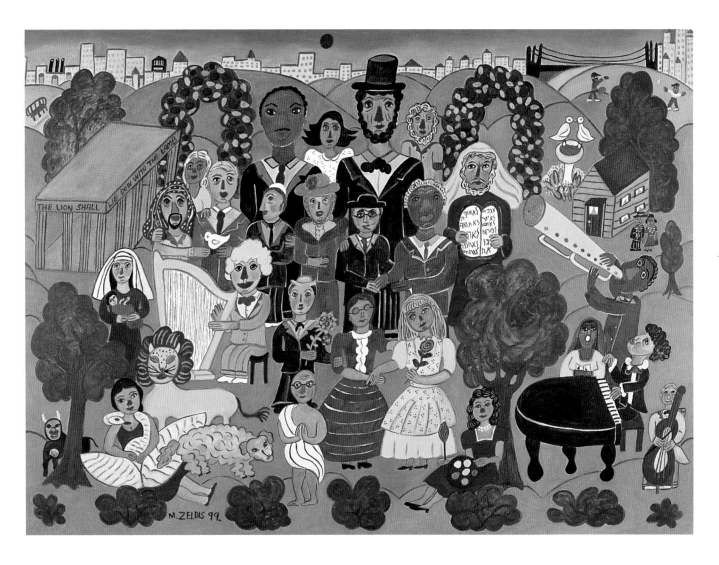

(Above) Peaceable Kingdom, 1999, Malcah Zeldis (1932-), oil on canvas, 30″x 40″. Collection of the artist, New York, NY

(Opposite) Memorial to Martin Luther King, Jr., 1987, Alexander A. Maldonado (1901-89), Oil on canvas, 22″ x 28″. Courtesy of The Ames Gallery, Berkeley, CA

"Dr. King dreamed for us and taught us how to dream for ourselves. He taught us to wrap our dreams in action and bring them out of the realm of hope into the realm of possibility. He taught us how to recognize possibility as the footstep of a dream. Then he showed us how to walk in those footsteps until we could stand at any front door, ride at the front of any bus, train or plane and walk in any university, business or church and expect a seat, expect a position, expect an education. Dr. King taught us to dream big and then he taught us how to boldly step forward and make our dreams a reality."

—Malaika Favorite

202

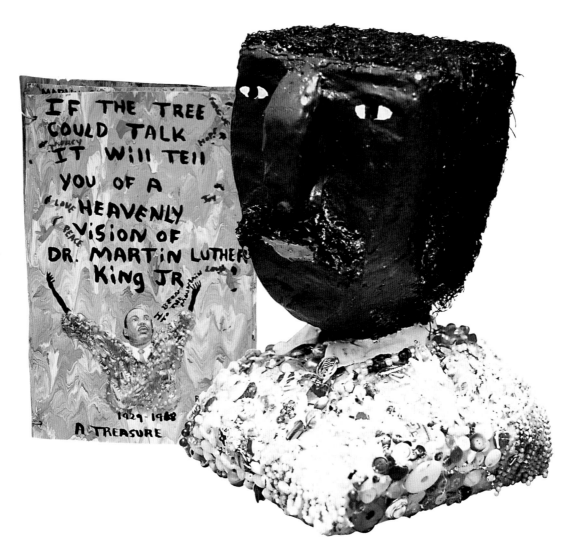

(Above) Martin Luther King (with tin book), 1999, Mary Louise Proctor (1960-), carved wood and tin, 16″ x 11″. Collection of Gerrell Fae Stevens, Tim Denesha and Andrew Morrison

(Opposite top) Georgia Voter, 2000, Malaika Favorite (1949-), mixed media on tin, 18″ x 14″. Courtesy of Stella Jones Gallery, New Orleans, LA

(Opposite bottom) Dream Big, 2000, Malaika Favorite (1949-), mixed media on tin, 16″ x 14″. Courtesy of Stella Jones Gallery, New Orleans, LA

Vote Because
of All the hard
work Someone
else did to
give you the

right to

Vote

Vote because Martin
died for your rights.

Dream

I HAVE A DREAM

I HAVE A DREAM

Big

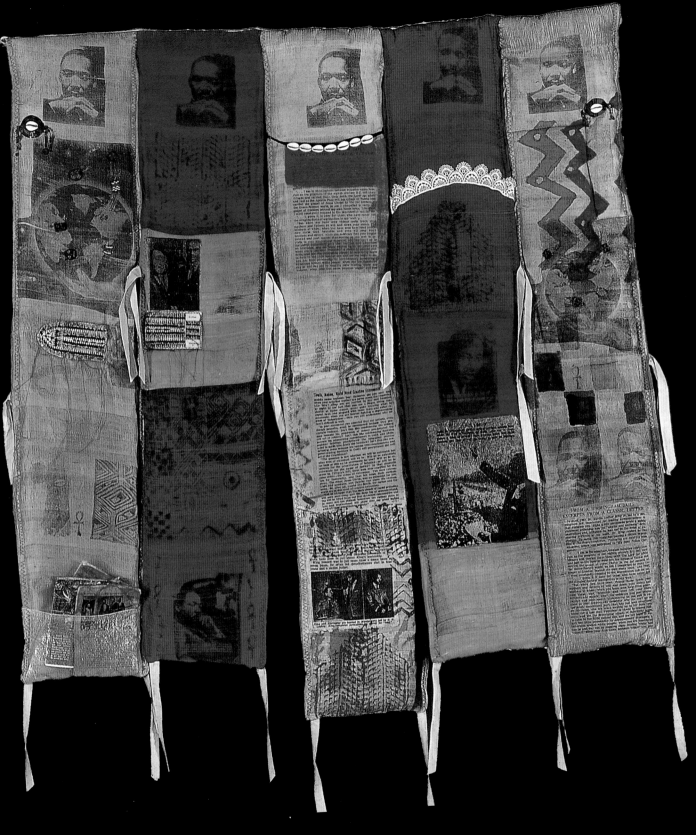

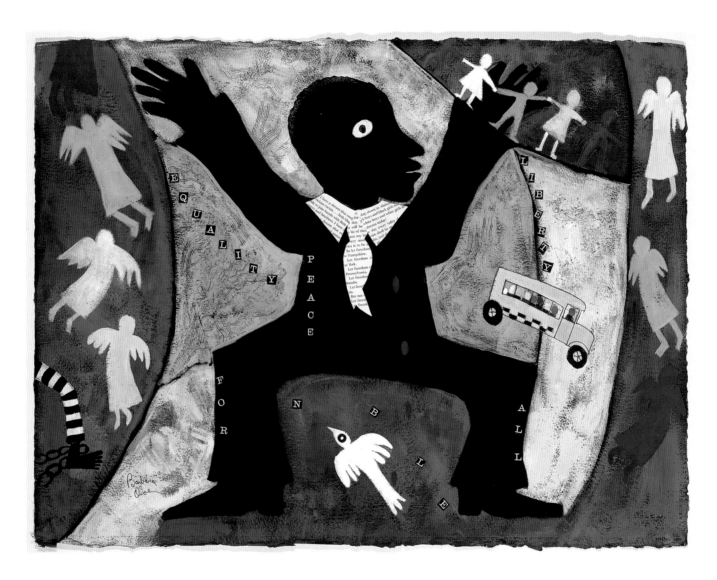

(Opposite) From a Birmingham Jail: MLK, 1996, L'Merchie Frazier (1951-), silk photo transfer, dyes, beads, 40″ x 42″.

Smithsonian Institution, Washington, DC. Photograph courtesy of Hakim Raquib

(Above) I Have a Dream, 1999, Barbara Olsen (1935-), mixed media on paper, 22″ x 30″. Collection of the artist, Chagrin Falls, OH

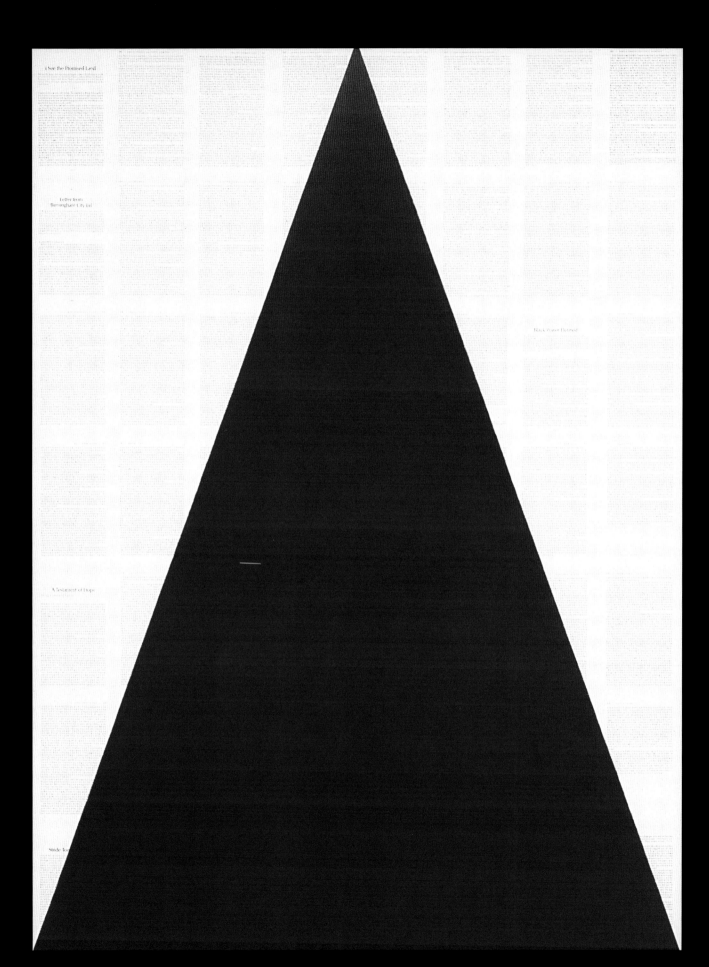

I See the Promised Land

Letter from
Birmingham City Jail

A Testament of Hope

Stride Toward

Black Power Defined

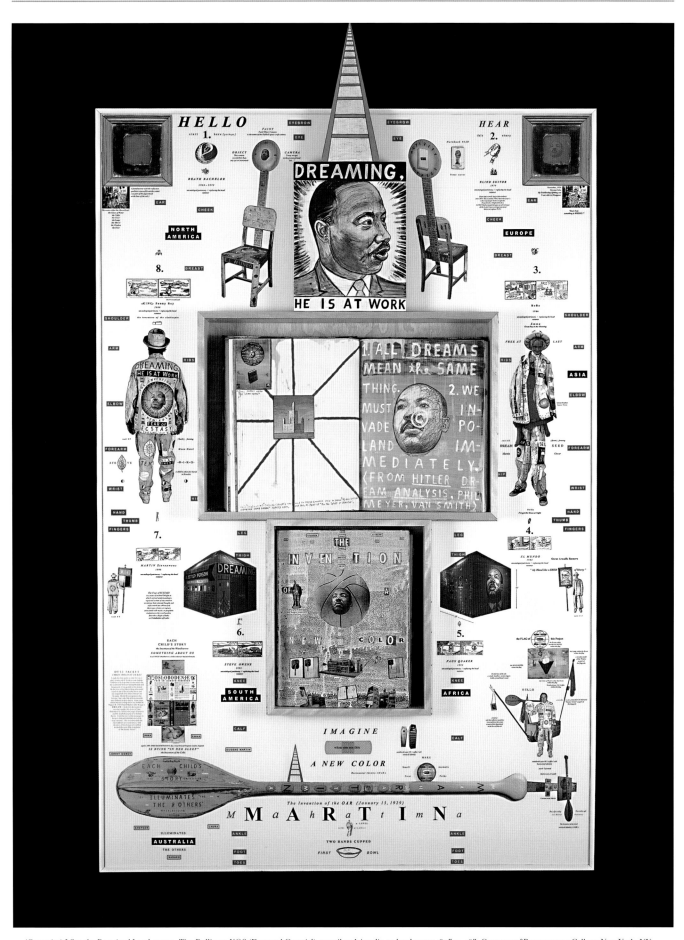

(Opposite) I See the Promised Land, 2000, Tim Rollins + KOS (Emanuel Carvajal), pencil and Acrylic on bookpages, 62″ x 46″. Courtesy of Baumgartner Gallery, New York, NY

(Above) Daily Painting with Log Books, 2001, David Dunlap (1940-), mixed media, 67-1/2″ x 42″. Collection of Nelle Owens Museum of Incandescent Light, Sweet Springs, MO

207

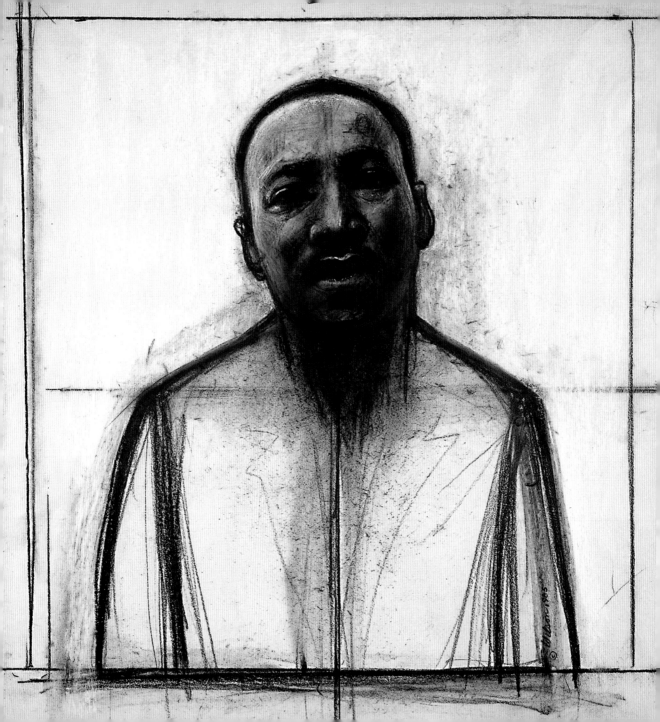

Martin Luther King Jr.

A MAN WENT FORTH WITH GIFTS.

HE WAS A PROSE POEM.
HE WAS A TRAGIC GRACE.
HE WAS A WARM MUSIC.

HE TRIED TO HEAL THE VIVID VOLCANOES.
HIS ASHES ARE
READING THE WORLD.

HIS DREAM STILL WISHES TO ANOINT
THE BARRICADES OF FAITH AND OF CONTROL.

HIS WORD STILL BURNS THE CENTER OF THE SUN,
ABOVE THE THOUSANDS AND THE
HUNDRED THOUSANDS.

THE WORD WAS JUSTICE. IT WAS SPOKEN.

SO IT SHALL BE SPOKEN.
SO IT SHALL BE DONE.

—GWENDOLYN BROOKS—

(OPPOSITE) STUDY FOR SCULPTURE OF MARTIN LUTHER KING JR., 1985, JOHN WILSON (1922-), CHARCOAL AND PASTEL, 20-13/16″ x 21-15/16″,

MUSEUM OF FINE ARTS, BOSTON, MA © JOHN WILSON/LICENSED BY VAGA, NEW YORK, NY

A GLOSSARY OF PEOPLE, PLACES AND EVENTS

REVEREND RALPH DAVID ABERNATHY: A clergyman and civil rights leader, born in Linden, Alabama in 1926. He was ordained a Baptist minister in 1948, received a B.S. degree in mathematics from Alabama State College in 1950 and an M.A. degree in sociology from Atlanta University in 1951. Later that year, he became pastor of the First Baptist Church, Montgomery, Alabama. Together with Martin Luther King, Jr., he founded the Montgomery Improvement Association in 1955 and the Southern Christian Leadership Conference (SCLC) in 1957, organizations devoted to achieving equality for blacks in the United States. Frequently jailed with King for acts of civil disobedience, Abernathy was King's closest associate during the civil rights campaigns of the late 1950s and early '60s. When King was assassinated in April 1968, Abernathy succeeded him as president of SCLC. As such, he led a march in support of a strike by Memphis, Tennessee, sanitation workers on April 8, 1968, and led the Poor People's Campaign march and encampment in Washington, D.C., in May 1968. He remained president of the SCLC until 1977. His autobiography, *And the Walls Came Tumbling Down* (1989), discusses his role in the Civil Rights Movement. He died in 1990.

ALBANY, GEORGIA: The location of the "Albany Movement" of October 1961 to August 1962, whose leaders wanted to maintain pressure on the government until all forms of racial discrimination were dismantled. They conducted marches, sit-ins, and other protests to achieve voting rights and desegregation. These demonstrations were the precursor to civil rights events in Birmingham, Alabama.

AMENDMENTS TO THE U.S. CONSTITUTION:

AMENDMENT 13–PASSED BY CONGRESS, JANUARY 31, 1865 AND RATIFIED DECEMBER 6, 1865. Neither slavery nor involuntary servitude, except as a punishment for crime whereof the party shall have been duly convicted, shall exist within the United States, or any place subject to their jurisdiction.

AMENDMENT 14–PASSED BY CONGRESS JUNE 13, 1866 AND RATIFIED JULY 9, 1868. All persons born or naturalized in the United States, and subject to the jurisdiction thereof, are citizens of the United States and of the State wherein they reside. No State shall make or enforce any law which shall abridge the privileges or immunities of citizens of the United States; nor shall any State deprive any person of life, liberty, or property, without due process of law; nor deny to any person within its jurisdiction the equal protection of the laws.

AMENDMENT 15–PASSED BY CONGRESS FEBRUARY 26, 1869 AND RATIFIED FEBRUARY 3, 1870. The right of the citizens of the United States to vote shall not be denied or abridged by the United States or by any State on account of race, color, or previous condition of servitude.

AMISTAD: The Amistad Revolt of 1839 was a shipboard uprising of 49 Africans that took place off the coast of Cuba. The participants who fought for their freedom set off an intense legal, political and popular debate about slavery in America when their schooner "Amistad" ("Friendship") wound up in U.S. waters. Their plight caught the attention of American abolitionists, including the former President John Quincy Adams, who mounted a legal defense on the Africans' behalf. In March, 1841, the United States Supreme Court upheld the freedom the Africans had claimed for themselves and in January 1842, the 35 Amistad Africans who had survived the ordeal returned to their homelands.

ANNISTON, ALABAMA: The town where the first bus of the Freedom Riders was burned in May, 1961. A mob brutally beat the Riders upon their arrival in Birmingham where they were arrested for breaking segregation laws and served time in Parchman Penitentiary.

ELLA BAKER: Born in 1903 in Norfolk, Virginia, Baker graduated from Shaw University in North Carolina and then moved to New York City where she soon became a social justice activist through her work with the Young Negroes Cooperative League, the WPA, and the NAACP. She returned to the South and became the first executive director of the Southern Christian Leadership Conference in Atlanta, Georgia. She was instrumental in unifying the scattered student sit-in groups into a coherent national student movement called the Student Nonviolent Coordinating Committee (SNCC). She also helped form the Council of Federated Organizations (COFO) and the Mississippi Freedom Democratic Party (MFDP). She later returned to New York City and remained active in the fight for human rights until her death in 1986.

JAMES BALDWIN: Born in Harlem in 1924, Baldwin came of age as legal segregation in the United States was ending. His work reflects the rise of the Civil Rights Movement and his writings are known for their honest, perceptive, and painful descriptions of the effects of racism on both black and white Americans. Some of his best known novels include: *Go Tell It On The Mountain* (1953); *Notes of a Native Son* (1955); *Tell Me How Long The Train's Been Gone* (1968); and *If Beale Street Could Talk* (1974). He was a member of CORE's national advisory board and remained a social activist and writer until his death in 1987.

BENJAMIN BANNEKER: Born in 1731 in Maryland, Banneker was a self-taught astronomer and mathematician as well as a tobacco farmer. He is best known for his almanacs of ephemerides-tables that give the positions of the planets and stars for each day of the year. They were published from 1792-1797 by northern abolitionist societies and President Jefferson's praise of his work was used as part of an antislavery campaign. He died in 1806 in relative obscurity.

DAISY BATES: Along with her husband, L.C. Bates, she was the publisher of the Arkansas State Press, the local black newspaper. She was the president of the Arkansas NAACP and served as the liaison between the "Little Rock Nine" (children) and the School Board of Central High in Little Rock, Arkansas in 1957.

DR. RALPH BUNCHE: Dr. Bunche was born in 1904 and educated at UCLA and Harvard. He taught political science at Howard University and wrote *A World View of Race* (1937.) Bunche was the first black person to win the Nobel Peace Prize, which was awarded to him in 1950 for his successful mediation of the Arab-Israeli conflict at the time of the founding of Israel. Subsequently he became Undersecretary of the United Nations, a post he held from 1955-1971. He died shortly after his retirement from the U.N. in 1971.

STOKELY CARMICHAEL: Born in Trinidad, Carmichael formed his political beliefs early, attending Howard University in favor of scholarships offered by white universities. After graduating in 1964, he began work on voter registration in Mississippi with the Student Nonviolent Coordinating Committee which he would later lead. Carmichael's activities, and those of other volunteers in Mississippi, led to the formation of the Lowndes County Freedom Organization, a forerunner of the Black Panther Party. He supported the liberation of Cuba, and was a leading figure in the global pan-Africanist movement at the time of his death in Guinea, West Africa, at the age of 57.

SEPTIMA CLARK: She was a major grassroots organizer for the Civil Rights Movement. In 1956, she became the director of workshops at the Highlander Folk School in Monteagle, Tennessee--the South's leading integrationist study center. She became the supervisor of SCLC's teacher training program and taught citizenship education classes in the late 1950s. One of her best known students was Rosa Parks. In 1960, she organized the first conference of student activists at the Highlander Folk School.

CROZER THEOLOGICAL SEMINARY: In 1867, during the tumultuous years following the Civil War, a Baptist industrialist named John P. Crozer, donated the building and land in Chester, Pennsylvania, for the Crozer Theological Seminary. Dr. Martin Luther King, Jr. was a student from 1948-1951. In 1970, the institution relocated to Rochester, New York, to merge with the ecumenical Colgate-Rochester Divinity School.

CONGRESS OF RACIAL EQUALITY (CORE): An interracial group that was formed to fight for black rights which was founded on a local level in Chicago in 1942 and became a national organization the following year. As the first black protest organization to use the techniques of nonviolent protest and passive resistance, CORE pioneered the sit-in and first used it in 1943 to integrate a Chicago restaurant. CORE also started the "Freedom Rides" in 1961 to protest segregation in interstate transportation facilities.

DEXTER AVENUE BAPTIST CHURCH: In 1954, the Reverend Martin Luther King, Jr. was installed by his father as the 20th pastor of this Montgomery, Alabama church.

FREDERICK DOUGLASS: He was born a slave in 1817 in Maryland and worked in a Baltimore household as a young boy where he was surreptitiously taught to read by the mistress of the house. In 1838, he escaped to Bedford, New York. As a fugitive slave, he addressed the Massachusetts Anti-Slavery Society and during the early 1840s represented the abolitionist group by giving speeches about the severity of slavery in America as well as abroad. He was the founder and publisher of the aboli-

tionist newspaper, the *North Star*, for 17 years. After the Civil War, he served in diplomatic positions for the U.S. government in Santo Domingo, Washington, D.C., and Haiti. He continued to fight against segregation until his death in 1895.

W.E.B. DUBOIS: He was born William Edward Burghardt DuBois in 1868 in Massachusetts. At the age of 15 he was the first black student to graduate from the Great Barrington High School and at 27 the first black to receive a Ph.D. from Harvard. He taught at Wilberforce University in Ohio and at the University of Atlanta in Georgia. His book *Souls of the Black Folk* (1903) was a landmark examination of African American history and the emergence of social change. His fundamental belief that political and social equality should be an immediate priority for black Americans gave him a platform for his frequent protests. He co-founded the Niagara Movement with William Monroe Trotter, which was the precursor to DuBois' more notable creation of the NAACP. As the editor of the NAACP's magazine *The Crisis*, he attempted to inform citizens about racial progress. In 1961, he became a member of the Communist Party and in 1963, he renounced his American citizenship to become a citizen of Ghana. He died on August 27, 1963, one day before the March on Washington.

EBENEZAR BAPTIST CHURCH: Located in Atlanta, Georgia, this church was founded in 1895 by the Reverend Adam Daniel Williams, Martin Luther King, Jr.'s maternal grandfather. Early on, the Rev. Williams used the pulpit and the church to gain rights for Negroes in Atlanta. In 1932, the Reverend Martin Luther King, Sr. became pastor of the church and continued to build it into one of the most important and influential churches in the city. In 1948, the Reverend Martin Luther King, Jr. was ordained to the Baptist ministry here and in 1960, became co-pastor with his father.

JAMES FARMER: Born in Marshall, Texas, in 1920, he was the son of a college professor who was the nation's first black to earn a doctoral degree. As a divinity graduate student in 1942 at the University of Chicago, he formed the Congress of Racial Equality (CORE) with Bayard Rustin and a group of students. He served as the national director of CORE from 1961-1966 and organized the first "Freedom Ride" in 1961. He left CORE after disagreeing with its growing emphasis on black separatism because he believed that integration into mainstream society should be the goal of blacks in the United States. He later became the assistant U.S. secretary of Health, Education, and Welfare in the Nixon administration from 1968-1970; the executive director of the Coalition of American Public Employees from 1975-1981; and a college professor at Virginia State University.

JAMES FORMAN: Born in 1928, he spent most of his childhood with his grandmother in rural Mississippi and in the ghettos of Chicago with his parents. He became a teacher and a journalist who worked for the *Chicago Defender*, eventually returning to the south to cover the growing Civil Rights Movement. He was the executive secretary and director of International Affairs of SNCC in the 1960s. He served as an adjunct professor of Anthropology at American University and president of the Unemployment and Poverty Action Committee.

TIMOTHY THOMAS FORTUNE: Born in 1856 to slaves in Jackson County, Florida, T. Thomas Fortune was editor and founder of the *New York Age*, the most influential black newspaper of its time. He was a political leader who helped to establish the National Afro-American League in 1890, and the National Afro-American Council in 1898–forerunners of modern civil rights organizations. In his book, *Black and White: Land and Politics in the South*, he strongly favored full equality and opposed any form of discrimination. He died in 1928.

FREEDOM RIDES: Organized in May, 1961 by James Farmer of CORE, to test compliance with the Supreme Court ruling to integrate interstate buses and public facilities, a group of blacks and whites chose to ride Greyhound buses from Washington, D.C. to New Orleans, Louisiana. During their first attempt, one bus was burned outside of Anniston, Alabama; they were beaten in Birmingham, Alabama; and then arrested and jailed for breaking segregation laws. On a second ride a week later, they were beaten by a mob at a Montgomery bus terminal and federal marshals were sent in to restore order. A few days later, the "Freedom Riders" traveled from Montgomery to Jackson, Mississippi, escorted by National Guardsmen. In Jackson, they were arrested for breaking segregation laws and sent to jail. The original riders never reached their destination of New Orleans, but other volunteers conducted "Freedom Rides" throughout the South that year. Their actions precipitated U.S. Attorney General Robert Kennedy's request to the Interstate Commerce Commission to issue regulations requiring the full desegregation of buses and terminal facilities engaged in interstate travel.

MAHATMA (MOHANDAS K.) GANDHI: In India, Gandhi led a movement beginning in 1915 to win independence from Great Britain through nonviolent protest. He disobeyed

British laws, led the Indian masses in peaceful demonstrations and was frequently jailed. Over the years he attracted the support of the majority of Indians, and by the 1940s world opinion had turned against the British, who finally granted independence to India in 1947. Martin Luther King believed that Gandhi's ideas and use of nonviolent social protest were the only way American blacks could win the full rights of citizenship.

HENRY HIGHLAND GARNET: He was born in 1815 as a slave in Kent County, Maryland. He escaped in 1824 and was educated at the Oneida Institute in Whitesboro, New York. He was an eloquent speaker, but his radicalism (particularly expressed in a speech he made in Buffalo in 1843, in which he called upon slaves to rise and slay their masters) caused his influence to decline. He was opposed and superseded in leadership by the more moderate Frederick Douglass. Garnet served as a Presbyterian pastor in Troy, New York, New York City and Washington, D.C. In 1881, he was appointed minister to Liberia, but he died two months after his arrival there in 1882.

FANNIE LOU HAMER: Born in 1917, as the twentieth child of Mississippi sharecroppers, Hamer went on to become a grassroots Civil Rights leader. She was the leading Mississippi Freedom Democratic Party delegate in 1964 who testified to the Democratic Party Credentials Committee—and to several million Americans watching the live television coverage of the proceedings. She eloquently spoke about her attempts to become a registered voter in the Mississippi Delta, her subsequent firing from her job, her family's eviction from their home, and her torture in a local jail. "Is this America, the land of the free and the home of brave, where we are threatened daily because we want to live as decent human beings?" Mrs. Hamer asked. She remained a strong voice in southern politics until her death in 1977.

HOPWOOD V. TEXAS: A 1996 case in which the U.S. Fifth Circuit Court of Appeals invalidated a University of Texas Law School admission policy that included race among its criteria for acceptance. The Court held that the practice of providing preferential treatment to minorities in a public university's admissions policy was repugnant to the Constitution. Advocates of affirmative action fear that the decision handed down by the appeals court is the beginning of the end of affirmative action programs. The Hopwood ruling has forced universities to explore alternative ways to diversify their student bodies.

REVEREND GEORGE D. KELSEY: He was born in 1910 in Columbus, Georgia, graduated from Morehouse College in 1928 and later received a Ph.D. from Yale University. He was a professor of religion and philosophy at Morehouse College and Drew University. Kelsey was one of Martin Luther King Jr.'s favorite professors, as well as a mentor who encouraged Dr. King to become a minister. Dr. Kelsey wrote *Racism and the Christian Understanding of Man* (1965) and the book's definition of racism was used by many leaders of the Civil Rights Movement in the 1960s. He died in 1996.

JAMES LAWSON: He began his involvement in the Civil Rights Movement as a divinity student at Vanderbilt University and was active in the Fellowship of Reconciliation and the Nashville Student Movement (later organized into SNCC), which promoted Gandhian techniques of passive resistance. He later served as the executive director of CORE.

TOUSSAINT L'OVERTURE: When the National Assembly of France abolished slavery in its colonies through the "Declaration of the Rights of Man", L'Overture became the leader of a rebellion (backed by France) against Spanish and British forces to free slaves on the island of Santo Domingo. When victory was achieved he became a general of the French colony, but continued to fight to create an independent state. In 1802, Napoleon Bonaparte imprisoned L'Overture, but the island's struggle for independence would be won in 1804 when it became the new nation of Haiti.

REVEREND JOSEPH E. LOWERY: He was born in 1925 and raised in Huntsville, Alabama. After receiving a divinity degree, he entered the ministry of the United Methodist Church and was editor of a small black Birmingham, Alabama newspaper, *The Informer*. He has served the church for over 45 years in Mobile, Nashville, Birmingham and Atlanta. Lowery became the vice-president of the newly created SCLC in 1957, became chairman of the board in 1967 and served as president from 1977-1997. His dedicated focus has been not only on domestic and international civil rights but also on creating housing for poor and elderly blacks and the preservation of black colleges and universities in America.

BENJAMIN E. MAYS: Born in 1894, Mays was a Baptist minister and educator who was president of Morehouse College in Atlanta, Georgia, from 1940 to 1967. He was an important mentor to Martin Luther King, Jr., who graduated from the black college in 1948. As a theologian, Mays held the strong belief that racial segregation was morally indefensible. He died in 1984.

MOREHOUSE COLLEGE: In 1867, Augusta Institute was established in the basement of Springfield Baptist Church in Augusta, Georgia. Founded in 1787, Springfield Baptist is the oldest independent African American church in the United States. The school's primary purpose was to prepare black men for the ministry and teaching. Today, Augusta Institute is Morehouse College and enjoys an international reputation for producing leaders who have influenced national and world history. Dr. Martin Luther King, Jr. graduated from Morehouse College in 1948.

NATIONAL ASSOCIATION FOR THE ADVANCEMENT OF COLORED PEOPLE (NAACP): Founded in Febuary 1909 by a group of blacks and whites including Mary White Overton, W.E. B. DuBois, and William English Walling, the NAACP's goal was to achieve absolute political and social equality for African Americans. The founders agreed to use every available means to publicize the neglected issues of civil and political equality for African Americans. As a leading civil rights organization, the NAACP continues its mission to achieve equal citizenship rights through peaceful and lawful means.

DIANE NASH: In 1961, she was an 18-year-old college student at Fisk University and a SNCC leader in Nashville, Tennessee. As a veteran organizer of lunch counter sit-ins, she organized and coordinated students to take the places of original and injured Freedom Riders. As a direct result of her efforts, the "Freedom Rides" continued throughout the summer all over the South. The SCLC hired her in 1963 to organize students in Birmingham, Alabama.

REINHOLD NIEBUHR: He was born in 1892 in Wright City, Missouri. Niebuhr graduated from the Yale Divinity School and served as pastor of Bethel Evangelical Church in Detroit. In 1928, he began teaching at Union Theological Seminary until his retirement in 1960. As a theologian, political activist and Socialist, he urged clerical interest in social reforms as expressed in his books *Moral Man and Society* (1932), *Christianity and Power Politics* (1940), and *The Nature and Destiny of Man* (1941-1943). In his later works, such as *Faith and History* (1949), Niebuhr dropped much of his social radicalism and preached "conservative realism" arguing for balances of interests. He died in 1971.

ROSA PARKS: Rosa Parks achieved a place in history as the catalyst in the Montgomery Bus Boycott, a public confrontation which brought Martin Luther King, Jr. to national attention. On December 1, 1955, Mrs. Parks boarded a bus in Montgomery, Alabama, took a seat in a section reserved for whites and refused to move. Her action was not taken at the request of civil rights groups, but her individual effort and her arrest triggered a boycott of the city's bus lines. Martin Luther King, Jr., then a young clergyman in Montgomery with little experience in the techniques of mass protest, organized 17,000 black Americans. The success of the boycott so enraged local authorities that they sued immediately to have it declared illegal. A little more than a year later the United States Supreme Court ruled that Alabama laws requiring segregated seating on public conveyances were unconstitutional. She has continued to be involved in civil rights matters, and has received numerous awards for her efforts. Her initial step toward desegregation will never be forgotten. As Dr. King noted, Rosa Parks was "the great fuse that led to the modern stride toward freedom."

PROPOSITION 209: A referendum that "Prohibits the California state, local governments, districts, public universities, colleges, and schools, and other government instrumentalities from discriminating against or giving preferential treatment to any individual or group in public employment, public education, or giving public contracting on the basis of race, sex, color, ethnicity, or national origin." Proponents of the referendum believe that not every white person is advantaged, nor is every minority or woman disadvantaged; and that minorities and women can compete without special advantages. Those against Proposition 209 believe that it will eliminate programs for historically disadvantaged groups such as women and minorities.

WALTER RAUSCHENBUSCH: He was born in Rochester, New York in 1861. In 1886, he was ordained and began work among German immigrants as pastor of the Second German Baptist Church in New York City. In 1902, Rauschenbusch was appointed professor of church history at Rochester Theological Seminary and became a leading figure in the Social Gospel Movement that sought to rectify economic and social injustices. He died in 1918.

HIRAM RHOADES REVELS: Born in 1822 of free parents in North Carolina, he became a minister of the African Methodist Episcopal Church. He recruited three regiments of black troops during the Civil War and served as a chaplain for black regiments. He was elected to the Mississippi State Legislature in 1869. The following year he was chosen to complete Jefferson Davis' last term in the Senate and thus became the first African American senator in 1870. He died in 1901.

JO ANN ROBINSON: An Alabama State College english professor and the leader of the Women's Political Caucus (WPC), a group of 300 educated black women who had been concerned with voter registration and segregated public facilities since 1946. After Rosa Parks' arrest in Montgomery in 1955, she helped organize and implement a one-day bus boycott that resulted in the year-long Montgomery Bus Boycott.

PETER SALEM: He was born in 1750 as a slave in Framingham, Massachusetts. Salem fought as a soldier in the American Revolutionary Army, although there was much controversy over whether black Americans should be allowed to serve. According to a widely accepted belief, he fired the shot that killed British Major John Pitcairn at the Battle of Bunker Hill on June 17, 1775. He died in 1816 in poverty.

SOUTHERN CHRISTIAN LEADERSHIP CONFERENCE (SCLC): Founded in 1957, the SCLC's mission was to rally and redirect the resources and leadership of southern churches into the growing movement for civil rights. Martin Luther King, Jr., as the SCLC's first president, advocated the principles and tactics of nonviolent resistance to white supremacy. Following Dr. King's death, Ralph Abernathy and Joseph Lowery served as successive presidents of the organization. Martin Luther King, III, the eldest son of Martin Luther King, Jr., became President of the SCLC in 1997.

STUDENT NONVIOLENT COORDINATING COMMITTEE (SNCC): Founded in 1960, after the success of sit-in campaigns in public places, the SNCC reached out to students and young people who were committed to civil rights reform. The organization was involved in the "Freedom Rides", "Freedom Schools", and the Mississippi Freedom Democratic Party to help desegregate public facilities and gain voting rights for blacks.

WILLIAM MONROE TROTTER: He was born in 1872 and graduated Phi Beta Kappa from Harvard. As a journalist and civil rights advocate, he spoke out against racism and created the Boston Literary and Historical Association for militant thinkers and co-founded the Niagara Movement in 1905 with W.E.B. DuBois. Like DuBois, he disagreed with Booker T. Washington's optimistic stance that America's social conditions were improving and that black people needed to find a way to get along with white oppressors. He promoted formal education for blacks, spoke out against the treatment of black soldiers in World War I, and petitioned President Theodore Roosevelt to end segregation in Washington, D.C. He died in 1934.

SOJOURNER TRUTH: Born in 1797 as a slave named Isabella in upstate New York, she gained her freedom in 1827 when New York abolished slavery and became a prominent abolitionist and activist for women's rights. Deeply religious, she believed that she was on a mission from God and took on a new name that directed her to travel to speak out about her causes. She died in 1883.

HARRIET TUBMAN: Born about 1821, Tubman escaped from slavery in Maryland when she was 28 by running away. However, she returned to the South to help other slaves escape by becoming a "conductor" on the Underground Railroad. Between 1848 and 1858, she brought out more than 300 slaves, including her own family. When the Civil War broke out, she welcomed a new opportunity to fight against slavery and worked for the Union Army. She died in 1913 and received full military honors at her funeral.

NAT TURNER: Born into slavery in 1800 in Virginia, Turner rebelled against the oppression of his owners. In 1831, Turner led a slave uprising that involved 60 to 70 slaves and resulted in the deaths of about 60 whites. Although the rebellion was put down and Turner was executed, his actions provoked resistance and antislavery debate. Conversely, another effect of the uprising was the enactment of laws to restrict slaves and discourage any efforts to educate the negro in the South.

REVEREND WYATT TEE WALKER: Walker is a pastor, theologian, civil rights leader, and cultural historian. He was involved in the founding of the SNCC and SCLC and was one of the key participants with Dr. Martin Luther King, Jr. in the "Freedom Rides", and the Albany, Birmingham, St. Augustine, and Selma Campaigns. He is an authority on the music of the African American religious experience and has traveled widely as a human rights activist. He is world commissioner of the Program to Combat Racism of the World Council of Churches and is president of the American Committee on Africa and the secretary-general of its Religious Action Network. He is also chairman of the Consortium for Central Harlem Development and the pastor of the Canaan Baptist Church of Christ in Harlem.

BOOKER T. WASHINGTON: Born a slave in 1856, the child of an unknown white man and Jane, a slave cook. From 1872-1876, he attended Hampton Normal and Agricultural Institute in Virginia, paid for by a white benefactor. In 1881, he successfully directed and developed Tuskegee Institute in Alabama, a school that trained black men and women in industrial and domestic skills. In 1900, Washington established the National Negro Business League (NNBL) to promote and protect the interest of black businessmen. His autobiography *Up From Slavery* (1901), furthered his opinion that blacks must work with whites for gradual social change and equality. Throughout his career he was a controversial leader who achieved a level of tremendous power and influence. He died in 1915.

WORKS PROGRESS ADMINISTRATION (WPA): U.S. work program for the unemployed. Created in 1935 under the "New Deal", it aimed to stimulate the economy during the Great Depression and preserve the skills and self-respect of unemployed persons by providing them useful work.

ARTIST BIOGRAPHIES

SAM ADOQUEI b.1962; Ghana –
In 1981 Adoquei came to the U.S. from Ghana via Europe. He studied extensively in Italy where he was inspired by the paintings of the Old Masters. His art reflects a synthesis of art influences from Ghana, the U.S., and Europe. Upon arriving in the United States, Adoquei was artistically inspired by Dr. King's words and inclusive attitude, especially with regard to immigrants of color in America. Sam Adoquei teaches art in New York City.

LEROY ALMON b.1938; Talapoosa, Georgia – d.1997
In 1979, Leroy Almon became an aide and apprentice to folk woodcarver Elijah Pierce, establishing the only known master–apprentice relationship between a contemporary African American folk artist and a non-family member. His work was centered around themes of religious, social, and moral images.

CHARLES ALSTON b.1907 – d.1977; North Carolina
Charles Alston lived in New York City and attended Columbia University where he received his B.A. and M.A. He taught at Utopia House, an after-school arts center in Harlem (Jacob Lawrence, at age 13, was one of his students) and at City University of New York and the Art Students League. He combined realism and close study of African art to express the daily injustices and indignities of his fellow citizens. Like many of his generation, he worked as a WPA muralist. In 1963, Alston co-founded SPIRAL to promote the work of African American artists.

LOU BARLOW b.1908 –
Barlow was influenced by socially and politically active parents who directed his activities toward liberal and humanistic causes. He worked as a graphic artist from 1934–39 for the WPA, creating social and political images. Barlow enlisted in the army as a medical artist during World War II. Medical art would consume his career until 1980, when he again began to do wood engravings. He was present at the Dr. King Memorial in 1984, which stimulated him to create *1963—We Had A Dream—1984*. He lives in New York City producing social and political art.

JEAN-MICHEL BASQUIAT b.1960 – d.1988; New York, New York
Jean-Michel Basquiat was raised in a middle-class neighborhood of Brooklyn and began to make graffiti on the streets of SoHo in the 1970s. His art ranges from 'tagged' metal doors to abstracted canvases. He incorporated a great deal of fragmented words, copyright symbols and linear drawing in his large-scale pieces. In 1984–85 he collaborated with Andy Warhol on a series of paintings. Basquiat contributed to bringing marginalized African American art into the mainstream. He is remembered for his unique contribution to modern art.

ROMARE BEARDEN b.1914; Charlotte, North Carolina - d.1988
Romare Bearden lived and worked in Harlem, New York for most of his career. Bearden was the son of an artist and was influenced at an early age by the constant company of other artists and musicians. He studied with George Grosz at the Art Students League. Known for his collages of urban and rural black life, he was part of the 306 group in Harlem as well as SPIRAL, organizations that contributed recollections of civil rights experiences. He was an outspoken advocate for African American art and artists. A major retrospective exhibition was organized under the auspices of the Phillips Collection, and is currently traveling throughout the United States.

PHOEBE BEASLEY b.1943; Cleveland, Ohio –
Phoebe Beasley was trained as an artist during the turbulent 1960s. She was inspired by the the Civil Rights Movement and the work of Dr. Martin Luther King, Jr. to create artwork which captured aspects of the personal suffering and sacrifice of the Movement. Beasley is a mixed media artist who works with both figurative and abstract content. She now serves as a commissioner for the Los Angeles County Arts Commission.

GARY BIBBS b.1960; Lexington, Kentucky –
Gary Bibbs grew up in Lexington, Kentucky, in the midst of the civil rights protests and boycotts in the South. Bibbs creates monoprints in order for viewers to learn of the injustices of his generation. Bibbs uses symbols, metaphors, colors, and characters to express the intense atmosphere of the Civil Rights Movement, specifically Dr. King's Assassination. He is a professor in the Fine Arts Department at the University of Kentucky in Lexington.

JOHN BIGGERS b.1924; Gastonia, North Carolina – d. January 5, 2001
John Biggers was a gifted narrative artist widely known for his complex symbolic murals based on African American and African cultural themes. Biggers studied at the Hampton Institute in Virginia under art educator Viktor Lowenfeld and was mentored by Charles White. While at Hampton, he was introduced to the art of the American Regionalists, and the Mexican Muralists Diego Rivera, David Alfaro Siqueiros, and José Clemente Orozco. In 1957 Biggers made his first trip to Africa. The experience transformed his life and work. Biggers created a visual diary of his travels, *Ananse: The Web of Life in Africa*. Alvia Wardlaw wrote about Biggers's resulting work, "That such glorious celebrations of the beauty and power of African culture were executed in the heart of segregated Texas is testimony to the enormous impact Africa had on this talented artist". Biggers continued to work as an artist while serving as the head of the art department at Texas Southern University.

WILLIE BIRCH b.1942; New Orleans, Louisiana –
Birch studied at formal institutions in Baton Rouge, New Orleans, Baltimore and New York. Birch's trained abstract modernist style transformed itself into a more figurative tradition, including the use of gouache and papier màché, heavily influenced by folk art and its documentary and decorative nature. Birch has sought to create a truthful narrative of the Civil Rights Movement, and to uncover the reality of these significant historical events. Birch's two favorite subjects are said to be black pride and racial prejudice, themes which he uses to raise consciousness among all races. He continues to live and work in New Orleans.

ANTHONY BONAIR b.1945; Trinidad –
Anthony Bonair was born in Trinidad and came to the United States in 1969. In New York, he studied photography with Roy DeCarava and at the International Center of Photography. His work has been included in numerous exhibitions including, *Black New York Photographers of the 20th Century*, at the Schomburg Center in New York City (1999), and *Committed to the Image: Contemporary Black Photographers* at the Brooklyn Museum (2001). Bonair has curated photography exhibits and produced a portfolio on black photographers for the Bibliotheque Nationale (Paris) in 1991.

KAY BROWN b.1932 –
Kay Brown was the only female member of a group of black artists called "Weusi" (Swahili for Black) in Harlem during the 1960s. They had a gallery called "Nyumba Ya Sanaa" (House of Art). She worked as a printmaking apprentice and eventually was asked to join the "brotherhood" of artists. Brown is currently writing a book about the Black Power art movement and lives in Washington, D.C.

CALVIN BURNETT b.1921; Cambridge, Massachusetts –
Calvin Burnett was trained at the Massachusetts College of Art and Boston University in painting, drawing, printmaking, and collage. Burnett has written several books including *Objective Drawing Techniques*, and has received several awards and honors for his art. He participated in the 1969 exhibition, *12 Black Artists From Boston*, at the Rose Art Museum at Brandeis University. Still Boston based, he is a professor at the Massachussetts College of Art.

ARCHIE BYRON b.1928; Atlanta, Georgia –
Archie Byron grew up in the segregated South and was witness to the Civil Rights Movement. His boyhood companion was Martin Luther King, Jr. and he sang in the Rev. King, Sr.'s church choir as a boy. Byron's experiences have influenced him to create portraits of Dr. King, and other images of life in the South. He served on the Atlanta City Council from 1981-1989. Byron lives in Atlanta, Georgia.

PAUL CADMUS b.1904; New York, New York – d.1999
Cadmus trained at the National Academy of Design in New York from 1919–26, and the Art Students League in 1928. Cadmus has created many images of the African American struggle, demonstrating a mastery of the dramatic figure types of the Italian Renaissance. Cadmus was known for painting controversial works of contemporary social conditions as a WPA artist in the 1930s. His image *To the Lynching* was created for an exhibition about lynching in 1935.

ELIZABETH CATLETT b.1915; Washington, D.C. –
Elizabeth Catlett is the granddaughter of freed slaves. Catlett was trained as a painter, printmaker and sculptor in the 1930s at Howard University and the University of Iowa. Catlett is a civil rights activist and feminist, constantly presenting images of the African American woman. Catlett eventually settled in Mexico and became a member of the Taller de Grafica Popular (T.G.P.) in Mexico City, a print collective whose aim was to use art to benefit their people. She retired as director of the School of Fine Arts of the National University of Mexico in 1976. Catlett lives in Mexico.

SUE COE b.1951; Tamworth, Staffordshire, England –
Coe was trained at the Chelsea School of Art, and the Royal College of Art, London, in illustration and commercial art. With the escalation of the Vietnam War, Coe was drawn to political activism, and went to New York in 1972 believing it was a more accepting atmosphere for her political and artistic work. She taught at the School of Visual Arts, NYC from 1973–78, and has had her art published in such magazines as *The New Yorker*, *Time*, *Rolling Stone*, and *Mother Jones*. Sue Coe is known as a political activist who uses her illustrations to critique a wide range of social issues. She resides in New York City.

GERALD CYRUS b.1957; Los Angeles, California –
Gerald Cyrus received an M.F.A. from the School of Visual Arts in New York City and worked as a staff photographer for the City University of New York. Cyrus has participated in such exhibitions as *Committed to the Image: Contemporary Black Photographers*, Brooklyn Museum, *Reflections in Black: A History of Black Photographers*, *1840 to the Present*, Smithsonian Insitution, *Black New York Photographers of the 20th Century*, The Schomburg Center, New York, as well as having his work represented in many distinguished collections. He works as a freelance photographer and lives in Philadelphia, Pennsylvania.

BRUCE DAVIDSON b.1933; Oak Park, Illinois –
Davidson was born in Chicago and studied photography at the Rochester Institute of Technology and the School of Art at Yale University. He worked for Eastman Kodak and *Life* magazine publishing his first photo-essay in 1954, before joining the Magnum Photographic Cooperative. Davidson continued to photograph images of life in the South, as well as the Freedom Marches until 1965. Davidson is best known for his photo-essays, specifically, for his photographs of an East Harlem Neighborhood, entitled *East 100th Street* (1970). Davidson is widely recognized internationally and has photographs in numerous museum collections. He lives in New York City.

ULYSSES DAVIS b.1913; Fitzgerald, Georgia – d.1990
Davis lived in Savannah, Georgia for most of his life. He was a self-taught sculptor who earned a living as a barber while raising nine children. Davis created carved wooden panels and sculpture decorated with found items. During the Civil Rights Movement, Davis created many wooden busts of leaders such as Martin Luther King, Jr., and other major historical figures.

LOUIS DELSARTE b.1944 –
Artist and Professor of Art & Humanities, Delsarte has been a professional artist for over 30 years. A graduate of the University of Arizona, he received additional training at New York's Pratt Institute. Delsarte's works are in some of America's most renowned public collections including the Corcoran Gallery of Art, Howard University in Washington, D.C., and the Metropolitan Museum of Art in New York City. Delsarte seeks to express what comes from within, using color and design with a sense of movement that is often cubist, abstract or expressionistic in nature. He is a master printmaker and muralist who has contributed to numerous public art works.

RICHARD W. DEMPSEY b.1909; Ogden, Utah –d.1987
Richard Dempsey was an abstract expressionist who studied at the California College of Arts and Crafts in Oakland, the Art Students League in New York City, and with African American artist, Sargent Johnson. Dempsey created *Southern Schools* (1945) in response to political and social unrest, and disgust with the events of that period. The painting is a strong representation of Dempsey's regional and cultural thematic form of realism. Dempsey was a recipient of many awards including the Golden Gate Exposition Award, San Francisco, 1940, the Times-Herald Annual Exhibition Award, Washington, D.C., 1943, and a Julius Rosenwald Fellowship, 1946. He has exhibited at the Corcoran Gallery and Howard University.

THORNTON DIAL, JR. b.1953 –
Thornton Dial, Jr., has complemented the Dial family school of art and developed his own legacy of southern African American art. The artist works at Dial Metal Patterns with other family members, in addition to producing his art. Thornton Dial, Jr. utilizes metal, paint, found objects, and wood to display consistent themes of nature, the working man and the African American experience. His style is influenced by Pop Art and African folklore. Dial lives in Birmingham, Alabama.

THORNTON DIAL, SR. b.1928; Livingston, Alabama –
Thornton Dial was born on an Alabama plantation to a sharecropping family and worked for over 30 years as a steelworker in his hometown. He is a self-taught artist working in Appalachian and southern traditions, who became known in 1987 for his powerful constructions of found materials. Dial compiles scrap metal, rope, carpeting, canvas, wood, and paint onto canvas boards. He confronts issues of racism as well as addressing social and political issues. He lives in Bessemer, Alabama.

HARVEY DINNERSTEIN b.1928; Brooklyn, New York –
Dinnerstein was born in the Jewish neighborhood of Brownsville, Brooklyn. His art was influenced by his heritage and the urban community. Dinnerstein studied art in New York City and Philadelphia. During the Civil Rights Movement, he traveled with his wife, Lois, and Burt Silverman to Montgomery, Alabama, to sketch the protests, boycotts, marches, and people of the Civil Rights Movement. They accomplished approximately 90 drawings in their ten-day stay in Montgomery, Alabama, of such leaders as Martin Luther King Jr., Rosa Parks, and E. D. Nixon, as well as the hundreds of participants in the Boycott. Dinnerstein continues to paint and teach in Brooklyn, New York.

MARK DI SUVERO b.1933; Shanghai, China –
Mark di Suvero is a sculptor, painter, and assemblage artist. He attended San Francisco City College and received his B.A. from the University of California in 1956. Di Suvero has exhibited extensively and his art has been featured at the Whitney and Guggenheim Museums. He won the Doris C. Freedman Award (1987), the Albert S. Bard Award of Merit in Architecture and Urban Design(1988), and a Special Recognition Award at the Art Commune, New York (1995). His work is in the collections of many major museums, including the Whitney Museum of American Art, the Dallas Museum of Fine Arts, and the Art Institute of Chicago. Di Suvero lives in New York.

CARL DIXON b.1960; Jackson, Mississippi –
Dixon started carving as a hobby while working as a brick mason. The artist carves and paints a portrait of Dr. King every year to commemorate his hero. Dixon lives in Houston, Texas.

JAMES ALVIN DIXON b.1958 –
Love and Devotion is a collaborative effort of brother and sister, James A. Dixon and Deborah Watkins. James A. Dixon, born in 1958, received an M.F.A. degree from Colorado State University. His professional interests are contemporary painting, bronze sculpting, and drawing. Deborah Watkins, born in 1954, is a successful entrepreneur who specializes in designer picture frames.

SAM DOYLE b.1906 – d.1985; St. Helena Island, South Carolina
Sam Doyle was a native of St. Helena Island, near Frogmore, SC, which is known for its preserved generations of slave culture, and the surviving Gullah culture of coastal West Africa. Doyle grew up nearly isolated from the mainland United States. He attended Penn School, the first school for freed slaves, where he was encouraged by a teacher to develop his artistic talents. Sam Doyle's simple yet powerful images capture the social context of his environment and the troubles of southern life.

DAVID DUNLAP b.1940; Kansas City, Missouri –
David Dunlap's art is highly influenced by the ethics of Martin Luther King, Jr. He remembers hearing the "I Have a Dream" speech just about the same time he began keeping his "daily log books", in which he now keeps his artwork. Since the 1960s, Dunlap has finished over 83 log books. He also creates elaborate installations possessing a strong narrative quality while addressing issues of social justice. Dunlap lives in Iowa City, Iowa.

ALLAN EDMUNDS b.1947, Philadelphia, Pennsylvania –
Edmunds received his B.F.A. at the Tyler School of Art, Temple University, Philadelphia and Rome, and his M.F.A. at Cardiff School of Art in Wales. His art is social narrative, and explores themes that are often autobiographical, self-reflective, and historical. Edmunds remembers visiting the Martin Luther King, Jr. Memorial, and hearing his "I Have a Dream" speech when he was 15 years old. These experiences sparked his interest in creating art relating to civil rights. Edmunds is the founder and director of the distinguished Brandywine Printmaking Workshop in Philadephia.

MELVIN EDWARDS b.1937; Houston, Texas –
Mel Edwards is a large-scale metal sculptor of primarily political themes. He attended Los Angeles City College, the Los Angeles Art Institute, and received his B.F.A. at the University of Southern California. Edwards is highly influenced by his travels to Africa. He created the *Lynch Series* in response to the common occurrence of lynching in African American history. He lives in Plainfield, New Jersey.

ELLIOT ERWITT b.1928; Paris, France –
Elliot Erwitt emigrated to the U.S. from Europe in 1939. He came to Los Angeles in 1941 where he studied photography at Los Angeles City College, 1942–44, and film at the New School for Social Research in New York, 1948–50. Erwitt was influenced by Edward Steichen, Robert Capa, and Roy Striker, whom he met while serving as a photographic assistant in the U.S. Army. After serving in France and Germany, he returned to the United States and joined Magnum Photos. He has created numerous monographs and a significant body of documentary work. He lives and works in New York City.

MALAIKA FAVORITE b.1949 –
Favorite remembers the Civil Rights Movement as a young child, and was inspired by Martin Luther King Jr.'s speeches and encouragement to African Americans. She paints images of historical and present day problems confronting African Americans using found materials instead of traditional media. Her art evokes a feminist spirit in African American culture. Malaika Favorite lives in Atlanta, Georgia.

TOM FEELINGS b.1933; Brooklyn, New York –
As a young man, Tom Feelings was inspired by black authors such as Langston Hughes, W.E.B. DuBois, and Richard Wright, who gave Feelings a sense of identity and heritage. Feelings was trained at the School of Visual Arts, NYC, and received an honorary doctorate in 1996. In 1964, he lived and worked for two years in Ghana as an artist, teacher, and illustrator for the *Africa Review*. Feelings' art reflects his responsibility as a black artist to express the enduring history of African Americans. He has illustrated over 20 books, and has won numerous awards, including the Caldecott and Coretta Scott King Awards. He lives in Columbia, South Carolina.

BENEDICT J. FERNANDEZ b.1936 –
In 1989, Benedict Fernandez published his 1960s photographs of Dr. King in a book called *Countdown to Eternity: Photographs of Dr. Martin Luther King Jr.* This portfolio contains 12 photographs taken during the last year of Dr. King's life, April 1967 to April 1968. Fernandez captured images of King at the Solidarity March in Central Park, King playing with his children, giving speeches in Chicago, preaching at Ebenezer Baptist Church, and numerous other commemorating images. Fernandez lives in New Jersey.

BOB FITCH b.1939 –
Bob Fitch began his career as a photographer in the mid-1960s. He was a staff photographer for SCLC, traveling throughout the South to document day-to-day events of the Civil Rights Movement. Fitch has documented social justice activities photographing Cesar Chavez and the United Farm Workers Union, Dorothy Day and the Catholic Worker Houses of Hospitality, and the war resistance efforts of Fathers Daniel and Phillip Berrigan. He finds photojournalism an effective way to support a variety of social justice causes. Fitch lives in Santa Cruz, California.

AUDREY FLACK b.1931; New York, New York –
Audrey Flack attended Cooper Union in 1951 and Yale University where she received her B.F.A. in 1952, studying under Josef Albers. She also attended NYU Institute of Fine Arts in 1953. She is known for her photo-realist painting, and during the 1960s created images from documentary news sources of public figures such as Presidents Kennedy and Roosevelt, and Adolf Hitler, as well as painting images of women. She considers art an exploration of visual data. Flack lives in New York City.

ROBERT FRANK b.1924; Zurich, Switzerland –
Robert Frank traveled the world before settling in the U.S. in 1953. In 1955 he received a Guggenheim Fellowship that enabled him to tour the United States for two years by car. Frank sought to photograph social issues of 1950s post-war America. He changed photography by capturing emotions of despair, depression, and boredom in his groundbreaking book, *The Americans*, published first in France in 1958, and then in the United States in 1959. Frank lives in New York City.

L'MERCHIE FRAZIER b.1951; Jacksonville, Florida –
L'Merchie Frazier was a member of the NAACP youth movement, traveling with this group throughout the South. She was involved at the age of 12 with issues of segregation and racism. Frazier came from a matriarchal family, learning to be strong in the face of adversity. She creates quilts and banners in a tradtional form documenting the Civil Rights Movement. Frazier has made a series of documentary quilts and banners incorporating the mythology and cosmology of African peoples. She lives in Roxbury, Massachusetts and is the director of education at the Museum of Afro-American History in Boston, Massachusetts.

LEONARD FREED b.1929; Brooklyn, New York –
Leonard Freed has produced a large body of work dealing with diverse social and political issues. In 1968, his work was published in a book entitled *Black in White America*. Photography became Freed's method of discussing violence and racial discrimination, as depicted in his studies of the Ku Klux Klan, German society, and his own Jewish roots. Freed joined Magnum Photos in 1972, and has produced projects for the vast majority of the leading domestic and international magazines.

REGINALD GAMMON b.1921 –
Gammon worked and lived in New York City during the 1950s and 1960s. He attended the March on Washington in 1963 and heard Martin Luther King, Jr.'s "I Have a Dream" speech, which he describes as, "charismatic and profound". His activity in the Civil Rights Movement continued when he joined the SPIRAL group in 1964. He lives and works in New Mexico.

PETER GEE b.1932; Leistershire, England –
Gee studied typography and design at the Cambrige and London Schools of Art. In 1962, Gee came to the United States and taught color workshops at The School of Visual Art, The New School, and Harvard University's School of Architecture. His early posters for the List Art Poster program, Pace Graphics, and covers for *Time* magazine taught him to paint with typography. His "Pop" posters and prints in the 1970s were shown in *Word and Image* at the Museum of Modern Art. Gee has exhibited his work widely, and lives and works in New York City and Provincetown, Massachusetts.

REGINALD GEE b.1964 –
Gee is a self-taught artist and writer living in Milwaukee, Wisconsin. In recent years, Gee has participated in dozens of shows, including *Soul of Black Folk*, *Folk Fest*, *The Outsider Art Fair*, *The National Black Fine Arts Show*, and *The Chicago Black Art Expo*. Gee incorporates his own visionary images, symbols, and numerology into his art. When asked how he learned about art, Gee replied, "I didn't. I still haven't learned. You just do it". The *Milwaukee Journal Sentinel* describes Gee's art as "tribal art–derived from Pop Culture and art magazines."

SAM GILLIAM b.1933 –
Sam Gilliam attended the University of Louisville where he and other black students banded together in response to discrimination in the university, galleries, and community. In the late 1960s he was known for his Abstract Expressionist art–unsupported canvases draped or suspended from walls and ceilings. He is also celebrated for his collages and canvases reminiscent of patchwork quilts, infused with design elements from traditional Western Africa and Southern U.S. styles. His work is in the collections of many major museums, including the National Museum of American Art and the Studio Museum in New York.

PAUL GOODNIGHT b.1946; Chicago, Illinois –
Goodnight was raised in New London, Connecticut and Boston, Massachusetts. He received a B.A. in 1976 from the Massachusetts College of Art. After returning from serving in the Vietnam War, he was so traumtized by images of the war that he was unable to speak. He used his art to communicate his thoughts and feelings, eventually regaining his physical voice. Goodnight lives in Chicago.

HARRY GOTTLIEB b.1895; Bucharest, Rumania – d.1993
In 1907 Harry Gottlieb emigrated with his family to the U.S. settling in Minneapolis, where he attended the Minneapolis Institute of Art (1915-17). In 1923, with his wife Eugenie, he participated in an artists' colony in Woodstock, New York. In 1935, he joined the Federal Arts Project and was one of the first members of the WPA's silkscreen unit. Until his death, he lived in Woodstock, New York.

215

PHILIP GUSTON b.1913 – d.1980; Montreal, Canada
Guston was a self-taught artist, briefly attending Otis Art Institute in Los Angeles. Guston alternated between drawing and painting to create images with strong social content. Between 1932–40, he worked as a WPA artist and executed several New Deal murals. In 1950 Guston settled in New York City and co-founded, with Jackson Pollock, the New York School of Abstract Expressionism. In the 1960s, Guston abandoned his 20-year involvement as a leading abstract painter of the New York School in response to a growing record of violence against Civil Rights activists. He developed a figurative style, using hooded Klan figures as symbols of hatred and bigotry in America. Guston received many awards and fellowships. His work is in the Guggenheim Museum, the Whitney Museum of American Art, and the Tate Gallery.

ROBERT GWATHMEY b.1903; Virginia – d.1988
Gwathmey was exposed to segregation growing up in Virginia. He attended the Maryland Institute of Art, and in 1930 earned a degree at the Pennsylvania Academy of Fine Art. Robert Gwathmey is known for his social realist paintings of the South. He was one of the first white artists to depict African Americans as dignified citizens. Gwathmey used modernist styles, with the use of bold colors and geometric shapes, as well as incorporating rural southern images, influenced by his Virginia childhood memories. He married artist Rosalie Hook, who produced a documentary on blacks in the South, which became a source of inspiration for his work.

CHESTER HIGGINS b.1946 –
The work of Chester Higgins was influenced by his mentors, P.H. Polk, Arthur Rothstein, Cornell Capa, Gordon Parks, and Romare Bearden. He has been a staff photographer for the *The New York Times* since 1975. His work has appeared in over a dozen major magazines, and six books of his work have been published . He recently published *Elder Grace: The Nobility of Aging*. Higgins lives in Brooklyn, New York.

RICHARD HUNT b. 1935; Chicago, Illinois –
Richard Hunt, printmaker, lithographer, and sculptor, graduated from the School of the Art Institute of Chicago in 1957. He is one of the leading contemporary metal sculptors, and regularly receives commissions for large public outdoor sculptures. His sculptures are often open-form pieces made from welded steel and auto parts in natural and manufactured forms. He received a Guggenheim Fellowship in 1962, and in 1965, worked for the Tamarind Lithography Workshop in Los Angeles. His work is represented in many museums and public spaces in the United States He lives in Chicago.

ROBERT INDIANA b.1928; New Castle, Maine –
Robert Indiana was trained at the Herron School of Art, Indianapolis (1946), the Munson-Williams-Proctor Institute, Utica, NY (1947–48), the School of the Art Institute of Chicago (1949–53), and the University of Edinburgh and Edinburgh College of Art (1953–54). After 1954, Robert Indiana settled in New York City. Indiana's early pieces were inspired by traffic signs, automatic and amusement machines, commercial stencils, and old trade names. In the 1960s, Indiana created sculpture assemblages and developed a vivid, coloristic style.

CARL IWASAKI b.1923; San Jose, California –
A self-taught photographer, Iwasaki grew up in California. He and his family were evacuated and sent to Los Angeles, and then to Hart Mountain, Wyoming, as part of the internment of Japanese Americans during World War II. Iwasaki was hired by the Relocation Authority to photograph Japanese Americans throughout the country. In 1948, he was hired by Time/Life, and continued to photograph for *Life* magazine until 1972. Later, he joined *Sports Illustrated*, for whom he photographed until 1989. His work has been exhibited by the Howard Greenberg Gallery, New York. Iwasaki lives in Denver, Colorado.

BILLY MORROW JACKSON b.1926; Kansas City, Missouri –
Billy Morrow Jackson is a versatile artist who works in different media. Jackson received formal training at Washington University and the University of Illinois, continuing his education after serving in the Marines in World War II. For a period of time he lived in Mexico where he observed and made woodcuts after Mexican Expressionists. His subject matter showed the injustices that poor people in Mexico suffered. A concern for issues of social justice continued through his career. Dr. King was a strong catalyst for Jackson's representations of racial injustice. He was deeply moved by Dr. King's humility and dedication to the Civil Rights Movement.

EASTMAN JOHNSON b.1824; Lowell, Maine – d.1906; New York, New York
Johnson was initially trained as a lithographer in Boston, but later became known as a portrait artist of such political and social figures as John Quincy Adams, Dolly Madison, and Mrs. Alexander Hamilton. Johnson later left portraiture and became interested in genre painting. In 1859, he was elected a member of the National Academy of Design, after painting *Old Kentucky Home – Life in the South*. This painting, which depicted slave quarters on a southern plantation, created much social debate, and a respectful reputation for Johnson. Johnson was an active participant in the art world, frequently exhibiting with the Society of American Artists. He helped found, and was a trustee for, the Metropolitan Museum of Art.

LOIS MAILOU JONES b.1905; Boston – d.1998
Lois Mailou Jones's career spanned over 60 years, and her work has been widely exhibited since 1973. Jones studied at the School of the Museum of Fine Arts, Boston, where she was the first African American to graduate. She also studied at the Academie Julian in Paris and Howard University. She worked extensively in the French-speaking world, in particular France, Haiti, and Senegal. As a professor of design and painting at Howard University for 40 years, Jones had a major influence on several generations of artists.

NAPOLEON JONES-HENDERSON b.1943 –
Napoleon Jones-Henderson studied at the School of the Art Institute of Chicago and at Northern Illinois University. Through the Research Institute of African Diaspora Art, which he founded, he conducts research on the black visual arts heritage. Jones has been active as a printmaker, textile, and enamel artist, and leather artisan. One of the original members of Africobra, Jones-Henderson has rooted his work in the aesthetic developed by that Chicago-based group, which in the late 1960s, sought to find a visual language with the intensity and power of black soul music. Henderson's work is frequently exhibited, and he has work in the collections of Hampton University, the Schomburg Center for Research in Black Culture, and the Art Institute of Chicago. He lives in Columbia, South Carolina.

CLIFF JOSEPH b.1927 –
Cliff Joseph expresses his deepest concerns for social injustice through his oil paintings. He began a series of paintings that addressed the social movement of Dr. King some years ago. He warns viewers of nationalism and its effects, and chooses to confront the viewer with his images. Joseph was a co-founder of the Black Emergency Cultural Coalition with Benny Andrews. A graduate of the Pratt Art Institute and the Turtle Bay School of Therapy, he now works as an art therapist and teacher.

JAMES KARALES b.1930 –
Karales was an active photojournalist during the Civil Rights Movement and Vietnam War. He worked for *Look* magazine from 1960–71. His stirring 1965 picture from the Selma March of marchers striding in silouhette has become an icon of the Civil Rights Movement. It was commissioned for a *Look* story called "Turning Point For the Church" which highlighted the white northern clergy's involvement in the struggle for civil rights. Mr. Karales produced many other important photographs throughout his distinguished career. He lives in Croton-on-Hudson, New York.

JACOB LAWRENCE b.1917 – d.2000; Atlantic City, New Jersey
Jacob Lawrence lived and painted in Harlem for most of his career. He taught at Black Mountain College, North Carolina; Art Students League; New School for Social Research; and the Pratt Institute in Brooklyn. He is best known for his "Migration Series". As a member of the 306 Group in Harlem, he was the first African American artist to be represented by a major commercial gallery, and the first to receive sustained mainstream recognition in the United States. Writing in the catalogue for Lawrence's retrospective exhibition at the Whitney Museum in 1974, art historian Milton C. Brown noted: "There is something monolithic about Jacob Lawrence and his work, a hard core of undeviating seriousness and commitment to both social and black consciousness...He has at the same time continued to insist on the larger human struggle for freedom and social justice in all the world and for all people."

ANNETTE LEMIEUX b.1957; Norfolk, Virginia –
Lemieux received her B.F.A. from the Hartford Art School, and has been exhibiting her art since 1980. Lemieux creates images based often on her personal experiences. Her work is in the Museum of Modern Art, New York; the Solomon R. Guggenheim Museum; Wadsworth Athaneum; the Museum of Fine Arts, Boston; the Fogg Art Museum; the Museum of Contemporary Art, Chicago; the Milwaukee Art Museum, and the Baltimore Art Museum. Lemieux has exhibited nationally and internationally and participated in the 2000 Whitney Bienniale.

216

JACK LEVINE b.1915; Roxbury, Massachusetts –
Levine studied painting at the School of the Museum of Fine Arts in Boston. He received an honorary degree from Colby College, 1946. Jack Levine forged his artistic identity as a Social Realist, depicting the injustices in contemporary society. Much of Levine's painting grew out of firsthand experience and observation of the local toughs, thugs, cops, and politicians in the South Boston of his youth. Through the 1950s and 1960s his work encompassed satirical themes and spoofs of classical myths. He has spent most of his career in New York City, where he presently resides.

NORMAN LEWIS b.1909 – d.1979; New York, New York
Norman Lewis was an Abstract Expressionist of the New York Movement in the 1940s. He began painting at the same time as other abstract artists who became known collectively as the "New York School." He studied under Augusta Savage, and was a member of the WPA. During the 1960s, Lewis, as a member of SPIRAL, helped to document experiences in the Civil Rights Movement. Lewis was a political activist, and used images of social injustice and the Civil Rights Movement in his work. Lewis co-founded New York's Cinque Gallery with artists Romare Bearden and Ernest Critchlow.

GLENN LIGON b.1960; Bronx, New York –
Glenn Ligon is a conceptual artist who often uses text with his images of African American issues. Ligon has incorporated famous African American texts from Ralph Ellison's *Invisible Man*, and Zora Neale Hurston's *How It Feels to Be Colored Me*. Ligon questions how the African American presence was documented throughout history, by themselves and others. In his 1993 series *Runaway*, Ligon assumes the persona of a runaway slave. He confronts the generalizations of exterior apperance, and how being colored becomes being obscured. Ligon lives in New York City.

MAYA YING LIN b.1960; Athens, Ohio –
Educated at Yale University, Maya Lin has designed and created art and architectural projects throughout the United States. Lin's work has included both public and private artworks, including the Vietnam Veterans Memorial (1982) in Washington, D.C.; the Civil Rights Memorial (1989) in Montgomery, Alabama; and the Langston Hughes Library (1999) in Clinton, Tennessee. Her work has been highly acclaimed and was the subject of an Academy Award-winning documentary film, *Maya Lin: A Strong Clear Vision*. She lives in New York City.

TRUDY. LUDWIG b.1959 –
Trudy Y. Ludwig received her B.A. in Art and Art History from St. Olaf College, her M.A. in Art History from George Washington University, and her M.F.A. in Studio Art from Towson University. She teaches printmaking at Maryland Institute College of Art, and Art History at Towson University. Her solo exhibitions include *Miracles and Madness: New Icons for a 20th Century Cathedral*, and *Grace Period*. Ludwig uses the traditional printmaking techniques of woodcut, linocut, and etching. She lives in Pikesville, Maryland.

DANNY LYON b.1942 –
From 1962–1964, Danny Lyon worked for the SNCC as a staff photographer. Under the direction of one of its leaders, James Forman, the SNCC enlisted and trained over a dozen photographers, set up networks for distributing its pictures, supported the Southern Documentary Project, and published photographic pamphlets and posters. He photographed extensively at SNCC demonstrations in Atlanta. Lyon's book *Memories of the Southern Civil Rights Movement*, one of several very important photographic essays of life in America done by Lyon, was published in 1992. He has received grants from the National Endowment for the Arts and the Guggenheim Foundation for filmmaking and photography. Lyon lives in New York.

WILLIAM MAJORS b.1930; Indianapolis, Indiana – d.1982
William Majors attended the Herron School of Art following a seven-year stay at a tuberculosis sanitarium. In the 1950s he studied at the Cleveland School of Art and in Florence, Italy, before settling in New York City. His teaching career spanned 23 years and included the Orange County Community College in Middletown, New York; California College of Arts and Crafts; University of New Hampshire; Rhode Island School of Design; Dartmouth College; and the University of Connecticut.

ALEX MALDONADO b.1901; Mazatlan, Mexico – 1989
Alex Maldonado emigrated to San Francisco during the revolution of 1910. He worked in shipyards, as a professional boxer, and at the Western Can Company. Upon his retirement from the Western Can Company, Maldonado was given a set of paints by his sister. This small set of paints started Maldonado's artistic career at age 60. Maldonado used a highly colored palette to render his personal imaginings and fantastic visions of nature and the built environment.

KERRY JAMES MARSHALL b.1955; Birmingham, Alabama –
Kerry James Marshall was raised in the Watts section of Los Angeles. He graduated from the Otis Art Institute in Los Angeles, and was a resident fellow at the Studio Museum in Harlem. Kerry James Marshall is a metaphorical figure painter. His images are fully descriptive of the struggles of the African American. His recent work, *Mementos*, is an evocation of the past, and in particular, a poignant meditation on the Civil Rights Movement. In 1997, Marshall received a MacArthur Foundation grant in recognition of his distinguished artistic career. He is known for his conceptualizing and confrontation of racial sterotypes. Marshall lives in Chicago, and teaches at the University of Illinois.

DAVID STONE MARTIN b.1913 – d.1992
David Stone Martin had a distinguished career as a graphic designer and was the art director of Folkways Records. Martin's graphic treatments went beyond fine art and stylish packaging to encompass a social concern previously lacking in jazz album cover design. Martin worked for the Tennessee Valley Authority during the Depression and developed strong feelings about the social inequities of the time. His unique combination of social consciousness and artistic attitude formed the basis for a new image of black musicians. His work is in the collection of the National Portrait Gallery.

EMANUEL MARTINEZ b.1947 –
Emanuel Martinez was on the western staff of the SCLC in the 1960s and helped to organize the Chicano faction of the Poor People's Campaign. He pays homage to Martin Luther King, Jr. for his work with the Chicano Peoples' Movement. Martinez lives in Morrison, Colorado.

GERALDINE MCCULLOUGH b.1922; Kingston, Arkanas –
Geraldine McCullough is a graduate of the Art Institute of Chicago, and received her undergraduate education at the University of Chicago. She also served as Chair for the Department of Art at Dominican University. Ms. McCullough has exhibited at many distinguished museums, including the National Museum of Women in the Arts; the Smithsonian Institution museums; and the Pennsylvania Academy of Fine Arts. Her sculptures are in public and private collections throughout the United States.

LEV T. MILLS b.1940 –
Mills graduated from the University of Wisconsin and received a Ford Foundation fellowship that allowed him to study at the University of London's Slade School of Fine Arts and at Atelier 17 in Paris. He is known for his work as a graphic artist and printmaker whose work contemplates contemporary notions of racial identity. He lives in Atlanta, Georgia, and teaches at Spelman College.

CHARLES MOORE : b.1931; Tuscumbia, Alabama –
Charles Moore is the son of a Baptist minister. He grew up witness to the harsh segregation laws of the South. After serving in the Marines, he attended the Santa Barbara Brooks Institute of Art. Moore was a staff photographer for the *Montgomery Advertiser*, *Alabama Journal* and *Life* magazine. Moore's photographs were sent out nationwide over the AP newswire, contributing to a flurry of outrage and support. He attended Dr. King's "I Have A Dream" speech, and participated in many sit-ins and demonstations. He lives in Florence, Alabama.

JOHN MOORE b.1939; Cleveland, Ohio –
John Moore had an early start to his artistic career—he took art classes at the Cleveland Museum Art School during Junior High. Later he attended Cuyhoga Community College and received his B.F.A. (1972) and M.F.A. (1974) from Kent State University. Moore chooses to paint on canvas in large geometric designs, in a restricted palette of black, white, red, and blue. In 1985, he moved to New York City, where he would teach and complete his artistic residencies. He has been exhibiting since 1975. Moore lives in New York City.

PHILIP MORSBERGER b.1933; Maryland –
Morsberger attended the Maryland Institute College of Art and received his B.F.A. from the Carnegie Institute of Technology. He also received a Certificate of Fine Art from the Ruskin School of Drawing in Oxford, England. He has taught at Miami University in Ohio; Rensselaer Institute of Technology; and the Ruskin School of Drawing.

GEOFFREY MOSS b.1938; Brooklyn, New York
Geoffrey Moss is recognized for his wide range of work: political satirical drawings, paintings, photography, and children's books. After receiving degrees from the University of Vermont and Yale University, he developed his non-traditional style that stands apart from the captioned cartoon genre. As a conceptualist forming a new metaphorical language, he is identified as being the first op-ed artist to be syndicated without captions. The first artist of this kind to appear on the op-ed pages of the *Washington Post*, he was with the *Post* for 23 years. During the Watergate Scandal, his "noir" graphic commentary was recognized with a nomination for a Pulitzer Prize. Moss lives in New York City.

ARCHIBALD J. MOTLEY, JR. b.1891; New Orleans, Louisiana – d.1981; Chicago, Illinois
Motley lived much of his life in Chicago, and was influenced by the vibrant Jazz culture of this city. He graduated from the School of the Art Institute of Chicago in 1918. One of the most important artists of his generation, Motley is best known for his stylized paintings of urban street scenes. Although Motley was restrained from a career in portraiture due to his race, he made a name for himself expressing the lives of African Americans and African American culture through his art. Motley continued this theme working for the WPA during the Depression. Motley traveled and worked in Paris and Mexico, and received a Guggenheim Fellowship in 1929.

MIKE NOLAND b.1958; Wynnewood, Oklahoma –
Noland has been very active as an artist after receiving his M.F.A. from Ohio State University (1982). He has had numerous solo gallery exhibitions, including the Carl Hammer Gallery in Chicago and the Harris Gallery in Houston, Texas. His love and respect for nature is a recurring theme in his work.

BARBARA OLSEN b.1935; Oakland, California –
Barbara Olsen began creating artwork for her own enjoyment while working as a nursery school teacher. She paints panels that resemble story quilts of historic women such as Harriet Tubman, Rosie the Riveter, Grandma Moses, and Annie Oakley. Olsen has been influenced by African American folk art—incorporating vibrant colors, large animals and personal struggles in her works.

ADEMOLA OLUGEBEFOLA b. Charlotte Amalie, U.S. Virgin Islands
Olugebefola's lithographic work has been shown in numerous museums, galleries and art festivals throughout North America, Africa, the Caribbean and Europe. A recent touring exhibition featuring 6 of his lithographs was on display at the Smithsonian Institution International Gallery in Washington, D. C. His work has been shown at the Charles Wright Museum, Detroit, MI, the Spelman Museum of Art, Atlanta, GA, and the Herbert F. Johnson Museum, Cornell University, Ithaca, NY. Recent solo exhibitions have included the Zilkha Gallery, Wesleyan University. He lives in New York City

JOHN OUTTERBRIDGE b.1933 –
Outterbridge remembers segregation in the South and the tenacious virulence of racism in the 1950s. He moved from Chicago to Los Angeles in the 1960s where he became an activist interested in the effort by black artists to gain access to galleries and museums for their work, including participating in protests at the Pasadena Art Museum. Outterbridge uses found objects in his works, and creates other objects to suggest found materials. He sees himself as an "artist in community", and uses his art to bring people together. He continues to work and teach from his studio in Los Angeles, California.

MARION PALFI b.1917; Germany – d.1978
As A. D. Coleman writes: "Marion Palfi practiced a form of advocacy journalism in which her own words and images, combined with textual material from other sources, were merged into extended statements on social, economic, and political issues. Unlike many of her contemporaries, Palfi never abandoned responsibility for the relationship between her imagery and its essential accompanying text..." Much of Marion Palfi's work was devoted to exposing discrimination and inequality in the United States. Her work was supported by the Taconic Foundation, the NAACP, the U.S. Department of Justice, as well as individuals including Eleanor Roosevelt, Edward Steichen, and Langston Hughes.

GORDON PARKS b.1912; Kansas –
Parks grew up the youngest of 15 children of a farmer in rural Kansas. Parks attended segregated schools in Kansas. He is a self-taught photographer, filmmaker, author, and composer. He was the first African American photographer hired by *Life* magazine in 1948. Parks also choreographed a ballet dedicated to Dr. Martin Luther King, Jr. Parks teamed up with author Ralph Ellison to produce photography to accompany

Ellison's writing, including, *Invisible Man*. A recent documentary of his life, *Half Past Autumn* was broadcast on HBO, and a retrospective exhibition of his photographs is touring under the auspices of the Corcoran Gallery. He lives in New York City.

DAVID PEASE b.1932; Bloomington, Illinois –
Pease studied at the University of Wisconsin where he received his M.F.A. Pease is a minimalist who typically incorporates impersonal, yet autobiographical, elements into geometrically surveyed configurations. Pease is interested in portraying the relationship of time, place, and activity in a scientific manner. He has shown in over 275 exhibitions, and has been granted numerous awards: a Guggenheim Fellowship (1965-66), a fellowship from the Pennsylvania Academy of Fine Arts (1978), and the Childe Hassam Fund Purchase Award (1970).

ELIJAH PIERCE b.1892; Baldwin, Mississippi – d.1984
Elijah Pierce was the son of an ex-slave and raised on a farm in northeastern Mississippi. He worked as a barber, preacher, and artist. Pierce gained recognition as a folk artist late in his life. He created predominantly painted and carved wood panels of biblical and slave scenes. Pierce traveled extensively across the United States, and used his carved panels to show during sermons he gave at churches and schools. Pierce has been documented in several films and in national publications. In 1954, he built his own barber shop which then became the Elijah Pierce Art Gallery.

HOWARDENA PINDELL b.1943; Philadelphia, Pennsylvania –
Howardena Pindell received a B.F.A. from Boston University and an M.F.A. from Yale University. She was influenced by Martin Luther King's encouragement of people and artists to speak out against injustice. She worked at the Museum of Modern Art in New York as curator of prints and drawings. As an artist she has worked to create equality in the arts through film, paintings, and photographs. She lives in New York City.

ELLIOT PINKNEY b.1934; Brunswick, Georgia –
Pinkney received his B.A. from Woodbury University in Los Angeles. He is a poet, painter, mural, and graphic artist currently living in Compton, California. Pinkney has painted numerous murals for youth centers, community buildings, libraries, and a metro station in Los Angeles. Pinkney's art and poetry is published in his books, *Heart and Soul, Down Home Places,* and *The Homeless*. Pinkney has received awards from the cities of Los Angeles and Compton, the State of California, in addition to the Letham Foundation, and the Theatre Guild-American Theatre Society awards.

HORACE PIPPIN b.1888; West Chester, Pennsylvania – d.1946
Pippin lived most of his life in Goshen, New York, and taught himself to draw and paint. He served in the U.S. Army in France during World War I and was injured by a sniper, losing his arm. Pippin developed a special painting technique as therapy and to accommodate his disability. Pippin painted many works depicting the daily activities of African American life and his interest in the history of emancipation, such as abolitionist John Brown, the *Abraham Lincoln Series* (1942-43), *Mr. Prejudice* (1943), and *The Whipping* (1941). Pippin's work was highly influenced by the growing tensions of the 1940s, specifically the Detroit race riots of 1943, and segregated regiments during World War II.

ALEX POWERS b.1940; Virginia –
Alex Powers decided that content and meaning in art was more important than form, design or decoration. This led to a career of painting focused on issues such as racism, economic inequality, religion, and human origins. He has been a self-employed art teacher and artist for 30 years. Alex Powers lives in Myrtle Beach, South Carolina.

DANIEL PRESSLEY b.1918; Wasamasaw, South Carolina – d.1971; New York, New York
Pressley was the son of a farmer and quilter, and the grandson of former slaves. He was a self-taught artist known for his wood panel reliefs. Pressley describes his wood sculpture as culturally traditional, and a "lost art" influenced directly from his enslaved ancestors. Pressley spent time in Ohio and lived in Brooklyn, New York from 1943 on. His work was exhibited in *Urban Outsiders* (1988), *Art of Black Diaspora* (1987), *New Black Artists*, Harlem Cultural Council with Columbia University (1969), and is in the collection of the Schomburg Center, New York.

MARY LOUISE PROCTOR b.1960; Tallahassee, Florida –
Proctor was raised by her grandparents. When growing up, she was influenced by religious preaching, and felt it was her calling, too. In 1994, after a devastating fire killed several members of her family, Proctor heard a "voice" that told her to paint. She feels it is her mission to paint as directed by the visions she receives from God and that is why she signs her paintings "Missionary Mary Proctor".

MARTIN PURYEAR b.1941; Washington, D.C. –
Martin Puryear was educated at the Catholic University of America, and after his undergraduate studies, traveled to Sierra Leone and West Africa with the Peace Corps, as an alternative to enlistment in the Vietnam War. He studied at the Swedish Royal Academy of Art, and later received his M.F.A. from Yale University. Choosing not to return to the United States, Puryear was led to the wood carving schools in Stockholm, Sweden. Martin Puryear was a part of the Minimalist Movement of the 1960s and 1970s and is now known for his powerful sculpture in wood. He recently completed several large-scale projects, including a sculpture for the J. Paul Getty Museum in Los Angeles. An exhibition of his sculpture is touring the country through 2002.

ROBERT RAUSCHENBERG b.1925; Port Arthur, Texas –
Rauschenberg attended the Kansas City Art Institute and School of Design; the Académie Julian in Paris; and studied under Josef Albers at Black Mountain College, North Carolina. After traveling and living in Europe, he moved to New York. Like many of his contemporaries, he utilized the printmaking medium to a great degree. He created hundreds of different prints spanning the course of his career. Rauschenberg is often referred to as the father of Pop Art. His work has been widely exhibited throughout the world, and he is the recipient of numerous major awards. As recently as January 1998, the Guggenheim launched an retrospective covering his career of more than 50 years, and establishing him as one of the most significant artists of our time. He lives in Captiva Island, Florida, and New York.

EUGENE RICHARDS b.1944; Dorchester, Massachusetts –
A freelance photographer, independent filmmaker, and writer, Eugene Richards is the author of 11 books, including *Few Comforts or Surprises: The Arkansas Delta* (M.I.T. Press, 1973), *Cocaine True, Cocaine Blue* (Aperture, 1994), *Dorchester Days* (Phaidon Press Ltd., 2000) and *Eugene Richards: 55* (Phaidon Press Ltd., 2001). Richards is the recipient of numerous awards for photography, including a Guggenheim; three National Endowment for the Arts grants; the W. Eugene Smith Memorial Award; and the Robert F. Kennedy Lifetime Achievement Journalism Award for coverage of the disadvantaged. Richards lives in Brooklyn, New York.

FAITH RINGGOLD b.1934; Harlem, New York –
Faith Ringgold is a painter, quilter, mixed media sculptor, performance artist and author. She received her B.A. and M.A. in Fine Art from City College of New York. Professor Ringgold is the recipient of more than 75 awards, including 15 Honorary Doctor of Fine Arts Degrees. Ringgold's art has been exhibited in the United States, Europe, Asia, South America, the Middle East, and Africa. Her art is included in many private and public collections, including The Boston Museum of Fine Arts; the National Museum of American Art; the Museum of Modern Art; the St. Louis Art Museum; and the Studio Museum in Harlem. Noted for her virtuosity and excellence of artistic achievement, Ringgold has won more than 30 awards for her books, including a Caldecott Honor and the Coretta Scott King award. Her public commissions include life-size mosaics, story quilts, and murals. Ringgold makes her art to reflect the long struggle for justice by African Americans. She lives in Englewood, New Jersey, and La Jolla, California.

LARRY RIVERS b.1923; Bronx, New York City –
Born Larry Grossberg, in 1940 he began his career as a jazz saxophonist and changed his last name to Rivers. He attended Julliard, where he had his first encounters with art. Rivers received his formal training at the Hans Hoffman School, studying under William Baziotes and Willhem de Kooning. Rivers addresses black cultural representations by placing subjects in classical paintings to create juxtapositions of typically assumed roles. Rivers was represented in the Sao Paolo, Brazil Bienniale. He has traveled through Central Africa and made a documentary *Africa and I* (1967). Rivers lives in New York City.

NORMAN ROCKWELL b.1894; New York – d.1978
Norman Rockwell had a great deal of formal education, concentrating on illustration. He moved to Arlington, Vermont in 1939, and this influenced his art to reflect small town American life. For 47 years, Rockwell painted for the *Saturday Evening Post*. Rockwell began to politically challenge his audience in his *Four Freedoms: Freedom of Speech, Freedom of Worship, Freedom from Want, Freedom from Fear*, inspired by Franklin Delano Roosevelt's 1943 speech. Rockwell's work illustrates some of his deepest concerns and interests including civil rights, America's war on poverty and the exploration of space. From small town atmosphere to large political concerns, Rockwell illustrated an evolving documentary of American life.

TIM ROLLINS AND K.O.S. (KIDS OF SURVIVAL) b.1955; Pittsfield, Maine –
Tim Rollins currently lives and works in New York City where he directs student teams of artists called K.O.S. (Kids of Survival), based in studios in the South Bronx and Chelsea neighborhoods of New York City, as well as in San Francisco and Memphis. K.O.S. is an organization devoted to creating collaborative artwork

inspired by multicultural issues. The group has had over 50 solo exhibitions, and is represented in over 30 permanent museum collections.

MARSHALL RUMBAUGH b.1948 – Wilkes-Barre, Pennsylvania
Marshall Rumbaugh still lives and works in Pennsylvania and is noted for his painted wood sculpture. Self-taught as a sculptor, Rumbaugh studied history and art history at Syracuse University. Later he worked as an archaeological illustrator in England. During his successful career as a commercial artist, his works were shown at the Philadelphia Museum of Art, the American Folk Art Museum, and the DeYoung Museum in San Francisco. His original work is in many private and public collections, including The National Portrait Gallery.

RAYMOND SAUNDERS b.1934; Pittsburgh, Pennsylvania –
Saunders received formal training at the Pennsylvania Academy of Fine Arts; University of Pennsylvania; Carnegie Institute of Technology; and the California College of Arts and Crafts. Toni Morrison has said of the artist that in his assembleges, "from an environment of the lost, the discarded, Saunders creates another wholly inscribed world of found things". Saunders creates work based on his impressions of Africa drawn from his travels in the 1970s and his attitudes toward the black artist's role and responsibilities. He lives in Oakland, California, and Paris, France.

PAUL SCHUTZER b.1931; Brooklyn, New York – d.1967
Paul Schutzer studied art at the Brooklyn Museum School of Art and Cooper Union. He attended Brooklyn Law School, but was drawn away to pursue his passion for photography. In 1956 he joined *Life* magazine and soon established an international reputation with his intimate, revealing photographs of John F. Kennedy. In 1961 he joined the Civil Rights Movement and rode the buses through the South. In a letter to his wife, Bernice, he wrote: "Tomorrow there's a chance I may be hurt. I'm going on the bus with the 'Freedom Riders'. The magazine ordered me not to go, but the very reason for not going is the reason I must..." Schutzer was the recipient of numerous awards for his distinguished contribution to photojournalism. His was a life cut short by the ravages of war.

ROBERT SENGSTACKE b.1943 –
Robert Sengstacke lives in Chicago, Illinois. He has been a photojournalist for over 41 years in Chicago and New York with an interest in documenting the African American experience. Sengstacke captured images of Dr. King and the civil rights activists in the 1950s. His photographs have been published in *Life, Ebony, Jet, Essence, The New York Times*, and *The Washington Post*. Sengstacke's photography is included in a collection of photographs at the Schomburg Center. Recently, Sengstacke's photographs were featured in *We Shall Overcome*, a Civil Rights exhibition created by the Smithsonian Institution in 1998.

BEN SHAHN b.1898; Kovno, Lithuania – d.1969
Shahn's family emigrated to New York in 1906. He was initially trained as a lithographer, but came to be known for his large body of work in the tradition of Social Realism that included paintings and prints. He attended New York University and the National Academy of Design. In 1931-1933 he achieved fame with a series of gouache paintings inspired by the Sacco-Vanzetti case, combining realism and abstraction in the service of sharp sociopolitical comment. In 1933 he assisted the Mexican muralist Diego Rivera with his Rockefeller Center mural, documenting social struggle, war, poverty, and politics, and worked for the Public Works of Art Project. In 1935-1938 he depicted rural poverty as an artist and photographer for the Farm Security Administration. After World War II he concentrated on easel painting, poster design, and book illustration.

BURTON PHILIP SILVERMAN b.1928; Brooklyn, New York –
A student at Pratt Institute and the Art Students League, Silverman has taught at the School of Visual Arts and the National Academy of Design in New York. His work has been widely exhibited at major institutions including: the Delaware Art Museum, the Philadelphia Museum of Art, and the Brooklyn Museum. Silverman had a retrospective exhibition at the Butler Institute of American Art (1999). He is well-known for his portraits in *The New Yorker* magazine. Resisting contemporary influences, he has stayed true to his realist style of figurative painting. Silverman lives in New York.

BERNICE SIMS b.1926; Hickory Hills, Alabama –
Bernice Sims received her high school diploma at the age of 52 and began to paint shortly after her graduation. She was inspired by visits to Mose Tolliver's home where she was exposed to his folk art creations. Sims is known for her memory paintings of scenes from the southern past. In the 1960s, Bernice Sims was a civil rights activist who encouraged and registered young African Americans to vote. Sims creates genre paintings of southern life and the struggles for civil rights such as the Selma March and the Birmingham protesters. She lives in Brewton, Alabama.

IN THE SPIRIT OF MARTIN

MONETA J. SLEET, JR. b.1926; Owensboro, Kentucky – d.1996
In 1969 Moneta J. Sleet, Jr. became the first black American to win a Pulitzer Prize in photography. His major contribution to photojournalism was his extensive documentation of the Civil Rights Movement. In 1956 Sleet met Dr. Martin Luther King, Jr., just as he was emerging as the leader of the Civil Rights Movement. When Dr. King was assassinated in 1968, Moneta Sleet covered the funeral, resulting in the Pulitzer Prize-winning photograph of Dr. King's grieving widow Coretta and daughter Bernice. Sleet received many awards including one from the National Urban League in 1978. His work has appeared in numerous museum exhibitions, including at the Art Institute of Chicago, and the Metropolitan Museum of Art.

CLARISSA SLIGH b.1939 –
Clarissa Sligh was a participant in the Civil Rights Movement. As a youth, she was involved in the court hearings and desegregation of Virgina schools in 1958. Her experiences of discrimination and segregation motivated her to continue civil rights work. Clarissa Sligh received her B.F.A. in 1972 and M.F.A. in 1999 from Howard University. Her artwork blends photographic and documentary images with personal references. She frequently uses Constitutional texts and Amendments to accompany her photographs to present the intensity of her personal experience. Sligh lives in New York City.

ALVIN SMITH b.1933; Gary, Indiana –
Alvin Smith is a painter, illustrator, and mixed media artist. Smith trained formally at the Universities of Iowa and Illinois, NYU, Kansas City Art Institute, and Columbia University Teachers College. He was an art teacher in New York public schools and lectures frequently on art education. Smith departs from iconographic symbolism and cultural icons, to focus on space, beauty, and human emotion. Smith's work is in the collections of the Dayton (Ohio) Museum; Mount Holyoke College, Massachussetts; the Gary (Indiana) Public Library; Tougaloo College, Mississippi; and Atlanta University, Georgia.

BEUFORD SMITH b.1939; Cincinnati, Ohio –
Beuford Smith is a self-taught photographer who began freelancing in the late 1960s. He was deeply involved in the Civil Rights Movement, capturing some of the finest images of African American political activists. He has received awards from the Art Directors Club, the Aaron Siskind Foundation, and is the recipient of a New York Foundation for the Arts Fellowship in 2000-2001. He is active in African American arts, publishing photographs in *A History of Black Photographers 1840-Present*, *Reflections in Black*, and *Collecting African American Art*. Smith was an associate curator of the exhibition, *Committed to The Image: Contemporary Black Photographers*, at the Brooklyn Museum of Art, 2001. He lives in Brooklyn, New York.

MARY TILLMAN SMITH b.1904; Brookhaven, Mississippi – d.1995
Mary T. Smith grew up in southern Mississippi where she received little formal education due to a hearing impairment. Mary Smith worked as a sharecropper, babysitter, and gardner, finally retiring in 1975. A sense of isolation from her disability, and harsh criticism from outsiders led Mary to decorate her home and yard as a personal diary of her life. Smith was a careful, intentional artist who incorporated television images, popular illustrations, and religious content into her work. Her pieces were mainly painted on wood or tin, and range from two inches to life-size.

VINCENT SMITH b.1929 –
Vincent Smith studied at the Brooklyn Museum of Art School and the Skowhegan School of Painting and Sculpture in Maine. Smith, like many black artists of the 1950s, experienced discrimination through having his work rejected by many galleries and museums. This lead him to encourage and work with other African American artists who were excluded as well. Smith has taken many trips to Africa and incorporates African elements into his art. Vincent Smith lives in New York City.

TRAVIS SOMMERVILLE b.1963 –
Travis Sommerville was raised in Georgia and Tennessee, and this inspired his investigation into the complexity of self and racism in the South. As the son of a minister and Civil Rights activist in the conservative South, he often experienced white racism due to his father's liberal views toward integration. His series of "portraits" began with a large work on paper that incorporated an image of JFK. Over the past years, he has been painting each critical period of his life via a surrogate—an image of a person who influences who and what he is. Somerville continues to explore perception of self through public events and personal memory of the history of the South. Through art making, he is investigating the continued complexity of racism.

MAY STEVENS b.1924; Boston, Massachusetts –
May Stevens received her B.F.A. from the Massachussetts College of Art in 1946, was a member of the Art Students League (1948), and the Academie Julien (Paris, 1948). She was living outside New York City with a small child at the time of the Civil Rights Movement and desperately wanted to go South, but could not. She surrounded herself with television and newspaper images of the time—and these became her inspiration. She immersed herself in everything she could get her hands on. The "Big Daddy" paintings of the late 1960s and early 1970s, dealt with the war in Vietnam and American racism. She lives in Santa Fe, New Mexico.

ALMA THOMAS b.1895; Columbus, Georgia – d. 1978
Alma Thomas lived most of her life in Washington, D.C. In 1924, she was the first student to graduate from Howard University's Art Department. She received her M.A. from Columbia University. Thomas was a highly distinguished colorist, painter, and educator who became a full-time artist upon retirement from secondary school-teaching in 1960.

JOE TILSON b.1928; London, England –
Tilson studied at St. Martin's School for Art, London, 1949-52, and the Royal College of Art, London, (1955). He is a multimedia and Pop artist. Tilson has traveled and exhibited extensively in Europe, specifically Spain and Italy. His work was represented in the 1961 Paris Biennale. Tilson continues to exhibit widely throughout Europe. He lives in London, England.

LEO TWIGGS b.1934; St. Stephen, South Carolina –
Leo Twiggs utilizes African American hereditary batik art as painting, using them in a similar fashion. He chooses to use batik to present themes influenced by his experiences in the segregated South and his hometown of St. Stephen. Twiggs received his B.A. from Claflin College, his M.A. from NYU, and was the first African American to receive a Ph.D. from Georgia University. Dr. Twiggs lives in Orangeburg, South Carolina.

ROBERT VICKREY b.1926; New York, New York –
Robert Vickrey is a realist painter, who utilizes classical egg tempera in his portraits. He attended Wesleyan and Yale Universities, and worked under Josef Albers and Lewis York. His images are highly symbolic, typically depicting the horrors and violence of war. Robert Vickrey has created 78 portraits for *Time* magazine. Between 1952–1963, Vickrey was in nine annual exhibitions at the Whitney Museum. His works are in the collections of the National Museum of American Art, the Smithsonian Institution, the National Academy of Design, the Brooklyn Museum, the Chrysler Museum, and the Corcoran Gallery.

PAUL ANDREW WANDLESS b.1967; Miami, Florida –
Paul Andrew Wandless was raised in Delaware and received his B.F.A. from the University of Delaware, and Masters degrees from Minnesota State University and Arizona State University. Wandless' work references and chronicles his everyday interactions and experiences. His works are self-portraits reflecting concerns, beliefs, and musings on his surroundings and day-to-day life. Wandless uses clay, oil paint, found objects, text, bold colors, and custom glazes for his experiential sculpture. His work ranges from glazed ceramics, oil paintings, and prints to wall sculpture. He lives in Havertown, Pennsylvania.

ANDY WARHOL b.1928; Pittsburgh, Pennsylvania – d.1987; New York, New York
Andy Warhol was born to Czech immigrants. He studied at the Carnegie Institute of Technology, Pittsburgh and settled in New York City in 1949. In New York he got his start in the commercial art world working for the Bonwit Teller department store, *Vogue,* and *Harper's Bazaar* magazines. Between 1956-1960, he traveled to Europe and Asia. In 1960, Warhol made his first comic-strip based images. He used the medium of silkscreen on canvas to make his famous images of Marilyn Monroe, Campbell Soup Cans, and Jackie Kennedy. His *Race Riot* series was created in response to the media coverage of the Civil Rights Movement.

ARLISS WATFORD b.1924 – d.1998
Largely self-educated, Arliss Watford was a television repairman and self-taught sculptor who started carving for his own pleasure. He began carving totems about 1980 to draw attention to his TV repair shop, that was evolving toward his first passion "Watford's Used Furniture, Antiques and Objects of Art." Watford carved compact, smoothed and simplified figures which he fashioned from cedar, and finished with a smooth patina.

220

SHERMAN WATKINS b.1940; Danville, Virginia –
Sherman Watkins graduated from Oklahoma University and served overseas in the U.S. Air Force for 20 years. Although he was not able to participate directly in the marches and protests of the Civil Rights Movement, he kept himself informed of the activities of the Movement, and painted his own documentary images of the events. He lives in Hampton, Virginia.

IDELLE WEBER b.1932; Chicago, Illinois –
Idelle Weber studied at Scripps College in Claremont, California, and received her M.F.A. from UCLA. Weber is identified as a photo-realist and printmaker. She manifests Pop-inspired silhouettes to photo-realist close-ups of found items to produce expressionist landscapes. In 1989–1991, Weber was the assistant professor of Art at Harvard. Idelle Weber's work is in permanent collections at the Albright-Knox Gallery, Buffalo; the San Francisco Museum of Modern Art; the Smithsonian Institution; and the Worcester Art Museum.

DAN WEINER b.1919 – d.1959
Dan Weiner was born in 1919 in New York to Russian/Romanian immigrant parents. He lived in Harlem and attended classes at the Art Students League and Pratt Institute. When he was 15, he received a camera from his uncle and in 1942 became a full-time freelance photographer and worked with Valentino Sarra. He taught at the Photo League School and worked as a photojournalist. In 1959, while on assignment, he was killed in a plane crash in the mountains of Kentucky.

CHARLES WELLS b.1935 – New York, New York –
Wells attended Amherst College, pursuing the craft of writing. After discharge from the Navy in 1958, he worked on a novel while living in New York, attempting to support himself by selling his art. Inspired by a book cover drawn by Leonard Baskin, Wells sought him out and arranged to serve as his apprentice. Wells later taught art at Smith College in Amherst, Massachusetts. He has had several one-man exhibitions in New York and Washington of prints, drawings, and sculpture. Wells was awarded the American Academy in Rome Fellowship in sculpture, and the National Institute of Arts and Letters Award to enable him to study sculpture in Italy.

CHARLES WHITE b.1918; Chicago, Illinoia – d.1979
At the age of seven, Charles White began painting. He studied at the Art Institute of Chicago, the Art Students League, and Taller de Grafia (Mexico). During his distinguished career, he taught at Howard University and Otis Art School in Los Angeles. White's exhibitions included more than 30 one-man shows, among them *Charles White: An American Experience* at the High Museum (1976). He was also the recipient of numerous awards, notably, from the National Academy of Design, and the American Academy of Art. He married artist Elizabeth Catlett in 1941 and they lived in New Orleans and Mexico. Most of his work deals with social and economic themes in Black America.

JACK WHITTEN b.1939; Bessemer, Alabama –
Whitten was educated at the Tuskegee Institute, (Alabama) and at Southern University in Baton Rouge, Louisiana. Throughout his childhood, he experienced segregation. He was trained and participated in the Civil Rights Movement as a nonviolent protester. Whitten met Dr. King in Montgomery in 1957, and was present at his 1963 "I Have a Dream" speech. His paintings are primarily memorials, dedicated to powerful guardian figures whose lives have touched him personally. Whitten's work includes a series of paintings dedicated to Martin Luther King, His work

expresses the tumultuous events and range of emotions experienced as a result of Dr. King's assassination. Whitten was a teacher at Pratt Institute, and received a Whitney Museum Fellowship in 1964. He lives in New York City.

JOHN WILSON b.1922 –
John Wilson received degrees from the School of the Museum of Fine Arts, Boston, and Tufts University. He studied at Fernand Leger's school in Paris, and in Mexico. A painter, printmaker, illustrator and educator, he has taught at the Pratt Institute and Boston University. John Wilson's painting, prints, and sculpture have been exhibited throughout the United States and abroad. His work is in many public and private collections including: The Museum of Modern Art (New York); The Bezalel Museum (Jerusalem); and the Carnegie Institute (Pittsburgh). Wilson is the recipient of numerous awards and honors, including a John Hay Whitney Fellowship, and a fellowship for sculpture from the Artists' Foundation. John Wilson is listed in *Who's Who in America*, and included in the Smithsonian Institution's Archives of American Art. John Wilson lives in Brookline, Massachusetts.

ERNEST C. WITHERS b.1922 –
Ernest Withers has lived in Memphis, Tennessee his entire life. Withers was a freelance photographer who covered the Civil Rights Movement in depth from the Emmett Till murder trial in Sumner, Mississippi, in 1955, to the Poor People's Campaign of 1968. Withers published a 20-page response entitled the *Complete Photo Story of Till Murder Case* in 1955. Withers continued to document images throughout the Civil Rights Movement.

HALE WOODRUFF b.1900; Cairo, Illinois – d.1980
Hale Woodruff grew up in Nashville, Tennessee, and lived in Atlanta, Georgia and New York City. He attended the Herron School of Art in Indianapolis from 1920–1924, and studied in Europe from 1927–1931. He was a professor at Atlanta University and New York University. Woodruff experienced discrimination from galleries and museums, and was once denied entrance to a lecture by Grant Wood because of his race. Wood learned of this and chided the High Museum, after which Woodruff and his black students were allowed entrance. Along with Romare Bearden, Charles Alston, and Norman Lewis, he founded SPIRAL—a group of artists who explored their common cultural experiences as black artists.

PURVIS YOUNG b.1943; Miami, Florida –
Purvis Young grew up and lives today in the Caribbean community of Overtown in Miami. Young was inspired and heavily influenced by the Caribbean immigrant culture and was mentored by Silo Crespo, an Afro-Cuban Santeria priest. Young creates large-scale murals in the streets of Overtown. His images of the struggling community span walls, documenting and reflecting the spirit of this community. "The art of Purvis Young is equal parts calligraphy, music, and graffiti. Its basic themes bump, collide, and eventually unite to reveal the chaotic and cacophonous dance of birth, death, and all that transpires in between in the artist's world," said Paul Arnett in *Souls Grown Deep Vol. II.*

MALCAH ZELDIS b.1931, Bronx, New York –
Malcah Zeldis is a self-taught artist who grew up in Detroit and currently lives in New York City. Zeldis has been greatly influenced in her work by Martin Luther King Jr., Abraham Lincoln and Gandhi. Her images evoke her feelings of immense communal harmony, and her artistic and emotional freedom. She illustrated Rosemary Bray's book *Martin Luther King, Jr.*

Born in 1956, I grew up in the turbulent '60s in a world with a backdrop of an unwanted war in Southeast Asia, racial injustice at home, a new drug culture, politcal unrest and four tragic assassinations which would profoundly effect all of our lives. I was only twelve when Dr. Martin Luther King, Jr. was murdered in 1968. The news was unbelievable to me. I could not understand why someone so dedicated to peace, freedom, and equality could meet with such a horrible end. I remembered how my mother and her sisters cried when John F. Kennedy was killed, I was only seven then. When I was nine, it was Malcolm X. Then we lost Bobby Kennedy only two months after Martin was gone. Dr. King's death proved to be the end of innocence for me. I had been drawing since I was very young, and had become a dedicated artist by age twelve. The death of Dr. King motivated me to create his portrait. Portraits of the slain civil rights leader now elevated to martyrdom, had replaced Spiderman and Batman on my list of priorities. One of these portraits of Dr. King found its way to Mrs. Coretta Scott King due to the efforts of my mother. Many months later, we received a response from Mrs. King. What a thrill! Thank you Mrs. King for making a big impression in the life of a little African American boy. Special thanks to Gary Chassman for his vision and for thinking of me for this once-in-a-lifetime project. Thanks also to my friend and creative director at Chadwick Communications, Chad Chadwick for his never-ending support. **–RANDELL PEARSON, BOOK DESIGNER**

CONTRIBUTOR BIOGRAPHIES

DONZALEIGH ABERNATHY: The youngest daughter of civil rights leader Reverend Ralph David Abernathy, her memories of the Civil Rights Movement serve as a wellspring of emotion for her leading role as Sara in the Lifetime Television show "Any Day Now". Abernathy is devoted to a variety of social causes, and is a founding member of the New Road Schools, which promotes cultural, religious, racial, and economic diversity. She recently completed a photo-essay entitled *Partners in History: Martin Luther King, Jr., Ralph David Abernathy and the Civil Rights Movement* which chronicles the Civil Rights Movement and the mutually dependent friendship of the movement's leaders. A native of the South, Abernathy lives in Los Angeles.

GWENDOLYN BROOKS: Gwendolyn Brooks was born in 1917, in Topeka, Kansas, and grew up in the slums of Chicago. Brooks published her first poem by the age of 13. She taught English at a number of colleges and in the 1930s served as the publicity director of the NAACP. *A Street in Bronzeville* (1945) established the central theme of her work, chronicling the cares of city-dwelling black Americans and her novel *Annie Allen* (1949) made her the first African American to win the Pulitzer Prize. In her 27 books, she offered insight into the African American culture, commentary on the impact of racial and ethnic identity on life, and a vision of the pressures of day-to-day existence. Brooks received more than 50 honorary doctorates, two Guggenheim awards, the National Endowment for the Arts Lifetime Achievement Award and was appointed to the American Academy of Arts and Letters. She died in December 2000.

GARY M. CHASSMAN: Chassman, born in 1940 in New York City, was educated at The Walden School, where he was first made aware of issues of racial discrimination. While attending Bradley University in Peoria, Illinois in the late 1950s, Chassman was a member of the NAACP, and was actively involved in the Civil Rights Movement. Chassman is the founder of Verve Editions, a producer of art and illustrated books. As creator and developer of the exhibition and book, *In the Spirit of Martin: The Living Legacy of Dr. Martin Luther King, Jr.*, Chassman is again addressing his life-long concerns for issues of civil rights and social justice. His career in publishing spans over 20 years. He is publisher of Tinwood Books, and was previously affiliated with Callaway Editions, and Aperture Books.

STANLEY CROUCH: Born in 1945 in Los Angeles, California, from 1965 to 1967, he worked as an actor and playwright in both Studio Watts and the Watts Repertory Theatre Company. From 1968 to 1975, he taught at the Claremont Colleges. In the fall of 1975, Crouch moved to New York City, writing for *The Village Voice* and *The SoHo Weekly News*. From 1979 until 1988, he was a staff writer for the *Voice*. His writing has also appeared in *Harper's*, *The New York Times*, *Downbeat*, and *The New Republic*, where he is a contributing editor. He has served as Artistic Consultant at Lincoln Center, and is a founder of "Jazz at Lincoln Center". His collection of essays and reviews, *Notes of a Hanging Judge*, was nominated for an award in criticism. In 1993, he was the recipient of a MacArthur Foundation grant. Crouch is presently writing the scripts for a television miniseries entitled *Jazz: The Music, The People, the Myth*.

NIKKI GIOVANNI: Yolanda Cornelia "Nikki" Giovanni was born in Knoxville, Tennessee, in 1943 and raised in Ohio. In 1960, she entered Fisk University, where she edited the literary magazine and participated in the local chapter of SNCC. After receiving her B.A., she entered graduate school at the University of Pennsylvania. In her first two collections, *Black Feeling, Black Talk* (1968), and *Black Judgement* (1969), Giovanni reflects on the African American identity. Recently, she has published *Blues For All the Changes: New Poems* (1999), *Love Poems* (1997), and *Selected Poems of Nikki Giovanni* (1996). Her honors include the NAACP Award for Literature in 1998, and the Langston Hughes award for Distinguished Contributions to Arts and Letters. Several magazines have named Giovanni Woman of the Year. She is currently a professor of English and professor of Black Studies at Virginia Tech.

JUNE JORDAN: Jordan was born in New York City in 1936. Her books of poetry include *Kissing God Goodbye: Poems, 1991–1997* (1997), *Naming Our Destiny: New and Selected Poems* (1989), *Living Room* (1985), *Passion* (1980), and *Things That I Do in the Dark* (1977). She is also the author of children's books, plays, a novel, and *Poetry for the People: A Blueprint for the Revolution* (1995). Her collections of political essays include *Affirmative Acts: Political Essays* (1998). Jordan's honors include a Rockefeller Foundation grant, the National Association of Black Journalists Award, and fellowships from the Massachusetts Council on the Arts, the National Endowment for the Arts, and the New York Foundation for the Arts. She is a professor at the University of California, Berkeley where she directs the "Poetry for the People" program.

STEVEN KASHER: Born in 1954 in New York City, Kasher is an artist, photographer, writer, curator, and art dealer. He is the author of *The Civil Rights Movement: A*

Photographic History, 1954–1968, as well as numerous articles on art and photography. He has been the curator of eight photographic exhibitions about the Civil Rights Movement. In addition, he was curator of "The Art of Hitler" an exhibition about Nazi aesthetics and its repercussions. Kasher lives in New York.

WALTER LEONARD: Dr. Walter J. Leonard is well known for his outstanding contribution to quality education for all and his devoted service to the Civil Rights Movement. He has been inspired in these activities by a deep and enduring belief that all parts of American society should have access to the great privileges, opportunities, and resources that America offers. Born in Alma, Georgia, he attended Savannah State College, Morehouse College, Atlanta University's Graduate School of Business, Howard University School of Law, and Harvard University Business School. Dr. Leonard has served as assistant dean of both Howard and Harvard University Schools of Law. He was the principal drafter of the Harvard Plan, a blueprint for efforts in higher education to establish equal education and employment opportunity. While at Harvard, he was founding chairman of the W. E. B. DuBois Institute. From 1977-1983, Dr. Leonard was president of Fisk University. He is a visiting scholar of the Centre for Socio-Legal Studies and an honorary member of Wolfson College, University of Oxford, England.

JULIUS LESTER: Dr. Lester was born in 1939 in St. Louis, Missouri, and grew up in Kansas, Tennessee, and Arkansas. In 1960 he graduated from Fisk University and became politically active in the Civil Rights Movement and pursued his interest in music. He hosted a radio and television show in New York City in the late 1960s. In 1971 he joined the faculty of the University of Massachusetts, Amherst where he is a professor in the Judaic and Near Eastern Studies Department and adjunct professor in the History and English departments. Lester is the author of more than 30 books including *And All Our Wounds Forgiven*, a novel suggested by the life of Martin Luther King, Jr. He also serves as lay religious leader of Beth-El Synagogue in St. Johnsbury, Vermont.

JOHN LEWIS: Lewis was born the son of sharecroppers in 1940 outside of Troy, Alabama. He received a B.A. from Fisk University and is a graduate of American Baptist Theological Seminary in Nashville, Tennessee. For more than 40 years, Lewis has been in the vanguard of progressive social movements and the human rights struggles in the United States. As a student, Lewis organized sit-in demonstrations at segregated lunch counters and participated in the "Freedom Rides". From 1963 to 1966, he was the chairman of the SNCC and became a recognized leader in the Civil Rights Movement. In 1963, at the age of 23, he was one of the planners and a keynote speaker at the "March on Washington". In 1965 he led 600 marchers across the Edmund Pettus Bridge in Selma, Alabama. Lewis has remained a devoted advocate of nonviolence. He remains active in his work for civil rights, and has served as a Democratic United States Congressman from Georgia since 1986. He published his account of the Civil Rights Movement, *Walking With the Wind* in 1998.

BERNICE JOHNSON REAGON: The daughter of a Baptist minister, Dr. Reagon performed with the SNCC Freedom Singers during the height of the civil rights struggles. In 1973, she founded the African American female vocal group Sweet Honey in the Rock. A historian and scholar, Reagon is Distinguished Professor of History at American University and Curator Emeritus at the Smithsonian Institution. Her numerous publications include *We'll Understand It Better By and By: African American Pioneering Gospel Composers* (1992) and *We Who Believe in Freedom: Sweet Honey in the Rock--Still on the Journey* (1993). She has been the recipient of a MacArthur Fellowship and the Charles Frankel Prize for outstanding contribution to the humanities.

HELEN M. SHANNON: Ms. Shannon was born in St. Louis, Missouri. She has degrees in Art History from Stanford University and the University of Chicago and a doctorate from Columbia University. Her dissertation explored the introduction of African art to the United States in the 1910s and 1920s. Ms. Shannon specializes in American Modernism, African American, and African art. She worked at The Detroit Institute of Art and The Metropolitan Museum of Art, and has taught at Rutgers University and Sarah Lawrence College. She is an independent scholar and curator living in New York City. Ms. Shannon was a "foot soldier" in the Civil Rights Movement when she attended a previously all-white elementary school.

GRETCHEN SULLIVAN SORIN: Ms. Sorin holds a B.A. from Rutgers University in American Studies and an M.A. in Museum Studies from the Cooperstown Graduate Program. She has more than 20 years experience as an exhibition curator. Ms. Sorin served as the guest curator of the widely acclaimed traveling exhibition "Bridges and Boundaries: African Americans and American Jews". She is currently the director of the Graduate Program in Museum Studies at the State University of New York at Cooperstown. She is a council member of the American Association for State and Local History.

ACKNOWLEDGEMENTS

First, I wish to recognize the artists without whose artistic expression this exhibition could not even have been contemplated, let alone realized. Many of these talented and dedicated people offered encouragement, immense cooperation and support, and most of all, their vision and dedication as artists. To them, I owe a deep debt of gratitude. Nor can I ignore or forget the artists who are no longer living, but whose spirit is alive in the extraordinary work contributed to this exhibition on their behalf. To these artists and the scores of others whose work for lack of space or availability could not be included—we are all forever in your debt—thank you. To all who were willing to loan art work to the exhibition—collectors, artists, museums, and galleries—I am so very grateful. But no more grateful than the hundreds of thousands of people who will be deeply affected and enriched by their visit to the exhibition itself.

A number of wonderful and talented people gave greatly of themselves by contributing original writing to the exhibition catalogue. Each of them is an enormous talent, and a marvelous human being. To Nikki Giovanni, I read and reread your marvelous poem. Walter Leonard, your foresight and vision are evident in whatever you do. Donzaleigh Abernathy, you and your talent are the legacy. June Jordan, all your acts are affirmative—and essential. Stanley Crouch, capturing the essence of what we feel but cannot express. John Lewis, you have shown us what is possible. Bernice Johnson Reagon, whose expression and emotion embodies our time. Julius Lester, from the depth of your heart, each tale is told. And finally Gwendolyn Brooks, who has left this earth, but whose words will always resonate within us.

Over the past several years of planning, research and development of the project, I have been guided, mentored and aided by many, many people. These able individuals have, almost without exception, been gracious, encouraging, deeply supportive and generous of spirit. I am forever in their debt. I want particularly to extend a heartfelt and enthusiastic thank you to Dr. Walter J. Leonard, who believed in the project, and in me, and who believed that I would see it through. To Barry Gaither, I want to extend my warmest wishes for his advice and assistance, and in leading me toward other wonderful people who he knew would be so very able in guiding the project. First among those to whom I was sent by Barry is Gretchen Sullivan Sorin, Principal Curator, whose warmth and goodwill were always in abundant supply, and whose depth of knowledge was equally apparent. To the other members of the Scholars Committee, Steve Carter, artist and friend—thank you for believing and caring. To Leslie King-Hammond, my deep appreciation for her insight and guidance. My gratitude as well for introducing me to Dr. Helen M. Shannon, Associate Curator. To Helen, my appreciation for her consummate knowledge, and tireless pursuit of so much of the art used in the exhibition. Steve Kasher's knowledge of photography brought a valuable dimension to the project. I am appreciative of his efforts.

Dena Andre was the first person I asked for advice. She was welcoming and generous with her ideas and information. I want to thank the people at The Smithsonian Institution Traveling Exhibition Services, (SITES), my collaborators, whose hard work contributed greatly to this exhibition. To Freddie Adelman, my appreciation for her recognition of the potential value and importance of this exhibition. To all the other members of the SITES team, Katherine Krile, Josette Cole, Sandra Narva, Andrea Stevens, my sincere appreciation for their hard work in the face of uncertainty. To Anabeth Guthrie who was a breath of fresh air—my thanks for your enthusiasm and interest. Annie Elliott, Director of Development, was at all times gracious, generous of spirit, and tenacious beyond any reasonable expectations—I owe you an unforgettable debt of gratitude.

Jon Gregg, Director of the Johnson (Vermont) Studio Center fed and sheltered the project team, affording us several days of intensive meetings at the Center, asking nothing in return. To Jon, our sincere thanks. I wish also to thank the Lintilhac Foundation and Robin Lloyd for their early financial support.

Over the three years this project was in development, Verve Editions was graced with the presence and hard work of several marvelous staff persons. Deborah Binder, Hannah Morris, and Maea Brandt all contributed greatly, motivated by their belief in the project. Steven West's contribution has been of incalculable importance. Steve was always there, bringing to his role, intelligence, insight and wit. He is irreplaceable. Steven, colleague and friend my heartfelt admiration. A number of dedicated interns from the University of Vermont labored hard on this project. Often long beyond that which was asked of them. Eliza and Julie Shanley, John McGurk, John DeLeo and, of course, Brandan Hardie, whose early research validated the premise on which the project was based. Without these fine people, we could not have achieved what we did. To Alyce Perry, my warm and heartfelt appreciation for all that you brought, and continue to bring to the project. Kathleen Friestad interrupted her personal life to apply her particular skills to the manuscripts, assuring us of "perfect pages".

Several wonderful designers are responsible for the richness and beauty of the exhibition catalogue: Randell Pearson, Art Director and chief designer for this book whose talents are lavishly displayed, Tai Tran, Associate Designer, whose interest and involvement were so very valuable, and Stacey Hood, whose talents are only exceed by her generosity of spirit. Michael Jager, Meghan Pruitt, and Kevin Kaszuba of Jager Di Paola Kemp Design contributed the design and development of the web site—to all of you bravo! Their work was masterful and their generosity unstinting. Rebecca Gubkin made it happen with grace and style. Michael, Meghan, Kevin and Rebecca, thank you so very much. I want to offer my respect and thanks to Paul Arnett, and Matt Arnett, of Tinwood Books who believed in the project and were so very helpful in bringing it to fruition. I cannot fail to mention Judy Arnett— Thank you for your expression of warmth and friendship. To Jane Fonda and William S. Arnett who are contributing in many important ways to the realization of this book, and to the wider awareness of the artists and their work—thank you so much for what you are doing.

I am deeply indebted to PepsiCo for their extreme generosity in sponsoring the national tour of this exhibition. A very special thanks to Ms. Jacqueline Millan for believing in this project—without her and Pepsico, it could not have become a reality. I want also to recognize The Martin Luther King, Jr. Center for Nonviolent Social Change for their sincere interest in the project, and for their kind cooperation and assistance. It is the hope of all of us that this exhibition will in some small way serve to further the message of Dr. King.

Finally, to Deborah Boothby, dear friend and wonderful wife whose love and caring are always present, and without whom there would be so much less in life.

CURATORIAL TEAM

Project Director	*Principal Curator*	*Visual Art Curator*	*Curator of Photography*
GARY MILES CHASSMAN	**GRETCHEN SULLIVAN SORIN**	**HELEN M. SHANNON**	**STEVEN KASHER**
Burlington, Vermont	Cooperstown, New York	New York City, New York	New York City, New York
Executive Director	Director, Graduate Program in Museum	Independent Curator and Scholar	Independent Curator
Book & Exhibition Developer	Studies, State University of New York		

SCHOLARS COMMITTEE

DR. WALTER LEONARD	**DR. LESLIE KING HAMMOND**	**EDMUND BARRY GAITHER**	**STEPHEN M. CARTER**
Chevy Chase, Maryland	Baltimore, Maryland	Boston, Massachusetts	Burlington, Vermont
Visiting Scholar, Oxford University	Dean of Graduate Studies, Maryland	Director, National Center of	Associate Professor of Art
	Institute College of Art	Afro-American Artists	University of Vermont

STAFF FOR VERVE EDITIONS

DEBORAH G. BOOTHBY	**T. STEVEN WEST**	**DEBORAH BINDER**	**MAEA BRANDT**
Burlington, Vermont	Burlington, Vermont	Edmonds, Washington	Burlington, Vermont
Research Associate	Administrator	Project Coordinator	Project Coordinator

BRANDAN HARDIE	**ALYCE PERRY**	**JULIE SHANLEY**	**ELIZA SHANLEY**
Project Research Intern	Senior Project Intern	Project Intern	Project Intern
University of Vermont	University of Vermont	University of Vermont	University of Vermont

PUBLISHED ON THE OCCASION OF THE TRAVELING EXHIBITION,
IN THE SPIRIT OF MARTIN: THE LIVING LEGACY OF DR. MARTIN LUTHER KING, JR.,
CREATED AND DEVELOPED BY GARY CHASSMAN, VERVE EDITIONS,
AND ORGANIZED FOR TRAVEL BY THE SMITHSONIAN INSTITUTION TRAVELING EXHIBITION SERVICE
IN COOPERATION WITH THE MARTIN LUTHER KING, JR. CENTER FOR NONVIOLENT SOCIAL CHANGE.

THE EXHIBITION WAS MADE POSSIBLE BY PEPSICO, INC.

Smithsonian Institution PEPSICO THE KING CENTER

THIS BOOK WAS DEVELOPED AND PRODUCED BY

VERVE
EDITIONS

BURLINGTON, VERMONT
verve@together.net
inthespiritofmartin.com
COPYRIGHT © 2001 BY VERVE EDITIONS
ALL RIGHTS RESERVED, INCLUDING THE RIGHT OF REPRODUCTION IN WHOLE OR IN PART IN ANY FORM.

PUBLISHED BY

TINWOOD BOOKS

ATLANTA, GEORGIA
www.tinwoodbooks.com
ISBN: 0-9653766-5-6

10 9 8 7 6 5 4 3 2 1

LIBRARY OF CONGRESS
CATALOGING-IN-PUBLICATION DATA IS AVAILABLE

PRINTED IN ENGLAND

BOOK DESIGN

CHADWICK COMMUNICATIONS LLC
NEW YORK, NEW YORK
www.chadwickcomm.com
RANDELL PEARSON . SENIOR DESIGNER
TAI TRAN . DESIGN ASSOCIATE

STACEY HOOD . PRODUCTION ASSOCIATE